*Elizabeth L. O'Leary*

# *At Beck and Call*

THE REPRESENTATION OF

DOMESTIC SERVANTS

IN NINETEENTH-CENTURY

AMERICAN PAINTING

*Smithsonian Institution Press*

WASHINGTON AND LONDON

Acquiring editor: Amy Pastan
Editor: Lorraine Atherton
Production editor: Jack Kirshbaum
Designer: Alan Carter
Production manager: Ken Sabol

Library of Congress Cataloging-in-Publication Data

O'Leary, Elizabeth L.
At beck and call : the representation of domestic servants in
nineteenth-century American painting / Elizabeth O'Leary.
p.    cm.
Includes bibliographical references and index.
ISBN 1-56098-606-9 (pbk. : alk. paper)
1. Domestics in art.    2. Painting, American.
3. Painting, Modern—19th century—United States.    I. Title.
ND1460.D65043    1996
758'.964049'097309034—dc20            95-49655

British Library Cataloging-in-Publication data available

Manufactured in the United States of America
00  99  98  97  96      5  4  3  2  1

∞  The paper used in this publication meets the minimum requirements of the American
National Standard for Permanence of Paper for Printed Library Materials Z39.48-1984.

*At Beck and Call*

*For John*

# Contents

# *Acknowledgments*

It is with much gratitude and pleasure that I acknowledge several individuals and institutions that have made this study possible. First, I thank Roger B. Stein for his generous direction and ongoing encouragement over the past nine years. He opened for me the exciting possibilities of considering American art within the broader framework of social and political history. Under his guidance, *At Beck and Call* was formulated and had its first incarnation as my doctoral dissertation at the University of Virginia. Other faculty members in the McIntire Department of Art—Christopher M. S. Johns and Judith Wilson, now at Yale—kindly reviewed versions of this manuscript and contributed valuable suggestions. Cindy S. Aron, who teaches American history in the Corcoran Department of History, also gave me significant criticism and advice. Moreover, I appreciate the various departmental grants and assistantships that helped support my study and research.

I am especially indebted to the Smithsonian Institution for granting me a one-year predoctoral fellowship in 1990–1991. During my residency at the National Museum of American Art, I had the privilege of working under the guidance of Lois M. Fink, whose careful reading and insights helped shape the direction of the project. As a fellow, I had the opportunity to explore the vast resources of that and other Smithsonian museum and research facilities: the Archives of American Art, the National Portrait Gallery, the Inventory of American Painting, the Catalogue of American Portraits, and the Peale Family Papers. I thank the following professional staff members at various Smithsonian agencies for their kind assistance: William H. Truettner, National Museum of American Art; Ellen H.

Grayson, formerly of the Peale Family Papers; Cecilia H. Chin, Martin R. Kalfa-tovic, and Patricia M. Lynagh, NMAA/NPG library; Jan Stuart, Louise A. Cort, and Ann Yonemura, Freer Gallery of Art/Arthur M. Sackler Gallery; and Fath Davis Ruffins, National Museum of American History. My work at the Smith-sonian was also enhanced by a supportive intellectual community of pre- and post-doctoral fellows at the NMAA Research and Scholar's Center, including David Brigham, Theresa Leininger, David McCarthy, Alex Nemerov, Michael Plante, Kathleen Pyne, David Steinberg, and Michele Wallace.

Other scholars have given me valuable gifts of their time, consideration, and expertise over the past few years. David Lubin has been particularly helpful in offering criticism of early drafts. I also thank Tom Baker, David Berreth, H. Nichols B. Clark, John d'Entremont, Ronald Fields, Robert Douglas Hunter, Peggy LeVine, Barbara J. MacAdam, Phyllis Palmer, Barbara Ryan, Jean Wetzel, Richard Guy Wilson, and Jean Fagan Yellin. I am very grateful to members of my former writing group, Barbara Brady, Julia Kellman, and Arlette Klaric. Shawn Linehan and Judy Thomas were instrumental in taking copy photographs and compiling public-domain images. For both logistical and moral support, I give special thanks to my friends Eric Denker and Paula Warrick.

At the Smithsonian Institution Press, Amy Pastan deserves particular recog-nition for her consistent enthusiasm and sound advice. Production editor Jack Kirshbaum, copy editor Lorraine Atherton, and designer Alan Carter oversaw the development of this project from manuscript to book with skill and thought-ful regard.

Most essential, however, were the continued love and advocacy of three dear people. My longtime friend Kay Parish spent countless hours reading and editing pages of my manuscript—a labor of love that I will never be able to repay. My mother, Ruth LeMay Lokey, early on nurtured my interest in history with stories of our ancestors, including the saga of my great great-grandfather who, as a bound servant, eloped to America with his master's daughter. Mother continues to provide bright, wondrous examples of new beginnings and abiding faith. And my husband, John Martin, to whom this book is dedicated, has been unfailing in his good humor, encouragement, and—most important—patience. To each, I offer deep appreciation.

*At Beck and Call*

# *Introduction*

The household is a school of power. There within the door, learn the tragi-comedy of human life. Here is the sincere thing, the wondrous composition for which day and night go round. In that routine are the sacred relations, the passions that bind and sever. Here is poverty and all the wisdom its hated necessities can teach, here labor drudges, here affections glow, here the secrets of character are told, the guards of man, the guards of woman, the compensations which, like angels of justice, pay every debt: the opium of custom, whereof all drink and many go mad. Here is Economy, and Glee, and Hospitality, and Ceremony, and Frankness, and Calamity, and Death, and Hope. —Ralph Waldo Emerson

In 1867, Ralph Waldo Emerson proposed that one could discover the human dimensions of power by entering the door of the private household. This was not a new concept for the renowned essayist and philosopher, who long sought to discover the moral foundations of the nation as revealed within the microcosm of the home. Much earlier, in his well- known address to the American Scholar, he encouraged an exploration of the "meaning of household life." On the eve of the Civil War, he again argued, "The household is the home of the *man*, as well as of the child. The events that occur therein are more near and affecting to us than those which are sought in senates and academies. . . . It is what is done and suffered in the house, in the constitution, in the temperament, in the personal history, that has the profoundest interest for us.[1]

Throughout the nineteenth century, American painters were also drawn to the household. On many levels—inadvertently or consciously, subtly or explicitly— their images communicate their understanding of the hierarchy found within the private realm. They also reveal their perceptions of the power structure within the national household itself. Fact, fiction, and artistic convention intermingle in their constructed visions of American home and family life in which women defer to men, children to parents, and servants and slaves to masters and mistresses. Just as the proud patriarch in Francis W. Edmonds's *Taking the Census* of 1854 (fig. 3-5) was pictured in the process of enumerating the members of his family for a census taker, the painter himself undertook the process of defining and describing the

I

universal American household: father, mother, children, and—just behind the matriarch's chair—the maidservant.

This six-part study examines the representation of domestic servants in nineteenth-century painting and explores the ways in which the images embody societal prejudices, fears, and expectations concerning those individuals—both black and white—who labored in the home. Individual images have been discussed previously in important studies such as *The Painters' America: Rural and Urban Life, 1810–1910* (1974), by Patricia Hills; *Winslow Homer's Images of Blacks: The Civil War and Reconstruction Years* (1988), by Peter Wood and Karen Dalton; and *American Genre Painting: The Politics of Everyday Life* (1991), by Elizabeth Johns. However, over time, servants have often been misidentified, ignored, or overlooked in discussions of American painting. Perhaps, like their historical counterparts, the figures became invisible in the shadowy margins and compositional interstices of canvases.[2] *At Beck and Call* approaches servant imagery as a theme—not as an iconographic checklist but as a consideration of the ways a young, democratic citizenry delineated its own practices and experiences of servitude. Like Emerson's vision of the household, the composite picture is complex, with its "wondrous composition" of contradictory and shifting dynamics. Nowhere else in the American imagination have associations of race, ethnicity, class, religion, and gender converged more fully than in the figure of the domestic servant.[3]

From 1800 to 1920, the presence of hired, bound, or enslaved servants in middle- and upper-class homes was commonplace. At any given time, between 15 and 30 percent of all private residences in the United States included at least one domestic worker. A great many servants lived in the houses where they worked and, as a result, were at the beck and call of employers throughout their waking hours. As part of larger, more specialized staffs, they functioned as cooks, scullions, nurses, housemaids, laundresses, lady's maids, waitresses, butlers, valets, and stewards. Most, however, worked alone as they performed all manner of general housework. Requiring little education or training, service consistently remained a low-status occupation that drew heavily from the ranks of unskilled, impoverished laborers. Moreover, with the feminization of the household in the nineteenth century, domestic labor became first and foremost a woman's job. Service would remain the primary occupation for working women until the 1950s.[4]

Because of the difficult conditions, prejudice, and social stigma that were inexorably associated with the occupation, free, native-born whites tended to shun it as degrading. This was especially true in the second half of the century, when service became disproportionately dominated by immigrants and African Americans, who had few other prospects for employment.[5] By the thousands, these "outsiders" were systematically introduced into the heart of American homes. The situation provided an unusual nexus in which white, Anglo-Saxon, Protestant families had

daily contact with persons of different cultural or racial backgrounds, and at the same time, household workers gained the opportunity to observe and assimilate bourgeois behavior and values. Functioning as quasimembers of the family, servants traversed the invisible yet sharply defined boundary between public and private spheres. Attending the family's needs and demands, they remained at the physical and psychological perimeter of its intimate circle.

Although plentiful in nineteenth-century homes, domestic servants appear only sporadically in American painting. For some artists, so-called women's work may have seemed too dull a topic to commit to canvas. Others, associating the subject with the comic, ribald stereotypes that flourished in the illustrated press, may have found the subject too vulgar for polite society. I believe many discovered that the portrayal of domestic workers brought its own set of difficulties and discomforts. The relationship between the American server and the served was at best an uneasy one, full of friction and a source of social and political confusion. Several painters did, however, treat the subject at least once. My initial compilation of images produced approximately 150 paintings dating between 1710 and the present, of which I have selected 79 for discussion. As there are many roles in domestic service, the purposes that the paintings themselves serve are similarly diverse. They range from portraits of family retainers to anecdotal stereotypes in genre scenes. Some figures perform as symbols of a family's leisure-class status. Others are brought forward for the viewer's consideration as exotic objects of curiosity or sexual desire.

In an attempt to consider the various images in their social, cultural, and political contexts, I have consulted contemporary accounts of the relationship between master/mistress and servant in novels, plays, essays, articles, lectures, governmental reports and surveys, personal diaries, and letters. Unfortunately, the workers themselves rarely left records, though their comments and testimonies were documented with more frequency in later decades when the Progressive Era fostered an interest in household reform. The great bulk of surviving primary texts—like the paintings themselves—were created by and for a public whose sensibilities rarely considered or comprehended the workers' point of view. In seeking broader understanding, I have turned to more recent investigations in the disciplines of American studies, history, sociology, African American studies, and women's studies. The conceptual framework of my book is indebted to Faye E. Dudden's *Serving Women: Household Service in Nineteenth-Century America* (1983), which identifies two distinct, successive forms of service. The first, which she describes as "help," had its inception in the strong republican impulses of the post-Revolutionary decades and fostered a tentative egalitarian relationship between families and workers. The second developed after the 1840s following the massive influx of immigrants into household positions. According to Dudden, as relations became more strained as a result of this dramatic change, employers increasingly began to per-

ceive and describe their workers as "domestic servants"—terminology that heralded a growing social distance between the two. African American workers, however, were almost always considered "servants"—a widespread euphemism for house slaves in the South and a term that endured for black domestics on both sides of the Mason-Dixon line long after Emancipation.[6]

Arranged chronologically, the book addresses specific themes, issues, and questions: How do the images function? How do the paintings reinforce, perpetuate, or subvert societal attitudes toward the serving class? Do the patterns of representation reveal a shift in the perception of workers from help to domestic servants? Are dominant ideologies concerning immigrants, black workers, Roman Catholics, and working-class women revealed in the treatment of the theme? Also, are there differences in portrayals between black and white or male and female servants? Did the artists borrow conventions from literature or the popular press? And how closely do the paintings emulate European prototypes in style and theme? Although the book's principal focus is nineteenth-century American painting, images from the colonial period and the early decades of the twentieth century are included. Examples from European art as well as various American prints, illustrations, and advertisements are offered as material for comparison. *At Beck and Call* is not an all-inclusive survey of extant representations. Because the major market for art in the nineteenth century was concentrated between Boston and Baltimore, the Atlantic and the Mississippi, the study is consequently somewhat limited geographically to the northern and mid-Atlantic regions. Furthermore, in consideration of space, several images had to be consigned to mentions in the notes or eliminated from discussion altogether. This project is intended as an initial study from which future investigations may spring.

The first chapter introduces and clarifies the ways in which early nineteenth-century conceptions and representations of service were formulated from previous colonial experiences of indentured servitude and chattel slavery. It discusses some of the earliest American images of household laborers and the ways in which the representations are related to English mezzotints and engravings. Chapter 2 then explores the ambivalence with which artists approached the subject in the years between 1790 and 1840. As painters developed national themes in genre painting, household help was often vaguely defined. This section examines the ways in which both white and black, free and enslaved workers were represented during a period when egalitarian and democratic rhetoric dominated American political thought.

In considering the artistic and social atmosphere of the decades at mid-century, Chapter 3 focuses on the paintings of Lilly Martin Spencer. Like many of her male counterparts, Spencer borrowed conventions from seventeenth-century Dutch genre painting to construct her images of home life. Yet the spirit and detail of

her paintings were also shaped by her personal knowledge of the domestic realm as daughter, wife, and mother. More important to this study, she also drew upon her own experiences as a homemaker who hired, supervised, worked with, and fired female servants—some of whom appear as principal figures in her best-known canvases. Through an active correspondence that covers nearly forty years, Spencer has left compelling glimpses of the struggles of a working mother dependent upon hired household labor. Her papers and paintings, examined together, provide a unique chronicle of an artist's involvement and investment in the mistress-maid relationship. They record her own shifting perceptions during the time when Americans were requiring a greater social distance between themselves and their hired workers.

Chapter 4 examines the development of ethnic and racial stereotypes during the middle decades of the century and the ways in which they informed the portrayal of servants in painting. The chapter begins with a look at the effect of the tremendous influx of Irish Catholic immigrants to the United States. After the late 1840s, the troublesome Irish Bridget quickly became the stock characterization for immigrant maids in both written and visual imagery. During the same years, the African American persona was sharply defined and typecast into several different roles, many of them variations on the prevailing stereotype of the docile and obedient black servant. The second half of the chapter explores some of these manifestations—Dinah, Auntie, and Mammy—and the ways in which the stereotypes were used to advance the cause of both sides of the slavery argument in the years before and during the Civil War. Chapter 5 considers the nation's rapid industrial and commercial expansion in the last quarter of the century. Newfound prosperity and a more cosmopolitan outlook inspired many Gilded Age Americans to look to Europe for standards in manners and tastes. As a growing emphasis was placed on leisure, comfort, and the proper observance of social deportment, class structure appears to have become more rigid. Domestic servants were increasingly set apart by special uniforms, titles, duties, and precincts within the home. This section investigates the ways in which servant imagery was adjusted to convey the rising status of a fashionable urban elite. It also explores the growing preference of wealthy American collectors for European peasant imagery and the attempt by some artists to find an indigenous alternative by creating picturesque delineations of maidservants.

Finally, Chapter 6 examines the oeuvre of the Boston School artists in the years between 1892 and 1923. Best known for Vermeer-inspired interiors filled with antique furnishings, objets d'art, and well-bred ladies who drift off into quiet thought, this group of painters also pictured maidservants performing household duties. For the most part, the maids are portrayed as efficient and compliant workers; they are also strikingly beautiful. Carefully positioned and consciously deco-

rative, the servant figures are displayed much like other ornamental possessions within well-ordered interiors. The images give little evidence of the mounting tensions beyond the parlor doors or, to be more precise, belowstairs. In Boston, the much-described Servant Problem was intricately related to the Irish Problem, since the overwhelming majority of workers were Irish immigrants. This final section examines the ways in which the paintings both mask and reveal the frictions between Brahmin families and the newcomers who threatened their social and political hegemony in turn-of-the-century Boston.

A consideration of servant imagery cannot be separated from an examination of the difficult, intricate history of American servitude. In delineating household workers, artists had to consider and give visual form to socially and politically sanctioned practices of class, race, and gender subordination. In so doing, their images both articulate and mediate an ongoing disparity between democratic ideology and custom. Through the study of past representations, I believe we can see more clearly the "invisible" work and workers of today. We may also better assess the ways in which current society still perpetuates unequal and exploitative practices against an immigrant and minority female labor force that continues to serve the American family. As sociologist Judith Rollins has observed, the examination of domestic service affords an extraordinary opportunity: "the exploration of a situation in which the three structures of power in the United States today—that is, the capitalist class structure, the patriarchal sex hierarchy, and the racial division of labor—interact."[7]

If, as Emerson contends, the household is a school in which we learn about power structures within the society at large, then the study of servant imagery will contribute to our understanding of those dynamics and, ultimately, provide important iconological clues to our understanding of the American experience. We cannot wholly recreate the aesthetic and social milieu in which each painting was made nor, with certainty, fully reconstruct the artists' intentions. But by exploring the images in context—in acceptance of Emerson's invitation to step "within the door" of these illusory households to learn more of human life—we may arrive at new meanings of that experience.

*Chapter One*

# The Custom of the Country: The Colonial Era

When British traveler Henry Fearon toured the United States in 1818, he discovered that he and many of his fellow Englishmen made a grave mistake by addressing American domestic workers as "servants." To his surprise, they were told quickly and firmly that in the new republic there were no servants, no masters, and no mistresses. An offended worker informed Fearon that she was, in fact, "a woman citizen." Clearly, the visitor thought, the error was one of semantics only.[1] Servants had been a part of Anglo-American society since its earliest settlement. Twenty of the 104 Pilgrims who sailed to Plymouth on the Mayflower came over as servants. The Roanoke colonists were Sir Walter Raleigh's bondsmen, and the first two women who arrived at Jamestown were a settler's wife and her maid.[2] Nevertheless, Fearon stumbled onto an ambivalence in the United States at the beginning of the 1800s concerning issues of class, race, and servitude—an attitude that had taken form over previous centuries in colonial British America. To reach a better understanding of the representation of domestic workers in nineteenth-century American painting, a look at the early history of the institutions of servitude and slavery and an examination of images produced during the colonial era are in order.

## Indentured Servitude and Revolutionary Thought

At least half of all white persons who emigrated from Britain and continental Europe during the colonial period arrived as bound servants. As hired labor in the

New World was both limited and expensive, men and women were brought over to provide a work force—the scarcest element of production. Fundamentally, it was a system that peopled the colonies while providing the labor to cultivate goods for the European market. "This trade was the backbone of the whole migratory movement," historian Abbott Smith asserts. "Neither imperialist visions and necessities, nor charitable impulses, nor religious enthusiasm, nor desire for landed possessions kept it going, but simply the fact that colonists wanted white laborers and were willing to pay merchants and ship owners for bringing them."[3]

As early as the 1620s, white servitude was a firmly entrenched system. The crucial labor supply comprised indentured workers who contracted terms of service before emigrating, redemptioners who paid for a transatlantic passage with subsequent bound labor, transported convicts and debtors, and a few political and military prisoners. In return for a specific period of labor, masters agreed to pay passage fees and to provide food, drink, clothing, shelter, and, in rare instances, a small wage. On completion of the term, some paid freedom dues, which included anything from land, money, and clothing to tools and livestock—though such benefits decreased over time. Each colony regulated terms of treatment and length of contract, a standard that became known as "the custom of the country."[4]

Overall, an estimated 350,000 white laborers were imported between the years 1580 and 1775. At first colonists attempted to mold Native Americans into servile workers. When that strategy failed, they relied on the mass importation of workers—voluntary and involuntary—from Europe and Africa. In every colony, white servitude preceded black slavery. After an initial reliance on indentured workers, the Caribbean and southern mainland colonies turned to African slaves for the bulk of their labor needs. However, the demand for white laborers continued in the remaining colonies, especially the Chesapeake and mid-Atlantic regions.[5]

The first indentured servants came predominantly from England; after 1680 the chief sources of labor were Ireland and Germany. Most workers came out of economic necessity with little training and few skills. Two-thirds were men and boys, who were put to work in agriculture, husbandry, and—less frequently—trades and crafts. The smaller percentage of women worked primarily in tasks of family economic production: cooking, spinning, weaving, and sewing. On large plantations female bond servants were acquired to provide domestic labor for the considerable number of menservants. In the earliest decades, some indentured women were purchased for the prospect of marriage. Such was the case of Mary Morrill, Benjamin Franklin's maternal grandmother, who was bought by her future husband at the cost of twenty pounds. The importation of servant brides diminished when regions established stable female populations.[6] Although the majority of servants were newly arrived, bound workers were also drawn from local "middling" and poorer populations. The term "servant" was used in a general way to signify various

situations of dependency: indentured workers, slaves, apprentices, hired men or women who worked for a limited period of time, or unmarried females who exchanged domestic labor for room and board. Orphans and young children of families who could not support them were bound out by church committees and courts, a practice that continued long into the nineteenth century.[7]

Models of contract labor in America had precedence in preindustrial English systems of apprenticeship and husbandry wherein young people worked for a brief period at neighboring farms or businesses. However, colonial circumstances, modified by economic necessity, were more rigid and harsh. A servant bound himself or herself to work for a much longer term, typically a period of four to seven years. The indenturing process became an impersonal contract between strangers, thereby losing many of the familial and community associations long prevalent in the Old World.[8]

On the whole, life was difficult for colonial servants. Length and conditions of terms varied, but everywhere the status of indentured servants was that of property. They, the work they did, the clothing they wore, and every minute of their contracted time belonged entirely to their masters. Servants could not marry without consent, vote, or engage in trade. Their labor could be sold, auctioned, bequeathed, or hired out—even if it meant separating family members. Servants and slaves alike were subject to corporal punishment; culprits were castigated with whipping or branding for various offenses. Runaways and those charged with crimes or fornication often found themselves sentenced to additional years of labor.[9] The system offered an exceedingly hard and sometimes dangerous way of life; it was also easily exploited. Workers bound to harsh masters and mistresses were underfed, overworked, and physically and sexually abused. The mortality rate among servants was high. Considering the risks and the circumstances, several years of laborious bondage could be a very high price to pay for passage to the American colonies.[10]

Thousands of the English and European poor who knew little or nothing about the hardships that awaited them were nevertheless drawn to the New World by the promise of a better life. The chief incentive was the idea that having served their terms, they could eventually acquire land or trades of their own.[11] This idea was put forward by promoters and speculators whose job it was to recruit laborers. In 1666, George Alsop wrote a treatise encouraging settlement in Maryland. In his listing of the abundant qualities of the colonies he noted that they were especially suitable for those "whom Providence hath ordained to live as Servants." Having himself worked four years under an indenture, Alsop proclaimed an appealing formula for advancement: "Dwell here, live plentifully, and be rich." Like similar tracts and broadsheets, his treatise exaggerated the opportunities afforded the immigrant. Nevertheless, it offered one of the earliest pronouncements that

the New World provided an escape from servitude that could not be found in Europe—a notion that would be amplified on both sides of the Atlantic throughout the eighteenth century.[12]

Despite those promises, the American colonies before the Revolution were neither egalitarian nor democratic. The colonists brought with them concepts of a society ordered by hierarchical patterns of deference and condescension. It was a patriarchal system: wives and children deferred to the father, servants to family members, and masters and mistresses to social superiors. For generations, colonial Americans maintained a respect for gradations in rank, believing that stratification provided an order for the common good.[13] They also found justification in the Bible for maintaining a servile class. Obeisance to superiors is addressed in several passages, including Ephesians, wherein children are admonished to obey their parents and servants their masters "with fear and trembling, in singleness of your heart, as unto Christ; . . . Knowing that whatsoever good thing any man doeth, the same shall he receive of the Lord, whether he be bond or free." Even former servant George Alsop, with his ready assurances of social mobility, conceded that it was the "common and ordained Fate that there must be Servants as well as Masters."[14]

In both England and the colonies, service was traditionally considered a demeaning occupation that carried the stigma of menial labor and economic and physical bondage. Servants were often perceived as ignorant, immoral, or lazy persons incapable of succeeding in an honorable livelihood. Although opportunities for advancement in the colonies were being extolled, American servants did not escape the ignominy of the institution. In fact, as nearly all bound workers and slaves in British America were called servants—including transported debtors and convicts—colonial servitude gained additional unsavory connotations.[15] At the very least, servants were perceived as difficult. In 1758, Benjamin Franklin offered a wry suggestion for avoiding potential problems: "If you would have a faithful servant, and one that you like, serve yourself." Most bound laborers wanted nothing better than to escape service and claim personal independence. Franklin, himself, had run away from his own indenture contract thirty-five years earlier.[16]

The nearly two-hundred-year tradition of white servitude informed the powerful language of the Revolutionary War. Speeches like Patrick Henry's famous oration before the Virginia House of Burgesses addressed, of course, political subjugation: "Is life so dear or peace so sweet as to be purchased at the price of chains or slavery? . . . I know not what course others may take, but as for me, give me liberty or give me death!" But such words also alluded to personal bondage. Historian John Van der Zee has observed,

There were few colonial Americans untouched by the practice of indentured servitude. It was the state of destitution most immediate to everyone, the

wall-less prison and poorhouse. . . . It haunted the colonial imagination. . . .
It gave to words like "liberty," "freedom," and "tyranny" a physical reality that
people were willing to suffer and die for. It is the forgotten undercurrent of
the American Revolution. . . . We are, in fact, as Americans, the descendants
of bound people, tied now by that binding in ways we have forgotten.[17]

As Britain and the colonies came to armed conflict, the call for liberty became
more strident. The revolutionary language referred to the oldest historical meaning
of liberty, that is, the freedom of an individual as opposed to servitude.[18] The
rhetoric drew from radical social and political thought formulated over the previ-
ous century from the anticourt faction of the English Civil War, John Locke's con-
cept of natural rights, the French Enlightenment theory of the philosophes, and
more recent dissent voiced by British opposition leaders such as Joseph Priestley
and Richard Price. Priestley, among others, saw evidence of a coming millennium
in America's ascent, the heralding "of a new era in the history of mankind . . . a
change from darkness to light . . . from a most debasing servitude to a state of
most exalted freedom."[19] Critics were quick to charge a gross inconsistency in that
"the loudest yelps for liberty" came from slaveholders.[20] The call for freedom, how-
ever, conjured up multiple images of bondage among a people who, in many cases,
had risen out of servitude and who feared the unhappy prospect of returning.

## Social Mobility and the Serving Class

The desire to transcend class boundaries was widely diffused on both sides of the
Atlantic in the eighteenth century, and servants were not immune to the impulse to
rise. With an expansion of commerce and industry came opportunity for wealth
and social advancement among middle-class families. Correspondingly, wage-earn-
ing domestic workers were in growing demand, and their numbers increased
steadily. As British servants gained more bargaining power they exercised an abil-
ity to go from position to position. Becoming alarmed at the perceived insubor-
dination, the upper classes responded with a barrage of reactionary tracts, pam-
phlets, and books. Leading authors including Jonathan Swift and Daniel Defoe
joined in the attempt to define and direct a more restrictive master-servant rela-
tionship.[21]

Contemporary British popular culture, however, also celebrated the growing
economic and social mobility of a once-fixed servant class. The most famous servant
personality of the eighteenth century was the title character in Samuel Richard-
son's 1740 epistolary novel, *Pamela; or, Virtue Rewarded*. Pamela Andrews, a beau-
tiful young maid, is everything a serving woman was expected to be—industri-

ous, diligent, and loyal. When she consistently resists the sexual advances of her new master, virtue is indeed rewarded when the reformed libertine makes her his wife. The story of Pamela's ascent from maid to mistress was an enormous success in England and the American colonies. In two years, the novel went into its sixth printing and was translated into several languages.[22] When Alexander Hamilton journeyed through the colonies in 1744, the Scottish immigrant noted in his *Itinerarium* that the best-selling books in New England included *Pamela* and a derivative story titled *The Fortunate Maid.*[23]

British painter William Hogarth offered his own visual correlations of the theme of humble worker turned aristocrat. Like Richardson's *Pamela,* some of his narrative paintings and prints evoke a sympathy for virtuous, hardworking servants. For instance, *A Rake's Progress* (1735) subverts the traditional equation of privilege with character. It tells the story of Tom Rakewell, an immoral young nobleman who becomes sick and destitute as he squanders his inheritance. He is consistently aided by the ever-faithful Sarah Young, the servant he seduced and impregnated. Despite her low station, the maid is constant and good. She pays the rake's debtors, visits him in prison, and—faithful to the end—brings him food after he is committed to Bedlam Hospital for the insane.[24]

Hogarth's longest narrative series, *The Idle and Industrious 'Prentice* (1747), tells a tale in twelve engravings of two fellow apprentices "where the one," explains Hogarth, "by taking good courses, and pursuing points for which he was put apprentice, becomes a valuable man, and an ornament to his country: the other, by giving way to idleness, naturally falls into poverty, and ends fatally." The series culminates in the final two images wherein the industrious apprentice becomes Lord Mayor of London and his counterpart is executed at Tyburn. The series found enormous favor in America. The best selling of all prints in the colonial era, it sold consistently from the time of its initial publication until the 1770s.[25]

If the colonists inherited concepts regarding social stratification and servitude from Europe, they also formed visual images from Old World prototypes. European and English representations of both white and black servants were available in British America primarily through engravings and mezzotints. The market for prints grew quickly; by the 1770s, the colonies were purchasing about one-third of the entire British print export trade. Immigrant and native-born artists alike employed these graphics as a major source of inspiration as they developed their own provincial versions and extensions of European styles.[26] White maids, valets, and grooms appear as secondary figures in conversation pieces and genre scenes by British artists such as Hogarth, Joseph Highmore, and Gaven Hamilton. French genre prints of *scènes galantes* include dutiful retainers who attend to the needs of noble personages. Yet colonial American portrayals of white servants are nearly nonexistent.[27]

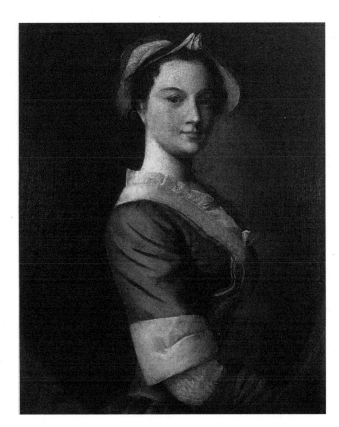

Fig. 1-1. Robert Feke (1705– 1750), *Pamela Andrews,* ca. 1742, oil on canvas, 31 × 24 in. (78.7 × 61 cm). Museum of Art, Rhode Island School of Design; bequest of Sarah C. Durfree.

Among their small number is the so-called *Pamela Andrews* by Robert Feke (fig. 1-1). This bust-length image of a beautiful young woman is supposed to represent the fictional maidservant of Richardson's novel. It was painted in Newport, Rhode Island, around 1742, a couple of years after the novel was published. One of the native-born artist's earliest canvases, it was produced just after his ambitious group portrait of the Isaac Royall family. The original model was probably a family member—his young sister or sister-in-law.[28] Feke's Pamela is a dark-haired woman seated in profile. With her face turned in three-quarters view, she looks confidently at the viewer with a tiny smile. Her white headwear, ruffles, and cuffs contrast with the stiff brown cloth of her dress. The cap comes to a point at the center, suggestive of the typical "pinner" cap worn by maidservants with the dangling lappets pinned together in the front.[29] At the same time, the woman's delicately gloved arms and hands belie a menial status. In the novel, the famous maidservant is described as having a beauty "that itself might captivate a Monarch; and of the Meekness of a Temper, and Sweetness of Disposition" that made her the superior of all women.[30] Close inspection of the canvas reveals several revisions

around the face and cap, suggesting that Feke reworked passages in his attempt to match the idealization. The young painter relied heavily upon images in English mezzotints to form his vision of feminine beauty and virtue. After completion, the portrait remained in Feke's possession throughout his life. It traveled with him when he relocated to Boston in 1745 and may have been on view in his studio there.[31]

Around this time another young painter, John Greenwood, was beginning his own career in that city. The self-taught artist may have had Feke's Pamela in mind when he decided to portray a local maidservant. Greenwood's mezzotint *Jersey Nanny* (fig. 1-2) was advertised for sale in the *Boston Gazette* in 1748 as a portrait of Ann Arnold. Though nothing is known today about the sitter, it is clear from the image and inscription that she was a domestic servant. Nanny is shown turning slightly to the left, in a half-length format. She wears a patched calico dress with a plaid kerchief around her shoulders. Her bodice is closed across her large breasts with straight pins, suggesting that she serves as a wet nurse. Atop her scraggly hair is a pinner cap. Despite her unkempt appearance and ruddy complexion, Ann Arnold seems unself-conscious as she presents herself to the viewer. Her buxom body commands the picture space. Like Feke's Pamela, the nanny looks out with a subtle smile. The legend below reads,

> Nature her various Skill displays
> In thousand Shapes, a thousand Ways;
> Tho' one Form differs from another,
> She's still of all the common Mother:
> Then, Ladies, let not Pride resist her,
> But own that NANNY is your Sister.

Greenwood was a member of a prominent Boston family that made its fortune in shipbuilding. Although his father and brother were Harvard graduates, the young artist could not attend college because of financial difficulties. He produced the mezzotint of the nursemaid shortly after the conclusion of his own indenture as an engraver's apprentice.[32] Greenwood's reversed fortunes and his stint as a contract laborer may have contributed to his awareness of the struggles of the servant class and likely affected his humorous yet sympathetic rendering.

*Jersey Nanny* is the artist's own rendering of the virtuous-servant theme produced in the decade when it was popularized by Richardson's novel, the narrative engravings of Hogarth, and even by Feke, Greenwood's Boston colleague. The sharp naturalism of the mezzotint offers a wry parody of the idealized Pamela. However, the viewer is encouraged by Greenwood's text to recognize the blowsy woman as one whose virtue transcends social class or physical appearance.[33] The ap-

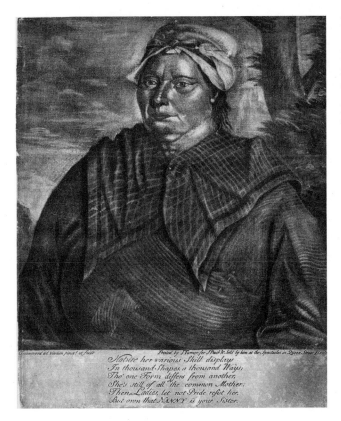

Fig. 1-2. John Greenwood
(1727–1792), *Jersey Nanny,*
1748, mezzotint, $9\frac{5}{8} \times 7\frac{3}{4}$
in. (24.4 × 29.7 cm).
Courtesy Museum of Fine
Arts, Boston; gift of
Henry Lee Shattuck.

peal may also be a tongue-in-cheek reminder that some American "ladies" were themselves recently or a mere generation or two removed from domestic service, hence sharing the common sisterhood of bound labor.

The growing notion of class transcendence, diffused through popular culture, helped loosen the strict boundaries in British society. This was especially true in the colonies, where there was already more fluidity of class lines. Like their counterparts in England, American bond servants also chafed at their limitations. Some could actually use the skills, observations, and connections acquired in service as vehicles for later advancement. Philip Fithian noted in his journal of 1773–1774, "Hence, we see Gentlemen, when they are not actually engaged in the publick service, on their farms, setting a laborious example to their Domesticks, and on the other hand we see labourers at the Tables and in the Parlours of their Betters enjoying the advantage, and honour of their society and conversation."[34]

Although most gains were modest, there were certainly success stories of prominent citizens who were at one time bound laborers. Charles Thomson, a secretary of the Continental Congress; Matthew Thornton, a signer of the Declaration of In-

dependence; Daniel Dulany, a prominent lawyer in Maryland; as well as several members of the Virginia and Maryland assemblies, all were previously bondsmen. George Washington was named after George Eskridge, an indentured servant who rose to become a member of the Virginia House of Burgesses and foster father to Washington's mother. The most spectacular case is that of Anthony Lamb, who, like Hogarth's idle apprentice, faced execution at Tyburn in 1742. In a last-minute commutation of his sentence, he was transported to Virginia as an indentured prisoner. After serving his time, Lamb made his way to New York City, where he eventually became a respected owner of an instrument maker's shop. His son expanded the business and, as one of the city's leading gentry, helped lead that colony's patriot effort during the Revolutionary War.[35]

The notion of such rags-to-riches opportunities in the colonies was best articulated in the popular *Letters from an American Farmer,* published in London in 1782. Through the voice of James, a fictional Pennsylvania farmer, J. Hector St. John de Crèvecoeur presented his own observations as a naturalized landowner in America. Never a servant himself, Crèvecoeur—the son of petty nobility in Normandy, ex-soldier, and surveyor—cleared and farmed 120 acres in Orange County, New York. His letters were constructed from his memoirs compiled just before and during the Revolutionary War.[36] In his often quoted third letter, "What Is an American?" Crèvecoeur outlines a process that he calls the "great metamorphosis," whereby the European peasant is transformed from servant to freeholder:

> If [the poor immigrant] behaves with propriety and is faithful, he is caressed, and becomes as it were a member of the family. He begins to feel the effects of a sort of resurrection; hitherto he had not lived, but simply vegetated; he now feels himself a man; . . . he begins to forget his former servitude and dependence, his heart involuntarily swells and glows. . . . He is encouraged, he has gained friends; he is advised and directed, he feels bold, he purchases some land. . . . He is naturalized, his name is enrolled with those of other citizens of the province. Instead of being a vagrant, he has a place of residence. . . . From nothing to start into a being; from a servant to the rank of master; from being the slave of some despotic prince, to become a free man, invested with lands, to which every municipal blessing is annexed! What a change indeed! It is in consequence of that change that he becomes an American.

The rewards of this agrarian ideal, however, were not realized through the efforts of one individual alone. Crèvecoeur's industrious farmer acknowledges the assistance of others. James describes his wife's abilities in raising chickens, sewing, and baking. She, in turn, is helped by a "wench." When the farmer lists his assets, he in-

cludes his Negro slaves, whom he describes as "tolerably faithful and healthy."[37] Despite their proper behavior and faithfulness, they do not experience the same metamorphosis to free citizenship.

## Dual Systems of Servitude

If there were opportunities in colonial British America for white servants to ascend ranks and merge silently into the growing middle class (or, in some instances the ruling class), such mobility was not accorded African Americans. In the seventeenth century, a few of the earliest black laborers may have served under an indenture contract and, like white servants, were freed on completion of their terms. White and black servants worked side by side and shared the frustrations and derogation of their status as unfree workers. In some instances they ran away together or formed bands of resistance, as was the case in 1676 during Bacon's Rebellion. Yet, from their first introduction to the colonies in 1619, it appears that black laborers were generally perceived as a distinctive, separate population to be held in permanent bondage. Servitude and slavery shared characteristics as labor institutions, but race became the ultimate criterion for subordination.[38]

There was no precedent for chattel slavery in English law. It was only after the initial settlement of America that the English followed the Portuguese and Spanish in the practice of enslaving Africans. The pressing need for labor played directly into the rapid formation of the "peculiar institution," and by the 1640s, slavery was legitimated by British legal codes. Eventually black slaves made up the largest body of laborers imported into America. Their numbers increased year after year, gaining an initial impetus during the English Civil War, when the white servant trade was disrupted. By 1780, nearly one and a half million West Africans were brought to the colonies, the majority being sent to sugar plantations in the Caribbean. As slavery became vital to commercial prosperity, the British government gave official backing to the trade, and Parliament appropriated thousands of pounds for the maintenance of slave stations on the coast of Africa.[39]

Black workers were believed to answer colonial labor requirements more successfully than whites. They appeared to endure the hot climate of the plantation colonies better; they were sustained with cheaper housing, food, and clothing; and they replaced themselves to some extent by procreation. Unlike most whites who bound themselves over, Africans were a captive people. Their distinctive cultural and physical differences from whites made them easy targets for exploitation and capture. Practicing many languages, customs, and religions, newly arrived Africans were clearly not "Christian"—a term that was increasingly employed to differentiate white servants.[40] In a 1685 letter, William Penn explained the crucial ar-

gument for the growing preference of slaves over white servants: "for then a man has them while they live." By the end of the seventeenth century, the status of black laborers hardened into slavery, an obligation of perpetual servitude endured for their lifetimes and inherited by their children.[41]

With the shift from white servants to black slaves came a newly formed solidarity among all classes of whites in a common prejudice against persons of dark complexion. A growing fear of slave insurrection fed the inclination to grant white servants rights and benefits previously denied them, such as the ability to file suit or give testimony. Such social and legal differentiation encouraged unequal treatment.[42] For example, an early Pennsylvania law for "the better regulation of servants" required the imposition of extended service on whites who were caught stealing. Black workers found guilty of the same crime were to be severely beaten. "Increasingly," writes historian Winthrop Jordan, "white men were more clearly free because Negroes had become so clearly slave."[43]

## Images of Obedience

As it became fashionable in the eighteenth century for aristocratic British families to own black servants, particularly houseboys, the number of Africans brought to England from the West Indies steadily increased. The enslaved youths were expensive but highly desirable possessions, and by mid-century, London newspapers were filled with advertisements for black children. Bought and sold at inns and coffeehouses, boys and girls were trained as house servants and groomed as domestic pets. They were tricked out in colorful livery and fancy turbans suggestive of exotic Oriental princes. Many were collared with close-fitting bands of silver, usually engraved with a master's name and address to facilitate capture if the bearer ran away.[44]

Livery, the special uniform that signified servant status, was traditionally required for the lowest echelon of house servants. In earlier centuries, particular colors indicated specific noble families, but color schemes eventually became an open choice. Menservants were arrayed in costumes of bright colors and rich materials, oftentimes embellished with gold trim and lace. In general, female domestics had no particular distinguishing costume; caps and aprons were worn by mistresses and maids alike. Turbans were reserved for black servants, a vague allusion to the African laborers held captive by the Muslims in the Middle Ages.[45]

Images of black house slaves increasingly populated the backgrounds and margins of eighteenth-century English paintings. In portraiture, the inclusion of an African page served to endow a sitter with an aura of aristocratic privilege and affluence and sometimes to signify colonial business interests. A convention that

Fig. 1-3. Godfrey Kneller (1646–1723), *Captain Thomas Lucy,* 1680, oil on canvas, 84¾ × 59¾ in. (215.3 × 151.8 cm). Charlcote Park, England; courtesy National Trust Photographic Library.

Fig. 1-4. William Hogarth (1697–1764), *Taste in High Life*, 1746, etching, 7¾ × 10⅜ in. (19.7 × 26.4 cm). Colonial Williamsburg Foundation.

European painters had employed since the sixteenth century, examples are found in paintings by artists ranging in time from Titian and Anthony Van Dyck to Godfrey Kneller and Joshua Reynolds.[46] In Kneller's large parade portrait of *Captain Thomas Lucy* (1680, fig. 1-3), the officer is portrayed with a liveried page. Lucy stands at ease, center front, as he holds his sword and hat. The black servant, nearly cropped out of the picture at right, attends the captain's horse. His silver slave collar gleams in the light.

The presence of a fancifully dressed page could also offer a satirical jab at the affluent vulgarity of the beau monde. In Hogarth's engraved scene *Taste in High Life* (1746, fig. 1-4), a turbaned black child has been lifted to sit on the corner of a table at left. He kicks up his feet and smiles with pleasure as the mistress fondles his face. At the same time, he possesses and pets a ceramic mandarin figurine. The little slave is presented as yet another exotic acquisition in the household of an ambitious and ostentatious family.

## Representing American Servants

If representations of white domestic laborers from the colonial period are almost nonexistent, images of black workers "are also rare, and those that do exist occur within a white context," as art historian Ellen Miles has observed.[47] The overwhelming majority of servants seen in extant colonial American paintings are black attendants whose portrayals follow established British conventions. Visual systems of delineation, presentation, and placement reveal a clearly structured hierarchy of power relationships.

The child servant in Justus Engelhardt Kühn's *Henry Darnall III as a Child* (ca. 1710, fig. 1-5) is the earliest extant depiction of an African American subject and is also the earliest representation of a domestic servant in American painting. Kühn undoubtedly studied European paintings and prints—including those of his former countryman Kneller—as he made his way from Germany to the Annapolis, Maryland, area in 1708. In this painting, the artist has positioned his young aristocratic subject firmly in the center with a body servant close at hand. In the likeness of the young slave, it is difficult to determine if Kühn was portraying a specific individual. The figure may well have been modeled from Darnall's personal attendant.[48] To the left of his master, the slave is dressed in earth tones—subdued colors in comparison to Henry Darnall's brilliantly colored brocade coat and mantle. The African boy's metal slave collar also contrasts with the other's ruffled cravat. While kneeling to offer a bobwhite brought down by his master's arrow, the slave assumes a posture of supplication. Their separation by a balustrade underscores the difference in standing between the two boys. In the painting's pendant (*Eleanor Darnall,* ca. 1710, also in the collection of the Maryland Historical Society), the young master's sister is portrayed in a similar stance and setting. However, a spaniel—whose head she strokes—replaces the accompanying figure of a slave. The correlation of black servant and pet dog is not arbitrary; rather the association is a frequent configuration in contemporary English painting. Images of dogs and black servants were introduced, sometimes interchangeably, to insinuate a patrician subject's ability to command loyalty. Animal and slave shared the status of pets in aristocratic households, and both wore collars signifying bondage and possession.[49] In this respect, Kühn's portrayal of the young slave in the act of retrieving fallen game alludes to doglike allegiance.

Other representations of young black pages are seen in John Hesselius's portrait of Charles Calvert of 1761 and Ralph Earl's *Gentleman with Negro Attendant,* from about 1795. Like Kühn, Hesselius employed formal devices to convey social and racial hierarchy. In his double portrait (fig. 1-6), he positioned Calvert, the five-year-old son of Lord Baltimore, at center, standing firmly with feet apart.

Fig. 1-5. Justus Engelhardt Kühn
(active ca. 1708–1717), *Henry
Darnall III as a Child,* ca. 1710,
oil on canvas, 54¼ × 44¼ in.
(137.8 × 112.4 cm). Collection of
The Maryland Historical Soci-
ety, Baltimore.

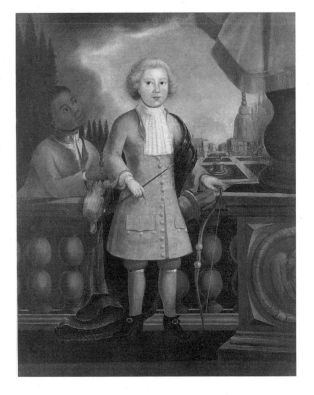

Calvert is fussily dressed in pink satin with white lace, a blue satin mantle, and a white plumed hat—rococo trappings of noble birth. The boy points to a distant city—likely Baltimore—a symbol of civilization and his heritage. His young black servant awaits nearby. Half-crouching in a lower position at left, he awkwardly straddles a drum. The attendant is richly dressed in gold embroidered livery, yet a broad black neck band hints at the traditional slave collar. Positioned in the shadows against the dark hues of the bushes, he turns his back toward the city vista. The figure is crowded to the picture's edge; his right hand and leg have been cropped, leaving his body visually incomplete.[50]

A handsome slave child and his aristocratic master are portrayed in a similar manner in Ralph Earl's double portrait made about 1795 (fig. 1-7). Earl, an American-born painter, was directly influenced by British grand-manner portraiture in the last quarter of the century. Facing imprisonment for his loyalist sympathies during the Revolution, Earl fled to England disguised as the servant of a British officer. In his seven-year exile, he studied in the studio of Benjamin West and closely examined the portraiture of Joshua Reynolds and Thomas Gainsborough. When Earl returned to the United States, he produced this painting of a gentleman who has been tentatively identified as James Duane, mayor of New York.[51] That the

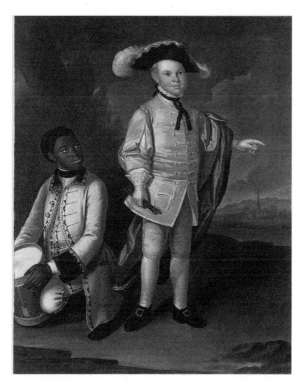

Fig. 1-6. John Hesselius (1728–1778), *Charles Calvert,* 1761, oil on canvas, 50¼ × 39⅞ in. (127.7 × 101.3 cm). The Baltimore Museum of Art; gift of Alfred R. and Henry G. Riggs in memory of General Lawrason Riggs; BMA 1941.4.

sitter is affluent is attested to by his richly embroidered waistcoat and powdered wig. He directly engages the viewer with an unflinching, confident gaze. As seen in previous portraits, a young black boy waits unacknowledged at the subject's elbow. The child looks upward with patient devotion. The letter he offers connects the sitter with the outside world of business, society, and politics—concerns far removed from the realm of the small servant, who dutifully functions as a vehicle of communication.

A less formal portrayal is offered in *Peter Manigault and His Friends* (fig. 1-8), a small ink and wash drawing by George Roupell. One of the rare genre scenes produced in colonial America, the picture records a gathering of officers and gentlemen at Peter Manigault's South Carolina home. It offers a view of an evening's entertainment given by the prosperous planter around 1760. It also provides a candid look at the less-than-pleasant duties of a slave boy. With Hogarthian effect, Roupell depicts eight boisterous men enjoying their host's punch and wine. An inscription on the back of the drawing identifies each, including the artist, who is seated at the bottom left corner of the table.[52] At far right stands the black servant, the only figure not identified by Roupell. The small boy, liveried yet barefoot, is obviously fatigued by the lengthy revelry. Unable to leave and not permitted to

Fig. 1-7. Ralph Earl (1751–1801), *Gentleman with Negro Attendant*, ca. 1795–1796, oil on canvas, 30 × 25 in. (76.2 × 63.5 cm). New Britain Museum of American Art, Harriet Russell Stanley Fund; photograph by E. Irving Blomstrann.

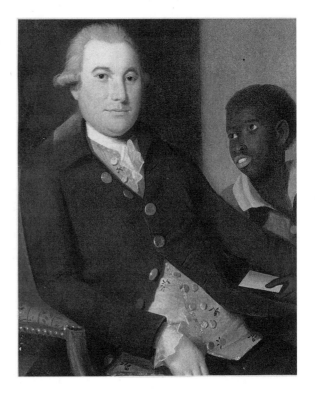

sit, he props himself against the wall. While the men offer each other another round of toasts as the midnight hour approaches, the houseboy seems as captive as the large black bird whose cage is located next to him on the window seat.

Black menservants were also included in two paintings of George Washington: a full-length portrait painted by John Trumbull before 1780, and *The Washington Family,* by Edward Savage, of 1796. Trumbull's *George Washington* (fig. 1-9) is an interesting blend of truth and artifice. Completed in London as a gift to an Amsterdam banker, it was formed from the artist's own memories of the general he served as an aide-de-camp. However, Trumbull also borrowed Washington's face and pose from a contemporary portrait by Charles Willson Peale. In his version, Trumbull chose to include a black groom—a figure that closely resembles the turbaned servant depicted in Joshua Reynolds's *John Manners, Marquess of Granby* (fig. 1-10) of 1766. As in the English portrait, the servant has been positioned behind a horse; only his young face appears above the animal's back. But unlike Reynolds's brooding page, the slave looks attentively toward Washington.[53]

The inclusion of the page may have served to elevate Washington to a gentleman's status in the eyes of a European audience that had come to associate such attendants with aristocratic portraiture.[54] But Trumbull, who had firsthand knowl-

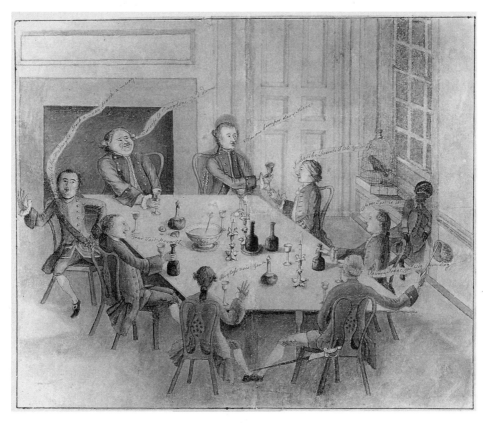

Fig. 1-8. George Roupell (d. 1794), *Peter Manigault and His Friends,* ca. 1760, ink and wash on paper, $10\frac{3}{16} \times 12\frac{3}{16}$ in. (25.9 × 31 cm). Courtesy Winterthur Museum.

edge of Washington's personal staff and habits, also could have included the boy as an accurate portrayal of the circumstances of the slave-owning general. (Trumbull himself brought a black manservant to accompany him on battle campaigns.[55]) When the artist duplicated the full-length portrait in 1792 (Yale University Art Gallery), he eliminated the black groom and substituted a white military aide as the secondary figure. In the final decades of the century, fancifully dressed black attendants were gradually eliminated from American portraiture. Perhaps they had become uncomfortable reminders of the question of slavery in an era when liberty was being exalted.[56]

In the years of peace directly following the Revolutionary War, American-born painter Edward Savage sketched the family of newly elected President Washington. Savage set the oil study aside for six years, during which time he traveled to England to pursue training as a printmaker. While in London, he returned to the image

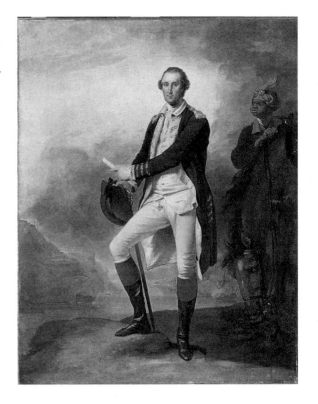

and, perhaps influenced by the iconography of European portraiture, decided to
include a black male servant. The artist is said to have engaged John Riley, a free-
man in service to the American ambassador, as the model for the liveried atten-
dant. The final portrait, *The Washington Family* (plate 1), was completed in 1796
upon Savage's return to the United States.[57]

In the finished painting, the family members are shown at Mount Vernon gath-
ered at a table on a portico overlooking the Potomac River. Seated at left, Wash-
ington casually rests his elbow on the shoulder of his adopted grandson, George
Washington Parke Custis. At the general's left hand are papers, his sword, and a
large map of the new Federal City. His wife, Martha, is seated opposite. With her
granddaughter, Nellie Custis, she holds the edges of the plan, to which she points
with her fan. As in Savage's original study, the four figures fit comfortably in the
composition and are visually balanced. The servant, crowded into the right cor-
ner, seems an obvious afterthought as he stands blocked behind Martha Washing-
ton's chair. His hands are hidden, one being tucked into his vest front. Savage
carefully delineated the faces of the family, later noting with pride that the por-
traits were "generally thought to be likenesses."[58] Their features are modeled with
attention to light and shadow. Yet the servant is nearly faceless; his dark figure is
obscured in the shadowy recess of the corner. Only the edges of the metal buttons

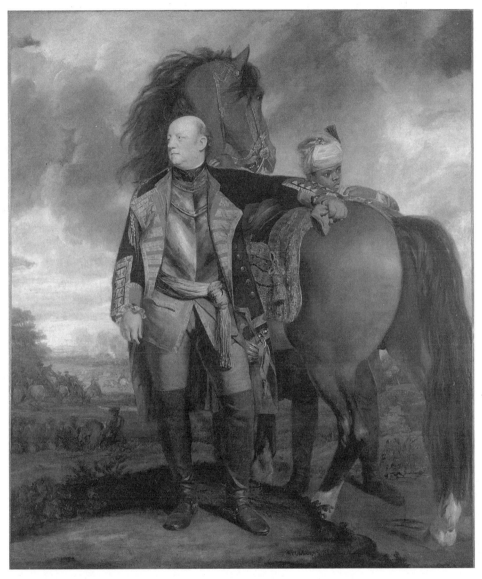

Fig. 1-10. Joshua Reynolds (1723–1792), *John Manners Marquess of Granby*, 1766, oil on canvas, 97 × 82$\frac{5}{16}$ in. (246.4 × 209.1 cm). The John and Mable Ringling Museum of Art, Sarasota, Florida.

of his gray and red livery are illuminated. Although an adult male, the manservant has been relegated to the female side of the painting, where he offers no competition of standing with the white-haired paterfamilias.

When Savage interpreted his painting into a stipple engraving, he identified each of the Washington family members in the print's legend, but he made no

mention of the black attendant.[59] Over time, however, the African American figures in both the Trumbull and Savage portraits were identified as William Lee, Washington's orderly who accompanied him on his military campaigns. After the war, Lee returned to Mount Vernon as the president's manservant. Washington freed him in his will "as a testimony of my sense of his attachment to me and for his faithful services in the Revolutionary War."[60] Neither painting, however, offers a true portrait of Lee. The page in the Trumbull portrait is a stock characterization lifted out of the European repertoire, and the vaguely defined attendant in the Savage painting was modeled after another man. Neither artist attached great importance to capturing an accurate likeness of William Lee per se. The figures function not as portraits but as signs of status, deference, and loyalty.

When colonial artists depicted black female servants, they typically portrayed them in the role of nursemaids attending the children of their white owners.[61] John Hesselius included such a figure in the portrait of his infant son, *Gustavus Hesselius, Jr., and Servant Girl* (ca. 1767, fig. 1-11). Working five years after the completion of his painting of Charles Calvert (fig. 1-6), the artist appears to have borrowed the convention of the black attendant to make a statement about his own newly acquired prosperity. Hesselius married a wealthy widow in 1763 and subsequently became the owner of a large plantation near Annapolis. As a gentleman landowner, he acquired a working staff of both white indentured servants and black slaves.[62]

In his son's portrait, Hesselius elevated the infant on a platform or table. The fair-haired baby is nude but holds a swath of pale gray drapery across his lap. He is seated on a red velvet cushion and supports himself by one pudgy arm in a pose that comes directly from a mezzotint of Kneller's painting of Lord Brey.[63] With a knowing, mature face, the smiling baby looks directly out. He is brightly illuminated against the dark background, but as in *The Washington Family,* the light is contained, hardly spilling onto the figure of his black nurse at the right. The individualized features of her face suggest that the young woman's portrait may have been taken from life. She is presented in a three-quarter view and wears closely cropped hair and a green gown with white sleeves and ruffles. Looking intently at the infant, she offers him a peach with her left hand. Young Hesselius twists his upper torso away, ignoring both the gift and the giver. The servant's arm reaches between the baby's bare legs to place the fruit in his lap—an intimate gesture that suggests her responsibility for the bodily care and cleanliness of the infant boy. The slave woman appears diminutive, portrayed with a head that is of similar size to the baby's. As she looks up to the infant from a sitting or kneeling position, her lower body and right arm are blocked by the table and cushion. The change in background colors, suggestive of an open doorway, also visually separates her from the space of the child.

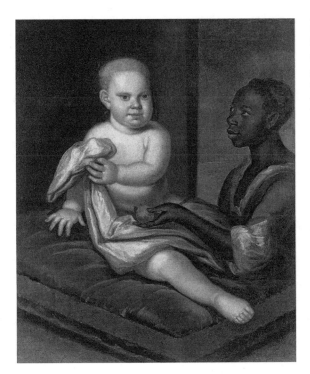

Fig. 1-11. John Hesselius, *Gustavus Hesselius, Jr., and Servant Girl*, ca. 1767, oil on canvas, 29⅝ × 24¾ in. (73.7 × 63.2 cm). The Baltimore Museum of Art; Purchase Fund; BMA 1945.91.

The portrait is believed to have been painted posthumously. Young Hesselius and his sister both died in October 1767, likely victims of one of many prevalent contagious diseases. That would explain the rather awkward portrayal of the child in comparison to the nursemaid's more naturalistic presentation. A tale later developed, perhaps inspired by the painting, that the baby perished from a peach poisoned by his nurse.[64] In colonial society, Africans were believed to have special knowledge of herbs and roots and an expertise in concocting strange and even lethal potions. At a time when disease struck often and sometimes mysteriously, stories of poisonings were particularly rampant, and fearful families suspected the black servants who prepared and served their food.[65]

Through their formulaic depictions of docile and contained slaves, artists offered reassuring images of white control to a society afraid of black revolt. African Americans appear as secondary figures who literally hover beside their masters. Frozen in indefinite expectancy and rapt attention, the figures recall traditional European portrayals of worshipful saints or earthly donors who bow before a divine presence. While encouraging a similar response in the viewer, the slaves offer little visual competition. They are pushed to the edges or into the backgrounds of compositions, and they are systematically obscured by color, shading, and overlapping.

Often relegated to the lower registers, they are cropped by barricades or the edges of the picture plane. Sometimes shown without hands or legs, the slave images ironically parallel the physical acts of fettering or dismemberment inflicted on African Americans to render them "safe."[66] The adult manservant who stands in the Washington family portrait loses the semblance of masculine power through feminine association.

## Portraits of Achievement

In the 1770s, portraits were produced of two individuals—one white, one black—who, despite their beginnings as servants, gained a certain amount of public distinction. *William Buckland,* produced between 1774 and 1787 by Charles Willson Peale, and *Phillis Wheatley,* produced in 1773 by an unknown artist, share similar qualities, yet they evoke the distinctly different realities and circumstances of the subjects.

William Buckland, the sitter in Peale's portrait (fig. 1-12), came from London to Virginia as an indentured servant in 1755. He was bound out to Thomison Mason, who engaged the young joiner to complete his brother's plantation home. For four years, Buckland supervised a team of laborers to create the elegant interior of George Mason's Gunston Hall. At the end of his term, and with a glowing recommendation written on the back of his indenture contract, Buckland set out to establish himself as an independent builder. His reputation grew, and he gained several prestigious commissions, including the Hammond-Harwood House in his chosen city of residence, Annapolis. When he sat for his portrait, Buckland was forty and a successful master builder who commanded his own servants and slaves. He died unexpectedly before the portrait was finished, and Peale eventually completed the painting thirteen years later at the request of the builder's family.[67]

Peale presents Buckland actively at work, a celebration of the subject's industry and skill.[68] As he designs elevations, the builder is surrounded by the attributes of his profession. Before him is a table with his drawing instruments; in the background, a classical portico appears superimposed over scaffolding. The base of a wide column seems to spring from the sitter's broad shoulders, suggestive of his strength and solidity. Buckland pauses mid-thought, pen in hand, to look out with a warm, direct gaze that invites the viewer into his company. The smile on his lips and the hand on his thigh evoke an air of confident ability. No hint of the builder's former subservient status is present.

William Buckland is the living personification of Crèvecoeur's servant who undergoes the "great metamorphosis" to become an American freeholder—a transformation shared by his portraitist. American-born Charles Willson Peale rose

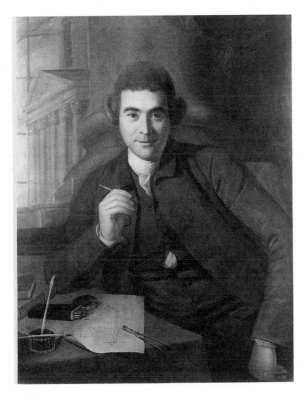

Fig. 1-12. Charles Willson Peale (1741–1827), *William Buckland,* 1774–1787, oil on canvas, 36¾ × 27½ in. (93.0 × 69.9 cm). Yale University Art Gallery; Mable Brady Garvan Collection.

from an impoverished boyhood and skirmishes with the law over debt to attain the upper echelon of his society and profession.[69] In 1754—near the time that Buckland was signing his indenture in England—young Peale bound himself out to an Annapolis saddle maker. In his autobiography, the painter recalled the sense of liberation he experienced when his term as an apprentice came to an end:

> How great the joy! how supreme the delight of freedom. . . . it is not possible for those who have never been in such a situation to fully feel the sweet, the delightful sensations attending a release from a bondage of 7 years and eight months, . . . from sun rise to sun sett, and from the beginning of Candle light to 9 o'clock, . . . under the control of a master, and confined to the same walls and the same dull repitions of some dull labours.[70]

Buckland sat for Peale at a time of burgeoning republican feeling and libertarian rhetoric. In the portrait, Peale seems to recognize and celebrate his own confident brand of self-made man. An ardent egalitarian, the artist championed personal and political freedom. Yet he also exhibited the inconsistencies of his time concerning

equal liberty for African Americans. In a diary entry of 1778, Peale speculated that the owning of slaves contributed to a general degeneration of southerners. In the same year, however, he also recorded a desire to purchase a "Negro boy to wait on me, I have long wanted one." Peale included the conventional figure of a slave child in a group portrait of his brother James's family. Little more than the ghostly hint of a person, the face of the small girl barely emerges from the dark background of the conversation group.[71]

It was from the shadowy perimeters of a white household that Phillis Wheatley first found inspiration as a poet. Kidnapped from Africa when about eight years old, she was enslaved and then purchased by John Wheatley, a Boston tailor. She quickly learned the English language and, within two years, was reading the Bible and studying Latin. Trained as a personal maid to the Wheatley women, the African girl was granted freedom from household duties to read. By age fourteen, she published her first poem in the *Newport Mercury,* which describes a narrow escape from a shipwreck. In an accompanying note to the newspaper, Phillis explained that she learned the story from two mariners who came to dine when "this Negro Girl at the same Time 'tending Table, heard the Relation."[72]

The maidservant continued to write and soon attracted wide public notice. Her talents made her an intellectual novelty in her master's household and an exotic curiosity in Boston salons. In a few years, she had attracted enough celebrity that a volume of her verses, *Poems on Various Subjects, Religious and Moral,* was selected for London publication in 1773. By 1800, the book had gone into five editions circulated on both sides of the Atlantic. Traveling to London, she met British gentry and nobility, including the Lord Mayor Brook Watson. Voltaire read her poems and pronounced them "très-bon vers anglais." The slave poet continued to publish her verses, including an ode to Washington, with whom she corresponded.[73] By 1778 the young woman had gained her freedom and married a free black man. Unfortunately, her chronically unemployed husband was eventually imprisoned for debt. Wheatley turned to scrubbing floors in a boardinghouse to support herself and her family. At the age of thirty-one, she died alone and in poverty while giving birth to her third child.[74]

A portrait of Phillis Wheatley was engraved in 1773 as the frontispiece of her book (fig. 1-13). It was based on a painting—now missing—that may have been produced by the African American artist Scipio Moorhead.[75] The young woman is pictured in a dark gown with white fichu, apron, and pleated mobcap. A bow on her cap and dark band of ribbon at her throat are her only ornaments. She is seated at an oval stand that holds paper, ink, and a small book. As in the Buckland portrait, Wheatley is pictured actively engaged in creative work. However, the pose may have also served to give proof of her ability. Just as the publishers included certificates of authenticity in her book to verify that the verses were in fact written

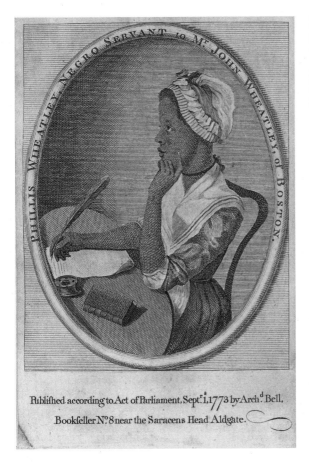

Fig. 1-13. Unknown artist (after Scipio Moorhead?), *Phillis Wheatley*, 1773, engraving, $5\frac{1}{16} \times 4$ in. (12.9 × 10.1 cm). National Portrait Gallery, Smithsonian Institution.

by one who had been "an uncultivated Barbarian from *Africa*," the portrait authenticates her talent by portraying her in the act of writing. The tabletop has been tilted to reveal that she indeed controls the pen that puts words to paper.

The young writer, also like Buckland, is pictured as she momentarily pauses to collect her thoughts. Yet she does not look toward the viewer. Instead, she gazes upward in a pose that traditionally suggests consultation with a muse. In this instance, the devout young woman's gesture may also be seen as an appeal for heavenly assistance. On another level, the gesture also resembles the attitude of black attendants in colonial portraiture who gaze upward at their earthly owners. No master is pictured, yet his presence is nonetheless interjected by the oval legend of the engraving that enframes the portrait: "Phillis Wheatley, Negro Servant to Mr. John Wheatley of Boston." Though the image presents the features of a renowned poet, the encircling text qualifies her accomplishments by revealing the nature of her dependence. Thus, John Wheatley gains credit for his servant's

efforts; the poet gains notoriety *because* she is a slave. Her eyes seem to scan her name and the words "Negro Servant," as if to direct the viewer to that important underlying fact. In this way, the subject herself appears to wonder at the incredible achievements of a teenage slave girl.

The American Revolution acted to undermine both chattel slavery and white indentured servitude. Although isolated cases of bound servants survived as late as the 1840s, the indenture system ceased to be important in any part of the United States after the war.[76] At the same time, antislavery arguments increased in direct proportion to libertarian calls for political freedom. Addressing the obvious hypocrisy of colonial claims of inalienable rights in the face of domestic slavery, the Continental Congress voted to discontinue the slave trade in 1774. By the 1790s, most of the northern states had enacted laws that provided for the gradual emancipation of African Americans. Chattel slavery was not entirely eradicated, nor would it be for years to come, even in the North. Nevertheless, the Revolution marked a crucial point at which the North and South diverged.[77]

A dual system of servitude flourished in the new republic on the eve of the nineteenth century. Southern states continued to rely on black slaves to meet their requirements for menial labor. In New England and the mid-Atlantic regions, domestic service positions were filled by free or soon-to-be manumitted blacks and by poor native and immigrant whites, most of whom earned subsistence wages. However, in all regions, the lowest level in the hierarchy of the serving class fell to black workers, both slave and free.[78]

The portrayal of black servants in American art was built on British traditions of representing slaves as docile attendants, figures who functioned primarily to elevate the importance of white subjects. That colonial artists rarely chose to depict white servants may have resulted in part from the growing ambivalence surrounding the issues of class in a country that was built on the institution of indentured servitude. In the years before and after the Revolution, Americans—including descendants of servants and former servants—sought political and personal legitimacy. Anxious to overcome a common European view that they were a population of vagrants and criminals, Americans distanced themselves from the stigma of bound service.[79] One way to do this was to embrace wholeheartedly the republican ideology that put forward the concept that merit came not from class privilege but from virtue and industry. Servants could become valued citizens, no longer enslaved by a despotic master or ruler; leaders, in turn, would become servants of the people. Another way was to draw sharp distinctions between those who could transcend bonds of dependence and those who could not. In this process, African Americans were excluded from the "great metamorphosis." Color became identified with caste, and black people were inexorably associated with servitude.[80]

*Chapter Two*

---

# A Republican
# Independent Dependent
## 1790–1840

After a successful conclusion of the hard-fought Revolutionary War, the nascent United States Congress drew up a national code of laws. Among other benefits, the Constitution's preamble proclaims the "blessings of liberty for ourselves." Yet few American leaders imagined or wanted a social system that lessened the prerogatives of upper-class, white males. When Abigail Adams implored her husband, John, to "remember the Ladies" in the new legal system, he articulated a growing fear of social upheaval and anarchy in the wake of war:

> I cannot but laugh. We have been told that our Struggle has loosened the bands of Government every where. That children and Apprentices were disobedient . . . that Indians slighted their guardians and Negroes grew insolent to their masters. But your letter was the first Intimation that another Tribe more numerous and powerful than all the rest were grown discontented. . . . Depend upon it, We know better than to repeal our masculine systems.[1]

Women, children, both free and enslaved African Americans, newly arrived immigrants, and the poor were traditionally subordinated in colonial society. Were they now to share with privileged men equal status and rights of citizenship? This crucial question contributed to the confusion and ambivalence that surrounded the relationship between server and served in the years following the Revolution through the Age of the Common Man in the 1830s.

Ambiguity also informed the representation of domestic servants in this period. White servants were hazily defined in both verbal and pictorial imagery. African

American workers were rarely pictured as anything other than subordinates—a perpetuation of colonial modes of representation. The figures of black servants and slaves were regularly isolated within compositions by conventions that clearly signal separateness.

### Contrasts and Hazy Distinctions

As delegates gathered in Philadelphia to draw up the new Constitution in 1787, a remarkable play opened in New York City. *The Contrast,* by Royall Tyler, was the first comedy with American themes to be professionally staged. Through a series of comparisons, the story attempts to define a national identity. The character of Colonel Henry Manly represents the ideal American—honest, sober, direct. His foil, Billy Dimple, affects ostentatious forms of address and fashion commonly associated with European aristocracy.[2]

Their differences are underscored by the subplot interactions between Manly's servant, Jonathan, and Dimple's valet, Jessamy—subordinates who emulate and sometimes exaggerate their masters' personalities. With Jonathan, Tyler establishes the archetypal country Yankee, a stock character who appears in literature and folk culture throughout the nineteenth century. The honest yeoman's rough sincerity and pronounced love of freedom captured the American imagination. Within decades, Brother Jonathan would be transformed into Uncle Sam, the better-known personification of those ideals.[3]

Proud of his status as a citizen, Jonathan displays a republican contempt for social distinctions between "quality" and "other folks." Yet when Jessamy calls him a servant, he roars, "Servant! Sir do you take me for a neger,—I am Colonel Manly's waiter." He continues, "I am a true blue son of liberty, . . . no man shall master me." To substantiate his claim, Jonathan produces a contrast of his own: that being between himself—a free landowner's son—and one whom many perceived as the only American servant—the black worker. Yet despite the character's protests, Tyler clearly portrays Jonathan as an underling. His naïveté and backwardness are meant to evoke laughter from a sophisticated audience that understands social strata and, hence, the differences between the Colonel and his manservant.[4] The change of Jonathan's occupational title, the playwright asserts through Jessamy, is a "true Yankee distinction, egad, without a difference."[5]

Servitude and slavery persisted in varying degrees and manifestations throughout the new republic. At the same time, the country continued to be celebrated as a place where "talent and worth are the only eternal grounds of distinction."[6] Authors of American conduct books encouraged readers to be sensitive toward household workers, "servitude being settled in opposition to the natural equality of

mankind, it behooves us to soften it." One went as far as to advise readers to converse with servants "as if you were their Equal."[7] Under these conditions, even the lowest workers were emboldened to claim freedom as an individual right.

Contemporary observers from Europe often found themselves uneasy with this blurring of status. In 1818, Englishman Henry Fearon noted an independent spirit in both political and personal realms. Like other foreign commentators, he discerned a resultant "want of *social subordination*" among domestic servants.[8] By the 1830s, French aristocrat Alexis de Tocqueville had determined during his American travels that "the lines between authority and tyranny, liberty and license, and right and might seem to [both master and servant] so jumbled and confused that no one knows exactly what he is, what he can do, and what he should do."[9]

With the loosening of class boundaries, many Americans themselves developed misgivings about a perceived "contagion of rebellion" spreading among persons "wholly unprepared for their new situation."[10] On New Year's Day in 1790, Abigail Adams reprimanded her servants for celebrating the occasion too liberally. She wrote, "The common people, who are very ready to abuse Liberty, on this day are apt to take rather too freely of the good things of this Life."[11] Shortly afterward, President George Washington sent two of his white domestics to the workhouse for misbehavior. Privileged families still expected deference and obedience from subordinates and were ready to exact it through firm discipline.[12]

A wary attitude toward the lower orders emerged on the heels of Shays' Rebellion of 1786, during which hundreds of armed farmers and laborers in western Massachusetts, most of them veterans, rioted against taxation and inequalities in property qualifications. The uprising is mentioned in *The Contrast* when Jessamy, perceiving Jonathan's free spirit, asks if he had taken part with the insurgents. Jonathan answers, "Put your ear this way—you won't tell?—I vow I did think the sturgeons were right."[13] Though Tyler verifies a general leveling of social distinctions in his play, he nevertheless interjects this small note of warning. Even within the comic and seemingly loyal figure of Jonathan lurk the dangerous seeds of class unrest.

An essential factor that contributed to the growing sense of independence among domestic workers was the decline of the indenture system. The Revolution and the War of 1812 disrupted the regular flow of European immigrants. A steady reduction of the cost of transatlantic passage eventually eliminated the need for all but the poorest individuals to indenture themselves. Moreover, at the close of the colonial period, the almost total substitution of black slaves for white bound laborers was fully established in the mid-Atlantic and southern regions. In the North, where service was gradually transformed into wage labor, workers began to exercise freely their ability to change positions in search of the best conditions.[14]

In the 1820s, the ascendance to the presidency of Andrew Jackson, a backcountry lawyer and military hero, gave credence to long-standing egalitarian percep-

tions. The so-called Age of the Common Man,[15] which extended into the 1830s, was self-defined by contemporary analysts who assumed that an absence of aristocratic titles denoted an absence of class stratification. Several articulate Europeans such as Tocqueville, Harriet Martineau, and Frances Trollope toured the United States and published lengthy observations on the democratic experiment. Americans, including Timothy Dwight and James Fenimore Cooper, contributed their own accounts of national life and manners. Together they describe a society generally composed of "middling" orders accorded equal conditions and opportunities.

To illustrate the permeability of class boundaries, Martineau documented the circumstances of a New England butler. An employee of the president of Harvard, the manservant also held the honorable position of major of the horse in the local militia. "On cavalry days, when guests are invited to dine with the regiment," Martineau related, "the major, in his regimentals, takes the head of the table, and has the president on his right hand. . . . The toasts being all transacted, he goes home, doffs his regimentals, and waits on the president's guests at tea."[16]

Tocqueville, however, discerned a gap between American ideology and practice. While a "fancied equality" between families and servants was created through public opinion, he explained, there existed "an actual inequality of their lives."[17] An anonymous Philadelphia author articulated a similar observation at the same time. Great error was made, he argued, by those who confounded American political and social systems. "There is perfect freedom of political privilege, all are the same upon the hustings, or at a political meeting," he noted, "but this equality does not extend to the drawing room or the parlour." The writer goes on to list distinct ranks in American society, consigning servants—"a necessary evil"—to the lowest realms.[18]

All were certainly not the same in a political sense or otherwise. "The Jacksonian era witnessed no breakdown of a class society in America," historian Edward Pessen has recently asserted. "If anything, class lines hardened, distinctions widened, tensions increased." As property qualifications for the vote and the holding of office were gradually removed state by state, white males remained the only true beneficiaries of democratic reform. Despite numerous accounts of egalitarian impulses, women, children, Native Americans, immigrants, slaves, and free African Americans actually suffered a loss of standing. Personal subjugation came to be justified on the grounds of social and economic dependency and inferiority.[19]

## Republican Independent Dependents

In the decades between 1790 and 1840, American servants became legendary for their class sensitivity. Calling one a "servant" or referring to a "master" or "mistress" became a grievous affront to workers, who gained wide reputation for quit-

ting at such provocation.[20] Contemporary travelogues describe testy domestics who firmly rejected the servant title.[21] One offended housekeeper retorted that she was, in fact, a "woman citizen." Another, paralleling Jonathan's stage proclamation, informed a visitor that none but blacks were servants.[22] The word became so loaded that an 1830s etiquette book assured its readers that individuals who closed their letters with the traditional "I have the honour to be your very obedient servant, etc." did not compromise themselves by evoking inferior status.[23]

It was at this time that the Americanism "help" became a less offensive substitute. Theoretically, helping was a peer relationship based on the premise of obliging; a worker performed service as a freely adopted, temporary favor. In her ground-breaking assessment of domestic service in the United States, Lucy Salmon connected the era's disuse of the term "servant" with several factors: the stigma associated with the criminal and debtor elements of colonial servitude, the southern adoption of the title for slaves, the leveling tendencies that prevailed in a new country, the literal interpretation of the preamble of the Declaration of Independence, and the dissemination of French social and political theories.[24]

While the term "help" quickly gained popular currency, other titles were also formed to disguise the subordinate nature of service. Catharine Sedgwick concocted "republican independent dependent," a description that embodies American ambivalence by neatly giving status and, at the same time, taking it away.[25] In *Live and Let Live* (1837), she presents two matrons who debate terminology for the hired help. One settles on yet another popular label:

> "But stay, Sara, don't you call your servants servants?"
>
> "No, I call them domestics."
>
> "Heaven be praised! I expected you would say *help*. . . . But, honestly, don't you think servant sounds more natural, and is the more convenient name?"
>
> "Yes, but I think the wishes of those who bear the name should be consulted, and we all know that servant is so disagreeable to them especially, to the best among them, that it requires some courage and a little hard-heartedness to use it in their presence."
>
> "But is not much of this rank pride, Sara? Are they not discontented with their subordinate condition, and ought they not learn that a person may be as truly respectable in one grade as another?"
>
> " . . . The truth is, we are in *transition state;* the duties of which, as it seems to me, are imperfectly understood; and as to the names he would be a benefactor who should introduce those satisfactory to all parties."[26]

The concept of helping presupposes that the one in need is already occupied with household labor. In these early decades, the duties of work and home were still

intertwined in a predominantly agrarian culture. That the household was still a place of economic production contributed to the fluidity of boundaries between public and private realms, as well as between family members and workers brought in to serve them. Wealthy urban residences and modest rural homes alike procured the assistance of "hired hands" and "help." Particularly in New England and in the northern countryside, workers were drawn from neighboring families of similar socioeconomic standing. These servants shared the conditions of the family, and in turn, employers assisted with chores.[27]

## Imaging the Help

The popular reframing of the role of service in this period had implications for modes of portrayal in the visual arts. White servants were delineated in paintings, drawings, and prints as helpers whose status is vague or, as Sedgwick's matron put it, "imperfectly understood." A cooperative relationship is presented in a hand-colored etching published around 1820 by an unknown artist in *The History of Little Jackey Horner* (fig. 2-1). Above the rubric of "Industry," maid and mistress are shown working together in the kitchen. Patty, the servant, has her sleeves pushed up as she concentrates on rolling out dough. Her mistress brings foodstuffs from the larder and directs her:

> "Come Patty, she said,
> "My good little maid;
> "Come; let me have all things in order.
> "Move quickly we must,
> "So you make the crust,
> "And mind, and crimp nicely the border."

The representation conveys a companionable spirit and shared labor between mistress and maid, though the verse underneath makes clear who gives and who receives the orders.

No help had a more ambiguous position in the household than the impoverished female relative. Many eighteenth- and nineteenth-century orphaned cousins and poor maiden aunts exchanged domestic labor for a place to live. In the earliest years, such women were frequently consigned to the family spinning, hence the term "spinster." Typically, compensation came in the form of room, board, gifts, and tips—paternalistic practices that further confused boundaries between kinship and service.[28]

Families also recruited unrelated single women as unpaid maids and housekeepers. In his 1823 novel, *The Pioneers,* James Fenimore Cooper portrays Re-

Fig. 2-1. Unknown artist, *Industry,* hand-colored etching published in *The History of Little Jackey Horner* (Baltimore: Nickerson and Nicholson, ca. 1820), p. 10. The Metropolitan Museum of Art; gift of Lincoln Kirstein, 1964.

markable Pettibone, the middle-aged woman who manages the home of widower Judge Templeton. The author describes her as intolerant of "the idea of being governed, or of being compelled to pay the deference of servitude." When explaining her position, Remarkable evokes the face-saving notion of helping: "I thought the situation a good one seeing that I was an unmarried body, and they were so much in want of help so I tarried."[29]

When Charles Willson Peale pictured his own family in a large group portrait (1770–1773, completed 1809), he included the figure of his housekeeper. In *The Peale Family Group* (fig. 2-2), the family is gathered around a table to witness a drawing lesson. At the viewer's far left is the artist's brother, St. George, who sketches a portrait of his mother, Margaret, and a little niece, both seated opposite him. To the right sits another brother (and artist), James, and bending above them with head tucked is the portraitist himself, Charles Willson Peale. At center is the artist's wife, Rachel, who holds a child on the table. Above stands her sister-in-law, Margaret Jane, who, like Rachel, looks out with an engaging smile. Quite

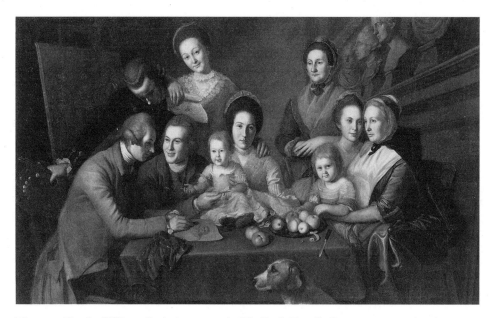

Fig. 2-2. Charles Willson Peale (1741–1827), *The Peale Family Group,* ca. 1770–1773/1809, oil on canvas, 56½ × 89½ in. (143.5 × 227.3 cm). Collection of The New-York Historical Society.

near the artist's mother is another sister, Elizabeth, who sits so close to her parent that their faces nearly touch. Completing the grouping are Margaret Durgan (called Peggy), the family housekeeper who stands at right, and Argus, the dog, whose profiled head is seen before the table at bottom center.[30]

John Adams was favorably impressed with this monumental conversation piece when he saw it in Peale's Philadelphia studio. In a letter to his wife, Abigail, he observed of the sitters "a pleasant, a happy Chearfulness in their Countenances, and a Familiarity in their Airs towards each other."[31] This was certainly the effect for which Peale was striving, as evidenced by his original title (and inscription), *Concordies Anima*—harmony embodied.[32] Indeed, when studying the painting we see a group of people who are physically familial and familiar. They form an intimate gathering. Leaning comfortably into each other, they are intertwined with arms that encircle and hands that caress.

Peggy Durgan seems the exception. Her arms are folded along the top of Elizabeth's chair in a closed gesture that separates her from the others. Moreover, her expression is withdrawn and lacks the cheerfulness ascribed by Adams. As a standing figure, Peggy is the visual correlation to Margaret Jane, but her smaller stature, somber clothing, and averted gaze reduce her to a secondary status. Just where she is supposed to be in the pictorial space is unclear, for her brown dress and

shadowy face tend to push her back visually. Peale orders his family catalogue by gender, placing the three brothers to the left and the multigenerational females to the right. Except for his mother, who turns to have her likeness recorded, Peale presents all of the adult women squarely in line with the picture plane. However, like the devoted Argus, Durgan turns to face the patriarchal cluster at the other end, privileging that group over the mistress before her. Though the housekeeper was the lifelong companion of the senior Mrs. Peale, the honored place at the matriarch's right hand is given to a true-born daughter who sits between the two.

Peale explained Peggy Durgan's position in the family in his autobiography. As the orphaned niece of his mother, she was brought as an infant into the household, where later, as a girl, she served as the artist's own nursemaid. When the adult Peale invited his widowed mother to live in his Philadelphia home, Durgan was brought along. Unlike the family, the housekeeper was a pious Catholic. Peale related that on their coming to reside with him, he offered to purchase for her a seat in the local chapel—an offer she declined. Never married, Durgan served as companion to the artist's mother, as nurse to the next generation of Peale children, and as the one who "attended to all the domestic concerns." In short, Peale wrote, "during her whole life she was devoted to the service of the family."[33]

While it is clear that Durgan was an economic dependent, she was not entirely subservient. The artist related how she petted and, "as some people would say," spoiled his son Raphaelle by secretly supplying the boy with homemade bread against his father's wishes. The incident was "one instance of her affection," Peale wrote, "but we will not say, that it was a very judicious measure."[34] Through this minor act of insubordination and her refusal of the gift of the church pew, the housekeeper seems to have exercised her own limited independence. That Peale would include her in the family portrait is understandable, considering her relationship as cousin and foster sibling. However, her presence also functions as a testimonial to the family's generosity. A poor female relation of a different faith, she was a double recipient of benevolence, having first been taken in by Mrs. Peale and then by her son. Her visual separation attests to her subordinate status and, perhaps, to some contentious feelings on the part of the painter.

For a large and ever-growing household like the Peales', domestic labor was constant and difficult. In 1798, Raphaelle wrote to Peale to tell him that his stepmother—the painter's second wife—was nursing a blister on her finger after a particularly stringent bout of cleaning: "It was her intention to write yesterday—but know all *Men* that day was—*Woefull Saturday*—the Important day was big with Buckets & Brooms, not a smile Graced the long visage of any of your household— Even Gunner [the dog] slunk into the inner Cellur with his Tail between his legs." At the end of the letter, the son reminds Peale that "my Mother says you must not forget to *Get* her a little girl," meaning to procure a child servant.[35]

Homeless children provided the most inexpensive source for domestic servants. In the early years of the century, orphans were still subject to placement practices based on Elizabethan poor laws. As in the colonial period, parents who could not provide for their children would "put them out" as servants or apprentices to relieve the economic burden to their families. Such youngsters commonly served as live-in laborers until they were eighteen. In return for unpaid work, they were given a place to live and, supposedly, the opportunity to learn some skills. Boys were usually placed in agriculture or trade situations; girls (often called "little girls") were usually sent to perform cleaning or child care.[36] In 1804, Margaret Bayard Smith described the new addition to her staff as "a fine little girl of 5 years old bound to me by Dr. Willis. While I work, she plays with [my daughter] Julia and keeps her quiet, she is gay, good temper'd and well behaved."[37]

A child servant is pictured attending the door in John Lewis Krimmel's *Country Wedding, Bishop White Officiating* (fig. 2-3), of about 1814. The artist staged the genre scene in a boxlike setting and populated it with figures dressed in Sunday finery for a nuptial event. In the rustic keeping room, the bride and groom stand before an elderly clergyman, and the maid of honor draws near to hold the bride's glove. The parents are seated to the left, and other family members encircle them. A latecomer is directed to the ceremony by a young girl who attends the door.

At first glance, the small attendant seems to blend easily with the family. Yet, when the *Analectic Magazine* published the engraved image in 1820, the figure was identified as a servant.[38] In performing her duties, the girl is excluded from the social gathering; accordingly, the figure is marginalized to the outskirts of the composition. The child assumes the traditional servant's position at the doorway, acting as intermediary between the outside world and the private realm of the family. With her back to the viewer, hers is the only face completely hidden. She wears a blue pinafore tied at the neck and holds it draped over her right arm. Beneath is a plain beige dress that is tucked up and back to reveal a brown petticoat underneath. This bunching of the outer skirt is a centuries-old gesture made by women to get excess folds out of harm's way during chores. It also serves as a clothing convention that readily signifies a working girl or woman.[39]

## Krimmel and the "New School of Painting"

Although previous artists experimented with genre imagery, John Lewis Krimmel was the first to make a serious effort at depicting everyday American life. His efforts led the way for a flourishing of American genre painting from the 1830s through the 1850s.[40] The German-born artist came to the United States in 1806 after receiving professional training in Stuttgart. After settling in Philadelphia, he regularly

Fig. 2-3. John Lewis Krimmel (1786–1821), *Country Wedding, Bishop White Officiating,* ca. 1814, oil on canvas, 16$\frac{3}{16}$ × 22$\frac{1}{8}$ in. (41.1 × 56.2 cm). Courtesy Pennsylvania Academy of the Fine Arts, Philadelphia; gift of Paul Beck, Jr.

toured the Pennsylvania countryside, where he collected sketches of domestic activities. Krimmel synthesized these studies with compositions and themes borrowed from printed images by William Hogarth and Scottish artist David Wilkie. He helped popularize genre painting by producing painted copies of Wilkie's prints and exhibiting them alongside his own canvases.[41] After attending an exhibition of Krimmel's replica of Wilkie's *Blind Fiddler* in 1813, an anonymous critic responded as if it were the original: "Mr. Wilkie may be considered the founder of a new school of painting—he appears to have copied nature very closely without her deformities; he has given all the character and finish of Teniers without his vulgarities. . . . we believe his school of painting well fitted for our republican manners and habits and more likely than any other to be appreciated at present."[42]

The development of genre painting with native themes was an essential component in the quest for American self definition. Scenes produced in the early decades of the century are typically static, self-contained, and rendered with graphic precision. With their highly anecdotal and descriptive qualities, they convey the illusion of presenting a faithful, objective record. Nevertheless, much like Tyler's play, the images function as rhetorical constructs that interpret and define political and social relationships.[43]

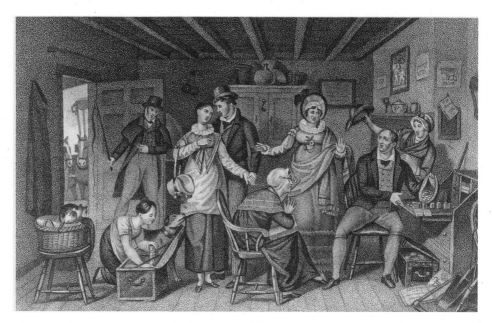

Fig. 2-4. Charles Goodman and Robert Piggot, engravers, after John Lewis Krimmel, *Departure for a Boarding School,* 1820, aquatint, 5¼ × 8 in. (13.3 × 20.3 cm). Illustrated in *Analectic Magazine* 2 (1820), facing p. 421. Collection of The New-York Historical Society.

In 1816, one critic protested that American life was ill-suited for portrayal since it lacked the novelty and interest of European genre: "Have our peasantry individuality enough to ensure the artist, who may study and delineate their habits, a lasting fame? Is there enough that is peculiar in their costume, their manners, their customs and features to enable an observer at once to recognize them in a picture?"[44] Experiencing the same difficulties in visually defining servants, Krimmel produced images in which it is somewhat difficult to recognize the "peasantry."

In 1820 *Analectic Magazine* published engravings of two additional genre paintings by Krimmel (figs. 2-4 and 2-5). An accompanying article explains that *Departure for a Boarding School* and *Return from a Boarding School* were meant to be viewed together and describes the narration in detail. The prints portray a country household where the daughter takes her leave for and then returns from school. Between the two images, Krimmel contrasts her demeanor before and after she acquires a "city education." In the first engraving (fig. 2-4), she is being collected by the school mistress, whose carriage waits outside. The simply dressed girl reluctantly bids her beau and family good-bye. Near the doorway at left, a maidservant of similar age finishes packing her trunk. Kneeling on the floor in a short-sleeved

Fig. 2-5. Unknown engraver after John Lewis Krimmel, *Return from a Boarding School,* 1820, engraving, $4\frac{1}{4} \times 7\frac{3}{16}$ in. (11.4 × 18.3 cm). Illustrated in *Analectic Magazine* 2 (1820), facing p. 507. Collection of The New-York Historical Society.

work dress and pinafore, she carefully places a Bible among her young mistress's belongings. The article does not refer to the worker specifically as a servant; rather she is described as the "little girl" and "girl in waiting."[45]

The second print (fig. 2-5) suggests some passage of time. The returned daughter, wearing a party frock, is shown seated at a new pianoforte. She has redecorated one side of the family room in keeping with her newfound gentility. With a miniature portrait of a uniformed officer in one hand, she turns to reject her former boyfriend. Her grandmother, the accompanying text notes, witnesses the rebuff with astonishment. Even the family dog recoils in confusion. Occupied with new trinkets, the young woman has kicked over the spinning wheel, signifying that household labor is now beneath her. Her mother stands at center as an intermediary between realms of work and leisure. While she wears an apron that indicates her participation in domestic chores, she also points to her daughter's diploma and finishing-school drawings with, the article relates, "mistaken pride and fondness."[46]

Krimmel has positioned the maid on the opposite side of the composition from the daughter. The worker has prepared and now serves a meal on the freshly set table at left. Before her are evidences of her labors: a water-filled washtub for soiled

dishes, two different brooms, and a cleaning rag. She beckons to the master of the house—whose spade indicates that he, too, is midchore—and entreats him to put away the alarming tuition bill and eat. Though her low status is indicated through dress and presentation, the servant acts as a fully functioning, productive member of the household. Acting in compliance with her role, she carries out her duties with industry and loyalty. Her virtue, established in the first image by her association with the Bible, contrasts with the indolence and inconstancy of a daughter who literally turns her back on the simple values of her parents.

Implicit in the image's moral are the merits of appropriate conduct, a notion reinforced at the time by Sarah Savage. In her *Advice to a Young Woman at Service,* the author adopts the guise of a former domestic to prescribe proper behavior for workers. Assuming that they share "the same country, the same religion, the same virtues" as employers, she assures them that equality is at work in the relationship. "But our creator, for wise purposes has made our outward state, at least for a time, in some things to differ," she continues. "Many are rich, while others are poor; but there is a continual shifting of circumstances, especially in our happy country, where all have an opportunity of rising by virtue and industry."[47]

Krimmel's 1813 painting *Quilting Frolic* (plate 2) represents a scene in which the roles of mistress and servant are not only indistinct but nearly indecipherable. He pictures the moment when revelers arrive at a country home after a quilt has been put together by several neighboring women. The celebration of the community piecing of a coverlet was a traditional entertainment that was often accompanied by music and dance. In 1790, Martha Ballard wrote in her journal, "My girls had some neighbors to help them quilt a bed quilt, 15 ladies. They began to quilt at 3 hour pm. Finisht and took it out at 7 evening. There were 12 gentlemen took tea. They danced a little while after supper. Behaved exceedingly cleverly. . . . Were all returned home before the 11th hour."[48]

In Krimmel's multifigured tableau, three men are ushered into the common room by young women who participated in the quilting. They are accompanied by a black fiddler in ragged clothes who provides music for the evening. The guests seem to have arrived early, since the quilt is just being taken from its frame. A surprised woman looks up from the floor where she kneels to clean up scraps of fabric. Above her, an older woman pauses from laying out bread on a newly set table. Two children are present: a boy who, dressed in good clothes, pockets some stolen sweets and, at center, an aproned black girl who holds a tray full of cups and saucers. In the background is seated the grandfather, who, with his dog, warms himself at the crackling fire.

The interplay among the central figures suggests the humorous consequences of role confusion.[49] Exactly who is the mistress of the house is "imperfectly understood" by the young man at center. With a hand to his hat, he tentatively glances

toward the bonneted woman at the table. This older worker, likely the hired or related help, pauses from her task and points down with a smile to the woman at her feet. Here at last is the hostess, betrayed primarily by the startled look on her face. She has been caught unprepared as she tidies the floor. By placing the mistress at a lower level than her workers, Krimmel has reversed the traditional method for portraying rank.[50] The woman's raised hand indicates her alarm at being found in such an unseemly position; at the same time it also points to the child servant at her side.

The young black girl's bare arms strain with the weight of the heavy, mismatched crockery. However, she turns to smile at the lively entrance of the revelers and fiddler. Krimmel was one of the first painters to distort African American features for comic effect. In this image, he has given both the child and the fiddler broad grins and wide, red lips. He also employs the stereotypical association of African Americans with music.[51] The figure of the black servant has further significance. It would be to the mistress that the maid offers the prepared tray for inspection and direction. The dark complexion of the little worker would have been an immediate, unmistakable sign of subservient status to a contemporary audience; her gesture of obeisance acts as the key to unraveling the household hierarchy.

## *Emphatically a Servant*

If the status of white help appeared ambiguous in representations from this period, African American servants were generally portrayed in ways that left little question as to their place in society. Feudal patterns of deference and condescension came to be guided more by racial than class differences.[52] The newly articulated notion of helping did not extend to black workers in American homes. As one British observer put it, "The negro is not a help; he is emphatically a servant."[53] House slaves had little say about the length and type of service they performed. Free black domestics often remained in service indefinitely, ruled by a poverty that required no pretense of obliging. Employers continued to expect from African Americans a deference that they no longer obtained from white servants. What they came to view as prickly exercises of independence in whites they would typically perceive as gross insubordination in blacks.[54]

In 1781, a female slave in Massachusetts tested the principle of personal liberty in court. Earlier, when shielding her sister against the violent anger of their mistress, Elizabeth Freeman received a crippling blow to her arm with a heated kitchen shovel. She immediately fled the household, refusing to return. Having once overheard when serving at the table that all people were proclaimed equal and free under the new state constitution, Freeman decided to bring legal action against

her owners. Represented by Theodore Sedgwick, an attorney who later became a congressman and a U.S. senator, the black woman won her suit. She gained not only her freedom but a monetary settlement for damages. Thereafter, she remained in the Sedgwick household as a hired nurse.[55] Among her young charges was Sedgwick's daughter, Catharine, whose reflections on American domestic service are quoted earlier. In her memoirs, the author described Freeman as "the main pillar of our household." She continued,

> Mumbet (mamma Bet) . . . though absolutely perfect in service, was never servile. . . . [She] had a clear and nice perception of justice, and a stern love of it, an uncompromising honesty in word, and deed, and conduct of high intelligence, that made her the unconscious moral teacher of the children she tenderly nursed. . . . Truth was her nature—the offspring of courage and loyalty. In my childhood I clung to her with instinctive love and faith, and the more I know and observe of human nature, the higher does she rise above others.[56]

Elizabeth Freeman was almost seventy in 1811 when Catharine's sister-in-law, Susan Ridley Sedgwick, delineated her likeness in a miniature portrait on ivory (fig. 2-6).[57] In this exceptionally sympathetic portrayal, she is presented in a three-quarters pose, dressed in a blue empire gown, gold beads, and white fichu and ruffled cap. While her furrowed face and gray hair give testimony to her age, her direct gaze is alert and knowing. The miniature portrait *Elizabeth "Mumbet" Freeman* functioned as a personal memento of a beloved family member. Nearly four inches square, it is too large to be worn or carried; rather, the painting is for display in the home. Like her heroic story, Mumbet's image was passed down through the family. Catharine, who was eventually buried next to her in the Sedgwick plot in Stockbridge, described her sense of reverence in the company of the older woman: "I well remember that during her last sickness, when I daily visited her in her little hut—her then independent home—I said then, and my sober after judgement ratified it, that I felt awed as if I had entered the presence of Washington." Freeman's historic lawsuit was instrumental in the push to eliminate slavery in Massachusetts. However, in an ironic action bespeaking the ambivalence of the era, her employer and defender, Theodore Sedgwick, helped draft the country's first fugitive slave law in 1791.[58]

After 1800, African Americans faced growing restrictions in society, a paradoxical turn considering the great advocacy of personal liberty during the Revolution. In the first twenty years after the drafting of the Constitution, all attempts to abolish slavery at the federal level fell to defeat in the face of a strengthening proslavery bloc. Heightened fear of black insurrection followed the bloody overthrow of the French in Santo Domingo and well-publicized slave rebellions led by Gabriel

Fig. 2-6. Susan Ridley Sedgwick (ca. 1789–1867), *Elizabeth "Mumbet" Freeman,* 1811, watercolor on ivory, $4\frac{5}{8} \times 3\frac{7}{8}$ in. (11.8 × 9.8 cm). Massachusetts Historical Society.

Prosser and Nat Turner in Virginia. Winthrop Jordan observes that the "Revolution perpetuated itself and thereby drove home to Americans the dangers of their own thinking."[59]

In the South, laws tightened to drive out free blacks and to make it more difficult for slaves to obtain their freedom. Changing economic patterns dictated the preservation there of the "peculiar institution," especially after the introduction of Eli Whitney's cotton gin. In the "free" states of the North, African American males were disenfranchised in all but four states, and property qualifications and local custom barred them from the polls. Black people were systematically excluded from and segregated in stagecoaches, omnibuses, theaters and lectures, churches, restaurants, hotels, schools, hospitals, and even burial grounds. In most instances, the only way an African American could gain admittance was as a personal servant. Historian Leon F. Litwack writes, "To most northerners, segregation constituted not a departure from democratic principles, as certain foreign critics alleged, but simply the working out of natural laws, the inevitable consequences of the racial inferiority of the Negro. God and Nature condemned the blacks to perpetual subordination."[60]

As in the eighteenth century, African physiognomy and color were examined

and heralded as natural evidence of racial inferiority. Pseudoanthropologists like Dr. Charles White argued that the physical variance of blacks from whites was indicative of their low position in the scale of a hierarchical Nature. Another common assumption held that the African's color was a mark of degeneracy in the human form—since, as it was commonly believed, Adam was white.[61] Racial theorists looked to the Bible to justify the continued subjugation of blacks. They argued that while Noah blessed his son Shem, the parent of the Caucasian race, he cursed Ham, the father of the Ethiopian people, declaring that a "servant of servants shall he be unto his brethren."[62] In the abolitionist newspaper the *Liberator*, a writer observed that the difference between slavery as it formerly existed in Europe and as it was manifested in America arose principally from the circumstances of color: "The slave is not only of a different race from his master, but the difference in personal appearance is striking and conspicuous. . . . These peculiarities become connected with slavery, and bring contempt and scorn upon every descendent of Africa, whether free or not."[63]

Because many white Americans had difficulty reconciling ideals of freedom with the realities of slavery and discrimination, the focus on physical difference between themselves and African Americans provided rationales in the justification of inequitable treatment. To lay claim to their liberties—and the hegemony of society as they knew it—they had to define who they were. The important process of self-definition in these first decades included the naming of who they were not.[64] In 1833, Englishman Thomas Hamilton noted that "the meanest American shopkeeper would redden with virtuous indignation" at the thought of his children working as servants. Because of the common identification of service with black laborers, he wrote, the menial occupation was "connected with a thousand degrading associations."[65] By proclaiming race privilege, white Americans—no matter their standing—could preserve the notion of class transcendence.

## *Images of Separateness*

One artist who delineated the features of American servants, both white and black, was the Baroness Hyde de Neuville. Anne-Marguerite and Jean Guillaume Hyde de Neuville were a French royalist couple in exile in the United States from 1807 to 1814. Within two years of their return to France after the Restoration, the Baron was named French minister, an appointment that brought them back for a second residency in the United States. Throughout their stay, the Baroness compiled a visual chronicle of her experiences. While most of her hundreds of watercolors are landscape and town scenes, she also produced figure studies of friends, neighbors, and some of the domestic workers in her household.[66]

Fig. 2-7. Anne-Marguerite Hyde de Neuville (1749?–1849), *Chambre Maid,* ca. 1810, watercolor, 8¼ × 5½ in. (21 × 14 cm). Collection of The New-York Historical Society.

One of these watercolors (ca. 1810, fig. 2-7) pictures a young blond woman seated in a ladder-back chair. She is shown in a three-quarter position and—though she holds a book in her muscular hands—looks straight ahead. The "chambre maid," as the artist describes her in the caption, wears a fancy, light-colored dress with a back flounce, ruffled collar, and embroidered hem. As a similar sketch of a "femme de chambre" by the Baroness is labeled "Sunday," this image may also portray the maid in church clothing. In order to represent the "costume de scrobeuse" (scrub-woman) in another study, the artist painted a young black woman, Jene, who is seated in a similar pose (ca. 1810, fig. 2-8). However, this domestic wears work clothing—a dark skirt and jacket bodice with rolled-up sleeves. Unlike her counterpart who sits bolt upright, Jene slumps in the chair. She fidgets with her empty fingers in a self-conscious manner, a gesture that also suggests the chapped and painful condition of a scrubwoman's hands. To associate the worker more explicitly with her labor, Hyde de Neuville pictures a water bucket and scrub brush nearby.

When viewed together, the images function dialectically. Except for the un-

Fig. 2-8. Anne-Marguerite
Hyde de Neuville, *Costume de
Scrobeuse,* ca. 1810, watercolor,
$7\frac{1}{2} \times 6\frac{1}{2}$ in. (19.1 × 16.5 cm).
Collection of The New-York
Historical Society.

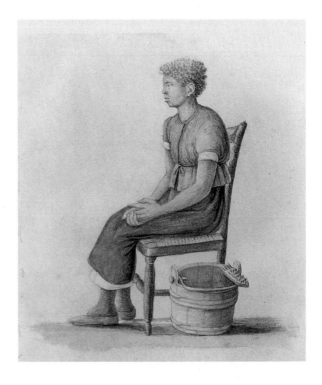

kempt condition of her hair, the white chambermaid could easily be identified as a
middle-class teenager who pauses from her reading. There is an air of youthful en-
ergy and confidence in her features, qualities that the couple generally admired in
American women. The Baron wrote to his family, "Too often in Europe, we have
only false ideas. A well dressed girl would be ashamed to make her own butter, or
employ herself in the kitchen. Here, it is quite different. Nobody feels it any dis-
grace to do useful work."[67] By pose and properties, his wife nevertheless delin-
eated the differences in status between the two workers. Jene is clearly presented as
a scullery maid or drudge, the lowest position in the hierarchy of household duties.

Alburtus D. O. Browere made a far less sympathetic rendering of a scrubwoman
in an 1833 oil painting. A landscape artist who worked primarily in Catskill, New
York, Browere dabbled with genre subjects during his student days at the National
Academy of Design.[68] In *Wash Day* (fig. 2-9), he portrays a black woman down
on hands and knees in the threshold of a fashionable New York City townhouse.
Near a water bucket, the robust worker grasps the same kind of pointed brush as
pictured in Hyde de Neuville's sketch; her other hand rests on a soap dish. She is
framed by the doorway as she works at the very border between interior and exte-
rior spaces. The servant not only attends the portal, but she cleans it as well.

The figure's cheerful, eager expression has been exaggerated to the point of car-

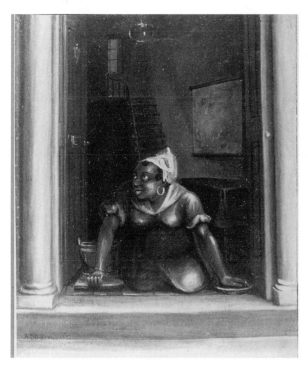

Fig. 2-9. Alburtus Del Orient Browere (1814–1887), *Wash Day,* 1833, oil on panel, 10 × 8 in. (25.4 × 20.3 cm). Present location unknown.

icature: rolling eyes, broad nose and face, and large lips. There is little hint of a scrubwoman's fatigue inadvertently captured in Hyde de Neuville's watercolor. Instead, Browere presents an early manifestation of the "happy darky" stereotype that suggests that African Americans were not only adaptable to but content with drudgery.[69] The painting also implies a degree of sexuality in the working woman. Her position on the ground has an animal quality as she leans her weight back on splayed knees. Highlights of pink pigment scumbled on the surface of the brown dress emphasize the roundness of her breasts and left thigh. Her parted lips are bright red, and the gold hoop earrings glint in the light. The portrayal hints at the prevalent cliché of the Negro Jezebel or Sable Venus. Black women were reputed to be irresistibly more earthy and passionate—a characterization that often served to justify their sexual exploitation by white men.[70]

Browere produced *Wash Day* in an atmosphere of heightened racial strife in the North. Rampant antiabolitionism, marked by individual attacks and mob violence against African Americans and their advocates, reached a peak in the years 1834–1837.[71] The employment of comic or sexual stereotypes by Browere—and, certainly, other artists throughout the century—produced images that could reduce or allay racial fears. Such images also perpetuated social distance between white families and the black women and men who served them.[72]

Domestic service offered one of the few occupations open to urban African American men. Following the economic crisis of 1819–1822, the United States experienced a surplus of trained laborers. Black males were systematically shut out of the job market; their absence from skilled and semiskilled occupations perversely worked to confirm their reputed inadequacies and perpetual dependency.[73] The valedictorian of the New York African School of 1819 summed up their plight: "What are my prospects? To what shall I turn my hand? Shall I be a mechanic? No one will employ me; white boys won't work with me. Shall I be a merchant? No one will have me in his office; white clerks won't associate with me. Drudgery and servitude, then, are my prospective portion. Can you be surprised at my discouragement?"[74]

Nevertheless, a handful of black men like Robert Roberts of Boston gained renown as professional butlers. Roberts, who was employed by Nathan Appleton and Governor Christopher Gore successively, also worked at residences in England and France.[75] In his book, *The House Servant's Directory* (1827), he describes the appropriate way to prepare rooms and offers procedures for proper deportment in serving at social functions. "There is not any part of a servant's business that requires greater attention and systematical neatness," he writes, "than setting out his dinner table, and managing for a party of sixteen or eighteen people."[76]

While Roberts was compiling notes for his instruction manual, artist Henry Sargent was delineating just such a dinner party. Once a student of Benjamin West, Sargent rose to social prominence in Boston as a military man and state senator. After his retirement in 1817, he returned to painting. *The Dinner Party* (fig. 2-10), painted four years later, is believed to commemorate the weekly meeting of Boston's Wednesday Evening Club—a private group of businessmen and professionals who desired conversation. The setting of studied elegance was probably modeled from the artist's own house in the Tontine Crescent.[77]

Through the archway of an adjoining room, Sargent portrays the group of gentlemen as they dine in the late afternoon. The room is meticulously accoutred with polished furniture, gleaming silver dishes and brass fire tools, and a lush carpet protected by a crumb cloth. The main course completed, fruit, nuts, pastries, and wine have been set out for the guests' enjoyment. A single taper has been lit—not for illumination, but for the lighting of tobacco. Two menservants are shown in attendance. A black steward stands in the distant corner at left, one hand grasping a lapel of his russet jacket. To the right, a white servant steps forward to carry a dish from the sideboard. He seems to have the "quick, but light and smooth step" recommended by Roberts, facilitated by the butler's required "thin pumps."[78] Both men are neatly dressed in coats and trousers that match the formality of the occasion.

That two servants are present emphasizes the host's wealth and status. While most Americans employed a single worker, prosperous households could main-

Fig. 2-10. Henry Sargent (1770–1845), *The Dinner Party,* 1821, oil on canvas, 59½ × 48 in. (151.1 × 121.9 cm). Courtesy Museum of Fine Arts, Boston; gift of Mrs. Horatio A. Lamb in memory of Mr. and Mrs. Winthrop Sargent.

*19.13*

Fig. 2-11. Henry Sargent, *The Tea Party,* ca. 1821–1825, oil on canvas, 64¼ × 52¼ in. (163.8 × 132.7 cm). Courtesy Museum of Fine Arts, Boston; gift of Mrs. Horatio A. Lamb in memory of Mr. and Mrs. Winthrop Sargent.

19. 12

tain larger, hierarchical staffs of specialized servants. Abigail Adams, for example, related that she employed "a pretty good Housekeeper, a tolerable footman, a midling cook, an indifferent steward and a vixen of a House maid, but she has done much better lately, since she finds that the housekeeper will be mistress below stairs."[79] The larger the group of servants, the higher the chances of in-fighting—a problem addressed by Roberts, who implored workers to get along with their comrades.[80]

*The Dinner Party* is unusual in two ways. First, it offers a rare portrayal of a white adult manservant in American painting. By the 1830s, service positions were dominated by women—a transition confirmed by visual representations. The male servants that were depicted are predominantly black or, more rarely, white boys or elderly men.[81] In this image, the white worker has been granted the active role. By contrast, the black attendant stands quietly as if waiting instruction.

Sargent's painting is also an unusual portrayal of a racially mixed staff. Henry Fearon noted at the time that "blacks and whites are seldom kept in the same house." Indeed, many white domestics refused to work alongside African Americans. When both were employed, black workers were traditionally relegated to the more difficult or dirtier jobs. Some exception was made for light-skinned workers, suggesting that elite service positions were granted according to shades of color.[82] In 1835, Margaret Bayard Smith contracted with Henry Orr to manage the dinner party she gave when Harriet Martineau visited Washington. In a letter, she related how she entrusted Orr to select the menu and to supervise her "girls." He was "the most experienced and fashionable waiter. . . . He is almost white, his manners gentle, serious and respectful, to an uncommon degree and his whole appearance quite gentlemanly."[83]

About three years after completing *The Dinner Party*, Sargent produced a pendant called *The Tea Party* (fig. 2-11). In a similar format, he depicted his own neoclassical parlor as seen through the deep folds of a velvet swag. More than forty handsomely dressed men and women are shown engaged in conversation among pieces of fashionable French and Sheraton-style furniture. At far left, Sargent has included a doorway framing a black butler. As the worker carries a tray with the silver tea set, he cuts his eyes to the doorway in anticipation of his entry. Isolated from the guests by a wall, he enters the public arena by request or order.

## Drawing a Line

The controlled use of space—both within the home as well as within the constructed precincts of a painting—gives emphasis to the hierarchy of family and servant. Thresholds clearly demarcate boundaries between social spaces. Visually, a

doorway becomes a frame; the lines of the opening contain the figure in a boxlike structure. James Oliver Robertson observes the controlling effect of lines:

> When Americans felt themselves or their beliefs threatened, they drew a line and dared their enemies to cross it. Children and adults drew lines on the grounds and in their imaginations, to separate themselves from danger. They gathered their friends behind the line; by definition, those on the other side of the frontiers were enemies. . . . Lines were drawn around peoples of color, frontiers to separate white Americans from others.[84]

Artists easily and frequently turned to simple compositional devices of spatial distancing and separation—including the laying down of thick, circumscribing lines—to set apart workers from families.[85]

The unknown artist who created the watercolor *The Picnic* (fig. 2-12) of about 1800, developed some imaginative solutions for the placement of a black steward. In this naive rendering, the painter depicts a genteel party who, having come to a pastoral setting by boat, prepare their lunch on a riverbank. The young men and women make themselves comfortable, arranging food and chairs under the trees. With no side rooms, corners, or doorways in which to place the manservant, the artist positions him in the moored canoe. The worker kneels in the bottom and hands provisions to a man on the shore. He is pictorially set apart from the party by three lines: the water's edge, the side of the canoe, and a chainlike rope.

The black attendant is also pictured in livery. His dark blue jacket with red facings and white epaulets instantly announces his servant status. The requirement of special uniforms for household workers, commonplace in the eighteenth century, fell out of favor in the United States in the early 1800s. Like coats of arms and royal titles, livery came to be associated with aristocratic foppery. Yet some members of the urban elite continued to mandate house uniforms, and those servants still required to wear them were typically black.[86] James Fenimore Cooper, using the voice of his fictional American character Cadwallader, noted that liveries were still employed in the city of New York in the late 1820s. However, he wrote, "they are far from frequent. They are always exceedingly plain, rarely amounting to more than a round hat with gold or silver band, and a coat, with cuffs and collars faced with a different color cloth."[87]

Through Cadwallader, Cooper also commented on the use of fancy or stately titles for black servants, "a quiet waggery in the notion, that takes pleasure in giving quaint names." He relates, "I have a gardener, who is a universally style[d] judge, and an old black family servant [who] is never known by any other name than that of governor."[88] The observation was an autobiographical one for the author, whose father's estate included a manservant known as Governor. Joseph Stewart—whose last name articulates his duties—was brought as a slave to reside in the wilderness

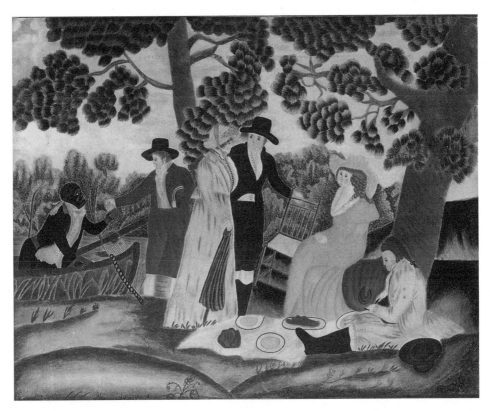

Fig. 2-12. Unknown artist, *The Picnic,* ca. 1800, watercolor, $13\frac{1}{8} \times 16\frac{3}{4}$ in. (33.3 × 42.5 cm). The Metropolitan Museum of Art; gift of Edgar William and Bernice Chrysler Garbisch, 1966. All rights reserved, The Metropolitan Museum of Art.

village of Cooperstown, New York. He was one of two slaves and five servants who attended the family at Otsego Hall. After gaining his freedom, Stewart continued to work as the Coopers' butler for the rest of his life and was interred in the family plot in 1823.[89]

In an 1816 portrait of Cooper's mother, *Elizabeth Fenimore Cooper,* painter George Freeman included the distant figure of Joseph Stewart (fig. 2-13). The aged widow is placed prominently in the center with her gloved hands folded across her lap. With a faulty use of one-point perspective, the artist has meticulously delineated the sitting room at Otsego Hall behind her. A granddaughter remembered that the older woman delighted in flowers and, as pictured, kept the south end of the long hall like a greenhouse. "She was a marvelous housekeeper, and beautifully nice and neat in all her arrangements."[90]

While Elizabeth Cooper's likeness is presented in careful detail, Joseph Stew-

Fig. 2-13. George Freeman (1789–1868), *Elizabeth Fenimore Cooper*, 1816, watercolor, $17\frac{1}{16}$ × $22\frac{3}{8}$ in. (43.3 × 56.8 cm). New York State Historical Association, Cooperstown.

art's features are vaguely suggested. The difference in their scale, even in this small watercolor, lends a commanding monumentality to Elizabeth Cooper. The manservant's diminutive form leans into the room from the far left doorway. He holds a water pitcher with his left hand; his right is hidden by the door jamb. His lower legs are obscured by a table that visually cuts him at the knees. There is about him an air of tentativeness, as if waiting for instruction or invitation into his mistress's precinct. The precarious lean, which places him both in and out of the room, underscores a servant's ambiguous position in the household. The water pitcher indicates his role as an instrument of Mrs. Cooper's housekeeping and gardening interests. The painting celebrates a woman who oversees the orderliness of her possessions—from the row of boxed plants at the end of the room to the black man who stands rooted in the box of his doorway.

A few years after Freeman's watercolor was completed, James Fenimore Cooper established himself as a popular author of historical novels. His literary scenarios match the carefully choreographed images wherein a character's status is revealed

by his or her placement within the household. In the first pages of *The Pioneers,* he explores the fluctuations of fortunes of "the two extremes of society" in the frontier regions of late eighteenth-century America. Cooper observes that it seemed a common occurrence for inexperienced masters to succumb to poverty and for servants, hardened by necessity, to succeed and become wealthy.[91] Despite this affirmation of the fluidity of the classes in the 1790s, Cooper—writing from his own conservative preference for social order in the 1820s—constructs a rigid hierarchy within the fictional household of Judge Templeton.

As the patriarch brings his daughter home from school in a carriage, they are greeted intermittently along their journey by the estate's servants, who appear in order of standing. Cooper first describes Benjamin Pump, a Cornish sailor who acts as "Major-domo," or chief steward. Next comes the previously mentioned Remarkable Pettibone, the housekeeper, who presses forward "as if a little jealous of her station." "In addition to these," Cooper writes, "were three or four subordinate menials, mostly black, some appearing at the principal door." The home's social strata become more of an issue when the daughter tries to determine where a visiting stranger is to eat. He could sit with the black servants, or he could join Benjamin and Remarkable at their meal. Judge Templeton announces that the young man will dine with the family rather than be subjected to such indignities. "Then sir," answers Elizabeth, "it is your own pleasure that he is a gentleman."[92]

The trileveling of domestic relations—family members over white help over black servants—was firmly established by the end of the 1830s. It is represented in a woodcut titled *Thanksgiving Dinner* (fig. 2-14), an illustration by an unknown artist in *The Universal Traveller,* by Charles A. Goodrich. In his broadly sketched travelogue, first published in 1836, the author describes Thanksgiving as a New England celebration: "Infancy, youth, and old age—all ranks, degrees, sexes and complexions, are rendered happy by its annual return; and all unite in heart, if not with the voice, in shouting its welcome."[93]

In the accompanying print, an extended family gathers around a large table. The grandparents occupy the honored position at the table's head; successive members are positioned by age so that the youngest children are seated at the other end. Those representing other "ranks, degrees, . . . and complexions" are also pictured. If they are united "in heart" with the family during this festive occasion, they are obviously excluded physically while they perform their duties. Seated at a slight distance to the right, a white nursemaid tends an infant. Her chair faces away from the table, yet she turns the baby so it may be a visual participant in the ceremonial meal. At center, in a large half-opened threshold, a black waitress or cook stands with a platter. She is set apart by the heavy frame of the doorway, and darkness almost engulfs her from behind. The servant's face and head cloth blend into shadows that render her nearly invisible.

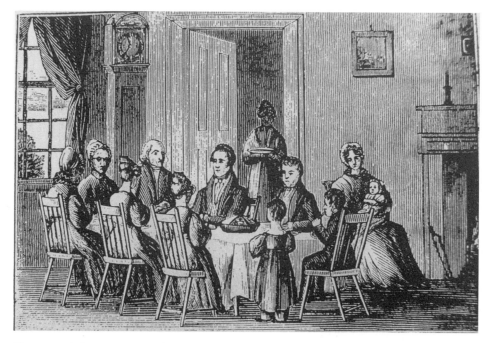

Fig. 2-14. Unknown artist, *Thanksgiving Dinner,* 1838, woodcut, published in Charles A. Goodrich, *The Universal Traveller* (Hartford, Connecticut: Canfield and Robins, 1838), facing p. 51.

In the first half-century of the newly formed republic of the United States, Americans were attempting to define themselves and their social relations in terms of prevailing political concepts. The later years of the period would be heralded as the Age of the Common Man. Although artists and writers fostered the notion that class lines were flexible, social boundaries were, in fact, never abandoned. Most masters and mistresses opposed the universal implementation of social and political equality and continued to enforce a distance between themselves and household workers.[94] Whether the coalescence of theory and practice succeeded or failed was dictated, in many respects, by the varying degrees of similarity or difference between families and servants. In following decades, the era will be viewed with nostalgia as the golden age of domestic service, in which hard-working, virtuous young people came to help as "a sort of interchange of family strength . . . always on conditions of strict equality."[95]

Pictorial representations both embodied and contributed to the uneven treatment of household workers. With the careful use of boundaries formed by the edges of doorways, walls, backs of chairs, or the physical separation from principal figures, artists were able to convey that domestic servants, though members of a

household, were nevertheless outsiders. White workers were portrayed as "independent dependents" who were, at the same time, included in and excluded from the intimacy of family life. While the dark complexion of African American figures readily identified them as culturally and racially different within domestic scenes, the predominant use of dividing lines and stereotypes supported an impenetrable zone of physical and psychological distance.

In the second quarter of the nineteenth century, changes will occur that will firmly set the boundaries between families and servants. Although "helping" will continue throughout the century in rural areas and frontier territories, white workers, soon dominated by a growing number of impoverished immigrants, will be increasingly perceived as a threat to family happiness and security. Moreover, this transition will coincide with a significant change from a master-servant to a mistress-maid relationship. Within the emerging ideology of separate gender spheres in the antebellum decades, women begin to command full responsibility for home and family life—a duty that regularly includes the supervision of female servants.

*Chapter Three*

---

# Lilly Martin Spencer: Images of Women's Work and Working Women, 1840–1870

In 1857, the Cosmopolitan Art Association of New York purchased four paintings by Lilly Martin Spencer for distribution to its membership. An unnamed writer for the association's journal gave one of these, *Shake Hands?* (1854, fig. 3-1), an especially glowing review:

> It is one of the few pictures whose popularity increases with every exhibition. A kitchen is revealed to us, and the paraphernalia of stove, kettles, pail &c., are in full relief. At a table stands the maid—we don't have *such* maids now a days!—with her hands just from the pan . . . she offers to "Shake Hands!" . . . The whole spirit and detail of this picture are incomparably excellent, and impress the beholder with a peculiar satisfaction. The face of the maid is a perfect study.

The commentary concluded, "No person is doing more than Mrs. Spencer to *popularize* art, and for that the people owe her a debt of gratitude which they do not fail to acknowledge, if acknowledgement is signified by appreciation."[1]

At the time, Spencer was at the apex of her career as an artist. Having produced canvases for the market for over fifteen years, she had gained a fair amount of acclaim in a profession traditionally dominated by men. Acquiring modest patronage in her early years, she achieved national recognition after the American Art-Union disseminated prints of her work. By 1859, writer Elizabeth Ellet could claim that "Mrs. Spencer's high position among American artists is universally recognized in the profession."[2]

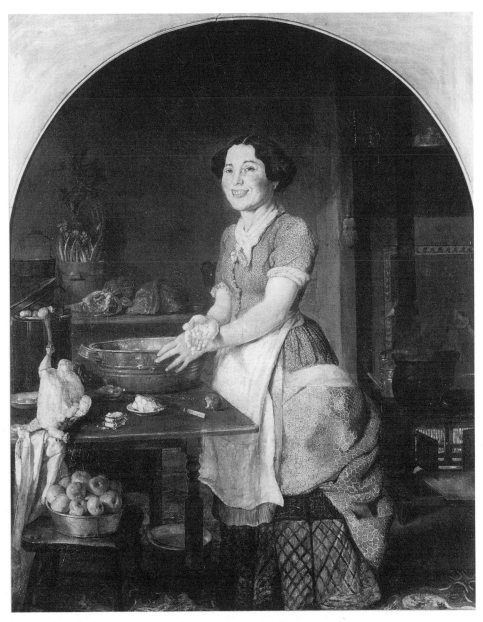

Fig. 3-1. Lilly Martin Spencer (1822–1902), *Shake Hands?*, 1854, oil on canvas, 30⅛ × 25⅛ in. (76.5 × 63.8 cm). Ohio Historical Society.

Spencer's success, however, was equivocal. She experienced constant difficulties in making a living from her painting, a dire circumstance considering that she was the principal and, at most times, sole provider for her growing family. Economic need forced her to produce canvases for sale as quickly as possible; parental responsibilities and societal attitudes toward women restricted her to the household. Turning to scenes at hand, she used her husband, children, and herself as models to create images of American home life. These narrative paintings were readily understood by an audience that had come to prize such sentimental views of domesticity and the carefully rendered details of a familiar physical world.

More important to this study, Spencer also drew from her experiences as a middle-class homemaker who hired, supervised, worked with, and fired female servants. The smiling woman in *Shake Hands?* was modeled after her own maid, one in a series of hired workers in the artist's home. Domestic servants freed Spencer from the constant burden of household chores so that she could work at her paintings; she, in turn, painted them at their tasks. Her several servant images prompt questions about the distinctions made in the antebellum period concerning women's work and working women. They also provide a record of the artist's own shifting attitudes at a time when Americans were increasing the social distance between themselves and household employees.[3]

## *The Dutch* Huys-Vrow *and Republican Virtues*

Spencer was certainly not unique in her focus on genre in this period. By the time she received her first critical notices, the taste for scenes of everyday life had long been established among painters and collectors in the United States. The earliest attempts at genre were based on the engraved work of British artists such as William Hogarth and David Wilkie—both of whom, in turn, were influenced by the Netherlandish genre of the seventeenth century. By the 1830s, American artists had direct access to Dutch and Flemish images through exhibitions, book illustrations, and loose prints. A proliferation of European art galleries in larger U.S. cities advanced the popularity of genre among collectors, who, in turn, regularly offered their holdings for public and private viewing.[4]

American artists responded by turning to these various sources for inspiration. Well-known practitioners including William Sidney Mount and George Caleb Bingham laid the groundwork for the surge of interest in scenes of everyday life. Art unions and associations helped generate a clientele by offering genre paintings and prints to the general public. This growing preference coincided with a nationalistic call for indigenous themes in literature and art. In his often quoted American Scholar address of 1837, Ralph Waldo Emerson exhorted authors to look

to the American experience for inspiration: "The literature of the poor, the feelings of the child, the philosophy of the street, the meaning of household life, are the topics of the time." To "embrace the common," painters adapted many of the characteristics of Dutch genre in the construction of their own homey, familiar scenes.[5]

Among the seventeenth-century prototypes were a large percentage of images showing the domestic chores of women—spinning, making lace, child care, and kitchen labor. In his exploration of Dutch genre, historian Simon Schama finds such images encoded with nationalistic and religious meaning. As the social and political bedrock of the Netherlands, the home became the locus of the inculcation of republican values to the citizenry. Scenes of proper domestic management implied a society with its patriotic and moral household in order. Cleanliness signified and affirmed the political separateness and fresh beginnings of the newly formed republic. "Home, then," Schama writes, "was both a microcosm and a permitting condition of the properly governed commonwealth."[6]

The Dutch images were also replete with figures of female servants, commonplace members of bourgeois households. In seventeenth-century art and literature, servant behavior often conveyed the state of the domestic realm. Virtuous workers performed tasks with efficient compliance, loyalty, and industry—thereby honoring themselves and their mistresses.[7] In *The Linen Cupboard* (1663, fig. 3-2), for instance, Pieter de Hooch presents a model working relationship in which *huys-vrow* (housewife) and maid work harmoniously together as they sort linen in a spotless interior. Images of sly, shiftless, or lascivious servants also abound—negative stereotypes that did not begin in the seventeenth century but were part of a long tradition of social mockery and ancient fool lore. Left unsupervised, wayward servants could turn a household upside down. "[Maids] were indisputably regarded as the most dangerous women of all," writes Schama, "for they represented the presence of the footloose inside the home. Unmarried but nubile, entrusted with essential domestic work (but notoriously untrustworthy), they were thought of as a kind of surreptitious fifth column for worldliness, stationed in the heart of the conjugal home."[8] *The Dissolute Household* (ca. 1668, fig. 3-3) is one of several of Jan Steen's allegories commenting on the plight of a careless mistress. While she nods off in a drunken stupor, her husband flirts with a prostitute, her children steal from her pocket, a dog raids the food, and, in the background, the maidservant is free to loot the cabinet.[9]

With its didactic focus on family and references to Protestant and republican values, the domestic genre of the Netherlands became a particularly appealing vehicle for Americans who wished to produce views of their own young republic. As they employed similar stylistic conventions—friezelike composition of figures, boxlike settings pierced with openings for doors and windows, indirect light sources, and the meticulous rendering of details—they derived analogous themes

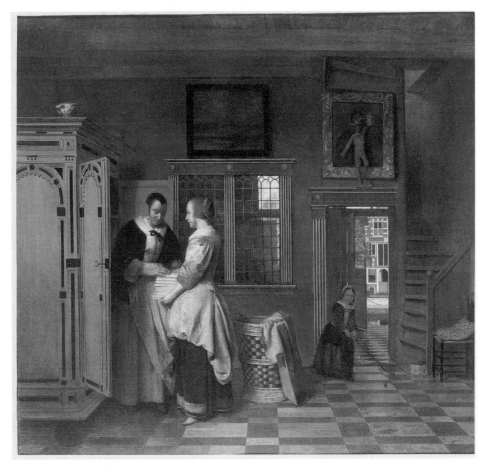

Fig. 3-2. Pieter de Hooch (1629–after 1684), *The Linen Cupboard,* 1663, oil on canvas, 28¼ × 30½ in. (70 × 70.5 cm). Collection of the Rijksmuseum, Amsterdam, The Netherlands; photograph © Rijksmuseum-Stichting, Amsterdam.

of middle-class prosperity and domestic order. Their images also include servant figures, those household members who grew increasingly suspect through the middle decades of the century.

## Ordering the American Family

Before Spencer entered the competitive arena of professional art, Francis W. Edmonds had already helped bring domestic genre into the mainstream. A prominent New York banker, he punctuated his painting career with long absences, dur-

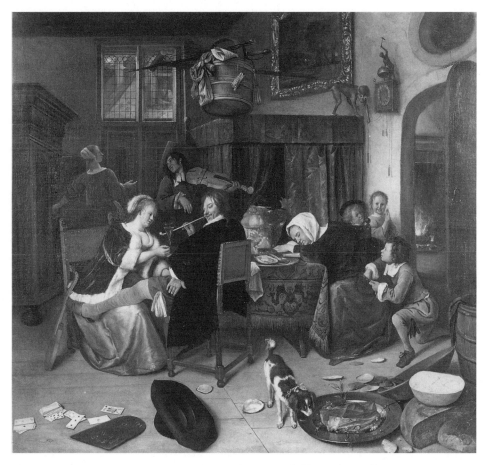

Fig. 3-3. Jan Steen (1625/26–1679), *The Dissolute Household,* ca. 1668, oil on canvas, 31¾ × 35 in. (80.6 × 88.9 cm). Courtesy Board of Trustees of the Victoria and Albert Museum.

ing which time he focused on Wall Street. Nevertheless, he made significant contributions to the art community as an officer of the National Academy of Design, a director of the American Art-Union, and a founding member of the Century Association. In the 1840s, Edmonds turned from the increasingly urban environment of New York to create images of simple, rustic home life based on Dutch prototypes. He first became familiar with seventeenth-century art through *A Practical Treatise on Painting,* by John Burnet (London, 1827), excerpts of which were distributed in National Academy classes. The early art text featured more than sixty engravings of Dutch paintings, many of them genre. During an eight-month sojourn to Europe in 1840–1841, Edmonds was able to make direct copies from

Fig. 3-4. Francis W. Edmonds (1806–1863), *The Image Pedlar*, ca. 1844, oil on canvas, 33¼ × 42¼ in. (84.5 × 107.3 cm). Collection of The New-York Historical Society.

Netherlandish art and compiled lengthy notations on techniques and "possible subjects."[10]

A few years after his return, he contributed *The Image Pedlar* (ca. 1844, fig. 3-4) to the National Academy exhibition. The small canvas portrays the visit of an itinerant peddler who offers an assortment of ceramic bric-a-brac to a farm family. Standing in the center of the drawing room, the visitor extends a dish of sweets to an older woman who pauses from peeling apples. She is likely the grandmother, the ranking matriarch who attracts the salesman's solicitations. A young mother, with baby on her hip, stands behind them and bends forward to observe the interchange. Her graceful Madonnalike appearance and downturned eyes suggest the modest qualities prescribed in the prevailing doctrines of womanhood. On the other side, a little girl pulls down a basket slung on the peddler's hip to discover a doll bundled in blankets.

The three male figures at left intently examine a small bust of George Washing-

ton. The group suggests the three ages of man in keeping with the generational study of the females opposite. Surrounded by attributes of man's domain—newspaper, clock, map, rifle and powder horn—a young father listens attentively as the grandfather offers his grandson patriotic lessons. The child, like his sister, adopts the trappings believed appropriate to his gender. He stands at attention before the face of Washington, carrying a toy drum on his hip and shouldering a stick gun. While the men pass on the traditions of civic duty to the boy, the women model the assumption of domestic responsibilities—a legacy for the little girl who already reaches for the ceramic baby.

Following the exhibition, an article in the *Knickerbocker* congratulated Edmonds on a successful painting: "All the figures are intelligent and the whole scene conveys to mind a *happy family*."[11] While going to some length to describe each of the various figures gathered together, the writer made no reference to the woman shown in the distant room at right. Like the other females, she undertakes a domestic chore. However, judging from her dress, activity, and separation from the group, the figure represents the family servant. Her overskirt is tucked up, and her bare throat and forearms are illuminated by light from a back window. Standing against a wooden table, she washes dishes over a tub. Another bucket of water rests on the bench behind her. While actively engaged in her task, she turns her head toward the doorway as if to listen to conversation in the main room. In keeping with the ambiguous status of help, her role is difficult to discern at first glance. Yet the worker's exclusion from the excitement of the peddler's visit speaks of rank even in this humble home.

Edmonds offers a similar ordering of the typical family in *Taking the Census* of 1854 (fig. 3-5). The painting commemorates an important policy change in the counting of Americans at mid-century. For the first time, the government required the listing of each person in a domicile rather than family groups. On the roster, everyone was to be included—beginning with the father, mother, the children in order of age, and, finally, other residents such as boarders and servants. In response to the growing concern about immigrants, the 1850 census also asked for each person's place of birth and the nationality of his or her parents.[12]

In Edmonds's painting, the family assembles before the great hearth. A census taker and his young assistant stand at right and record the information offered by the father, who carefully numbers the household members on his fingers. Edmonds signifies the familial hierarchy by placing the patriarch at center; stair-stepping down at left are his dependents: wife and baby, maidservant, boy and girl child. (Another toddler peeps over a table in the background.) Directly behind the wife's ladder-back chair are the subordinates in her care. As the father calls their names, the children hide behind their mother out of shyness or, perhaps, as a youthful joke. Joining them is the help, a girl or young woman who crouches behind her

Fig. 3-5. Francis W. Edmonds, *Taking the Census,* 1854, oil on canvas, 28 × 38 in. (71.1 × 96.5 cm). Collection of Erving Wolf.

mistress's chair for both support and protection. The sleeves of her red dress are pushed up and her head is wrapped in a yellow kerchief. The close association of the worker by action and proximity with the children underscores the ongoing perception of servants as childlike dependents.[13] Her giggling attitude contrasts with the budding middle-class gentility of the seated farm wife, who quietly listens to the interview in her dark, long-sleeved dress.

Again, Edmonds emphasizes the separate social spheres of men and women through the room's properties. The father's hat and riding crop lie on the floor as if he has recently arrived, implying that he works outside the home. Above him on the mantel are a clock, books, and a small portrait of Washington—the paterfamilias of the nation. The distinct vertical edge of the fireplace demarcates the realm of the wife, who holds a sleeping baby to her bosom. Three ears of corn, suggestive of her obvious fertility, hang above her head.[14] Inescapable in Edmonds's images and those of other artists at this time is the association of the household and family with female care and management. Women pictured within the realm of the home, whether mistresses or maids, were perceived as moving in their natural realm.

## Woman's "Appropriate Sphere"

In 1841, as nineteen-year-old Lilly Martin began her formal study of art, Mrs. A. J. Graves published *Women in America; Being an Examination into the Moral and Intellectual Condition of American Female Society.* The author's chief aim was

> to prove that [woman's] domestic duties have paramount claim over everything else upon her attention—that *home* is her appropriate sphere of action; and that whenever she neglects these duties or goes out of this sphere of action, . . . she is deserting the station which God and nature have assigned her. . . . Home, if we may so speak, is the cradle of the human race; and it is here the human character is fashioned either for good or for evil. It is the "nursery of the future man and of the undying spirit"; and woman is the nurse and the educator.

Graves underscored two key tenets of the ideology of separate spheres that developed and flourished after 1830: that woman had a preordained role and place in the home, and that by using her influence as "God's appointed agent of Morality," she could uplift the character of the family and, subsequently, the nation.[15] For the remainder of the century, this notion was put forward in a deluge of essays, sermons, poems, novels, and household manuals. Popular literature also fostered a corresponding set of sex roles that associated men with the public arena and women with private life.

While there had always been a division of labor by gender in American society, preindustrial families had formed a cohesive economic unit. Home and work were closely linked as husband, wife, children, and servants (including apprentices and slaves) labored together to produce goods for their own consumption, or for sale and barter. With the onset of industrialization, especially in the urbanizing North, commodity production shifted from the home to the central workshop and then to the factory. As wage labor became the primary means of economic support, the paths of adult men's and women's work diverged. Housework and child care became the full responsibility and defining labor of females.[16]

While women were, in effect, relegated to the home, their status was perceived chiefly as one of difference rather than inferiority.[17] They were to achieve a moral authority through demonstrations of piety, purity, submissiveness, and domesticity. New significance was assigned to the home as the redemptive counterpart to the sullied world of commerce and competition. "Our men are sufficiently money-making," Sarah Josepha Hale wrote in 1830. "Let us keep our women and children from the contagion as long as possible." Within the untainted domestic haven, republican mothers could infuse the next generation with familial and social values.[18]

This idealized role was, of course, based on a middle-class concept. Working-class women could scarcely afford to emulate the qualities of true womanhood extolled in prescriptive literature. For them, there were no sharp distinctions between public and private spheres.[19] Ironically, as home and work were separated in prevailing ideology, poor women pursued traditional female work for pay: sewing, laundry, housecleaning, and child care. Some contracted with manufacturers to do piecework at home or took in boarders to supplement the husband's income. Unmarried women sought the few low-paying jobs at factories and mills or resided with middle- and upper-class families as servants. As wage-earning menials, however, working women forfeited the ennobling benefits of domesticity that were accorded their employers. "Rising income was at the center of woman's sphere," writes social historian Nancy Woloch. "In reality few women could sever themselves completely from either home production or physical work. . . . A woman's clout did not increase if a family was poor, or if she was not attached to a dependable, income producing man."[20]

No matter the family's circumstances, the home remained an arena of heavy, difficult work. As Hannah Mullet, the longtime family servant in Louisa May Alcott's *Little Women,* put it, "Housekeeping ain't no joke."[21] Without the modern conveniences of plumbing, prepared foods, and efficient fuels, the routine tasks of running a household were endless and grueling. Common tasks included fetching wood and water, keeping light fixtures in order, treating stoves against rust, preparing meals, canning and preserving food, baking bread, washing dishes, cleaning rooms, emptying chamber pots, making and repairing clothes, and the much-dreaded washing and ironing of laundry. These chores were interspersed with social obligations, nursing the sick, and the constant demands of child care.[22]

This is not to say that all antebellum-era homemakers had the same work load. A woman's domestic burden depended on various factors: the size and makeup of the family, whether the household was in the city or country, the nature of her husband's work, and the amount of income. In an economy repeatedly buffeted by crises and panics, some middle-class families found themselves in a tenuous position. The slightest change in fortunes could quickly reduce them to working-class status. A wife's efforts often provided a crucial safety net. Through strategies employed since preindustrial times—careful purchasing, borrowing, scrimping, producing, or remaking household items—her domestic labors contributed in substantial ways.[23]

The more stable the family finances, the greater the likelihood that it would seek the paid assistance of another woman. Then the wife assumed the additional, time-consuming tasks of instructing and overseeing the servant. Paradoxically, the presence of a domestic worker compromised the ideological split between home and market. If the household functioned as a haven against a profane world, service

brought commercial transactions within its walls.[24] Employer hired employee, articulated conditions, evaluated performance, and doled out wages.

## Ladies, Women, Domestics, and Servants

The demand for servants grew steadily in the decades preceding the Civil War. At mid-century, some 15 to 30 percent of urban households included a live-in domestic. While upper-class homes typically supported a staff of three or more, most middle-income families employed a single maid-of-all-work, whose title described her duties.[25] Moreover, with the feminization of the home, the traditional master-servant relationship changed into that of mistress and maid. Males formed around 50 percent of the servant force in the eighteenth century; by 1850, domestic workers were nearly all female. Moving into the industrializing sectors of the economy, men would comprise less than 2 percent of American service at century's end.[26] Women became the "natural" choice for the duties and demeanor required of domestic workers. The desire to serve—to deliver loyal, unstinting attention to the needs of others—was touted as an inherently feminine quality. Behavior manuals described the sacrifice of self as woman's contribution to the social order. In *A Treatise on Domestic Economy,* first published in 1841, Catharine Beecher advised, "There must be the relations of husband and wife, parent and child, . . . employer and employed, each involving the relative duties of subordination. Society could never go forward, harmoniously . . . unless these superior and subordinate relations be instituted and sustained."[27]

The predominant reason for employing a domestic was the unceasing, back-breaking nature of housework. There is no question that the life of a homemaker—especially if she had a large family—was made substantially easier with a worker's help. However, the hiring of a servant also became an outward sign of middle-class status. While wives were expected to be knowledgeable in all phases of home and family care, their participation became more supervisory as they began to direct rather than perform. Freedom from the drudgery of menial chores became a badge of gentility.[28] In 1837, Catharine Sedgwick noted that exemption from manual labor had become "the *first* requisite for a *lady.*" When Lydia Maria Child arrived in New York City in 1841, she observed that it was "not genteel for mothers to wash and dress their own children, or make their own clothing."[29]

At mid-century, Catharine Beecher tried to redeem the reputation of female labor by arguing that housework was healthy for domestics and wives alike. At the same time, she acknowledged that "it is impossible for a woman who cooks, washes, and sweeps to appear in the dress, or acquire the habits and manners of a lady; that the drudgery of the kitchen is dirty work, and that no one can appear del-

icate and refined, while engaged in it." How housework had come to lose re-
spectability was clear, she explained: "It is because such work has generally been
done by vulgar people, and in a vulgar way, that we have such associations; and
when ladies manage such things as ladies should, then such associations will be
removed."[30]

Beecher was fighting a losing battle. She could not erase the stigma from do-
mestic labor and those who performed it. In the face of status anxiety, middle-
class Americans introduced a wider separation between themselves and their ser-
vants. Alarmed at the growth of such "anti-republican" attitudes, social observers
like William A. Alcott argued against the keeping of domestic laborers. The prac-
tice, he warned, set an example "of rich and poor, of superior and inferior, of de-
pendent and independent" before the children. Ralph Waldo Emerson was also
disturbed by the system that brought wage labor and social inequality into the
home. Advocating a democratic household, he invited his own kitchen staff to
dine with the family. Emerson called for a "revolution of opinion and practice in re-
gard to manual labor" that would bring about reform within the home. "It must
come with plain living and high thinking," he urged; "it must break up caste and
put domestic service on another foundation."[31]

The old calls for egalitarian connections between family and servant went un-
heeded; the relationship became more formal, distant, and often contentious. Shifts
in terminology underscored changing circumstances and perceptions. Popular lit-
erature employed expressions like "inferiors" and "superiors" to differentiate work-
ers from employers. The help were increasingly referred to as "servants"—a term
workers continued to find objectionable.[32] Beecher, however, asked for under-
standing and acceptance on the part of employees. In her *Letters to Persons Who
Are Engaged in Domestic Service* (1842), she offered a brief primer on the hierarchi-
cal nomenclature of the period:

> We find that it is common to call persons who have wealth and education,
> "*ladies,*" and persons who have no education, and labour for a support,
> "*women.*" And if a person who considered herself among the first, should
> hear a person say, "there is a *woman* in the parlour," instead of saying, "there
> is a *lady* in the parlour," she would in some cases feel offended. . . . Now this
> is exactly the case with you. You do not like to be called by the same name as
> is given to slaves in this land, and to the degraded servants of other coun-
> tries. . . . But you must not allow yourselves to be offended because people do
> not always know your feelings on this point, or do not always remember to
> regard your wishes.[33]

Whatever household workers were called, "good help" was seen as an increasingly
rare commodity. Supply was not equal to demand, especially in the densely popu-

lated urban regions of the North. Native-born whites had begun to leave service in favor of jobs in mills and factories, and a growing percentage of the labor pool consisted of unskilled immigrants from the lower classes of Europe. Beginning in the 1840s, the decade of the disastrous potato famine overseas, Irish Catholic women made up the largest bloc of foreign workers. In the middle decades, they outnumbered native servants in the eastern cities, sometimes by as many as four to one. Though positions continued to be filled by German, English, native white, and African American workers, the Irish Bridget became a stock character and the epitome of all the difficulties families encountered with domestic workers. While the following chapter will present a more thorough exploration of attitudes toward Irish servants and their resulting impact on visual representations, it is important to note that ethnic and religious differences contributed enormously to the widening gap between server and served in the decades at mid-century.[34]

The notion of helping began to give way in all but the most rural areas. No longer were servants perceived as good-natured, hardworking persons who temporarily obliged their neighbors. In 1841, even Emerson was complaining, "In every household the peace of the pair is poisoned by the malice, slyness, indolence and alienation of domestics. Let any two matrons meet, and observe how soon their conversation turns on the troubles from their *'help,'* as our phrase is." Catharine Beecher later commiserated that "the anxieties, vexations, perplexities, and even hard labor . . . from this state of domestic service, are endless; and many a woman has, in consequence, been disheartened, discouraged, and ruined in health."[35] The Servant Problem had been identified as a dangerous, insidious force destroying harmony in American homes.

## Lilly Martin Spencer, the Early Years

It was at this time, when women's roles and class distinctions were being defined and solidified, that Lilly Martin Spencer began her own struggle to balance the demands of household and professional labor. Despite the ideological rhetoric that posited female restriction from moneymaking, her concern and involvement with economic production was lifelong. As a child, she worked on her parents' Ohio farm, milking cows and tending crops.[36] On the occasion of her debut exhibition of a few paintings at her parents' church in 1839, a reporter for the *Marietta Intelligencer* described her as living in "plain but rural style" where she was "required to share the toil of the house and field." In her spare time, the article related, the teenager had covered the interior walls of her house with charcoal and crayon drawings. Included was a portrait of herself making bread: "This picture being alone, in a rough room full of barrels, meal tubs, and rubbish, and being drawn in

the rough plaster, has the most extraordinary effect. It represents a girl with a very pretty face, bending over her work, . . . sleeves rolled up, and both hands delving in the dough. One could not conceive of anything more natural."[37]

Finding the family's circumstances plain, the writer failed to perceive that the Martin household was possibly one of the best educated and most liberal in the region. The French-born parents, Giles Marie and Angelique Le Petit Martin, had met and married when serving as teachers at the French Academy in Exeter, England. There, they had two sons and two daughters, including Angelique Marie—known as Lilly—who was born in 1822. The family immigrated to the United States in 1830 and settled near Marietta, where Giles supported them by farming and teaching French at a nearby seminary. The educators taught their children at home.[38] The Martins came to America with the intention of setting up a community of families to live in a "harmonious system of mutual help and protection."[39] Although the original plan fell through, the couple maintained an active interest in communal living. In later years, they joined the Trumbull Phalanx near Braceville, Ohio, one of several communities based on the theories of French social critic Charles Fourier. The residents devoted themselves to agrarian life, rotating farm and household chores. A natural outgrowth of their utopian philosophy was an advocacy of such reform issues as temperance, abolition, and women's suffrage—the last being Angelique Martin's favorite cause.[40]

With the ongoing benefits and blessings of progressive parents, Lilly Martin took the unusual step for a young woman of leaving home to seek professional training. In an era when female efforts in the arts were typically viewed as leisure diversions, only a handful of women managed to turn their endeavors into vocations. As Josephine Withers writes, "Women *were* encouraged to be artistic, but they were not, of course, encouraged to become artists."[41] Gaining notoriety for her precocious work, Lilly caught the attention of Nicholas Longworth, wealthy lawyer and benefactor to numerous regional artists. The patron offered some assistance and made introductions on her behalf, prompting the young woman's move to Cincinnati in 1841. For almost three years, her parents took turns residing with her in a boarding house 130 miles away from their farm and each other. Giles struggled to find French pupils in the city and, at one time, bartered language lessons for his daughter's art instruction.[42] His wife frequently despaired over erratic income from the farm. The two never sheltered their daughter from their marginal circumstances. In a letter home, Lilly responded somberly, "If we give way to discouragement we are sure of one thing—that is, we shall sink." Seeing herself as a participant in the generation of family income, she was happy to report the sale of a painting in 1842, "the first one out of the family" and "the first one for money."[43]

Her parents' cross-state commuting ended when Lilly married Benjamin Rush

Spencer in the summer of 1844. The young man had immigrated to the United States from Ireland and worked in Cincinnati as a tailor.[44] Lilly did not allow matrimony to put an end to her professional career.[45] The following spring, she described the couple's joint efforts: "I think considering all, there is not anywheres, a more mutually industrious economical and persevering little couple. We have continued by strict management to pay our rent regularly, to keep ahead of debts, and by degrees to colect about us those things necessary to comence a little home, (and we have also prepared for the little stranger, for I shall have to speak of him or her) I have nearly all his little fixings ready."[46] In May, the first of their thirteen children was born (seven would die in infancy). When Spencer announced their son's arrival, she also informed her parents that her husband had lost his position.[47]

Over the next few years, Benjamin Spencer changed jobs repeatedly, finding himself dissatisfied with the amount and quality of work available to him. Eventually, he gave up the sewing trade to act as his wife's business agent. He also assisted her in the studio by preparing canvases and frames, varnishing, writing invoices and text cards, and, on occasion, helping with the painting itself.[48] In the 1850 census, the former tailor described himself as a "Professor of Painting," having learned something about process and technique from Lilly. It is not known, however, if Ben actually gave instruction to paying pupils. Ten years later, he listed his occupation as "Artist." By 1870, he had abandoned any claim to his wife's lifelong profession. Under the occupation column in this census, the response was "None."[49]

When Lilly's painting became the family's principal source of income, the couple relocated to New York City in 1848 to seek a more active art market. The move solidified the twenty-seven-year-old artist's assumption of the role of family breadwinner. Once settled, she embarked on a period of intense work, producing portraits and genre scenes by day while attending classes at the National Academy at night.[50] In the face of stiff competition and high expenses, she approached her vocation with grim determination. After the first couple of years she related, "It is only by continued exertions and strict economy in both of us, that we can live here at all—we have managed, by selling my finest pictures rather . . . at a sacrifice to have just what will get us our winter fuel and absolute necessities."[51]

## The Best Creature in the World

One of those necessities was a servant. For many of the next twenty years, even in times of financial stress, the Spencers engaged a maid-of-all-work. Their servant almost certainly lived in, a cozy arrangement since the family usually rented only

half a house.[52] It is not clear how many different women filled the position over time, but Spencer's paintings give evidence that at least two stayed with the family in the early 1850s. The women remain unnamed in the artist's surviving correspondence. Like other middle-class homemakers, Spencer typically referred to them as "girls."[53] On one occasion, she praised her current worker as "the best creature in the world."[54] Though her terminology conveys the traditional condescension of mistress to subordinate, Spencer's relationship with her employees during her early years in New York appears to have been congenial and, at times, affectionate.

To have time to paint, the artist had to maintain a cooperative alliance with her maid to ensure that the household ran smoothly. When both were overwhelmed, Lilly could sometimes recruit Ben to lend a hand. An incident in 1851 reveals the interdependent dynamics of the Spencer home. While the servant was minding the children (by now, three boys) in the basement one afternoon, the youngest injured his nose. The following day, as he suffered from painful swelling, his older brother became ill. Spencer had to turn over the care of the sick children to her husband, as neither she nor the maid could leave their work. "I had to go at the portrait, for my sitter came," she related to her parents. "The girl was washing and Ben had to hold little Charley on one knee and Angelo on the other, so we went through the day."[55] The duties of provider took precedence over those of mother and homemaker.

It seems logical enough that the artist, who repeatedly used family members as models, would also delineate the one other mature female in her home. Spencer did indeed assign her worker extra duty by laying claim to her visage as well as to her time and labor. Among the earliest of these images is a pencil sketch on brown paper labeled "Our Servant" (ca. 1851, fig. 3-6), in which she captured the quiet features of her maid as she concentrates on some sewing. The model may have been Jane Thompson, a Scottish-born woman in her mid-thirties who was listed in the 1850 census as a domestic in the household.[56]

The following year, a family friend paid a social call to the Spencer home and described the visit in a letter. Shown in by the maid, Margaret Bale and a companion were greeted by Lilly. The artist then took them into the studio to see a number of her recent paintings:

> There was one pleasing as well as [be]coming it was the Servants likeness which she took while washing. She was looking through the window at the time that something rather attracting and laughable was passing. She called Mrs. Spencer to come and see it, the position [of the servant] pleased her so well that she thought she must have her likeness, I never saw anything so striking before, for it was the same one that opened [the] door so we had a

Fig. 3-6. Lilly Martin Spencer, *Our Servant*, ca. 1852, pencil on paper, 12⅜ × 9 in. (31.4 × 22.9 cm). Private collection, Aledo, Illinois.

good chance to judge. . . . The bench and Clothes washboard Soap &c. looked so Natural it seemed as though we might almost pick them up.[57]

The domestic pictured in this painting, *The Jolly Washerwoman* (1851, plate 3), appears to be the same woman Spencer sketched at mending. Portrayed this time in a jocular mood, the maid pauses from her laundry task to acknowledge the viewer. With a wide grin across her face, her nose crinkles and her eyes narrow and fill with tears of laughter. As in the drawing, her shining black hair is parted down the center and combed smoothly back into a bun. Her brown calico dress is torn beneath one arm, and its rolled sleeve seems to strain against her plump arm.

The worker's good humor belies the physical discomforts of the strenuous task. Yet her raw hands and bent posture give testimony to demands of the hot, heavy labor. Of all household tasks, those associated with the laundry were the ones universally despised by homemakers and servants alike. Customarily, the wash was done on Blue Monday and took all day; the next day was given over to ironing. In her history of American housework, Susan Strasser describes the labor-intensive tasks:

One wash, one boiling, and one rinse used about fifty gallons of water—or four hundred pounds—which had to be moved from pump or well or faucet

to stove and tub, in buckets and wash boilers that might weigh as much as forty or fifty pounds. Rubbing, wringing, and lifting water-laden clothes and linens . . . wearied women's arms and wrists and exposed them to caustic substances. They lugged weighty tubs and baskets full of wet laundry outside, picked up each article, hung it on the line and returned to take it all down; they ironed by heating several irons on the stove and alternating them as they cooled, never straying far from the hot stove.

If a homemaker had any discretionary funds at all, she turned the arduous work over to hired labor—whether her own live-in servant, a commercial laundry, or an outside laundress who worked once a week either in the employer's residence or in her own.[58]

As Spencer constructed a recognizable likeness of her robust maid, she also produced a visual summary of the laundry process. The worker remains in a back-straining lean above the wooden tub full of water. The green paint of its rim and handles has been worn away with use. The servant balances her weight on sturdy arms and work-reddened hands; a washboard holding some laundry and a piece of soap rests against her aproned stomach. At her feet, a pile of dirty clothes awaits. The configuration implies that each article of clothing will be taken up, scrubbed in the sudsy water, wrung into a tight ball, and then placed into the tin basin in the foreground for later rinsing. A box of clothespins on the back table indicates the next step.

In the shallow, dark setting of the work space, Spencer has illuminated the worker and her paraphernalia with a clear light from the left. All details have been rendered in sharp focus—from the assortment of containers on the back shelf to the rumpled bodice in the pile at bottom left, with its intricate system of fasteners glistening in the light. The painting's linear contours and highly finished surface suggest the artist's absorption of the contemporary Düsseldorf style, which predominated in current American genre.[59] At the same time, her trompe l'oeil effects, including the bench that seems to jut into the viewer's space, attest to her study of the sharply focused naturalism of Dutch art. Having already observed seventeenth-century paintings and prints in the private holdings of her Cincinnati patron, Spencer enjoyed expanded access to such materials in New York.[60]

The smiling laundress closely resembles Gerard Dou's *Girl Chopping Onions* of 1646 (Royal Collection, Buckingham Palace). Although Pierre Basan had produced a reverse engraving of the earlier Dutch painting in his *Cabinet de Choiseul* portfolio (1771, fig. 3-7), there is no documentation of Spencer's having seen a copy of this or a similar print. Her painting, nevertheless, relates to the earlier image in composition, theme, and presentation. Mincing onions with a chopper, Dou's engaging maidservant leans over a large tub in a pose similar to Spencer's laundress. She

glances up to smile knowingly at the spectator, a convention used with regularity by Dutch genre artists to convey coquetry.[61] Dou's painting is further encoded with emblems that imply the woman's sexual availability.[62] Although Spencer's later kitchen scene lacks such obvious subtexts, her servant's warm expression invites intimacy, nonetheless.

Writer Elizabeth Ellet described *The Jolly Washerwoman* as an "impromptu scene in the artist's own kitchen."[63] Margaret Bale's letter related that the painting's inspiration came from a good-natured moment of sharing between mistress and maid. Spencer's discovery of her subject material was, perhaps, less spontaneous than either suggests. The artist was initially drawn to biblical, allegorical, and literary subjects, yet she found few buyers for such canvases after her relocation.[64] During her first year in New York, a Cincinnati friend wrote to suggest that she would have better luck if she persisted with domestic topics: "It is only because instead of two pictures of your peculiar 'genre,' you have not had twenty! The plain truth is that pictures remarkable for Maternal, infantine and feminine expressions in which little else is seen but flesh, white drapery, and fruits, constitute your triumphs, according to popular estimations."[65] In addition to the portrait commissions she continued to seek for regular income, Spencer apparently followed her

friend's advice. At this time, she began her steady output of sentimental and often humorous images of everyday home life.

As a woman, did Spencer feel impelled to forgo the elevated historical or literary subjects for themes that may have been deemed appropriate "feminine expressions?" There were certainly practical considerations behind her choosing such accessible subjects. In addition to the difficult business of producing and selling her work, she was tied to the home with continuous pregnancies and the concerns of housekeeping and child care. After interviewing the artist, however, Ellet concluded that Spencer chose her material "on account of the ready sale of such pictures."[66] At mid-century prominent male artists—including the highly esteemed Francis Edmonds—continued to find some success with domestic genre scenes. In 1852, after Spencer's *Jolly Washerwoman* sold at auction for an amount significantly above the asking price, she was encouraged to produce more images of domestic work and workers.[67]

She next began her own explorations around the theme of chopping onions. A small series of studies culminated with *Peeling Onions* (ca. 1852, fig. 3-8), a highly finished, three-quarter-length portrait of a cook who pauses from slicing an onion to wipe away tears with the back of her hand.[68] In Dutch style, Spencer has laid out in the foreground an elaborate still life in which fruit and utensils are assembled on one side and an unplucked chicken on the other. To heighten the naturalism, she suspends the handle of a spoon precariously over the table's edge. Though the dark-haired worker is attired and coiffed in a manner similar to the laundress in the earlier painting, the model seems to have been a different, more slender servant in the Spencer home.[69] She wears a gray dress with a pleated bodice and a thin line of tatted lace around the neckline. Three dressmaker's pins stuck in the fabric at her shoulder hint at the continuous and varied nature of household labor.

The cook's gesture conveys an interesting blend of vulnerability and power. Her tears come from the stinging vapors of the cut onion, yet the soft weeping acts as a reminder—or perhaps a parody—of the tender sensibilities ascribed to females in this period. At the same time, the sleeves of her dress have been rolled to reveal muscular forearms. She grips the onion and knife firmly; her strong-looking hands suggest a force that can wring life from a chicken. Despite her momentary weakness, the woman still maintains a determined, skillful control over her task.[70]

## *We Don't Have Such Maids Now a Days*

Using the same model, Spencer produced *Shake Hands?* (fig. 3-1), the full-length portrayal of a cook who merrily extends a dough-covered hand while making bread. The figure's overall appearance is one of attractive neatness as she turns a

Fig. 3-8. Lilly Martin Spencer, *Peeling Onions,* ca. 1852, oil on canvas, 36 × 29 in. (91.4 × 73.7 cm). Memorial Art Gallery of the University of Rochester; gift of the Women's Council in celebration of the 75th anniversary of the Memorial Art Gallery.

smiling face toward the viewer. She wears a mulberry-colored dress and white kerchief and apron. Her skirt has been tucked up to reveal the pale underside of the calico above a dark, slightly torn quilted petticoat. The servant has helped herself to an apple from the tin basin and, after taking some bites, has set it down on the table before commencing her chore. The setting is probably the artist's own kitchen, slightly shabby with its peeling paper and backless chair. Yet the whisk broom and knickknacks on the mantel, as well as the gaily patterned oilcloth on the floor, suggest a concern with order and appearance. The bounty of foodstuffs, including the liberal show of costly white flour, attests to the household's middle-class status.[71]

The painting again reveals the artist's empirical knowledge of domestic spaces and chores. All the ingredients for baking are pictured within the cook's reach: flour, butter, eggs, salt, yeast cakes. To the right, an iron cooking stove sits before a sealed fireplace; its grate is open, revealing the glowing embers within. On top rest three steaming pots. The two with lids are likely sources of hot dishwater; the open kettle stands waiting to receive the joint of meat and vegetables on the back table or, perhaps, the plump chicken on the other side of the cook's mixing basin.

The image also communicates some understanding of a servant's ambiguous social standing. Spencer has given her maid the direct gaze one shares with a friend or coworker, rather than the deferential look of subordinate to superior. Her expression communicates intelligence and humor as she reaches toward the viewer with the gesture of an equal. The intended partner might be her employer, a child, or—as suggested by the romantic picture of a couple walking arm in arm on the fireplace cover—a potential suitor. Her crossed arms emulate the pose of those decorative promenading lovers. At the same time, it is a closed gesture. Her body remains turned to the table, indicating that the task, not the visitor, takes priority. Nor does it appear that she will be shaking anyone's hand; she keeps her own hand palm up and thumb closed, making the physical handshake an impossibility. Etiquette books of the period advised that the initiation of a handshake was "the prerogative of the [socially] superior person." Inferiors were never to extend their hands first. The cook's gesture, then, becomes an empty one—made with the knowledge that the offer to shake might be considered inappropriate and remain unanswered.[72] Spencer nevertheless grants her cook the "upper hand" by the floury practical joke. The implication is that she remains untouched by choice: not only can she deliver an unwelcome, messy pat, but also the bone-handled knife on the table and the bucket of water at her feet offer other lines of defense against unwanted contact.[73] The unseen intruder may touch the maid, but only at his or her own risk. She is portrayed as a strong woman in control of her task, her space, and her person.

Spencer's depictions of personable domestics were unusual, possessing a mon-

Fig. 3-9. Jerome B. Thompson (1814–1886), *The Peep Show,* 1851, oil on canvas, 25 × 30 in. (63.5 × 76.2 cm). Courtesy Museum of Fine Arts, Boston; bequest of Martha C. Karolik for the M. and M. Karolik Collection of American Paintings, 1815–1865.

umentality and individualization rare in contemporary imagery. Her maidservants command their pictorial spaces as they move confidently through the activities the artist seems to have known so well. The *Cosmopolitan Art Journal* reviewer's exclamation that "we don't have *such* maids now a days!" could just as appropriately have been "we don't have such representations now a days!" Spencer's poised, competent maid in *Shake Hands?* differs sharply from the cowering, childlike servant in Edmonds's *Taking the Census* (fig. 3-5), a work produced and exhibited the same year.[74] Two other paintings by New York artists from this time depict domestics in the street. *The Peep Show,* by Jerome B. Thompson (1851, fig. 3-9), portrays a group of children who have gathered to view a traveling attraction brought to the curb by a top-hatted hawker. A young maid, shown at the right with her back to the viewer, is pictured with her overskirt pinned back and sleeves rolled up as if in midtask. She has set down her bucket of water as she pauses to observe

Fig. 3-10. James Brown (ca. 1820–after 1859), *The Young Pedlar,* 1850, oil on canvas, 24 × 19⅝ in. (61 × 50 cm). Toledo Museum of Art; Museum Purchase Fund.

the spectacle. Though her curiosity is childlike, she nevertheless displays a womanly form, both to the viewer and to the show's proprietor, who is pictured peeping at her.

Where the domestic in Thompson's painting tarries near the curb, the worker in *The Young Pedlar,* by James Brown (fig. 3-10), is shown cleaning it. This canvas, which Brown submitted to the 1850 National Academy exhibition, portrays a young boy who calls out his wares in a prosperous neighborhood. Behind him, a charwoman kneels on the sidewalk before the steps of a grand edifice. As she soaps down the newel post on hands and knees, her hair is coming loose from her head cloth and her cheeks are flushed from the exertion of scrubbing. The artist has given her harsh features and a scowl as she stares over her shoulder at the boy peddler. Perhaps she dislikes being interrupted, or she covets the scrub brushes in his basket. In relation to the top-hatted gentlemen who converse across the street and the active, entrepreneurial lad, the working woman has literally and symbolically been assigned the lowest position.

Illustrations of servants in popular books and magazines were less flattering. A kitchen scene from Timothy Shay Arthur's *Trials and Confessions of a Housekeeper* (1852, fig. 3-11) offers a contrast to Spencer's industrious, cheerful cook. The cartoon—and Arthur's story—portray a slovenly servant who, while reading a cheap

Fig. 3-11. Unknown artist, illustration in T. S. Arthur, *Trials and Confessions of a Housekeeper* (Philadelphia: Lippincott, Grambo, 1852), p. 20.

novel, allows the meal to burn and the cat to snatch the company turkey. The mistress in the story goes through a series of workers and finds each lacking. "Good cooks always have bad faults," she tells her husband, "and I am looking for its appearance everyday."[75]

*Shake Hands?* became the most publicized of Spencer's kitchen scenes. After exhibition in New York and Cincinnati, the painting was mass-produced for the general public, first as a lithograph by the Parisian firm Goupil and then as an engraving by Rogers and Phillibrown. The Cosmopolitan Art Association chose the latter as the frontispiece for its December 1857 journal. With the wide circulation of these prints, *Shake Hands?* secured Spencer's reputation as a painter of humorous domestic scenes—a reputation that both helped and hindered her career.[76]

## From Kitchen to Parlor

For the 1856 National Academy exhibition, Spencer completed companion paintings, *The Young Husband: First Marketing* and *Young Wife: First Stew.* The first depicts a bearded young man who returns from a shopping expedition with an overloaded grocery basket on his arm.[77] He shifts his weight and grimaces as poultry and vegetables spill to the ground. Spencer's other canvas, *The Young Wife: First Stew,* featured two female figures—a mistress and her maid. Though the painting is presently unlocated, a version of the image survives in bas-relief as an ornamental, cast-metal plaque (fig. 3-12).[78] It reveals a kitchen in which a wife, incongruous in a softly draped gown, prepares vegetables at a work table. Appearing as discomfited in her new role as her husband does in his, the untrained homemaker turns away

Fig. 3-12. Unknown arti-
san after Lilly Martin
Spencer, *The Young Wife:
First Stew,* after 1856, cast
metal bas-relief plaque,
$7\frac{1}{2} \times 5\frac{1}{2} \times 1\frac{1}{2}$ in. (19.1 ×
14 × 3.8 cm). Private col-
lection.

from her task with an expression of distress. The painting may have been another
version of the onion-peeling theme.

Behind the young wife, her aproned maidservant chews a finger as she intently
studies—or perhaps giggles at—her mistress's struggling attempts. The scene
echoes a passage in a contemporary behavior book that warns young ladies, "Your
common sense teaches you how sadly embarrassed a dependent woman must be
who is unskilled in the arts of the kitchen and the laundry. . . . She is degraded
who cannot perform them; and even a poor ignorant Irish girl will despise a mis-
tress whose household skill is beneath her own."[79] Spencer's mistress and maid ap-
pear equally inexperienced and puzzled by their task. The image subverts the pre-
vailing concept that women were naturally suited for domestic labor by implying
that cooking and housework were learned, not inherent, skills.[80]

Spencer must have been sharply disappointed by the harsh critique the two
paintings received in *The Crayon.* Initially, the unsigned writer praised her tech-
nique as unsurpassed: "We should be willing to place the face of the servant girl in

[*The Young Wife: The First Stew*] by the side of any American artist's work." Yet the reviewer went on to pronounce the images "so entirely mistaken in their aim, that they become painful rather than pleasing. . . . Mrs. Spencer has a truly remarkable ability to paint, but unfortunately ruins all her pictures by some vulgarism or hopeless attempt at expression." After criticizing the artist's descent to mere humor, the writer asked, "Is there in her woman's soul no serene grave thought, no quiet happiness, no tearful aspiration, to the expression of which she may give her pencil? Being a woman, she should have some deeper, tenderer conceptions of humanity than her brother artists, something, at all events, better worth her painting, and our seeing, than grinning house-maids or perplexed young wives."[81] The reviewer, writing for a periodical that adopted a Ruskinian dedication to the promotion of edifying art, evidently considered the overtly humorous aspects of Spencer's paintings indecorous—especially for a woman—and the subject of domestic labor too vulgar for genteel audiences. The writer stopped just short of calling the artist unladylike for choosing "frivolous and whimsical" subjects. Spencer appears to have responded almost immediately to the inference that she somehow lacked a lady's sensibilities. At this point, she ended her companionable, empathetic representations of household workers.

Two months later, the *Cosmopolitan Art Journal* announced that the artist had agreed to contribute some paintings to its annual offering of premiums. As if in response to *The Crayon*'s recent attack, the journal's editor assured readers that Spencer "is a lady whom to know is to admire." The article quoted from her own descriptions of the new canvases. One, Spencer wrote, represented

> a handsome, coquettish girl, apparently busily engaged peeling apples. She is teased by some person whom the picture does not show, who is trying to kiss her, as we see by the expression in her face. She quietly seizes a spoon from the bowl of molasses on the table beside her, and has it ready poised to give the "provoking fellow" a daub. She looks around with arch expression and laughing eyes, and says, "Kiss me, and you'll Kiss the 'Lasses." The still life on the table covered with good things, will be beautifully rendered. In fact, I intend it shall be the best thing of the kind I have yet produced.[82]

Following the earlier formula of *The Jolly Washerwoman* and *Shake Hands?*, the figure in *Kiss Me and You'll Kiss the 'Lasses* (1856, fig. 3-13) directs her smile to the viewer beyond the picture plane. Of the three images, her expression appears the most teasing—"coquettish," to use the artist's word. Despite the explicit flirtatiousness of the young woman, she is nevertheless portrayed as resistant to male advances.[83] The artist has reworked the narrative of *Shake Hands?* but has packaged it in more genteel wrappings. The playfully defensive young woman is not a hired domestic but a middle-class wife or daughter. Her idealized face, shown in soft

Fig. 3-13. Lilly Martin Spencer, *Kiss Me and You'll Kiss the 'Lasses,* 1856, oil on canvas,
$30\frac{1}{16} \times 25\frac{1}{16}$ in. (76.3 × 63.7 cm). The Brooklyn Museum; A. Augustus Healy Fund.

half-light, resembles more closely that of the artist instead of her previous servant models. She wears a sweeping, lace-trimmed green dress and apricot apron, and her slippered feet tread on a patterned carpet. She does not prepare the ordinary staples of a meal (bread, vegetables, or poultry); rather, she attends an abundant display of fruit—apples, grapes, berries, and a pair of golden pineapples, dear commodities for urban families. A sharp knife, like the one wielded so powerfully by the cook in *Peeling Onions,* lies loosely and ineffectually between the second and third fingers of her right hand. Her principal and appropriately ladylike defense is a spoonful of molasses—sweetness.

As if to underscore the differences between this figure and a "grinning house-maid," the artist has shifted the sight of the viewer from the kitchen to the parlor, rooms that had become symbolic of the separate realms of maid and mistress.[84] One sees past the dining room with its rich display of fruit into a shadowy parlor, outfitted with fashionable rococo-revival furnishings. In order to produce "the best thing of the kind," Spencer changed her focus from the common chores of a kitchen maid to the lighter tasks of a genteel ingenue.[85] Yet, significantly, the figure is not shown in the parlor. Appropriate to its nature as a transitional piece, the image presents the young woman operating between the more formal, public room and the work space of the kitchen.

This painting's portrayal of material comfort and plenty was a stark contrast to the artist's personal life. Spencer had sent her paintings to the association on credit because she had no other prospects. By fall 1856, the market for her work had dwindled. In a despairing letter, she told her mother that she had not sold a single picture or had a portrait commission in eight months. She closed by mentioning that she had been working hard at chores all day and would again the next, "for we have no girl."[86] The following year brought little relief to the artist's financial difficulties or, in fact, to those of any other American. A series of bank closures between August and October 1857 instigated a nationwide depression. Unemployment in New York City tripled, leading to tremendous labor unrest and bread riots.[87] Even before the panic, Spencer described her circumstances as so narrow that she was unable to give her children any gifts for Christmas. "I did not feel as if we could afford yet to keep a girl," she wrote in March, "not merely on account of the wages, but on account of the exorbitant price of provisions through the winter . . . we had to be very prudent, but I found that every day I did less and less in painting."[88]

Finally, in order to paint again, Spencer had to risk hiring another servant—a frustrating task she described in great detail in another letter. At the beginning of a long diatribe, Spencer wrote, "I have often heard you dear Mother speak of the pitifull situation of poor servants but I tell you I don't pity them." Fourierists such as the Martins decried domestic service as a violation of human dignity and, at the

very least, advocated respect for all workers.[89] Brushing aside anticipated parental admonishments, Spencer continued,

> I do not like a girl that I cannot treat kindly, but it really seems that cannot be done now. I cannot be always watching over their shoulders; so I try to rouse their self-respect and to show them that I trust to their consciences, but pooh! they laugh in their sleeves at what they consider my stupidity and unsuspiciousness; . . . they take advantage to pilfer and to do nearly nothing; and to give me impudence over the bargain, and to say they were never used to live in a house where there was not modern improvements. . . . there must be an underground sewer so that the Madams may not be disgraced by being seen emptying slops in the street. The next thing their ladyships expect is gas and hot and cold water all through the house; . . . consequently I have the deuces own time with the beauties; some after coming to look through my house, to see if the place would suit them, and after making me go up and down, losing of course precious time, promise to come at such a time . . . and then . . . come to tell me they had changed their mind.

The artist claimed to have been in this frantic state for four weeks with "no less than five coming and going trying for a day or two and then leaving me all of a sudden." She finally settled on one woman who, after disappearing from the house for two weeks, returned with a promise that she would stay.[90]

Spencer vented her frustration over her "trouble with girls" in *Fruit of Temptation* (ca. 1857, fig. 3-14). The painting is presently unlocated, but the image survives in a Goupil lithograph published in 1857. In a scene following in the tradition of Jan Steen's dissolute households, a dismayed housewife enters her dining room to discover the sad consequences of trusting a neglectful servant. Mayhem reigns as children raid the table, helping themselves with both fists to fruit and sugar. A cat has jumped up to lap milk out of a pitcher, and a dog snaps at food left on a chair by the distracted maid. At left, the domestic has tossed her feather duster to the floor to primp before a mirror. She smiles approvingly at her reflection, unaware that her employer has entered behind her. Reversing pictorial convention by placing the mistress in the doorway and the servant in the family space, Spencer projects the hazards of permitting an employee too much autonomy and control. The artist had come to believe she could no longer treat workers "kindly," an attitude present in her subsequent portrayals. Having grown resentful of the untrained and, sometimes, faithless women whose labor she so desperately needed, Spencer began to produce images more in step with popular concepts of servants and service.

Current magazine articles and illustrations continued to offer derogatory portrayals of maidservants as mentally, culturally, and morally inferior. Mistresses were

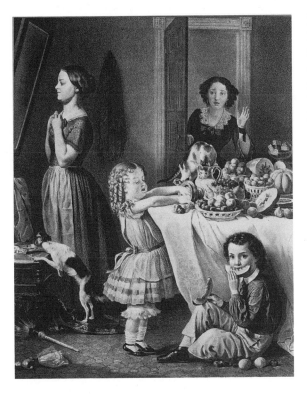

Fig. 3-14. Jean Baptiste Adolphe Lafosse after Lilly Martin Spencer, *The Fruit of Temptation,* ca. 1857, lithograph, 24½ × 20⅛ in.(62.2 × 51.1 cm), published by Goupil, New York. Ohio Historical Society.

advised to be kind but unfailing in their supervision; otherwise, their inattention would result in "ungrateful, impudent, idle" workers.[91] In January 1857, *Harper's New Monthly Magazine* printed two full pages of cartoons titled "The Miseries of Mistresses" with themes that paralleled Spencer's complaints. One shows a finely dressed domestic who haughtily gives notice, saying, "Yes, Ma'am, I am goin' away this very day. I ain't a-goin' to spile *my* hands making two fires every day. I don't live in nobody's house, where there ain't a Furnace." Another (fig. 3-15) depicts a slow-witted "Bridget" who informs a visitor at the door, "Indade, Misthress Smith isn't in the House. She tould me to tell you so, this very minit, when she set her eyes on you."[92] Six months later, *Harper's Weekly* published a cartoon version of the dissolute household (fig. 3-16), perhaps another source of inspiration for Spencer's painting. An angry mistress is pictured bursting into the nursery to ask two servants about the "Terrible Disturbance" from the six toddlers in their care. A nurse answers, "Oh, Mum, it's Dreadful!—Here's neether Me nor Mary can't Answer none of our Letters for the Rackett!" In many of these and other contemporary cartoons, the servants have been given small, upturned noses—facial features prevalent in caricatures of the Irish. Though Spencer did not mention the ethnic-

Fig. 3-15. Unknown artist, cartoon published in *Harper's New Monthly Magazine* 14 (January 1857): 286.

BRIDGET.—"Indade, Misthress Smith isn't in the House. She tould me to tell you so, this very minit, when she set her eyes on you."

ity of the many "beauties" she dealt with during her search for a domestic, the wayward servant in *Fruit of Temptation* presents a profile revealing a suspiciously small nose.

As the artist endured her long search for a maid-of-all-work, she began another related painting titled *The Gossips* (1857, unlocated), which she submitted to the National Academy exhibition of 1858. In the large, multifigural composition she expanded the theme of the dissolute household to encompass an entire group of workers. The image, according to Ellet, portrayed a tenement yard "where women are engaged in washing, preserving fruit, cooking, and other sorts of work." Distracted by a tale of scandal, they fail to notice that a child has fallen into a washtub, a dog has run away with a beefsteak, and a cat skims a pan of milk in a window.[93] A writer for *The Crayon* presumed from the figures' appearances and occupations (or lack thereof) that they represented "servant-girls out of doors, interchanging domestic news, surrounded with kitchen accessories." More generous than the review of two years before, the article pronounced the painting a qualified "master-

Fig. 3-16. Unknown artist, cartoon published in *Harper's Weekly* 1 (4 July 1857): 432.

piece." It again noted, however, a discrepancy between the virtuosity of Spencer's technique and her subject matter: "There is vigor of the brush, and a successful rendering of expression in this picture which astonishes as much as one is repelled by the intense vulgarity of the scene."[94]

When *The Gossips* was exhibited in Buffalo a few years later, the artist drafted a text panel to accompany the painting.[95] It explains,

> A gossiping scene is what is called low life, for though the [illegible] practice is followed among higher and more favored classes they are not picked for representing on canvas for two reasons, the first, because it must not even be hinted that they could fall so low, the next because in the midst of their style and laziness, gossiping among them has not the small advantage of being picturesque; which those who are poor, and have to do their own work (and that is what the term low life generally includes), the neglect of business and duty becomes more apparent.[96]

Though she presents the domestics in the painting as negligent and, in Beecher's words, as "vulgar people" doing work in "a vulgar way," Spencer allows the de-

scription to temper the class bias behind her representation with a small hint of remaining empathy for the laboring poor.

## The New Jersey Years

In the spring of 1858, Lilly and Ben moved their family to Newark, New Jersey, to escape the high cost of city living. The artist was able to make a down payment on a small house by bartering three portraits of the owner's family.[97] She rejoiced in their ability to raise produce and to avoid the risk of "actual starvation, as we used to sometimes be afraid of in the heart of a big city, notwithstanding my 'big reputation' as they call it."[98] Unfortunately, the move took her farther away from patronage, and by late 1859, the Spencers found themselves with few resources. Ben remade his own clothing to provide school outfits for the children, and Lilly did what she thought she "would never stoop to do"—hand-color photographs. She wrote that the family was once again forced "to do without a girl," news delivered with another complaining passage about the general wastefulness, thievery, and impudence of servants she did not have. Spencer believed herself an easy target "on account of my not being able to be continually watching them and as I have not time to be all the time showing a new girl what she had to do around the house."[99] Sporadically and whenever possible, she continued to engage the services of domestic workers in following years. Her servants included an Irish woman, Mary Carpenter, who was listed with the household in the 1860 census.[100] In the seven years after the move to Newark, the artist gave birth to four more children. Despite her increased responsibilities and the precariousness of the wartime art market, Spencer continued to produce paintings. The majority of these featured lighthearted themes of childhood and pets.[101]

In 1862, she created *Dixie's Land* (fig. 3-17), a small canvas portraying a little girl seated on the ground in a clearing of a dense landscape. The toddler is flanked on the left by a hound and, on the right, by her black nursemaid. Spencer described the image in a text panel for the same Buffalo exhibit in which *The Gossips* was shown:

> A scene in the flowery south a little human sunbeam, the light and hope of a happy home is playing among her native orange groves, equally as unconscious or guiltless, of the right or wrong around her. Dinah her nurse, is playing the accordion and singing Dixies land, more we think, to amuse her self than the baby. There is one though, near by, whose silent and disinterested watchfullness can be trusted, for old dog Tray is ever faithfull.[102]

Spencer, who had no firsthand knowledge of southern flora, improvised by filling the canvas with lush, near-tropical vegetation. Ferns grow thickly, and an orange

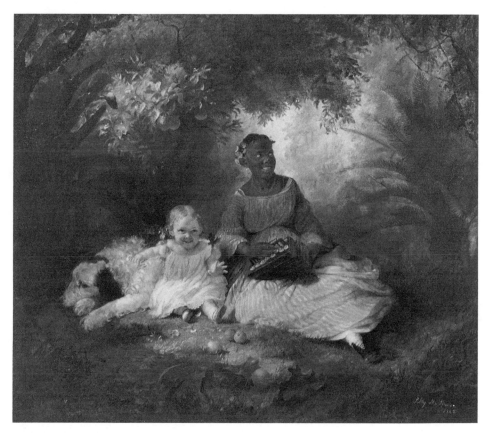

Fig. 3-17. Lilly Martin Spencer, *Dixie's Land,* 1862, oil on canvas, 20 × 25 in. (50.8 × 63.5 cm). Gesner Fine Art, Largo, Florida.

tree, ripe with fruit overhead, has dropped several bright orbs before the child. The painter may have formed her perception of southern landscape from her brother, who described it when he sought work in Florida in the early 1850s. Their parents described his travels as a journey to the "<u>sunny,</u> but mentally <u>dark</u> South."[103]

Spencer places the nursemaid in the center of the canvas but draws the viewer's attention to the golden-haired child by illuminating her in a spot of sunshine. The painter borrowed heavily from the written imagery of *Uncle Tom's Cabin* to portray her "little human sunbeam." Harriet Beecher Stowe's enormously popular novel, published a decade before, fired the American imagination and galvanized anti-slavery sentiment in the years before the Civil War. Stowe's characterizations of Uncle Tom, Aunt Chloe, Mammy, and Dinah had a significant impact on the visual representation of black servants throughout the rest of the nineteenth and into the twentieth century—an influence that will be discussed in the following chapter.

Stowe also developed a cast of white characters, including the genteel St. Clare family of New Orleans. Eva, their angelic daughter who pleaded for the freedom of their slaves, is described as "one of those busy, tripping creatures, that can be no more contained in one place than a sunbeam." She was "the perfection of childish beauty": dreamy, innocent, always dressed in white, with a "visionary golden head" and "deep blue eyes."[104] The same physical characteristics are present in the features of Spencer's southern child, who looks toward the viewer with a bright smile. However, the painted figure exhibits little of the deep attachment Eva held for her black attendants in *Uncle Tom's Cabin*. She offers no acknowledgment of her nurse; rather, she extends a pudgy hand to caress the fur of the nearby dog.

The young slave, Dinah, is presented as a distracted if not untrustworthy guardian. Wearing a pink-striped frock and fingering a red accordion, she is adorned with coral beads and gold hoop earrings. Tiny daisies are tucked in her plaited hair. Her face and upper body are veiled in shadows as she turns her head and cuts her eyes sharply to the right. She smiles, but it is not clear what amuses her as her attention is drawn away. Is there an unseen friend or suitor nearby? Perhaps she contemplates an escape to the freedom of northern regions or the Union lines. Unlike the "unconscious" child at her side, Dinah's glance seems to convey knowledge of the "right or wrong" Spencer refers to in her written text. The artist offers no explanation for the odd expression. Instead, she relates that the self-absorbed nurse entertains herself, while the child's well-being is assured by the reliable dog.

Spencer rarely depicted African Americans, and her correspondence contains little indication of her attitudes toward them.[105] Yet she appears to have relied heavily on common literary and visual stereotypes for her occasional representations. The popular press employed Dinah as a caricature of African American females. Most frequently, the character was associated with cooking—as is the case in Stowe's novel. In 1856, however, Dinah was pictured as the female counterpart of Jim Crow in a cartoon labeled "Illustrations of Ornithology" (fig. 3-18). Crow was the happy-go-lucky male character—usually a white in blackface—who sang and danced in minstrel shows for the entertainment of antebellum audiences. His name would eventually come to signify the strict segregationist policies legislated throughout the United States over the next century.[106] In the *Harper's* cartoon, the female Crow is pictured as an adolescent girl. Like Spencer's Dinah, she sits on the ground and is attired in a nice gown and beads. Instead of an accordion, she holds a fire bellows. The cartoon figure also grins broadly and cuts her eyes to the right. In this instance, her glance calls attention to a "James Crow" advertisement posted on the wall over her shoulder.

Dinah Crow's sidelong glance, pictured in both Spencer's painting and the *Harper's* cartoon, is also described in *Uncle Tom's Cabin*. The gesture belongs to

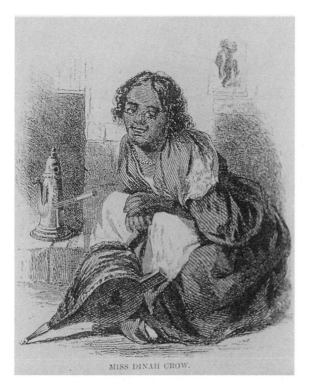

Fig. 3-18. Unknown artist, *Illustrations of Ornithology,* published in *Harper's New Monthly Magazine* 12 (January 1856): 286.

MISS DINAH CROW.

the little slave girl, Topsy, a "funny specimen in the Jim Crow line." When first introduced, this character offers a "most sanctimonious expression of meekness and solemnity over her face, only broken by the cunning glances which she shot askance from the corners of her eyes." In Topsy, Stowe created a shrewd, dark foil for the innocent and glaringly white Eva. She describes the two as "representatives of their races. The Saxon, born of ages of cultivation, command, education, physical and moral eminence; the Afric, born of ages of oppression, submission, ignorance, toil and vice!"[107] In *Dixie's Land,* Spencer invested her figures with similar attributes of virtue and vice.

The painter requested that the canvas be returned promptly from the Buffalo exhibition "as I am finishing its mate (which is one of my best pictures) its title is 'The Home of the Red White and Blue.'"[108] Spencer was referring to the large painting that would eventually be called *The Artist and Her Family at a Fourth of July Picnic* (ca. 1864, fig. 3-19). In this image, she portrays more than two dozen figures enjoying an Independence Day picnic on the banks of a river. To commemorate the celebration, she places an American flag in the hand of a young child at center who, atop his father's shoulder, waves it high. A Union soldier standing in the group to the left locates the scene in the North. He also serves as a reminder of

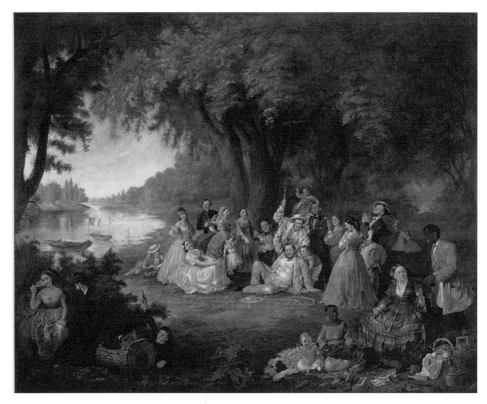

Fig. 3-19. Lilly Martin Spencer, *The Artist and Her Family at a Fourth of July Picnic,* ca. 1864, oil on canvas, 49½ × 63 in. (125.7 × 160 cm). National Museum of Women in the Arts; given in memory of Muriel Gucker Hahn by her loving husband, William Frederick Hahn, Jr.

the ongoing war, but a laughing woman nearby wears his kepi cap at a jaunty angle, as if to dispel any somber reflections during the festivities. In one of the scene's various subplots, the artist pictures her stout husband at center. His rope swing having just collapsed, Ben sits on the ground looking both startled and sheepish as the revelers laugh. Spencer shows herself coming to the rescue, appearing at left with a concerned expression and outstretched arms.

A faithful reproduction of the figures from *Dixie's Land* are at bottom center. In this version, the nursemaid glances over her shoulder to watch a black manservant pour wine into a matron's goblet. The recipient scowls at the steward's inattention, for while he joins in the laughter over Ben's fate, he accidentally spills the liquid onto her skirt. In the still life of assorted dishes and pails at the trio's feet, Spencer inserted a tiny placard that reads, "Fourth of July / Remember!" Red boxes of firecrackers, with a fuse exposed, lie nearby.

The firecrackers may intimate a potentially explosive situation beyond the obvious ire of the cranky matron. This image, produced by the daughter of abolitionists, portrays white northerners celebrating the memory of the Declaration of Independence while African Americans serve them. The scene brings to mind the same issues Frederick Douglass raised in his famous Independence Day speech at Rochester in 1852, when he reminded his white audience, "The blessings in which you, this day, rejoice are not enjoyed in common. The rich inheritance of justice, liberty, prosperity, and independence bequested by your fathers is shared by you, not by me. . . . This fourth of July is yours, not mine."[109] The Emancipation Proclamation was signed just over a decade later, and white Americans on both sides of the Mason-Dixon line continued to question the place of black people in American society. In 1867, New Yorker George Templeton Strong noted in his diary that "honest, patriotic people who exult over the downfall of slavery" were nevertheless startled at the prospect of blacks having a role in government. The problem, he asserted, went beyond skin color: "If Quashee is not a gentleman and a statesman, it is because he is degraded by servitude that has lasted for generations. . . . we are familiar with the notion of a nigger servant, bootblack, barber, or field hand, and not familiar with that of negro legislator."[110] Spencer's portrayals of black servants convey a similar, deep-rooted association of African Americans with service.

As she began her work on *The Picnic* in the middle of the war years, Spencer announced to her parents the birth of another son, Victor McClellan—so named to commemorate recent victories at Yorktown and Norfolk, and "the blowing up of that ugly nightmare, the Merimac." She offered a detailed description of the day on which the baby arrived. Despite the onset of contractions, she "worked like a trooper" as she supervised the spring planting of the garden. The forty-year-old Lilly directed her family and servant in the placement of every seed and plant "with the funniest nervous short orders, and peremptory pointing with my finger as if I were Empress of the world." She continued,

> and then I fairly pitched into the house, and huried the poor girl (whom I had also helping me in the garden) up the stairs in double quick time I tell you! to fix the room; one moment scolding her; the next moment laughing at our flurry, and the prospect of being soon relieved of all my troubles. . . . the moment she would be going to one thing, I would call her to run for Ben, to go for the nurse and the doctor, when she fairly laughed at the idea of my sending for them, thinking I was not sick—then the next moment I would say never mind, I am all well again, go on with what you are at.[111]

A few years later, the artist captured the bustle of her domestic troops in *The War Spirit at Home (Celebrating the Victory at Vicksburg)* (1866, fig. 3-20). Spencer pictured herself at right, this time in a lace-trimmed blue gown. As she reads an ac-

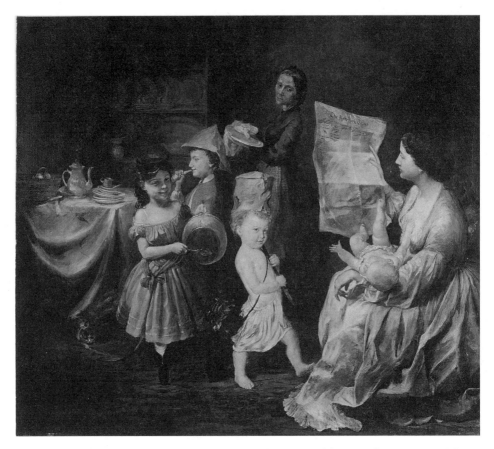

Fig. 3-20. Lilly Martin Spencer, *The War Spirit at Home (Celebrating the Victory at Vicksburg)*, 1866, oil on canvas, 30 × 32¾ in. (76.2 × 83.2 cm). Collection of The Newark Museum; purchase 1944, Wallace M. Scudder Bequest Fund.

count of the Union victory in the *New York Times,* she holds her most recent baby—this one a daughter. Three of her children form a juvenile military parade, complete with paper hats, a cooking-pot drum, and a stick gun. In the background at center, a maidservant dries dishes. She is somberly dressed in a dark gown with a checkered apron and wears her hair back in a black snood.[112] Spencer selected the end of the siege at Vicksburg as the premise for the impromptu family party. With postwar clarity, she knew the strategic importance of Grant's victory after the long Vicksburg campaign. The last Confederate fortifications on the banks of the Mississippi had fallen on July 4, 1863, effectively opening a western corridor to the federal army. On the same day, Southern forces had retreated after three days of intense fighting at Gettysburg. These dual Independence Day victories marked the turning point of the Civil War.[113]

Although Spencer once again used the likenesses of her own intimates, she probably intended the painting to represent the supportive spirit of an anonymous family whose husband and father had gone to war. The mother's stature as surrogate head is declared by the fact that she holds the newspaper, a traditional symbol of masculine authority.[114] At the same time, she has not abdicated her womanly duties; the infant on her lap touches her loosely covered breast as if it has just nursed. The painting may be approached as a mapping of the artist's own circumstances, though Ben did not enlist.[115] It indicates the absence of a male provider and a wife who carries the double burden of both mother and father. Moreover, Spencer reveals herself as a reluctant Madonna, for the painting's matriarch ignores the baby and compromises its precarious perch with her limp, downturned hand. Finally, the relationship between mistress and domestic appears strained, judging from the unhappy, almost glowering expression Spencer has given the servant. In this respect, the "war spirit" of the painting's title could also refer to an uneasy relationship between the wary maid and a mistress capable of giving imperious "short orders." The servant seems to be shut out of the family circle. She has not become wife to Spencer's female husband, nor does she appear to be companion or coworker. The dour maid is a far cry from either Spencer's earlier jolly washerwoman or congenial cook; she does not extend a hand or offer a smiling gaze. Perhaps the worker's face expresses weariness that Spencer herself felt, but dared not put on her own countenance. Instead, the artist presents herself as a cool mistress in control of her home and family, including a servant who dutifully obeys.

Spencer continued to produce paintings throughout the remaining years of the nineteenth century. The bulk of her output consisted of portraits (many from daguerreotypes), still lifes, and genre scenes of children and animals. She depended on the income from her work until her death in 1902 at age seventy-nine.[116] Perhaps because the public's taste for domestic genre decreased through the decades, the artist rarely returned to the kitchen scenes that were the hallmark of her most successful decade. As they disappeared, her once active interest in representing domestic servants also faded.

From her earliest years, Lilly Martin Spencer assumed the responsibility of creating sustenance with her hands. The young girl who pictured herself as a bread maker on the walls of a farmhouse kitchen became an adult breadwinner who provided for her family by producing paintings for sale or barter.[117] Her life brought no break from labor; she barely kept poverty at bay even with unending hard work. As a woman assuming many different roles, Spencer negotiated both public and private realms. Pushing beyond the female's "appropriate sphere," she experienced firsthand the tense fluctuations between middle-class ideology and the urgent necessities of working-class survival.

This tension is revealed in her representations of servants. As the result of a working woman's close observation of her own domestic coworkers, Spencer's early images give testimony to female humor, strength, and authority. When she painted her maid extending a hand to the world at large, she constructed an illusory human bridge where touch could transcend gender and class. At the same time, her depictions also celebrate the privileges of bourgeois life. On canvas, the artist could easily locate a servant within her kitchen. The placement of a domestic in her actual kitchen, however, was much more difficult, and dwindling finances sometimes forced her to do without. Losing precious painting time when she assumed the full burden of housework, she watched her family's economic and class stability deteriorate.

Under these pressures and with a desire to prove a gentility she could scarcely afford, Spencer became ambivalent and then hostile toward servants. With growing anger fed by a frustrating, ongoing search for a suitable helpmate, she distanced herself from household labor and laborers. Marginal circumstances also forced her to keep a sharp eye on the capricious tastes of the art-buying public, prompting her to adopt servant stereotypes prevalent in the popular press and paintings by her New York colleagues. Spencer's personal shift offers a microcosm of broader change in society's perceptions of domestic workers. By mid-century, most servants were immigrant or black. Their ethnic and racial differences were widely interpreted as signs of inferiority or regarded as threats. Artists perpetuated these biases in their visual representations of those who, Americans now believed, formed a distinct and separate servant class.

*Chapter Four*

# Bridget and Dinah: Images of Difference at Mid-Century, 1836–1876

For the issue of November 27, 1858, *Harper's Weekly* published four wood engravings by Winslow Homer, at this time a young freelance artist in Boston. Homer based his illustrations on an accompanying poem describing traditions of the American family at Thanksgiving: food preparation, the arrival of guests, the commemorative meal, and a dance.[1] His *Thanksgiving Day—The Dinner* (fig. 4-1) depicts a large, multigenerational gathering of kin and friends seated in a formal dining room. Presiding at center is a bespectacled patriarch who stands to carve the turkey. An empty place at bottom right invites the viewer to join the festivities. A wishbone is conveniently placed nearby so one may not only be thankful for the present bounty but also have the opportunity to wish for more.

In the turbulent years before the outbreak of the Civil War, Homer attempted to convey domestic harmony and abundance. In doing so, he also constructed a visual inventory of the blessings for which the universal American family gave thanks: a well-appointed home, copious food, loving family members, cheerful guests, and dutiful servants.[2] Though not described in the poem, his domestic workers take active roles—a black waiter pours wine and a white maid approaches the table with a steaming covered dish. Their bustling labor, however, precludes their own participation in the national and familial celebration.

At mid-century, images of domestic servants—both black and white—were hardly neutral. Whether portrayed as garish caricatures or the picture of silent obedience as in Homer's utopian rendering, they nevertheless signified the presence in the home of what had become the nation's two most problematic and suspect pop-

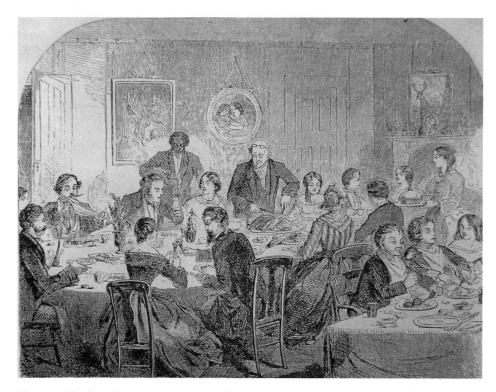

Fig. 4-1. Winslow Homer (1836–1910), *Thanksgiving Day—The Dinner,* wood engraving, 9¼ × 6⅞ in. (23.5 × 17.4 cm), published in *Harper's Weekly* 11 (27 November 1858): 761.

ulations: African Americans and Irish Catholics. A few years earlier, Congressman Abraham Lincoln considered the situation:

> Our progress in degeneracy appears to be pretty rapid. As a nation, we began by declaring that *"all men are created equal."* We now practically read it "all men are created equal, except *negroes.*" When the Know-Nothings get control, it will read "all men are created equal, except negroes, *and foreigners, and catholics.*" When it comes to this I should prefer emigrating to some country where they make no pretense of loving liberty—to Russia, for instance, where despotism can be taken pure, and without the base alloy of hypocrisy.[3]

Tensions between server and served grew proportionately to the changing demographics of the laboring population. From this period through the end of the century, the overwhelming majority of workers were either black or immigrant. Responding with the collective complaint that "good help" had vanished, families relinquished any pretense of forming egalitarian relations with those separated "by

a barrier of blood and religion."[4] Irish Catholic workers were subjected to the same sort of suspicion, prejudice, and ostracism that had consistently been directed toward African Americans. Like generations of black laborers before them, their outward differences were used to justify their status as a perpetual underclass.[5]

The uneasy preoccupation with a changing servant force shaped the ways in which household workers were portrayed in the illustrated press and, subsequently, in painting. Prescriptive images like *Thanksgiving Day—The Dinner,* which intertwines concepts of domestic tranquility with social hierarchy, could appeal to a tacit desire in mid-century viewers for the ongoing subordination of minority groups within the nation at large. It celebrates an orderly, stratified realm in which compliant outsiders know their place. At the same time, African Americans and Irish Catholic immigrants were consistently lampooned or vilified in popular literature, illustration, and the theater. Among the more prevalent stereotypes were characterizations of their behavior as servants.

## The Irish: The White Ones Are All Foreigners

Animosity toward the Irish did not begin when the potato blight of 1846–1849 led thousands of dispossessed workers to seek refuge in the United States. Since the colonial era, antipathy had grown from a distrust of their predominantly Roman Catholic background. Both Puritan and Anglican settlers, like their countrymen across the Atlantic, perceived Catholic countries and the Church as a threat to the English government. Hence, anti-Catholicism became a patriotic as well as a religious cause. Most colonial assemblies enacted laws forbidding Catholics—predominantly Irish settlers—the right to hold office or join militia companies. After the Revolution, many of those early exclusionary laws were translated into legislation in the new states.[6]

Figuring prominently in the final wave of indentured workers, Irish immigrants arrived in steady numbers. Like African Americans, they were regularly recruited to satisfy the need for labor, especially in northern cities. At the same time, they were often described as temperamental foreigners, ill-suited for domestic service. Writing from New York in 1790, Abigail Adams complained that her housemaid Polly was the instigator of "eternal mischief between others" and kept "the whole House in disorder, and gives a bad Name to the whole Family." She concluded, "The chief of the servants here who are good for any thing are Negroes who are slaves. The white ones are all Foreigners & chiefly vagabonds."[7] This lament was repeated through the early decades of the nineteenth century as the Irish competed with and often replaced African Americans in low-paying jobs.[8] During the 1830s, British traveler Harriet Martineau observed a general discomfort among Americans with

the prospect of bringing immigrants into the home: "There is no one subject on which so many complaints are to be heard from every class of American society as the immigration of foreigners. It is wonderful, to a stranger, to see how they fret and toil, and scheme and invent, to supply the deficiency of help, and all the time quarrel with the one means by which labour is brought to their door. . . . What would housekeepers do for domestic service without foreigners?"[9]

In the following decade, massive crop failures in Ireland forced thousands of its landless poor to follow earlier immigrants to the United States. The number arriving in American ports rose from 200,000 in the 1830s to 781,000 in the 1840s. The decade of the 1850s saw an increase to 914,000. By 1860, the Irish represented nearly half the nation's foreign-born population, constituting the single largest immigrant group in Boston, Philadelphia, and New York. They also formed sizable communities in Baltimore, Cincinnati, Cleveland, Detroit, Omaha, Denver, and San Francisco.[10] A large percentage of the new immigrants were young, single, and female. The social structure of postfamine Ireland left the daughters of the lower class with no resources and few alternatives but to leave their homeland entirely. In addition, Irish women seemed to be more readily accepted into the American work force than their male counterparts—a perception that prompted families to send over daughters instead of sons. Once established and employed, the young women sent back remittances to help fund passage for other relatives. Historian Hasia Diner has described this typical pattern as a "female chain" of sisters, aunts, and friends who came over one at a time.[11]

The impoverished Irish newcomers willingly and gratefully accepted positions as domestic servants. They arrived with cultural traditions of late or nonmarriage and gender segregation, which facilitated their easy entry into a market desirous of English-speaking servants. American employers took them into their homes by the hundreds, no matter how fresh off the boat or unskilled. In turn, service offered the immigrants a better opportunity to save money than did factory or mill work, as families provided room and board in addition to wages. With such mutual advantages in place, Irish women soon made up the largest ethnic group of domestics in the United States, a position they would maintain until after World War I. At the same time, the number of native-born white servants steadily declined. American workers were reported to have found service so odious and demeaning that they preferred lower-paying jobs elsewhere.[12]

This well-documented shift left most critics of the domestic scene nostalgic for what they described as a previous, golden age of service. In *The American Woman's Home* (1869), Catharine Beecher and her sister, Harriet Beecher Stowe, lamented that "well-taught, self-respecting daughters of farmers, the class most valuable in domestic service, gradually retired from it . . . and left the whole business of domestic service to a foreign population." The help of the past—assumed to have

been the same race and religion as the family—was heralded as intelligent, cheerful, and competent. She was a woman who could accomplish before noon "the amount of work which would keep a common Irish servant toiling from daylight to sunset." The paragon was pronounced an artifact of the past and the Irish usurper was perceived as her antithesis.[13]

What remained constant were the harsh realities of live-in service. Domestic work required physical strength and stamina, and it imposed isolation and a loss of personal freedom. The typical maid-of-all-work labored from around 5 A.M. until 9 P.M. and remained on call through mealtimes and at night. She had little choice about her food, sleeping space, and—increasingly—clothing. Free time was usually restricted to half a day each week and an occasional Sunday morning, and visitors to the residence were either restricted or forbidden entirely. A final but not inconsiderable drawback was the lowly status that continued to be associated with the occupation. The historic stigma of service and negative concepts regarding immigrants intertwined. "The Irish seemed more lower-class because they were in domestic labor," historian Blaine McKinley writes, "and the work itself seemed more menial because the Irish dominated it."[14]

This is not to say that after 1850 every servant in American homes was a refugee from the Emerald Isle. Southerners continued to rely on African American labor as house slaves became house servants after the Civil War. The smaller number of German workers tended to migrate to ethnic communities in cities such as Saint Louis and Cincinnati, where they sought positions in German-speaking homes. Scandinavian servants predominated in the midwestern states of Minnesota, Illinois, and Wisconsin. Chinese laborers—mostly men—filled domestic jobs on the west coast. Employers in southwestern territories found household workers among indigenous Mexicans and Native Americans.[15] These various populations were not entirely overlooked in contemporary complaints about the Servant Problem. In 1870, Francis Walker noted ongoing grievances against African American, Irish, German, and Chinese servants: "How slatternly is Dinah, how impudent Bridget, how stupid Wilhelmina, and alas! how fleeting were the delusive joys of Chang-Wang, son of the Sun."[16] The Irish Bridget, however, took most of the blame for the woes of the nineteenth-century housekeeper. Her legendary ubiquity had much to do with her control of the service market in northern cities, where most writers of domestic and popular literature resided.[17]

Bridget's faults were many, judging from contemporary essays, novels, diaries, and letters. The "daughter of green Erin" was reported to be a terrible cook, lazy, given to drink, temperamental, superstitious, and had the low standards of cleanliness of one born and bred in the bogs. Compounding the problem, she was also Catholic.[18] In 1864, Robert Tomes offered a fairly representative diatribe against the "Irish female peasant" who had become "both the necessity and plague of our

homes." In a long article titled "Your Humble Servant" in *Harper's New Monthly*, he observed, "As we can not dispense with her strong arms, we have to endure her ignorance, her uncouth manners, her varying caprices, and her rude tongue." Bridget's enthusiastic but backward approaches to housekeeping, he wrote, brought tears to the eyes of housekeepers. She cut off the tips of the asparagus and served up the tough stalks, bathed her feet in the soup tureen, scrubbed the eyes off family portraits with soap and water, and stirred the fire with a silver spoon. "Minor" offenses such as burning daily meals, breaking dishes, or "letting baby fall into the fire," Tomes glibly continued, "are such daily occurrences that they are hardly worth mention." One of her most annoying habits, the author noted, was her inclination to change places frequently: "The household is the scene of a perpetual revolution. To-day there is a change of dynasty in the kitchen, to-morrow in the chamber or nursery." Gaining bargaining power from a knowledge of sure employment, immigrants quickly learned to shop around for situations offering them the most advantages.[19] For many families, the most uncomfortable and often unsurmountable difficulty was the foreign maid's Roman Catholic background. Tomes noted a general impatience on the part of employers with their servants' frequent absences to attend Mass and their dietary requirements "when fish is scarce and dear." But worse was the fearful belief that there lurked "in every Catholic servant a Jesuit in disguise"—referring to the order most often suspected of militant, violent acts against Protestants.[20]

Anti-Catholic sentiment gained widespread legitimacy and momentum in the turbulent atmosphere of the 1850s. Never totally removed from American thought, mistrust toward the Roman faith only increased with the massive influx of Irish after the Great Famine. These years were marked by violent confrontations between nativists and Irish Catholics. Riots broke out in all major northern cities; mobs burned churches and convents, pulled down Irish residences, harassed nuns, and thrashed priests. Hostilities were fueled by a massive output of No-Popery literature, a campaign so effective that "the average Protestant American of the 1850s had been trained from birth to hate Catholicism." The Know-Nothing party, with its nativist ideology, rapidly gained political strength. At the apex of its influence in 1856, the party ran a viable presidential candidate in incumbent Millard Fillmore. Though his bid was unsuccessful, the political faction produced a creditable showing with 25 percent of the popular vote. Two years earlier, the Know-Nothings had gained control in Massachusetts by successfully filling the governor's seat, the entire state senate, and all but two seats in the house of representatives.[21]

Part of this crusade specifically addressed a perceived threat to families from Irish servants. Anti-Catholic speakers and writers accused household workers of being Jesuit spies who conveyed information to Rome via the confessional boxes of

their priests. They were also charged with plotting to convert the unsuspecting children in their charge. Josiah Gilbert Holland warned young mothers against trusting an Irish nurse, for she may "secretly carry the infant to a priest, and have it baptized in the Catholic church, herself standing godmother." A more frightening rumor spread in the mid-1850s throughout New England that Irish maids had been instructed to poison the food of their Protestant employers.[22] Alarmed homemakers boycotted or fired immigrant servants to secure the peace of mind from "having their dinners cooked and their beds made by Protestant hands."[23] With demographics clearly against them, employers seeking servants through the newspapers included the increasingly common stipulation "No Irish need apply." One New York advertisement reveals the prevailing mood: "Woman Wanted—To do general housework . . . English, Scotch, Welsh or German, or any country or color will answer except Irish."[24] These homemakers were destined to have a long wait or, like Bostonian Harriet Robinson, faced the difficult option of doing without hired help entirely. In 1864, after dismissing one more in a long line of Irish servants, Robinson wrote in her diary that she "was sick of [the maid] and help in general, and had rather live in peace and alone if I did have to work. I then went through the ceremony of washing my hands of the Tribe called 'Paddy.'"[25] In this antagonistic climate, Protestant employers threw up defensive barriers of wariness and distance.

## *Imaging the Stranger Within*

In the midst of this highly animated public discourse, American artists produced their own considerations of servant types and behavior. Building on established conventions of representation, painters like Lilly Martin Spencer could easily observe the growing anti-immigrant sentiment in the popular press. The theme of the "stranger in the gate" as the enemy within had become a familiar one. As discussed previously, Spencer produced *Fruit of Temptation* (ca. 1857, fig. 3-14) out of her own frustrations as a homemaker who struggled to find adequate, steady household help. Her theme of the negligent maid, however, was also developed by synthesizing Dutch antecedents with contemporary cartoons and illustrations.

Second only to the countless images published in magazines and newspapers, the lithographs of Currier and Ives had the largest audience of the period. Their multiple prints, based on compositions from a variety of artists, were inexpensive and attracted a vast circulation. Among the thousands of images produced, many represented current issues and events.[26] In 1863, Currier and Ives produced *The Domestic Blockade* (fig. 4-2) after a painting by Thomas Nast. In the seemingly lighthearted scenario, Nast addressed the rather serious rift that had formed be-

Fig. 4-2. Thomas Nast (1840–
1902), *The Domestic Blockade*,
1863, lithograph, $9\frac{1}{2} \times 7\frac{1}{4}$ in.
(24.1 × 18.4 cm), published by
Currier and Ives. Museum of
the City of New York; Harry T.
Peters Collection.

tween families and their immigrant servants. At the time, the artist was just be-
ginning his career as a political cartoonist. His biting illustrations—many exhibit-
ing a blatant hostility toward Irish Catholics—would be a regular feature in
*Harper's Weekly* over the next twenty-five years.[27]

In *Domestic Blockade*, Nast borrowed from prevailing martial parlance in the
midst of the Civil War. The well-publicized attempt by Union forces to seal nearly
3,500 miles of Confederate coastline had become a major challenge. Nast's block-
ade, on the other hand, takes place on the domestic front of the home, where the
combatants are two children who aggressively wage war against the family maid.
The worker is depicted in the familiar servant uniform of a dark work dress with
rolled sleeves, skirt turned up to the waist, and an expanse of quilted underskirt
showing beneath. She appears to have set up a temporary barricade in the doorway
to bar anyone from entering the space where she cleans. The obstacle is an over-
turned table reinforced with chairs, tubs, and cleaning implements. It appears,
however, that the children have turned the tables on her. They have seized the for-
tification and armed it with glass bottles, pointed gunlike at the captive maid. De-
fending herself with an upraised broom, the worker finds her movement is im-
peded, if not halted, by the banner-waving children. The boy, dressed in a

miniature version of the Zouave uniform worn by several New York companies, threatens her with a toy rifle and bayonet. His smiling sister—a diminutive Liberty in muslin gown—acts as standard-bearer, waving the American flag above her head. With a show of national symbols, Nast signifies that the youngsters represent the American side of the conflict. Conversely, the viewer is invited to conclude that the scowling domestic must be the enemy.[28]

The doorway once again becomes the boundary between servant and family. If not the site of physical combat, as in Nast's farcical image, the threshold nevertheless served as a battleground for psychological warfare waged in American homes. Several years earlier, *The Lady's Book* recommended, "When the mistress has any fault to find, or any admonition to give, let her call the domestic to the parlour door; deliver her reproof or command in as few words as possible: and have the door closed without further reply."[29] Servants were increasingly relegated to separate entrances and doors altogether, a system promoted by Catharine Beecher "as the best method of securing neatness, order, and convenience."[30] By controlling passage, employers demonstrated their command over domestic spaces. In visual imagery, the door helps establish clear separation between server and served.

Henry Bebie portrayed a more peaceful yet very controlled environment in his *Family Group at Breakfast* (ca. 1855–1860, fig. 4-3). Little is known about the Baltimore artist, who was born in Switzerland at the beginning of the century. Bebie anglicized his name from "Hans Heinrich" after his arrival in the United States in the 1840s. Although he gained a reputation as a portraitist, some examples of his genre work survive. In this canvas, Bebie exhibits the tightly composed manner of the Düsseldorf school. In a stagelike setting, the figures are front-lit, highly detailed, and delineated in a crisp, linear manner.[31]

The painting portrays a prosperous family gathered together for breakfast in the dining room. The neatly balanced composition suggests the orderly state of both the belongings and the inhabitants. A Federal-period china cabinet stands at center displaying a portrait bust. To the left is an elegant silver urn on a sidetable and, at right, a wall barometer. The table has been carefully arranged with coffee, milk, and rolls laid neatly on a crisp white cloth. The family—which includes a middle-aged couple, an adolescent daughter or younger sister, three small children, and an older, white-haired man—is engaged in a morning meditation on the Bible. The grandfather, with a toddler on his knee, reads from the scriptures while the adults listen prayerfully and a little girl shyly hides her face in her mother's skirt. As the family focuses on the concerns of the spirit, a servant attends to the more earthly requirements of domestic duties. The worker enters at left with the remainder of the family's meal. She is neatly attired in a dark dress with white cuffs, collar, cap and apron—a precursor to the livery that would soon be required

Fig. 4-3. Henry [Hans Heinrich] Bebie (1800?–1888), *Family Group at Breakfast,* ca. 1855–1860, oil on canvas, 25¼ × 30 in. (64.1 × 76.2 cm). Present location unknown. Copy photograph © 1944, Sotheby's Parke-Bernet.

of many American domestics. Standing in the doorway, she looks toward her seated mistress but receives no acknowledgment. The clear separation of servant from family is nothing new in American representation. At this time, however, the portrayal of an employee's exclusion from Bible study has deeper significance.

Controversy over differing versions of the Bible sharply divided Protestants and Catholics at mid-century. The issue first arose in the 1840s when religious societies in New York began distributing the King James translation to the urban poor. The Catholic church, preferring its own sanctioned text, strongly protested. When its disapproval extended to the reading of the Protestant Bible in public schools, the Church was accused of being against the scriptures entirely. In 1852, the conflict came to a head when Catholics demanded that schools either desist in requiring Bible study or direct public funds toward an extension of their parochial system. In

many towns and cities, including Baltimore, where Henry Bebie resided, the re-action was immediate and violent. In Oswego, New York, a Catholic child was se-verely beaten by his teacher for refusing to read from a Protestant Bible. With pub-lic support and approval, the school's trustees then expelled the boy. Eventually, the Church's strong position led to the passage of laws making it illegal to read the Bible in schools—an outcome that only served to confirm for its detractors the notion that the Roman Catholic denomination was not Christian at all.[32]

Some domestic writers implored Protestant families to take advantage of a ready-made opportunity to indoctrinate their servants in appropriate behavior. Otherwise, as Robert Tomes warned, "we may continue to live in fear of having our houses pulled down over our heads, or our throats cut every time the foreign element of our large cities is stirred to fermentation by some malicious dema-gogue." Families were encouraged to fulfill their moral duties by converting Catholic employees. "Every Christian pair must do *what they can* to bring these poor deluded servants, who swarm our cities and towns, to the knowledge of Jesus Christ," advised Rev. Daniel Wise in 1854. Even though they had been forbidden to listen by "tyrannical priests," he wrote, domestics could be won over to Protes-tantism by gentle instruction, by the placing of the Holy Scriptures in their hands, and by encouragement to attend family worship. "Let them be kindly invited to do so: if they comply, well; if not, we must submit to it until some pious Protestant girl can be obtained in her place."[33] The pious family circle in Bebie's painting ap-pears self-absorbed and closed. With no extra place at the table, there is little indi-cation that they plan either to include or to proselytize the obedient maid who stands apart in the doorway.

The less compliant servant depicted in *The Marchioness,* by Alfred Jacob Miller, finds little impediment in a closed door (fig. 4-4). Though the painting is undated, stylistic features suggest that Miller, another Baltimore artist, completed it in the 1860s. He pictures a young maid who stops her sweeping to look through a key-hole. Transfixed by the scene on the other side, she raises a hand to her face, ei-ther in surprise or—more likely—to shut one eye to aid her peeping. The artist has angled the handle of her forgotten broom to direct the viewer's gaze to the focus of her furtive attention. According to the title, the subject is a character from Charles Dickens's novel *The Old Curiosity Shop* (1841). Miller, who studied and painted in Europe in the years before 1843, was fond of popular literature by au-thors such as Walter Scott, James Boswell, Dickens, and Washington Irving. His sketchbooks abound with recognizable literary and theatrical scenes, including the preliminary drawing for this canvas. Best known for his paintings of the Ameri-can West, Miller rarely developed the literary sketches into oil paintings, *The Mar-chioness* being an exception.[34]

*The Old Curiosity Shop* had great popular success in the 1840s, when the story

Fig. 4-4. Alfred Jacob Miller
(1810–1874), *The Marchioness,*
ca. 1860, oil on panel, 11¾ ×
10⅜ in. (29.8 × 26.4 cm).
Walters Art Gallery, Baltimore.

was first published in weekly segments in the London magazine *Master Humphrey's Clock.* The enthusiasm of American readers for the serial matched that of avid followers in Great Britain. In Boston, hundreds lined the dockside to await the arrival of the periodical's latest issue, and crowds lined the quay in New York City to ask English sailors about the story's progress.[35] In one of its various plots, a diminutive maidservant is bound out to Samuel Brass and his sister, Sally. The nameless drudge is overworked, abused, starved, and locked in the basement each night. She comes to the attention of Brass's law clerk, Dick Swiveller, who early on discovers the girl peeping through keyholes. "The Marchioness," as he christens her, explains she is seeking both company and scraps of food. Ultimately, it is through her peeping that the evil intentions of her master and mistress are revealed. Swiveller befriends her, sends her to school, and eventually marries the tiny waif.[36]

In the Marchioness, Dickens created a comic Cinderella who spies for survival.[37] She appears in the novel's original illustrations, by George Cattermore and Hablôt Browne ("Phiz"), as a skeletal urchin whose body and face are obscured by an adult-sized apron and cap. In contrast, Miller's 1860s portrayal offers few of the characteristics of the literary servant. Though depicted in ill-fitting mules and a patched petticoat beneath her tucked skirt, this figure is hardly the malnourished and battered bond servant of Dickens's story. Rather, Miller pictures her with plump cheeks and rounded limbs; her glossy hair shines above a white blouse.

And unlike the hungry Marchioness, who resided belowstairs where "there was nothing that a beetle could have lunched upon," this servant shows no interest in the joint of meat hanging on the wall behind her. The only true resemblance of Miller's servant to Dickens's tiny drudge is their surreptitious surveillance. Such violation of privacy would have drawn little sympathy from an American audience exposed to steady rumors of Catholic spies. In that context, Miller's painting may have functioned less as an illustration of a twenty-year-old novel than as visual confirmation of the dangers of bringing aliens into the home.[38]

While the little maid peeps through the keyhole, the viewer spies on her. The beholder's gaze—catching the worker in an insubordinate act—emulates the process by which employers covertly watched their servants. Household literature encouraged such scrutiny not only to minimize potential theft or waste but also to ascertain whether jobs were performed satisfactorily.[39] A worker granted too much freedom might shirk her duties altogether. "When the mistress follows her constantly, and shows an energetic determination to be well served," commented Harriet Beecher Stowe in *The Chimney-Corner* (1868), "[the servant] shows that she can serve well; but the moment such attention relaxes, she slides back again." Such an "eye-servant," a worker who labored only when watched, could be caught only through careful observation.[40] The gesture of peeping through keyholes is also associated with prurient curiosity. While the artist does not reveal the object of the young maid's intense looking, the viewer's own voyeuristic gaze is rewarded with a full view of the trim figure of the preoccupied servant. Her ankles are revealed by short skirts, and as she bends over, she displays a fair amount of throat and chest.

Unlike Miller's Marchioness, the worker in David Gilmour Blythe's *Wash Day* (ca. 1858–1859, fig. 4-5) looks back, greeting the viewer with a leering, gap-filled grin. Blythe pictures her before a doorway in a dark basement room where she churns a tub of watery clothing with her feet. Raising her olive-green dress high, she reveals a red petticoat and much of her white, fleshy thighs. The artist added flashes of red pigment to her gold head wrap and to the cleavage of her breasts revealed by the low scoop of her bodice. Buxom and solid, she is no specimen of dainty womanhood. The figure seems to match a description of "our Celtic Bridget" written by Oliver Wendell Holmes in *The Autocrat of the Breakfast-Table* (1858): "She is of the serviceable, red-handed, broad-and-high-shouldered type; one of those imported female servants who are known in public by their amorphous style of person, their stoop forwards, and a headlong and as it were precipitous walk,— the waist plunging downwards into the rocking pelvis at every heavy footfall." The brawny worker, he writes, is "constituted for action, not for emotion."[41] While Blythe's domestic performs her laundry chore with some enthusiasm, a blond, barefooted toddler swishes clothing in a trough filled with water. Nearby, a pump releases a steady trickle into the basin, and in the shadowy corner above the child's

Fig. 4-5. David Gilmour Blythe (1815–1865), *Wash Day,* ca. 1858–1859, oil on canvas, 17⅜ × 13¼ in. (44.1 × 33.7 cm). Munson-Williams-Proctor Institute, Museum of Art, Utica, New York.

head, a cage with a small yellow bird is suspended from the ceiling.[42] Pictured in the left foreground is a large, water-filled tub with a red cloth hanging over its lip. The scene's pervading darkness evokes a dank, dirty existence. Diverging from the evenly lit, precise style typical of contemporary artists with Düsseldorf training, Blythe employed loose, painterly strokes and flickering light and shadow to heighten the sense of movement and mystery in his underground setting.[43]

It is not clear whether the laundress is meant to be in the home of an employer or in her own basement quarters. The youngster could be her child or her charge. Whatever the relationship, the toddler is free to play in the deep, potentially dangerous water. The worker's inattention implies either a lack of experience or simple negligence, a theme Lilly Martin Spencer explored in genre scenes at the same time. Her *Gossips* of 1857, for instance, pictures a group of chatting servants who fail to notice a boy who falls into a tub of soaking laundry. Very different, however, from Spencer's portrayal of domestic labor is the manner in which Blythe's washerwoman kneads laundry with her feet. The pose appears to be the artist's direct comment on the unconventional work methods employed by immigrant servants unassimilated to American ways.[44]

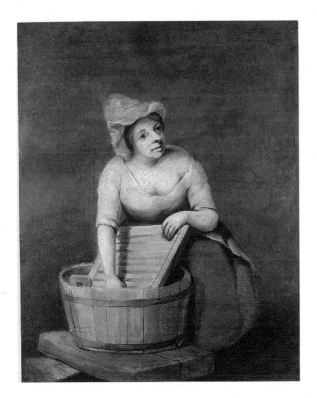

Fig. 4-6. David Gilmour Blythe, *The Washerwoman*, ca. 1854–1858, oil on board, $11\frac{3}{4}$ × $8\frac{3}{4}$ in. (29.8 22.2 cm). The Carnegie Museum of Art, Pittsburgh; gift of the Richard King Mellon Foundation, 72.34.6.

Inspired by cartoons, illustrations, and popular prints, Blythe's paintings tend toward caricature. An ardent nativist preoccupied with social and political issues, he was attuned to prevailing attitudes in the daily press. He focused on what he believed were the ills of American society—corruption, vagrancy, crime, and disease. Like others, he fixed blame on the growing number of foreign poor.[45] Raised in a strict Presbyterian home in rural Ohio by immigrant parents—a Scottish father and Irish mother—Blythe relocated to the Pittsburgh region in the 1840s as a self-taught portraitist. There, he met and married a young Catholic woman from Uniontown. The crisis of her death, within two years of their marriage, embittered Blythe toward the Roman church and triggered a severe dependency on alcohol—the primary cause of his own death sixteen years later. During the intervening years, he became a prolific genre artist whose patronage came from an affluent Protestant sector of Pittsburgh that shared his growing antipathy toward both immigrants and African Americans. By the time he produced *Wash Day,* the artist had fully embraced the Know-Nothing cause.[46]

Blythe had approached the laundress subject a few years earlier in *The Washerwoman* (ca. 1854–1858, fig. 4-6). In this small oil study, he produced a three-quarter-length view of a domestic who employs the more traditional mode of scrubbing

clothes with her hands. The sturdy figure, in gray hat and dress, bends over a wash-board and tub placed on a rough, wooden bench. She pauses from her task to look to the right with a small smile. Her dress is tucked at the waist above a brown underskirt; its sleeves are rolled to the elbows, and the wide neckline falls provocatively to one side. Unlike the domestic in *Wash Day,* the worker seems unaware of the viewer, who has been given an unimpeded glimpse of her plump, bare shoulder and much of her left breast.

## Dirty Work, Dirty Women

The laundresses in Blythe's paintings are displayed—or made to display themselves, as is the case of the uninhibited worker in *Wash Day*—in provocative ways that reveal their bodies. They are titillating images of women "constituted for action, not emotion," and are offered for the delectation of male viewers. By portraying servants as objects of both desire and derision, Blythe underscored the prevailing belief in the moral degeneracy of the immigrant lower classes. An audience steeped in the ideology of pristine womanhood and virtuous self-denial could read the images as affirmations of their own beliefs and fears concerning the strangers in their homes.[47]

Associating serving women with sexuality was not a new theme in American painting. It is implied in Greenwood's buxom *Jersey Nanny* (1748, fig. 1-2), Browere's kneeling scrubwoman in *Wash Day* (1833, fig. 2-9), Thompson's shapely housemaid in *The Peep Show* (1852, fig. 3-9), and, to look ahead, William McGregor Paxton's doll-like maidservants of the 1910s (figs. 6-1, 6-7, 6-9). In her study of Edgar Degas's images of laundresses in late nineteenth-century France, Eunice Lipton has linked sexual objectification with a strategy to "control workers, or one's fear of them . . . through contempt." Her argument may also apply to American representations:

A more specific form of bourgeois disdain involved sexualizing the poor. In the case of the commercial laundress in nineteenth-century middle-class culture, the emphasis on her sensuality and the persistent moral condemnation meant that she did not have to be taken seriously. Guilt about the quality of her work life, or fear of her potential anger, was side-stepped. She posed no dangers. . . . Far from being dangerous, the laundress remained a brute, if sometimes coquettish, sexual animal.

As long as laundresses were seen as immoral, they apparently deserved to earn less and to live in squalor. This selective redefinition of the conditions of their lives legitimized their exploitation—"one gets what one deserves."[48]

Though racial or ethnic difference seemed to hasten the process, the projection of turpitude onto laboring women was primarily a class issue. Clergymen, benevolence societies, physicians, and public health officials assumed that sexual licentiousness was, like drunkenness, a character flaw that kept the poor poor. Poverty would cease to exist, Catharine Sedgwick suggested earlier, if "the moral and physical laws of the Creator would be obeyed." She cited a minister in New York who "had known very few cases of suffering from poverty that might not be traced directly or indirectly to vice." Employers were advised to scrutinize household workers for some sort of inherent deviance. Lewd servants, they were warned, would initiate children "into habits of vice" or seduce weak-willed sons or husbands.[49]

Domestics certainly figured among those who gave birth out of wedlock or entered prostitution, but it was more typically the maidservant who was the victim of sexual seduction and abuse. Her isolation and lack of social and legal power made her vulnerable to the advances of the men for whom she worked.[50] The servant's appearance and actions invited speculation about her sexual availability. Domestic laborers brought to their chores a necessary physicality and robust strength that defied prevailing conventions of decorum. Scrubbing floors, wringing out laundry, and washing dishes required unrestricted body movement and clothing suitable for heat, dampness, and dirt. By turning up skirts, opening bodices, and rolling up sleeves, domestics exposed an amount of flesh that would be viewed as unseemly for a genteel homemaker. Furthermore, working-class women did not remain in the prescribed feminine sphere of the home; they ventured out alone to enter factories, mills, and other people's residences in search of income. Laundresses traveled unaccompanied to pick up and deliver wash, frequenting not just family dwellings but hotel rooms and bachelors' lodgings as well.[51]

Social historian Phyllis Palmer has argued that concepts of dirtiness and sexuality have been linked in the Western unconscious over the past two centuries. "Dirtiness," she writes, "appears always in a constellation of the suspect qualities that, along with sexuality, immorality, laziness, and ignorance, justify social rankings of race, class, and gender. The 'slut,' initially a shorthand for 'slattern' or kitchen maid, captures all these personifications in a way unimaginable in a male persona."[52] The cult of domesticity, which associated cleanliness with moral purity, made the split between mistress and maid all the more apparent. Middle-class wives and daughters gained gentility by turning over the grimier household labor to immigrants and women of color. Palmer explains, "Bourgeois women could attain this preciousness because working-class domestics scrubbed floors and stoops on their knees, emptied chamber pots, cooked every meal, scoured pots and pans, and laundered the family's clothing weekly. The wife's cleanliness was made possible by the domestic's dirtiness. Images of good and bad women were easily projected onto middle-class and working-class women."[53] Ladies with clean, dainty hands became

the unsullied angels of the home, while their servants became the opposite—"the repositories for images of sexuality and moral inferiority" and, in some cases, "legitimate sexual outlets for men." Palmer states, "At the simplest, ladies were *clean* and servants were *dirty*."[54]

Though domestic service attracted immense numbers of workers—enough to designate it the single largest female occupation in the nineteenth century—it never lost the stigma of debasement. When a financially needy Louisa May Alcott decided to take a position as maid-of-all-work for a minister in a neighboring town, her relatives "held up their hands in holy horror at the idea of one of the clan degrading herself by going out to service." She explained, "Teaching a private school was the proper thing for an indigent gentlewoman. Sewing even, if done in the seclusion of home and not mentioned in public, could be tolerated. . . . But leaving the paternal roof to wash other people's teacups, nurse other people's ails, and obey other people's orders for hire—this, this was degradation; and headstrong Louisa would disgrace her name forever if she did it."[55] Beecher and Stowe wrote, "To be the nurse of young children, a cook, or a housemaid, is regarded as the lowest and last resort of poverty, and one which no woman of culture and position can assume without loss of caste and respectability."[56] Whether native-born white, immigrant, or African American, Protestant or Catholic, a woman compromised her reputation by entering service.

This tension is evoked by William Henry Burr in *The Intelligence Office* of 1849 (plate 4), which portrays the selection process in which a matron interviews two women for a domestic position. The artist, who held a master of arts degree from Union College in Schenectady, was a portraitist and genre painter in New York City. He exhibited his work regularly at the National Academy of Design from 1841 to 1859, including this painting shown in 1850.[57] Its setting is an intelligence office, or employment bureau for servants. The office manager, who stands with a thumb hooked in an armhole of his gold waistcoat, holds out his hand as he awaits his client's decision. A crumpled copy of *The Sun* lies on the floor at his feet. Though the sign above his head reads, "Agent for Domestics / Warranted / Honest," the man's jaunty, open-palmed gesture suggests that his primary motive is monetary gain. His seated client is a well-dressed woman who clasps a furled parasol as she carefully studies the final candidates standing before her. Neither returns her gaze. One turns to the agent in nervous anticipation; the other—a petite young maid—has been positioned to look outward. Her attractive face, framed in a poke bonnet with a black veil, appears both serene and resigned. She seems to draw her long red coat across her breast in a self-conscious gesture that is both protective and modest. The garment falls open to reveal that she has come prepared, dressed in work clothes and an apron.[58]

Burr presents a sentimental version of an experience many genteel patrons found

distasteful. While families could locate servants through private recommendations or newspaper advertisements, intelligence offices were the largest supplier of domestics in towns, cities, and their suburbs. There, servants and employers registered, listed qualifications and requirements, and engaged in interviews—all for a fee. The honesty and ethical standards of the agencies varied from office to office. Managers were notorious for overregistering candidates or setting unusually high placement charges.[59] Charles Loring Brace described the "agonies of the 'intelligence' or 'non-intelligence' office: the ordeal of fifty severe-looking 'girls' of all ages, the cross-examination by the 'help,' the proud disdain with which a place is rejected" when the position didn't meet the worker's requirements. In the following decade, Mary Abigail Dodge was horrified by her excursion to an intelligence office. There she found "coarse, ignorant, unintelligent, un-helpful faces; such stolid indifference, such unshrinking self-assertion; such rude, brawny, worthless womanhood!" Dodge was "shocked to find suddenly springing up in my heart a sort of hate and hostility toward them. A distaste for republican and individual liberty, a longing for an absolute monarchy came over me."[60]

In portraying the moment just before the matron makes her selection known, Burr invites the viewer to participate in the candidate review. He brings the one maidservant to the forefront with her beauty, bright clothing, and direct appealing gaze. Pictured behind her are other unemployed domestics, stereotypical specimens of "coarse" and "brawny" women. Grouped together on a bench, they sit beneath a clock as if marking time without work.[61] Having missed the final cut, two exchange unhappy glances, perhaps in jealous speculation about the advantages of their competitor's youth and refined looks. In this marketplace of human commodities, is the attractive young woman the obvious choice? Entering the assessment process, a contemporary viewer may have paused with uneasiness.

Beneath the surface narrative of *The Intelligence Office* are subtle implications of flesh peddling and slavery. The maid's poignant glance outward could draw pity from those who would regret her descent into drudgery and, perhaps, sexual degradation. Indeed, there were widespread reports that some employment bureaus acted as fronts for the recruitment of women for brothels.[62] The exchange of knowing looks between older, veteran servants in the background may communicate their recognition of such a house transaction. Burr conceived and painted *The Intelligence Office* in the wake of the enormous popularity of *The Greek Slave,* by Hiram Powers. The world-famous sculpture portrays a Christian female captive who, stripped nude and bound, awaits her sale as a slave. It had recently made a national tour, coming to New York in August 1847. In response, Burr may have created his own, local version of the story of a young innocent being bartered into a different sort of slavery. The expression of the waiting servant seems to exude the same placid acceptance of fate that was celebrated in Powers's marble figure. A verse

of Henry Tuckerman's flowery poem "The Greek Slave," published in the *New York Tribune* on September 9, 1847, could also describe Burr's young domestic:

> What to thee a herd of gazers? What to thee a noisy mart
> Rapt in tranquil, fond seclusion thou are musing far apart;
> As the twilight falls around thee and thy matchless form I scan,
> Rising in serene abstraction, tho' it wears misfortune's van.[63]

The maidservant's intense red coat, however, could signify her already fallen state. The color's long-held association with prostitution comes from the New Testament book of Revelation, in which "Babylon the Great, the Mother of Harlots" (Rome) appears riding a scarlet beast and wearing scarlet and purple robes. The correlation of the hue with vice gained new currency when Nathaniel Hawthorne published *The Scarlet Letter* in 1850. His critically acclaimed novel, released the same year Burr exhibited *The Intelligence Office*, describes adulteress Hester Prynne as "a scarlet woman, and a worthy type of her of Babylon!" Approached in this way, the servant's engaging look might suggest a boldness inappropriate for a young woman. Finally, the maid's red garment may also allude to her Roman Catholic background. Following the Reformation, Protestants frequently interpreted the biblical Whore of Babylon as a personification of a seductive yet corrupt papacy.[64]

In 1868, Harriet Beecher Stowe cautioned employers against confusing a domestic's pleasing appearance with either ability or morality. She describes the type of woman "you will find in every intelligence office" who is quickly hired "by help of a trim outside appearance." But beneath the woman's delicate and genteel looks, she warns, lurks a hussy who wears no underlinen, sleeps in her clothes, helps herself to other people's belongings, and shirks her duties. "She is on free-and-easy terms with all the men she meets, and ready at jests and repartee, far from seemly." Her typical employment lasts from two weeks to three months, "when she takes her wages, buys her a new parasol in the latest style, and goes back to the intelligence-office." Stowe lamented that "the full amount of her mischiefs often does not appear at once."[65]

Domestic service and prostitution were inexorably linked in the public mind. In the 1830s, the New York Magdalen Society reported that there were thousands of "private harlots and kept misses, many of whom keep up a show of industry as domestics, seamstresses, nurses, &c in the most respectable families, and throng the houses of assignation every night." In his 1859 *History of Prostitution*, William Sanger made his own connection between the two historic recourses for poor women. After interviewing 2,000 imprisoned prostitutes, the physician related that half had worked as servants. Some, he ventured, actually entered prostitution to escape the long hours, menial labor, and harsh treatment they experienced in house-

" Nonsense, Mary! I tell you it is my firm opinion there's a
man in the house."

Fig. 4-7. Unknown artist, cartoon published in *Ballou's Dollar Monthly Magazine* 7 (May 1858): 502.

hold labor.[66] In "An Appeal to American Women," Catharine Beecher asserted that service had become so tainted by "the influx into our kitchens of the uncleanly and ignorant" that many women were forced to pursue "either a miserable pittance or the career of vice."[67]

With their cultural traditions of gender boundaries and religious training, few Irish Catholic women turned to prostitution. In 1860 Robert Tomes noted, "Though she does smell of incense and indulge in other abominations," Bridget and her sisters "have done less to swell that frightful 'social evil' of which so much has been said of late." The writer quipped that the Irish maid had, "in her homeliness, a natural safeguard."[68] Nevertheless, Irish servants were not exempt from the broad indictment of immorality against working-class women. The theme appears in several cartoons from the illustrated press in the years in which Blythe was painting his laundresses. A cartoon (1858, fig. 4-7) in *Ballou's Dollar Monthly* depicts a suspicious mistress who exclaims, "Nonsense, Mary! I tell you it is my firm opinion there's a man in the house." Her buxom, smiling maid spreads open her apron to shield a boyfriend crouching behind her. More explicit is the article "My Boarding House," by "Jacques," in *Harper's Weekly* of the same year. The author describes how he and his wife went to confront the cook about a theft of food. Entering her room unannounced, they found a surprise. The illustration (fig. 4-8) reveals that the Irish servant has a man hidden beneath her bed.[69]

Fig. 4-8. Unknown artist, cartoon published in *Harper's Weekly* 2 (9 January 1858): 21.

WHAT MY WIFE SAW UNDER THE COOK'S BED.

## *African Americans: Battling Outcasts*

The negative characteristics suggested in images of Irish serving women were an extension of American attitudes toward Irish Catholic immigrants in general. Bridget's foibles were also assigned to her male counterpart, but "Paddy" was considered the more temperamental, if not violent, of the two. The stereotype of the scruffy, savage Irishman who swings a knobby shillelagh permeated popular culture and public opinion.[70] This reputation for scrappiness was not unwarranted, for the Irish were often at the forefront of civil unrest and rioting in the second half of the century. Frequently, they directed their anger toward African Americans, their chief economic rivals for the already meager number of low-paying jobs. As the two groups clashed repeatedly, violence erupted in most of the cities of the urban North.[71]

    Irish and black workers also competed in the arena of domestic service. African Americans, who held most of the household positions in New York in the 1830s, were displaced at mid-century when Irish servants alone outnumbered the city's entire black population by ten to one. The huge immigrant influx effectively depressed wages and drove African Americans into peripheral jobs as hotel servants, waiters, seamstresses, laundresses, and ironers.[72] In 1855 Frederick Douglass lamented, "Every hour sees us elbowed out of some employment to make room perhaps for some newly arrived immigrants, whose hunger and color are thought to give them a title to especial favor." He noted that as the Irish took over "our avocation" as common laborers, cooks, and house servants, they also "assumed our degradation."[73] Many northern families expressed a preference for African

Fig. 4-9. Thomas Nast, *The Ignorant Vote—Honors Are Easy*, published in *Harper's Weekly* 20 (9 December 1876): 985 (frontispiece).

American employees, who through their long association with slavery were perceived as more submissive than the turbulent, inconstant Irish. Harriet Robinson's diary entries of 1864 recount her long, concerted effort to locate a black maid, a futile attempt in a Boston market flooded with immigrants. In the same year, New York journalist Robert Tomes, in the language of pseudo-Darwinian race theory, commented that "the old negro servants, once so common in our Northern kitchens and halls," were now "almost extinct through inherent weakness or the force of external pressure."[74]

The intense economic rivalry between immigrants and blacks also spilled over into politics. The newly organized Republican party supported social and economic freedom for African Americans, an ideology that directly threatened Irish domination of unskilled employment. In response, the immigrants rallied behind the opposing Democratic party to check the progress of the freedmen. Radical Republicans, like illustrator Thomas Nast, despised the growing influence of the immigrant bloc. After the Civil War, he blamed the failure of the Reconstruction system on a Democratic party full of unrepentant southerners and Negrophobic Irishmen—frequent targets of his *Harper's Weekly* cartoons.[75]

In an illustration published as the magazine's frontispiece in 1876, Nast portrays a vicious-looking Paddy who barely tips the scales in *The Ignorant Vote—Honors Are Easy* (fig. 4-9). In an attempt to measure which group might be the biggest

liability to the American political system, the scowling northern immigrant is weighed against a smiling southern black. Nast's figures present a contrast between Irish savagery and black amiability. Yet his image of the African American is hardly elevating. Portrayed with exaggerated features, patched clothing, and a silly grin, the figure is a Jim Crow type that had been popularized by minstrel shows. To create a seemingly benign foil for the menacing immigrant, Nast reverted to the cliché of African Americans as childlike and happy.

While the Irish character was frequently reduced to the fiery Paddy or the backward Bridget, it was the black persona that was split, defined, and typecast into several different roles in the second half of the century. If the Irish were perceived as difficult or even ferocious in the American imagination, African Americans were generally assigned the opposing qualities of docility and gentleness. Of the black stereotypes emerging at mid-century, the most abiding—Uncle Tom, Dinah, Auntie, and Mammy—were specifically associated with domestic service.

## *Your Very Obedient Servant*

In her exploration of images of blacks in nineteenth-century American painting and literature, Karen Adams describes the representations as "black shadows cast by white imaginations." They are all, she writes, "signs and symbols of white reality or fantasy." Painted images of black servants of this period generally convey an ongoing desire for—perhaps fantasy of—obedience in African Americans. They also support and promote the prevailing conception that blacks, as a people, were inherently subservient—a notion that historian George M. Fredrickson has labeled "romantic racialism."[76]

Both sides of the slavery issue drew from this perception. Many southerners insisted that simpleminded, childlike blacks required continued supervision and guidance for their own benefit. At the same time, some abolitionists represented the other side of paternalistic benevolence, arguing that slavery easily victimized a naturally pliable and obedient race. In 1839, Alexander Kinmont, a professor in the School of Scientific Education in Cincinnati, asserted that blacks were distinctly different from—though not necessarily lower than—whites. Because of "particular providence," he wrote, they exhibited a "willingness to *serve*, the most beautiful trait of humanity, which we, from our innate love of dominion, and in defiance of the Christian religion, brand with the name of *servility*, and abuse not less to our own dishonor than to their injury." In 1862, Rev. Joseph Henry Allen of Massachusetts echoed the theme, writing in the *Christian Examiner* that the Negro race "takes kindly to domestication, and receives its crumbs of a higher culture with grateful submissiveness."[77] All African Americans, however, were neither docile

Fig. 4-10. J. Goldsborough Bruff, detail of letter to the National Institute for the Promotion of Science, 14 August 1843. Smithsonian Institution Archives, Record Unit 7058, National Institute, 1839–1863, Box 9, Folder 6.

nor content. "To be dependent is to be degraded," was the declaration of a Negro convention in 1848. "Men may indeed pity us, but they cannot respect us." Nevertheless, southern blacks often adopted subservient postures to survive enforced bondage. Northern blacks had to negotiate a rigid discrimination that limited them to service positions—jobs they typically maintained by showing the required deference and humility.[78]

In nineteenth-century visual shorthand, a black figure could immediately denote servitude. When amateur paleontologist J. Goldsborough Bruff drafted a letter in 1843 to the National Institute for the Promotion of Science, he penned a rebus to offer his donation of fossils from the banks of the Potomac River. In his brief note, he substituted tiny drawings for words, such as a deer for "dear" and a profile of the nation's first president for "Washington City." After writing "Your very Obedient," Bruff drew a black man to signify "servant" (fig. 4-10). The small, detailed figure is barefooted and wears patched coveralls. He has removed his straw hat and, bowing low on one knee, raises one hand to his forehead. The pictograph is reminiscent of the ubiquitous caricature of a running black man used in southern and mid-Atlantic newspapers to advertise slave sales or runaways. In Bruff's adaptation, however, the man does not flee; rather, he leans forward to bow deeply in deference to an unseen master.

In his essay "Truth and Stereotype," art theorist E. H. Gombrich addresses the connection between language and symbols, noting that "language does not give name to pre-existing things or concepts so much as it articulates the world of our experience. The images of art, we suspect, do the same." To describe the visible world, artists develop a system of schemata. Gombrich argues that prevailing societal habits and expectations inform the production of such conceptual images. "The form of a representation," he writes, "cannot be divorced from its purpose

and the requirements of the society in which the given visual language gives currency."[79] Bruff's pictograph for "servant" functions in such a way.

At this time, the number of images of black people decreased in American painting, likely an effect of the growing debate surrounding the slavery issue. When artists did picture African Americans, they typically represented them as servants. Although painters seldom employed the harsh, grotesque style of caricature that predominated in the illustrated press, they nonetheless perpetuated the cliché of the compliant black attendant who elevates the white master or mistress through a fixed devotion.[80] Painters continued to employ conventions of visual separation, picturing black servants in doorways, corners, distant rooms or corridors, and behind chairs—positions that marginalize workers from families. These old, comfortable formulas must have answered the purposes and requirements, as Gombrich suggests, of an audience troubled by the changing role of black workers at mid-century. On rare occasions, artists would imply something beyond unthinking devotion on the part of the servants. However cognizant they appear of their surroundings and circumstances, the African Americans remain, nevertheless, liminal figures who react instead of act.

## Knowing Spectators

A Baltimore native, Richard Caton Woodville may have received early art instruction from Alfred Jacob Miller. He also had the opportunity to study the local collection of Robert Gilmor, Jr., which included genre paintings by seventeenth-century Dutch artists and their later American followers. Woodville developed a similar interest in producing narrative scenes of everyday life. In 1845, he went abroad to the Düsseldorf Academy, where, over the next several years, he refined a naturalistic painting style characterized by meticulous detail, deep colors, and smooth surfaces. Moreover, a fellow student noted that Woodville "always painted some subject characteristic of American life"—a wise strategy for a young artist who regularly shipped canvases back to the United States for exhibition and sale. One method he used to add a distinctly American flavor to his paintings was the inclusion of African American figures. The son of an affluent Baltimore banker, Woodville drew upon his own knowledge of the house servants who were predominantly slaves in antebellum Maryland. His black figures function as onstage spectators who help direct the viewer's attention to the story's central action.[81]

In 1846, Woodville sent over from Germany his first major painting, *The Card Players* (fig. 4-11), which was exhibited and received with great enthusiasm in New York.[82] The boxlike scene portrays a tavern room in which a prosperous, older traveler questions the honesty of two cardsharps with whom he plays. Looking

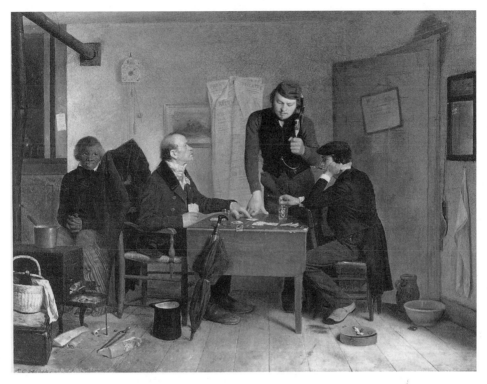

Fig. 4-11. Richard Caton Woodville (1825–1855), *The Card Players*, 1846, oil on canvas, 18½ × 25 in. (46.99 × 63.5 cm). Detroit Institute of Arts; gift of Dexter M. Ferry, Jr.

up with an angry expression, he points an accusing finger at one of the cards lying on the table alongside drink glasses, money, and smoking paraphernalia. His top hat, umbrella, and the greatcoat thrown over the back of his chair all suggest that he is midjourney. The game with the motley pair may have seemed a welcome distraction during his wait for the Baltimore-Washington stagecoach. Its arrival and departure schedule is posted on the door at right, which stands ajar. The atmosphere suggests transiency and, perhaps, the impending quick exit of the confidence men. Their wary victim already suspects what the viewer is allowed to see: the dour player to the right sits on a hidden card.

The painting's fourth figure, a black man with graying hair, is seated closely behind the traveler's chair. His position and his guardianship of a red-striped carpetbag suggests his identity as the man's servant. The worker faces a low iron stove; orange embers burn low in the brazier and kindling is scattered with other debris on the floor. He seems to be tending a copper pan, perhaps warming some grog from the nearby basket. In contrast to the mounting altercation at the card table,

Fig. 4-12. Richard Caton Woodville, *Old '76 and Young '48,* 1849, oil on canvas, 21 × 26⅞ in. (53.3 × 68.3 cm). Walters Art Gallery, Baltimore.

the man sits quietly with hands folded. Turning his attention from the stove with its crooked pipe, he casts a sidelong look toward the crooked men. Screened by the greatcoat, he takes advantage of his semiprivacy to observe the game's noisy and final conclusion.

Like the viewer, the servant seems to realize that his master is being hood-winked, yet he remains still and silent. Perhaps as an overworked subordinate, he gains some satisfaction from watching his owner's misfortune. On the other hand, the worker's still posture may convey his response to danger. Knowing the amount his master has had to drink and how much money is at stake, he might anticipate the game's potentially violent ending. Finally, his master's financial loss could pro-duce a different, unhappy consequence. As legal property of the ill-fated card player, the slave himself might be handed over as settlement for a final debt. In this respect, the black man's rapt attention may be focused on the quickly unfold-ing prospect of his own future.

Woodville included three black house servants in his *Old '76 and Young '48* (1849, fig. 4-12). Although they are less obvious figures than the knowing manservant in the earlier canvas, they nevertheless underscore the painting's central drama with their attentive focus. In this colorful, richly detailed scene, a family gathers about the son of the house, a soldier newly returned from the Mexican War. As he finishes a lavish meal, the wounded young man describes his battlefield experiences to the transfixed household. His grandfather, seated near the fire, looks down as he concentrates on the tale. Judging from the bust of Washington in the corner and the print of Trumbull's *Signing of the Declaration of Independence* above the mantel, the old gentleman is from the Revolutionary War period. As the young man gestures toward his grandfather's own youthful portrait as an officer in Continental uniform, his parents draw near. His sister peeps over her mother's shoulder, and the family hound lays its head on the young man's knee.[83] In the background at right are the vague figures of house servants crowded together in the open doorway. Though enveloped by shadows, their blurred features reveal a liveried manservant, a woman in a white turban, and another, less distinguishable man.

Woodville populated the painting with likenesses of his own family. Working from portrait sketches he had brought with him to Germany, he portrayed his parents and sister as the welcoming family and his younger brother as the wounded soldier. Woodville's great-uncle, Richard Caton, was probably the prototype for the elderly veteran. For the painting, the artist may also have been recreating his uncle's Maryland home, Brooklandwood, with its old-fashioned, colonial furnishings. Family correspondence describes the residence as staffed by at least twenty black servants, with no less than four waiting on the family at dinner.[84]

The trio of listening workers pictured in *Old '76 and Young '48* functions much like the pet at the knee of the young master, their quiet attention conveying faithful devotion to one who has, at last, returned home. The servants were described in the June 1850 *Bulletin* of the American Art-Union as drawn to the door by "lively curiosity."[85] Woodville painted the domestic scene against the background of a furious political debate over slavery that arose following the conclusion of the Mexican War. Until the late 1840s, there was a precarious balance in the United States Congress between slave and free states. Through treaty terms, defeated Mexico surrendered more than a million square miles to the United States. The South demanded that the vast western lands be admitted as slave territories, or it would secede from the Union. In early 1850, a settlement was crafted between North and South to deter dissolution. Part of the compromise was the enactment of the Fugitive Slave Act, a federal law permitting southern owners to reclaim runaway slaves in northern states. It subjected any person aiding, harboring, or obstructing the arrest of a fugitive to a fine or imprisonment. The "lively curiosity" of the black figures at the door in Woodville's painting offers a subtext of a broader concern

African Americans had about their future in the rapidly changing nation. Yet, as they stand listening from the distant threshold that demarcates the boundary between white and black realms, they seem to have little voice in either domestic or political discourse.[86]

The theme of a servant's careful vigilance appears in an earlier painting by George W. Flagg, *The Chess Players—Check Mate* (1836, plate 5). It reveals the dynamics of power within antebellum society as they were being played out in the microcosm of the home. Flagg constructed a triangular composition, forming the base with the figures of a woman and a man who are seated at a chess board. Their attractive youthfulness suggests they are a courting couple, finely attired for the game of romance as well as chess. At center stands a black serving woman, who leans forward and steadies crystal goblets and a decanter full of wine on a tray. Her figure forms the apex of the compositional pyramid, but hers is not the position of strength. Her inclined head and intense, sidelong glance shifts the viewer's focus to the young man, who, with a slight frown and chin in hand, contemplates his predicament. His opponent, who supposedly has announced checkmate, also studies his face. Though she believes she has cornered his king, she waits for him to verify her victory while she anxiously fidgets with coral beads. Both women seem suspended until he either makes a move or signals the end of the game by acquiescing.

The painting suggests the dual caste system that was pervasive in the nineteenth century, especially in the South—a hierarchy that privileged white over black, male over female.[87] Flagg spent most of his childhood in Charleston, South Carolina, where, as the son of a prosperous attorney, he gained an understanding of the relationships between white families and their black servants and slaves.[88] His observations come into play in this carefully balanced portrayal. He does not indicate to whom the maid is in service. If, indeed, a marriage proposal is in the offing, the black woman's future will change dramatically—whether by the acquisition of a new mistress or through mandatory relocation to another residence as the bride's personal attendant. Like the wary servant in Woodville's *Card Players* or the anxious group at the door in his *Old '76 and Young '48,* the maid closely watches the white figures before her. Her intense look implies devoted attention, but it also hints at a deeper investment in the outcome of this important match.

Another South Carolinian, Mary Chesnut, confided in her diary her wonder at the blank expressions of her house servants during the bombing of Fort Sumter in 1861. Despite the thundering of guns night and day, they appeared undisturbed. "Not by one word or look can we detect any change in the demeanor of these Negro servants," she wrote. "And people talk before them as if they were chairs and tables, and they make no sign. Are they stolidly stupid, or wiser than we are, silent and strong, biding their time." Two years later, when the war's outcome had become inextricably linked with the future of slavery, Chesnut was certain of a

change in the servants' attitudes. Nevertheless, she wrote, "they go about in their black masks, not a ripple or an emotion showing."[89] In composing the expression for the serving maid in *The Chess Players,* Flagg records the quick, knowing glances of understanding or consternation that penetrated the otherwise silent expressions of black domestics. To the oblivious couple at play, however, the resolute maid appears to offer up only refreshment and her own reticent black mask.

The serving woman's face is beautifully rendered, revealing Flagg's talents as a portraitist. Compared with the more idealized faces of the chess players, the domestic's features appear highly individualized, as if she were painted from life. With careful modeling of light and shadow, Flagg emphasizes the soft curve of her cheek, her delicately shaded complexion, her glistening eyes, and the satiny folds of the gray-blue head wrap. This naturalistic representation seems removed from the physical distortions in current stereotypes of African Americans. In defiance of traditional genre conventions, Flagg has positioned the servant at center as an integral part of the painting's narrative and compositional structure. The artist nevertheless communicates the figure's low status.[90] The courting couple ignores her; she is neither seen nor heard, as if she, too, were a chair or table. Like the display of fine furnishings and clothing, she functions as yet another possession—a status symbol for the genteel players. Her subservience could be read as a testimonial to their ability to command respect. Though beautifully rendered, she becomes as much an emblem of obedient servitude as the rough pictograph in Bruff's rebus.

A final, but no less important, function of the slave attendant in Flagg's painting is to serve as a foil for the young white miss. The ingenue is turned in profile to display a Roman nose and brow as well as a meticulously coiffed, oval head. Her neck has been elongated and her shoulders made to slope fashionably downward. An exoticized counterpart, the servant is portrayed in a thick brown cape pinned high at the throat. Her hair and the shape of her head are obscured by the angular head wrap. These heavy garments effectively offset the white muslin dress of the mistress, just as the maid's dark visage is meant to contrast with the mistress's tiny, white face.

## Catalogues of Difference

Flagg was newly returned from European training when he pictured the races side by side in *The Chess Players*. He used the opportunity to display his abilities for human portrayal—a goal that may explain his moving the usually marginalized servant figure to the center. The painting was also an exercise in the study and depiction of racial types.[91] The comparison of physical characteristics provided the framework for early nineteenth-century racial theories that posited the Negro as a

separate species from the Caucasian—a doctrine that gained new momentum after the publication of Charles Darwin's *On the Origin of Species* in 1859. The popular pseudosciences of phrenology and physiognomy, which examined the cranium and face, furthered interest in the comparison of the races. The findings of such studies invariably celebrated the classicized, Anglo-Saxon form as the ideal. Instead of focusing on a set of political and social ideals, Americans increasingly identified themselves in racial and hereditary terms. "The heightened consciousness of what were supposed to be white racial characteristics," writes George Fredrickson, "undoubtedly helped make it easy for many, on both sides of the sectional debate over slavery, to accept a stereotype of the Negro which made him a kind of anti-Caucasian."[92] Flagg's visual catalogue of difference invites comparison between white maiden and black maid. The painting offers an elaborate system of opposites: white and black, classical and exotic, leisure and labor, superiority and subordination.[93]

Such visual matching and comparison is the principal theme of *Her Mistress's Clothes,* painted by Harriet Cany Peale in 1845 (fig. 4-13). The small panel pictures a blond teenager who plays dress-up with her young black servant. The latter has been clothed in a deep-yellow gown and adorned with a full suite of gold-mounted cameo jewelry—earrings, necklace, belt, and arm band. To complete the transformation, the young mistress has braided and curled the girl's hair into high style. Pleased with the effect, she directs her servant's gaze toward a dressing-table mirror. The little maid looks at herself with a small, self-satisfied grin.

Peale's vision of childish play is heavily coded with prevailing concepts of both beauty and power. The artist was sharply attuned to current standards of feminine fashion. Before becoming the second wife of artist Rembrandt Peale (son of Charles Willson Peale), Harriet Cany worked in a fancy-goods business in Philadelphia. She studied painting with her future husband and, after their marriage in 1840, became his chief copyist, producing facsimiles of his work for sale.[94] In an 1847 letter, the artist chats about clothing styles with her husband's niece in Cincinnati. Describing several recent modes, she adds, "Gay plaids are universally worn for dresses,—by all ages from 5 to 50 years—with plaid scarves for the Neck."[95] It is likely that the artist enlisted her knowledge of fashionable detail in choosing the costumes for the painting's two figures.

The mistress is dressed simply in white with a plaid neck scarf—the accessory Peale later promoted. The kerchief could have been fashioned from the black child's own madras head wrap, handed over in an exchange of clothing. By contrast, the servant is elaborately outfitted in ballroom regalia. In 1845, however, an amused audience would have known that her empire-style costume was hopelessly outmoded. The high-waisted gown and cameo ensemble, characteristic of the neoclassicism of the 1810s, is something that could have come from an attic trunk. Nevertheless,

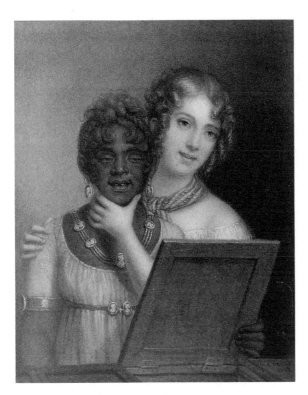

Fig. 4-13. Harriet Cany Peale (1800–1869), *Her Mistress's Clothes*, 1845, oil on tin, $10\frac{1}{8} \times 8\frac{1}{4}$ in. (25.7 × 21 cm). Courtesy Robert M. Hicklin, Jr., Inc., Spartanburg, South Carolina.

the naive servant seems to enjoy the finery. Her pleased expression calls to mind earlier cartoons and essays that ridiculed the elegant clothing and manners of the free black population in Philadelphia. In 1830, John Watson denounced the "aspirings and little vanities" of the city's "dandy *colour'd* beaux and belles" in their "display and vainglory—fondly imitating the whites."[96]

Peale produced her painting at a time of elevated racial tension in Philadelphia. In 1842, when black citizens formed a parade to celebrate Jamaican Emancipation Day, the participants were violently assaulted by white mobs—formed mostly of Irish workmen. The attack incited the destruction of black homes and churches and was followed by several days of terror during which African Americans appearing on the streets were harassed and beaten. Responding to the worst series of race riots in the city's history, the council passed ordinances limiting black assembly. While maintaining the largest population of free blacks of any northern city before the Civil War, Philadelphia gained a reputation for being one of the most restrictive. "There is not perhaps anywhere to be found a city in which prejudice against color is more rampant," asserted Frederick Douglass. "Hence all the incidents of caste are to be seen there in perfection."[97] A local audience having grown

uneasy with its large black community might have found Peale's portrayal of a domesticated African American reassuring.

The painting's most striking element is the strange positioning of the two figures. Handling the black girl as if she were a life-sized doll, the mistress controls her appearance and manipulates her movements. From behind, she grips the maid under the chin, her hand showing starkly white against the other's dark throat. The servant's smile dispels the odd visual effect that she is being strangled. Peale also produced an inadvertent allusion to black captivity by draping the servant in a chain of golden cameos. The necklace and wide arm band, as well as the tight grasp of the mistress, bolster the impression of white dominance and control.

African American females—whether northern or southern—were limited by more than political constraints; they were also circumscribed by prevailing notions of femininity and beauty. Doubly despised for their color and working-class status, black women found themselves exempt from the nineteenth-century glorification of true womanhood. "That man over there says that women need to be helped into carriages, and lifted over ditches, and to have the best place everywhere," stated abolitionist and former slave Sojourner Truth, in an address to the Ohio Woman's Rights Convention in 1851. "Nobody ever helps me into carriages, or over mud-puddles, or gives me any best place! And ain't I a woman?"[98] In wearing the cameos, the servant in Peale's painting bears the weight of ten classically formed, white female heads against her brown skin. The images are not unlike the idealized girl next to her.

When contemplating the question of beauty, Harriet Peale likely referred to *Portfolio of an Artist,* the small anthology of poems and short essays published by her husband the year before their marriage. The book quotes Joseph Addison's observation that "Nature has laid out all her art in beautifying the face; she has touched it with vermilion, planted in it a double row of ivory, made it the seat of smiles and blushes, lighted it up and enlivened it with the brightness of the eyes." Addison warned that "when we load it with a pile of super-numerary ornaments, we destroy the symmetry of the human figure, and foolishly contrive to call off the eye from great and real beauties, to childish gee-gaws, ribands, and bone lace." Another of the book's passages, "Beauty," offers a reflection by Samuel Johnson:

> The bloom and softness of the female sex are not to be expected among the lower classes of life, whose faces are exposed to the rudeness of the climate, and whose features are sometimes contracted by want, and sometimes hardened by blasts. Supreme beauty is seldom found in cottages, workshops, even where no real hardships are suffered. To expand the human face to its full perfection, it seems necessary that the mind should co-operate by placidness of content, or consciousness of superiority.[99]

In *Her Mistress's Clothes,* Peale has orchestrated an easy, lopsided contest. The blond girl is presented as a natural beauty who has no need for "super-numerary ornaments." She has been given classical features, rosy cheeks and lips, pearly teeth, and sparkling eyes. In her "full perfection," she is an Anglo-Saxon icon. The black figure, on the other hand, shows a complexion devoid of any rosiness; even the whites of her eyes have been made a dull brown. The artist has given her a slow, heavy-lidded expression. So there is no question on the part of the viewer whether the worker's enhanced appearance compares favorably with her white counterpart, Peale has blacked out one of her front teeth. The servant is the proverbial sow's ear that cannot be made into a silk purse. As such, she becomes the object of the audience's fun, as well as that of the controlling young mistress.

## Uncle Tom's Cabin

Codification of racial difference was presented in its most literary form in 1852 when Harriet Beecher Stowe published her two-volume novel, *Uncle Tom's Cabin; or, Life among the Lowly.* A regular contributor of domestic stories and household advice, Stowe gained immediate, international celebrity when she produced her tale of Uncle Tom, the fatally submissive house slave. In the language of romantic racialism, she constructed one of the most indelible characterizations of the "suffering Negro" who passively complies as his white owners determine his fate. Uncle Tom is a powerful martyr figure whose Christian principles of love, self-sacrifice, and forgiveness are unwavering in the face of many trials. He allows himself to be sold by his original master for the sake of other slaves, including his wife and children. When his next master, Augustine St. Clare, dies just before freeing the good man, Tom is sold to a cruel plantation owner who has no patience for the slave's religious convictions. When Tom refuses to reveal the escape plans of two slave women, he is fatally beaten, all the while praying to God that his murderous owner be forgiven. Stowe's novel underscores the slaves' lack of personal, legal, and political power. It also depicts house servants covertly listening as they move about their masters' homes to keep abreast of upcoming changes. On learning news that will affect their fates, they respond with Tom's resigned acceptance or, as in the story's alternate subplots, flee at their own mortal risk.

The writing of *Uncle Tom's Cabin* was inspired by the enactment of the Fugitive Slave Act in 1850, the law that legalized the hunting and capture of runaway slaves in the North. Stowe's book aroused enormous indignation among Americans who before had not been involved in abolitionist efforts. *Uncle Tom's Cabin,* which eventually became the most widely read novel in nineteenth-century America, had a significant effect on the rise of antislavery sentiment. Abraham Lincoln was re-

ported to have made the half-joking observation to the author that her sensational novel had precipitated the Civil War.[100]

Although the book proved to be an effective indictment of chattel slavery, it also gave vivid life to gross stereotypes of African American roles and behavior. The heroic yet pacifistic character of Uncle Tom fed prevailing notions of black docility and natural servility. Stowe also created the mischievous slave urchin, Topsy, as an experimental pet to be trained and controlled by her white mistress, Miss Ophelia. The cunning black child was presented as the dark opposite of the angelic white Eva St. Clare. In a literary passage echoing the earlier visual dichotomies of George Flagg and Harriet Cany Peale, Stowe contrasts Topsy and Eva as "representatives of their races."[101] As noted in the previous chapter, Lilly Martin Spencer may have had this text in mind when she produced her painting *Dixie's Land* (fig. 3-17) in 1862. Within a short period of time, excerpts and theater dramatizations reduced the characters in *Uncle Tom's Cabin* to the well-known archetypes that prevailed into the twentieth century.[102]

## *Dinah in the Kitchen*

If the dominant stereotype for the Irish maidservant was Bridget, the black female domestic was typecast as three stock characters: Dinah, Auntie, and Mammy. These general and often interchangeable roles were defined and developed at mid-century. Along with the male characters of Uncle Tom and Jim Crow, these fanciful personalities were packaged and widely diffused through the theater, the popular press, advertising, sheet music, and, eventually, phonograph recordings and film.[103] They remained dominant for more than a hundred years in American popular culture.

Dinah was most regularly identified as Bridget's counterpart. Unlike the Irish maid, however, she was typically associated with food: its preparation, dispersal, and enjoyment. The character is fully treated in *Uncle Tom's Cabin* as "Old Dinah, the head cook" for the St. Clare family. Stowe's lengthy description helped crystallize the stereotype that would long typify black cooks in both northern and southern kitchens. On her best days, Stowe writes, Dinah would "dress herself up in a smart dress, clean apron, and high, brilliant Madras turban." Her culinary skills were "native and essential . . . cooking being an indigenous talent of the African race." Dinah was an authoritative, self-taught worker who was "positive, opinionated, and erratic, to the last degree." In the kitchen she ruled supreme, and although her methods were "meandering and circuitous," there were seldom any failures in their end results.[104]

In an 1856 article outlining his travels in Virginia, the author writing under the name "Porte Crayon" also portrayed the cook as a plump black woman adorned

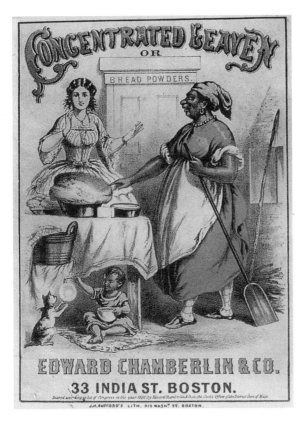

Fig. 4-14. Unknown artist, *Concentrated Leaven,* trade-card advertisement for Edward Chamberlin and Company, 1860, lithograph, published by John H. Bufford, Boston. Collection of The New-York Historical Society.

with a plaid head wrap and voluminous white apron. In written text and the accompanying illustration, she is depicted as one "who has grown sleek and fat on the steam of her own genius, whose children have the first dip in all the gravies, the exclusive right to all livers and gizzards, not to mention breasts of fried chickens—[and] who brazens her mistress, boxes her scullions, and scalds the dogs."[105] Not just a southern manifestation, Dinah became a regular feature in widespread advertisements for baking supplies. A trade card advertising "Concentrated Leaven" for Edward Chamberlin and Company of Boston (1860, fig. 4-14) presents her in all her blowsy extremes. Huge, gregarious, and with exaggerated facial features, she points out the successful outcome of the company's baking powder to her slender white mistress. Productive and strong, Dinah was often pitted against her genteel mistress as her dark and sometimes irascible opposite.

In the second half of the century, the Dinah character was toned down and transformed into a less threatening, jolly persona who exhibited the more submissive, obliging qualities of an Auntie. First appearing in the late eighteenth century, the "Aunt" or "Auntie" epithet was used to describe an elderly or mature black

woman. The appellation, like "Uncle," became a term that replaced titles of respect like "Miss" and "Mrs." or supplanted a person's name altogether.[106] Black maids-of-all-work, nurses, and cooks were so addressed, but it was the fictional Aunt Jemimah who became best known. In the tradition of Dinah, Aunt Jemimah was associated with cooking for and serving whites, and she was typically pictured in a red bandanna and white apron.[107]

The combination of apron and head wrap became the standard uniform for nearly all representations of black female servants—not to mention mature black women in general—in the decades following the 1850s. Although there are also images of white workers wearing kerchiefs and aprons (figs. 1-2, 3-5, 4-5), the attire—especially the head wrap—became a signifying emblem for Dinah, Auntie, and Mammy. Eugene Genovese calls it "a curious historical irony" that the head wrap lost its original, ethnic significance as it was transformed into a distinct badge of black servility. The label "handkerchief head," like "Uncle Tom" and "Aunt Jemimah," became a derogatory epithet signifying servitude and submissiveness in the twentieth century. "Yet originally," Genovese asserts, "nothing so clearly signified African origins and personal pride" as the wearing of the head wrap. The custom originated in West Africa, where headgear not only facilitated the conveyance of bundles but, on ceremonial occasions, also played a symbolic role. In some instances, the color, fabric, and way in which the headgear was tied conveyed information about the work or status of the wearer. Sustained in the American slave culture, the more elaborate modes of tying and wrapping survived in regions where slaves were least Anglicized, such as the Caribbean and the Carolina low countries.[108] In his individualized representation (plate 5), George Flagg rendered the attendant's bandanna with all its intricate twists and pleating—the significance of which is lost to the modern viewer. Most artists, however, portrayed the head wraps as simply tied scraps of cloth. They rarely missed an opportunity to picture them in bright calico, stripes, or plaid in order to provide their paintings with a colorful and somewhat exotic touch.[109]

An early image of the stereotypical black cook appears in Francis Edmonds's genre painting *The Bashful Cousin,* of about 1842 (fig. 4-15). The scene is based on a popular story by James Kirke Paulding, *The Dutchman's Fireside* (1831), which relates the tale of a courtship in upstate New York between a shy bachelor and a young woman whose ambitious mother promotes the match. In a humble interior, the maiden invites the visiting cousin to be seated, while her mother prods her husband to pay attention to the hesitant suitor. True to Paulding's novel, the group is attended by Aunt Nauntje, whose shadowy figure is seen through an open passageway as she makes her way across the hall with a platter full of food. In the story, the spunky black cook has a great deal of power in the Albany household. The despotic "African queen," Paulding writes, has an authority in the kitchen

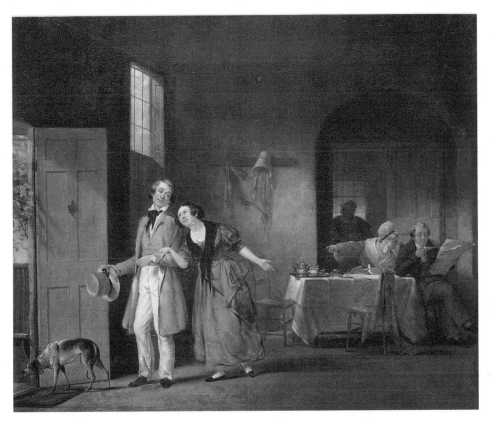

Fig. 4-15. Francis W. Edmonds (1806–1863), *The Bashful Cousin*, ca. 1842, oil on canvas, 25 × 30 in. (63.6 × 76.1 cm). © Board of Trustees, National Gallery of Art, Washington, D.C.; gift of Frederick Sturges, Jr.

"paramount to the mistress of the establishment and all other persons." On occasion, she chases her master out of her domain with a gridiron and toasting fork.[110] Edmonds's Aunt Nauntje, however, is subdued and contained. On canvas, she plays an insignificant role, a literal shadow of the written character. Backlit by a distant window, the servant's silhouette is framed by several rectangles: the window and its grid of panes behind her, the kitchen doorway in which she stands, and the large archway into the greatroom before her. On close inspection, one can just make out her bib apron with its white straps and the red kerchief drawn tightly across the forehead. Her plump form, located directly behind her mistress, is held in place visually by that woman's long, outstretched arm.

Several years later, Edmonds brought the image of the black cook to the foreground as a principal figure in *Devotion* (1857, plate 6).[111] The artist pictures an el-

derly, infirm man slumped in his bedroom armchair. The room's furnishings, the large cooking hearth in the back room, and the man's costume all place the narrative in the eighteenth century. A tripod table nearby holds a teapot, a blue-and-white porcelain cup, and a large brass bell that he rings for service. The cook is in attendance, standing before her aged master with a bowl of steaming broth. She blows gently to cool each spoonful as she feeds him. Old and bent herself, she is depicted in dark clothing, white scarf and apron, and a striped bandanna knotted over her right ear.

The maidservant performs her duties with the loyalty and care of an old retainer. Her nurturing gestures match those of Aunt Betty, described by William Meade in his *Sketches of Old Virginia Family Servants,* published in Philadelphia in 1847. "For twelve years," the author wrote, a devoted house slave named Betty Brown "fed her mistress with a neatness and attention which could not be surpassed. . . . and such confidence had the dear old lady in her, that she preferred being fed by her, even when her affectionate children were sitting beside her."[112] The writer, an Episcopal bishop, related this and other stories to illustrate the deep affection black "servants" maintained toward their white owners. Although Edmonds's painting and Meade's narrative suited contemporary rhetoric concerning faithful and contented blacks, such representations flew in the face of mounting antislavery arguments that stressed the cruelty of the institution. Abolitionists questioned the degree of devotion African Americans could sustain for the very people who kept them in bondage.

By 1857, the carefully crafted Compromise of 1850 had fallen apart after the Kansas-Nebraska bill opened up most of the Louisiana Purchase territory to slavery. The year before Edmonds painted *Devotion,* John Brown killed five proslavery adherents in Kansas, and in March 1857, the Supreme Court handed down judgment in the Dred Scott case, declaring that black persons, as noncitizens, had no constitutional rights.[113] In the midst of escalating anxieties over the slavery issue, an image like *Devotion* could have become politicized. Edmonds hedged against potential controversy by setting his genre scene in the distant past, a time when slavery was practiced in all the colonies.[114]

## Mammy

Edmonds's devoted cook conforms generally to the stereotypes of Dinah and Auntie. However, the figure also connotes ever-nurturing Mammy, the female servant who cares for and nurses white children or, in this case, a doddering old man. The name "Mammy," a variation of "Mamma," came into use in the eighteenth century as a term of endearment for older, black nursemaids. It gained currency in southern

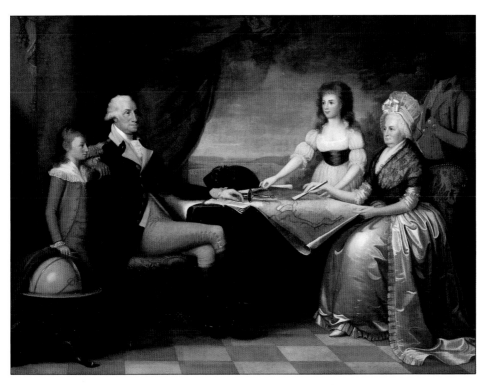

Plate 1. Edward Savage (1761–1817), *The Washington Family,* 1789–1796, oil on canvas, $84\frac{1}{8} \times 111\frac{7}{8}$ in. (213.6 × 284.2 cm). © Board of Trustees, National Gallery of Art, Washington, D.C.; Andrew W. Mellon Collection.

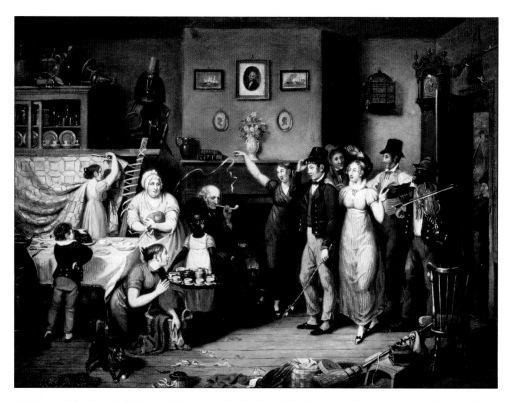

Plate 2. John Lewis Krimmel (1786–1821), *Quilting Frolic*, 1813, oil on canvas, $16\frac{7}{8} \times 22\frac{3}{8}$ in. (42.9 × 56.8 cm). Courtesy Winterthur Museum.

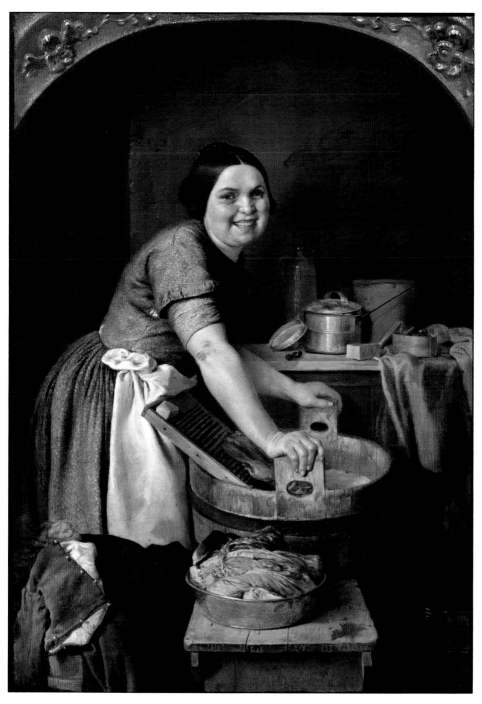

Plate 3. Lilly Martin Spencer (1822–1902), *The Jolly Washerwoman,* 1851, oil on canvas, $24\frac{1}{2}$ × $17\frac{1}{2}$ in. (62.2 × 44.5 cm). Hood Museum of Art, Dartmouth College, Hanover, New Hampshire; purchased through a gift of Florence B. Moore in memory of her husband, Lansing P. Moore, Class of 1937.

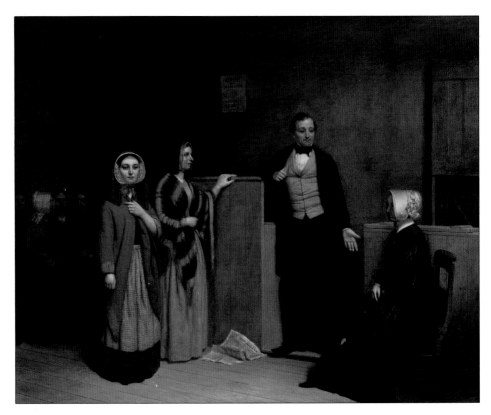

Plate 4. William Henry Burr (1819–1908), *The Intelligence Office,* 1849, oil on canvas, 22 × 27 in. (55.9 × 68.6 cm). Collection of The New-York Historical Society.

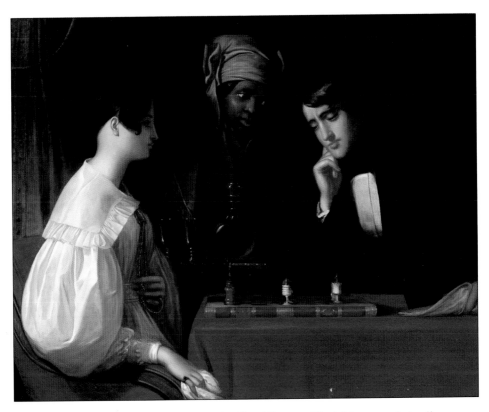

Plate 5. George W. Flagg (1816–1897), *The Chess Players—Check Mate,* ca. 1836, oil on canvas, 43¾ × 56 in. (111.1 × 142.2 cm). Collection of The New-York Historical Society.

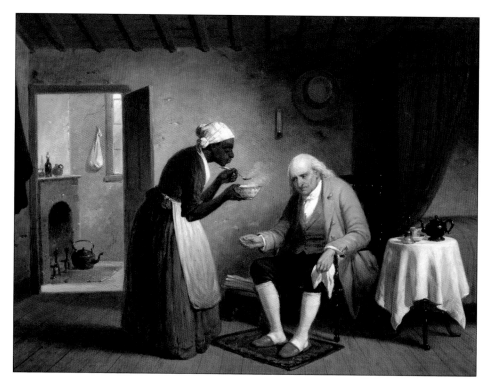

Plate 6. Francis W. Edmonds (1806–1863), *Devotion*, 1857, oil on canvas, $20\frac{1}{4} \times 24$ in. (51.4 × 61 cm). Godel and Company Fine Art, New York.

Plate 7. Edwin H. Blashfield (1848–1936), *Waterloo: Total Defeat,* 1882, oil on canvas,
20 × 15 in. (50.8 × 38.1 cm). Edward Wilson, Fund for Fine Arts, Chevy Chase, Maryland.

Plate 8. William McGregor Paxton (1869–1941), *The Kitchen Maid,* 1907, oil on canvas, $27\frac{1}{4} \times 22\frac{1}{4}$ in. (69.2 × 56.5 cm). Private collection; photograph courtesy Berry-Hill Galleries, Inc., New York.

regions in the early 1800s and, by mid-century, was used to describe black care providers in all regions. Mammy became the most pervasive of the stereotypes of African American servants. A mainstay for antebellum and reconstruction novels, her characteristics remained constant: she was fat and sexless, though with large breasts, and her head was always covered with a kerchief. Like Dinah, she was fiercely independent but ultimately kind and loyal. And she loved her white charges dearly.[115]

Typically, when a young slave girl showed an aptitude for minding the mistress's baby, she would remain in that position indefinitely to nurse all subsequent children. When the eldest daughter had children, the servant was often required to tend the next generation as well. Recounting the history of his own nursemaid, William Meade wrote, "She was my mother's nurse, then mine; and all my brothers and sisters were *her children;* and my own children have been in her arms, and shared her love." He described the Mammy's place in the household: "Next to 'Mamma,' she is the dearest to the infant; and the confiding love of the baby, in almost all instances, grows with its growth."[116] Mammy, eternal mother to scores of white children, was rarely described as having offspring of her own—a convenient perception that dispelled worry over divided loyalties. However, many slave nurses did indeed have their own children. Tending them in early morning or late at night, the workers had to leave them in another's care or alone while they served the master's children. Harriet Beecher Stowe touched on the myth of the childless Mammy in *Uncle Tom's Cabin* when she related that Eva's nurse developed her streak of "obstinacy" out of grief over being separated from her own infants. Although tired and ill, this Mammy was nevertheless portrayed as totally devoted to her little white charge: "She hugged her, and laughed, and cried, till her sanity was a thing to be doubted of."[117]

The author of *Uncle Tom's Cabin* constructed a deep, loving relationship between Eva and the enslaved house servants. The child enthusiastically embraces and kisses them—especially Mammy. Such mutual regard, however, was rarely translated into painted images. The formula of black Mammy and white child that predominated in paintings and photography long into the twentieth century typically depicts a child who, seated on the lap of its nurse, faces out and away. The guardian sometimes bends near to give the infant or toddler a caring look, but the child usually appears oblivious.

James Cameron employed this traditional mode of representation in his large group portrait *Colonel and Mrs. James A. Whiteside, Son Charles, and Servants* (ca. 1858–1859, fig. 4-16). Cameron studied art in Philadelphia and, briefly, in Italy. He journeyed to Nashville in 1850 in search of portrait commissions. There, he met James Whiteside, attorney, railroad businessman, and former mayor of Chattanooga. With Whiteside's encouragement, the artist relocated to that small but

Fig. 4-16. James Cameron (1817–1882), *Colonel and Mrs. James A. Whiteside, Son Charles, and Servants,* ca. 1858–1859, oil on canvas, 53 × 75 in. (134.6 × 190.5 cm). Hunter Museum of American Art, Chattanooga, Tennessee; gift of Mr. and Mrs. Thomas B. Whiteside.

growing city, where he successfully established a studio. The family portrait may have been produced as a token of appreciation to his wealthy benefactor.[118] It depicts the fifty-five-year-old Whiteside holding a book and pointing to a letter inscribed to the artist. Seated across from him at the marbletop table is his wife, Harriet, who pauses from her embroidery to meet her husband's gaze. When she sat for Cameron's portrait at age thirty-four, she had recently given birth to her ninth and last child.[119] A young slave boy enters from the left with two silver goblets on a tray. In the foreground at right is the family nurse, Jane, who holds one-year-old Charles on her lap. The young, light-skinned woman sits on the tiled floor, her dark dress forming an island around the baby's white form. She inclines her turbaned head to watch his face.

The painting's grand Italianate portico, with which Cameron obviously had some perspective problems, is imaginary.[120] The artist placed it on the northern brow of Lookout Mountain, overlooking Moccasin Bend on the Tennessee River and Chattanooga, which is seen in the distance at right. Although Whiteside's principal residence was located in the town below, he owned several acres along

this scenic mountain promontory. The entrepreneur planned to develop the property into a summer resort and had already begun to build a hotel there in the late 1850s. A propertied businessman, slave owner, and ardent secessionist, Whiteside celebrated the bombardment of Fort Sumter by lighting bonfires before his newly finished hotel in the months following the completion of Cameron's portrait. The Colonel died suddenly in 1861 and did not live to see the outcome of the southern secession. Cameron was compelled to abandon his studio and return to Philadelphia as war ensued. When Chattanooga fell to Union forces in late 1863, Harriet Whiteside was arrested as a Confederate sympathizer and deported to a northern stockade prison for the duration. The determined widow returned at war's end to complete her husband's enterprises on Lookout Mountain.[121]

As Cameron painted the Whitesides and their black house servants, the nation was on the brink of dissolving into warring slave and nonslave factions. Slavery was an important economic institution in Tennessee, with slaves representing one-third of the state's taxable property. In response to increasing abolitionist pressure and in the face of rising fears of slave revolt following John Brown's raid on Harpers Ferry, the Tennessee legislature enacted harsh restrictions on African Americans in 1859. Free blacks were forced either to leave the state or to face reenslavement.[122] Within this framework, Cameron's painting becomes a visual document not just of the family's social and cultural aspirations but also of their regional and ideological loyalties. The Whitesides are attended by well-dressed house slaves who subserviently perform their duties in their lavish, imaginary mansion. Of all the figures, only baby Charles looks out to engage the viewer. His contented gaze seems to imply a sense of security and, perhaps, entitlement to a continuing legacy of wealth and comfort provided by dark hands.

The kind of social distance implied visually by the white child's focus away from his nurse was not limited to the South. Writing in 1851 from Lenox, Massachusetts, Nathaniel Hawthorne described his impressions of the relationship between his five-year-old son, Julian, and the family's black cook and housekeeper:

> I ought to mention that Mrs. Peters is quite attentive to him, in her grim way. To-day, for instance, we found two ribbons on his straw hat, which must have been her sewing on. She encourages no familiarity on his part, nor is he in the least drawn towards her; nor on the other hand, does he exactly seem to stand in awe; but he recognizes that there is to be no communication beyond the inevitable—and, with that understanding, she awards him with all substantial kindness.[123]

In contrast, the infant pictured in *A Window, House on Hudson River*, by Worthington Whittredge (1863, fig. 4-17), has yet to be inculcated with such "inevitable" social or racial boundaries. In the setting of a richly furnished parlor,

Fig. 4-17. Thomas Worthington Whittredge (1820–1910), *A Window, House on Hudson River,* 1863, oil on canvas, 27 × 19½ in. (68.6 × 49.5 cm). Collection of The New-York Historical Society; on permanent loan from the New York Public Library.

Whittredge portrays a black nurse lifting a white baby above her lap. She is seated on a bench in a large bay window that frames a distant view of the Hudson River. Sunlight streams in the open casement to bathe the room with an airy, amber glow. Nurse and child are engrossed in face-to-face play, and the infant reaches toward its surrogate mother. The black care provider wears the conventional dark dress with white neck scarf and red head wrap. In this unusual composition, she is not relegated to the margins of the family space; rather, the nurse is free to enjoy the lush comfort in the heart of the parlor, the grand vista, and the child in her arms. The two are nearly encapsulated by the sunlit, transparent lace curtains and appear much like the objets d'art under bell jars shown on boullework pedestals on either side of the window. There are no hints in this peaceful and sheltered place of the political and mortal struggles being waged on the battlefields to the south.

According to his memoirs, Whittredge began his painting career in the home of Henry Ward Beecher, abolitionist and brother to Harriet Beecher Stowe. The artist had known Henry Beecher while growing up near Cincinnati and was taken in by

the young minister when he fell ill in 1839. During his year-long recuperation, Whittredge began to paint likenesses of the Beecher family members, including his host's soon-to-be-famous sister. He later recalled that during his stay, "slavery was one of the principal subjects discussed" in the household. Years later, moved by sympathy for the Union cause, the forty-one-year-old painter tried unsuccessfully to enlist in the federal army.[124]

As Whittredge followed the course of the Civil War from New York, he produced a series of quiet domestic scenes, among them *A Window, House on Hudson River* in 1863. The painter must have considered the symbolic implications of juxtaposing the black figure against the large, open window. Lincoln had issued the Emancipation Proclamation the preceding January, signaling a historic transition for the majority of African Americans—albeit a transition that depended on the outcome of the war. Though the nursemaid in the painting appears to have relative freedom of action and movement within her employer's home, the widely opened bay window implies the promise of a greater, more expansive freedom.

The symbolic threshold between enslavement and freedom was very real for someone like Harriet Jacobs, whose *Incidents in the Life of a Slave Girl Written by Herself* (1861) was published shortly before Whittredge began his painting. Under the pseudonym "Linda Brent," Jacobs penned the account of her escape from slavery. As a young mother in North Carolina, the author had been forced to choose between submitting sexually to her despised owner or witnessing the sale of her children. Instead, she ran away. After hiding for several years in the small crawl-space above her grandmother's porch, she eventually made her way north with the help of the Underground Railroad. Jacobs, like many other fugitives, found refuge and anonymity as a house servant in a northern home. She was hired as nursemaid to the infant daughter of writer and magazine editor Nathaniel Parker Willis and his wife, Mary Stace Willis. Later, the widower and his second spouse, Cornelia Grinnell, retained Jacobs to care for their new infants. When Jacobs's owners discovered her whereabouts in 1852, Cornelia Willis procured her servant's freedom by paying off the North Carolina family. Afterward, Jacobs wrote her memoirs "at irregular intervals, whenever I could snatch an hour from household duties." At the time of their publication, she remained in service to the family, which was then residing at Idlewild, their spacious new country home overlooking the river in Cornwall-on-the-Hudson.[125]

Whittredge may have known Willis through mutual friends connected with the Century Association, a club of prominent New York writers and artists.[126] Whether the painter had read Jacobs's powerful account or was aware of her precarious and dangerous story is unknown. The elegant interior in *A Window, House on the Hudson* is quite similar in orientation, design, and style to the drawing room at Idlewild. Both had large bay windows and river vistas. However, the scene was

likely modeled on the Louisa Nevins residence in Riverside, New York. The figure of the nurse in the painting, moreover, has a darker complexion than did the light-skinned Jacobs.[127] Nevertheless, Whittredge's painting might easily have been inspired by the tale of the slave nurse who found a safe and comfortable haven on the Hudson River. It could have reminded a contemporary audience of the hundreds of African American fugitives who took shelter in northern homes and who eagerly awaited a successful outcome of the war.

## Visits: The Old Nurse and the Old Mistress

On February 1, 1865, only weeks before the South's surrender at Appomattox, Congress approved the Thirteenth Amendment to the U.S. Constitution, declaring, "Neither slavery nor involuntary servitude, except as a punishment for crime, whereof the party shall have been duly convicted, shall exist within the United States, or any place subject to their jurisdiction." So ended the 250-year history of legalized chattel slavery and bound servitude in America. Freedom, however, did not necessarily mean immediate citizenship for African Americans. Following the end of the war, the South enacted a series of Black Codes, which barred Negroes from voting and holding office. The Radical Republican Congress responded with the Reconstruction Act of 1867, dividing the South into federally controlled military districts. Southern states would not be readmitted to the Union until they ratified the Fourteenth and Fifteenth amendments—those granting citizenship and suffrage rights to African Americans.[128]

Ironically, Congress attempted to impose black enfranchisement on the South but did not enact the same laws in the free states. African Americans in the North continued to be subjected to a highly discriminatory and segregated social system. As historian C. Vann Woodward notes, "One of the strangest things about the career of [the segregationist practices of] Jim Crow was that the system was born in the North and reached an advanced age before moving South in force."[129] The tough federal position against the South eroded by the early 1870s, under the influence of a Liberal Republican faction that supported local self-government and reconciliation with the former Confederate states. Reconstruction officially ended with a compromise in 1877: southern lawmakers promised to respect the rights of black people in return for the final withdrawal of federal troops and the reestablishment of home rule. Racial issues drew less attention as the government grappled with a serious depression in 1873, growing northern industrialism, and the development of the West. Individual states regained autonomy—a move that eventually resulted in the mass disenfranchisement and strict segregation of black citizens under the infamous Jim Crow laws of the 1890s.[130]

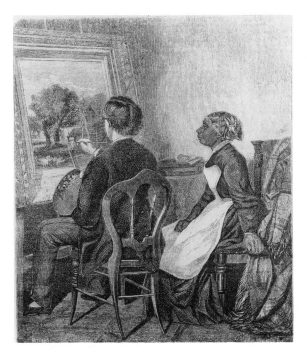

Fig. 4-18. Thomas Hovenden (1840–1895), *The Old Nurse's Visit*, 1872, engraving, $6\frac{15}{16}$ × $6\frac{1}{16}$ in. (17.6 × 15.4 cm), published in *American Agriculturalist* (January 1873): 28. Courtesy American Antiquarian Society.

From the turmoil created by the failure of Reconstruction and the long, ensuing debate over the abilities of emancipated slaves, there emerged a resurgence of the concept that black people were childlike and in need of white benevolence and supervision. Writers began to romanticize the paternalistic aspect of the antebellum slave regime, and artists responded with what black-history scholar Alain Locke has described as a "cotton-patch and cabin-quarters formula" of Uncle Tom, Auntie, and Mammy images—representations that grew even more sentimental by the century's end.[131]

*The Old Nurse's Visit,* by Thomas Hovenden, is one of the earliest postwar paintings to romanticize the loyalty of an old black family retainer. The location of the canvas, exhibited at the National Academy in 1872, is presently unknown, but the image survives in an engraving in the *American Agriculturalist* of January 1873 (fig. 4-18). It depicts a landscape painter at his easel who is observed from behind by an elderly, bespectacled black woman. She watches her former charge at work and leans forward with a faint smile. Her clothing—dark dress, white bib apron, and madras head wrap tied low over the forehead—suggests that she is still in service.

Hovenden was a young Irish painter who had immigrated to the United States in the middle of the Civil War. After studying and exhibiting in New York at the National Academy, he settled in Baltimore in 1868. *The Old Nurse's Visit* captured

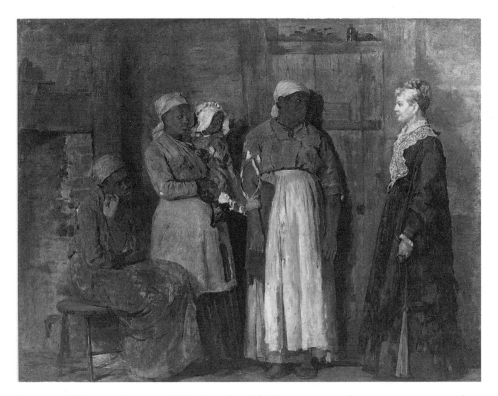

Fig. 4-19. Winslow Homer, *A Visit from the Old Mistress,* 1876, oil on canvas, 18 × 24⅛ in. (45.7 × 61.3 cm). National Museum of American Art, Smithsonian Institution; gift of William T. Evans.

the attention of that city's prominent art collector William T. Walters, whose subsequent support enabled Hovenden to complete his training in France.[132] The painting offers a variation on the studio-visit theme of paintings such as *The Painter's Triumph,* by William Sidney Mount (1838, Pennsylvania Academy of the Fine Arts), but with some important differences. Mount depicts an artist who displays his painting to a visiting farmer. In a good-natured blending of two cultures, the men stand together and exchange comments before the large canvas.[133] The figures in *The Old Nurse's Visit,* however, sit quietly apart. Hovenden's artist almost turns his back on the old care provider and does not seem to be soliciting observations from his visitor's "innocent eye."[134] Nor does the nurse offer comment; she assumes the role of passive spectator.

The interaction between black and white figures in *A Visit from the Old Mistress,* by Winslow Homer (1876, fig. 4-19), is strikingly different from Hovenden's visit and, for that matter, from any of the previous servant or slave representations. Homer's painting was one of several the artist produced following his visits to Pe-

tersburg, Virginia, in the mid-1870s that depict black life in the South.[135] *A Visit from the Old Mistress* is his most direct exploration of the altered relations between newly freed slaves and the white families they once served.

Former slaves experienced the difficult transition from dependence to autonomy after the war. Mary Chesnut's diary relates her own confrontation with the husband of her chambermaid following the southern surrender. After requesting wages for his spouse, the young man reminded her, "White people want a heap of waiting on, you know, ma'am." Chesnut answered, "I do not mean to give her one cent—for the best of all reasons. I have none to give her. You and your child are living in one of our houses free of rent. Ellen can go or stay as she pleases." The maid remained in unpaid service, as did many of Chesnut's other house slaves—"all at home quiet, orderly, respectfull, and at their usual work. There was nothing to show that any one of them had ever seen a Yankee or knew that there was one in existence." The exception was her former steward, Armsted, who had begun a small cobbler's business during the war. In her journal entry, Chesnut fumes over his refusal to return to her service:

> "Missis, when you let me learn to be a shoemaker, I thought I was done with being your house servant! Now you want to take me away from my shoe shop." Mr. Chesnut thought his impudence intolerable, and said he should go with me and resume his place as my butler, when I went to housekeeping in Columbia. I said, "Never! Never! Dissatisfied servants are not to my taste! I hope never to see Armsted's face again in this world!" Next day Armsted sent me a nice pair of shoes as a present. Mr. Chesnut asked: "What did you say to him yesterday?" "I told him he was an ungrateful wretch, and to keep to his trade, and that I had had enough of his disagreeable airs. And that pair of cloth shoes ends the chapter!"[136]

Homer's unusual painting conveys the tense atmosphere of that new chapter in southern race relations. Within a rustic interior, three black women are gathered near a brick hearth. They are dressed in ragged, patched clothing; two wear aprons and all wear light-colored head wraps. At center is a young mother who supports a little girl on her hip. They all gaze in silence at a visitor who stands near the door—an elegantly attired white matron. Homer pictures her in a dark gown— perhaps mourning—adorned with a frothy, white lace jabot. Her shining gray hair has been braided and curled, and she holds the satin ribbon of a large, closed fan that dangles at her side. The "old mistress" faces the group as if anticipating an invitation to be seated. From the black women's closed, unsmiling expressions, it appears that none will be forthcoming. The artist has depicted them in such a way that they form a united—and rather unwelcoming—front.

Working from his Virginia sketches, Homer created fairly naturalistic represen-

tations of African Americans, eschewing the distorted features favored in popular illustration. The image, as well as other oils and watercolors from his Reconstruction series, marks the artist's departure from the gross caricature that he employed in his representations from the previous decade.[137] The difference was noted at the time by George Sheldon, who described Homer's recent Negro studies as being, "in their total freedom from conventionalism and mannerism, in their strong look of life, and in their sensitive feeling for character—the most successful things of the kind that this country has yet produced."[138] *A Visit from the Old Mistress* is not entirely devoid, however, of stereotypical references. Homer invited old associations from his audience by depicting the women as plump, aproned, turbaned, and standing near a cooking hearth. When the painting was exhibited at the National Academy in 1880, a critic for the *Art Journal* described the figures as having a "dim and vague look . . . so patient and passive, and almost like that of dumb brutes." The reviewer goes on to characterize the women as fat, shapeless, and "looking out of the darkness of an old kitchen in a half-pleased and half stupid way."[139] Years later, in 1911, William Howe Downes still recognized in the figures traditional servant types, including a Mammy. He read into them an attitude of deference that would have been expected before a "grande dame" and saw in their faces a "humility of expression and the evident awe which the old mistress inspires."[140]

More recent Homer scholars, however, have consistently and convincingly interpreted the image as an adversarial standoff between the mistress and her former slaves. Certainly, there is little sign of either welcome or deference in the sturdy figures of the black women, who seem to turn as a group to face the visiting matron. Sidney Kaplan and Ellwood Parry have pointed to a similar composition Homer employed in *Prisoners from the Front* of 1866 (Metropolitan Museum of Art). The earlier painting depicts a confrontation between southern military prisoners and the northern officer who holds them captive.[141] In the later domestic scene, Homer replicated the physical and psychological gap between enemy factions. Peter Wood and Karen Dalton point to more obvious evidence within the image itself, noting the defiant gesture of the woman who remains seated near the fireplace: "No longer did a black woman feel obliged to rise from her seat when a white woman entered a room."[142]

In this painting Homer has subverted the long-established conventions of American servant imagery. He creates a subtle but unmistakable sense of a world turned upside down by systematically breaking the old rules of representation through a series of reversals. The woman at left who steadfastly keeps her seat is a telling change from the usual portrayals of dutiful subordinates who stand in readiness near or behind their superiors. Furthermore, despite the sharp contrast between the clothing of the genteel woman and her former slaves, Homer may have

introduced a wry twist by portraying the mistress in black-and-white widow's weeds—a costume that could also be read as pseudolivery. Standing in profile, the elderly woman draws herself up stiff and erect. Yet she is no more awe-inspiring than the dark, solid woman next to her. This imposing figure, whose frontal stance exactly mirrors the old mistress, appears unmovable. Both women are the same height, and their proximity brings them face to face as they stand within the rectangular frame of the doorway. The lintel above and a cross board at shoulder height nearly join the two, but the horizontal bands stop just short of the mistress, emphasizing the small but seemingly impenetrable gap between them.

All the servants meet the woman's eyes with unblinking frankness. Even the toddler has been lifted in order to face the visitor on an equal level. The child's mother is no Mammy tending white youngsters in the big house; rather, she enjoys the freedom of caring for her own baby. Homer has given this woman a wedding ring like the privileged visitor's, as if to imply a shared human condition and to suggest that they share the honorable status of wife and homemaker.[143] In this painting, it is the white visitor who is clearly the outsider. She is the one who is excluded from the extended family's circle. Though not entirely framed by the doorway, she is the one on the edge of physical and social boundaries.[144]

In several ways, then, the artist has unraveled and rearranged the hierarchical vision of the nation's family he created nearly twenty years earlier in *Thanksgiving Day—The Dinner* (fig. 4-1). By breaking with conventional modes of representation, Homer brought the typically marginalized servant figures to the forefront and discarded the old masks of docility. In doing so, he freed himself to explore their humanity.

Homer's image is exceptional among servant representations. His attempt to construct an image of change prompted exploration and inversion of the ways in which household workers had been historically portrayed. His image did not, however, accurately portray the dynamics of power between families and their immigrant and black domestic servants. Even as Homer was exhibiting *A Visit from the Old Mistress,* Reconstruction was ending. The black civil rights that came with emancipation were being systematically reversed. Industrialization that would bring wealth to the nation in the last quarter of the century would also bring an even wider gap between the upper classes and the laboring poor. With the emergence of what economist Thorstein Veblen would describe as the "leisure class," domestics would increasingly serve as conspicuous symbols of a family's monied status.

*Chapter Five*

# Caps and Aprons:
# Picturesque Servility, 1875–1910

In 1897, Lucy Maynard Salmon, professor of economics and history at Vassar College, published the first sociological study of household labor in the United States. While *Domestic Service* primarily addresses the results of her own 1889–1890 survey of employers and employees, it also offers a historical overview of the relationship between the American family and the American servant. Following a discussion of the colonial era, Salmon describes a "democratic condition" that ensued for help in the northern states in the first half of the nineteenth century. However, she goes on to note the widening social chasm that had developed from "changed and changing" political and economic factors in subsequent decades. The professor points to a significant sign of the change:

> Since the introduction of foreign labor at the middle of the century, the word "servant" has again come into general use as applied to white employees, not, however, as a survival of the old colonial word, but as a reintroduction from Europe of a term signifying one who performs so-called menial labor, and it is restricted in its use, except in a legal sense, to persons who perform domestic service. The present use of the word has come not only from the almost exclusive employment of foreigners in domestic service, but also because of the increase of wealth and consequent luxury in this country, the growing class divisions, and the adoption of many European habits of living and thinking and speaking.[1]

With the rapid economic growth that marked the last quarter of the century came an expansion of an urban-based middle class, which, among other things, could

better afford domestic service. Subsequently, the employment of household labor steadily increased, though the supply of workers never matched the seemingly insatiable demand. By the end of the 1870s, one-fourth of all urban and suburban households employed at least one servant.[2] While middle-income families continued to draw from an unskilled, predominantly immigrant and African American labor pool, upper-class households favored large, European-trained staffs. Through the next several decades, a stricter formality, modeled on perceived European practice, defined the working relationship. Servants were increasingly set apart by special uniforms, titles, duties, and stations. As never before in the nineteenth century, an American servant class became clearly visible.

The gap between employer and employee continued to inform the ways in which artists represented servants in painting and graphic media. Depictions of domestic workers conveyed the rising status of a more cosmopolitan upper class, as collectors and painters alike began to embrace European social and artistic conventions. From the 1870s through the early decades of the twentieth century, domestics were portrayed first and foremost as attractive, subservient women. As subjects, they provided artists the opportunity to explore the decorative qualities of the servant uniform and offered another avenue for delineating the female form. Servant imagery also provided additional opportunities for some artists to craft a subtle variation on the ubiquitous motif of the humble but picturesque peasant. An overview of the changing dynamics of late nineteenth-century society is helpful in understanding the significance of the paintings of this period.

## The Gilded Age

In 1873, Mark Twain and Charles Dudley Warner described a nation transformed by industrialization in their satirical novel, *The Gilded Age*. The authors could only begin to anticipate the dramatic changes that would come about over the next twenty-seven years. The novel's title was later appropriated to refer to this entire period—a time in which enormous personal fortunes were amassed alongside rampant unemployment, poverty, and labor unrest. It was an era marked by gilded life-styles, wasteful expenditures, and showy excess. "If the age had a motto," historian Sean Dennis Cashman writes, "it might well be, 'The ayes have it,' not only for the celebrated interest in voting stock, but also for the eyes that rejoiced at the glitter of gold, and the I's that define many of the pervasive social themes." He continues, "society was obsessed with invention, industrialization, incorporation, immigration, and, later, imperialism. It was indulgent of commercial speculation, social ostentation, and political prevarication but was indifferent to the special needs of immigrants and Indians and intolerant of black Americans, labor unions and political dissidents."[3]

Between 1875 and 1900, the nation nearly doubled its population and significantly expanded its domain as it granted statehood to nearly all its interior territories in a push to possess the continent. The exigencies of the Civil War had served to escalate the pace of industrial development and productivity, a trend that continued throughout the postwar decades. The transformation to a market economy instigated a massive movement of rural and foreign workers into the cities to seek employment in factories, foundries, and mills. New technologies, so optimistically celebrated at the 1876 Centennial Exposition, enabled the United States to match the combined manufacturing productivity of Great Britain, France, and Germany by 1890.[4]

Innovations in communication and transportation brought the distant states and territories of the growing nation together, and as society became increasingly urban, many prosperous Americans sought social and cultural connections with Europe. The number of newspapers and magazines more than tripled in the twenty years following the war. Despite economic fluctuations that included two severe depressions, they could report a steady increase in per capita prosperity to their mass audiences. Americans became both fascinated with and alarmed by the well-publicized maneuverings of passionate and sometimes ruthless entrepreneurs who became immensely wealthy through private empires of steel, oil, real estate, and railroads. In 1861, the United States could boast only three millionaires; by 1900, there were more than four thousand.[5]

Not everyone benefited from the rapid economic transition to industrial capitalism. Historian Alan Trachtenberg says of the period that "social contrasts reached a pitch without precedent in American life outside the slave South."[6] The long-held concept that there was "no impassable gulf between the low and the high" was still being perpetuated,[7] but the kinds of opportunities that permitted Andrew Johnson to rise from a tailor's indentured apprentice to become president of the United States or Cornelius "Commodore" Vanderbilt to advance from canal driver to railroad magnate were scarce. Few working-class Americans could experience the rags-to-riches mobility touted in popular literature and political and religious rhetoric. Nearly half of all laborers earned an income below the poverty line of $500 per year, and most experienced regular unemployment in an era troubled by recurring panics. Slums in cities and factory towns multiplied. Tired and disgruntled urban workers—the great majority of them immigrants—struggled with long hours, low wages, and overcrowded housing. Although their labor was crucial to the dramatic increase in productivity, the workers themselves were, for the most part, excluded from the benefits of the unprecedented prosperity.[8]

Working-class anger and frustration manifested itself most visibly in a series of labor strikes—the most violent of which occurred in 1877, 1886, and 1892–1893. These brutal confrontations of laborers with police and federal troops served only

to crystallize for privileged Americans their already negative stereotypes of laborers as dirty, uneducated, and subversive. The prosperous classes, bolstered by new social theories and a growing fear of labor and ethnic unrest, responded by forming a more tightly structured hierarchical society. Americans erected elaborate social barriers to restrict and control what was generally perceived as an alien and dangerous working class.[9]

Under these conditions, it became easier to justify contradictions to traditional republican ideologies of equality and natural rights. Social Darwinism, which swept though the nation in the 1870s and 1880s, provided a popular rationale. The theory, crafted by British philosopher Herbert Spencer, applies the principles of natural selection to social relations. Accordingly, both the ascendance of the powerful and the deterioration of the weak were viewed as logical outcomes of evolution. Each individual, Spencer reasoned, reaped the consequences of his or her own abilities or ignorance: "If they are sufficiently complete to live, they *do* live, and it is well they should live. If they are not sufficiently complete to live, they die, and it is best they should die."[10]

William Graham Sumner, Spencer's foremost American proponent, warned in his publications and lectures that social reform could actually hinder the nation's progress. According to the political science professor, governmental interference with the natural selection process would "burden the good members [of society] and relieve the bad ones" and ultimately "produce the survival of the unfittest."[11] In short, the prosperous classes owed nothing to their subordinates. Sumner asserted that there was no longer room in modern society for the "sentimental relations which once united baron and retainer, master and servant, teacher and pupil, comrade and comrade." The new social structure was based on a contract—"realistic, cold, and matter-of-fact."[12] Differences and conflicts between individuals, races, and nations were viewed as natural to the human condition. Distances between classes, therefore, seemed not only inevitable but inherent to natural order. Such concepts exacerbated the already difficult relations between employers and workers and contributed to a general hardening of the "realistic, cold, and matter-of-fact" contract between families and servants.

## The Stranger in the Home

The prevailing custom of live-in service continued to bring middle- and upper-class families into direct contact with individuals whose language, customs, and religions clearly marked them as outside the white, Anglo-Saxon Protestant mainstream. Some mistresses still approached their supervisory tasks as an extension of their moral duties. With maternal benevolence, they sought to inculcate raw, un-

trained servants with middle-class norms and values—an approach advocated by domestic guidebooks and magazines.[13] Others, like author Harriet Spofford, scoffed at such misguided "champions of the kitchen." In *The Servant Girl Question* of 1881, she argued that sympathy and attention should instead be extended to those who endured "the ignorance, the stupidity, the willfulness, the sloth, which have to be encountered, reasoned with, taught, cajoled, and overcome" in their daily dealings with hired workers.[14] Even those sympathetic to working-class women, such as journalist Helen Campbell, were not without bias. In her 1887 study of female laborers, she noted that most came from tenements, "the breeder of disease and physical degeneration for every inmate." She warned, "Out of these houses come hundreds upon hundreds of our domestic servants, whose influence is upon our children at their most impressible age, and who bring inherited and acquired foulness into our homes and lives."[15] Though Campbell's intentions were to encourage reform in the living conditions of wage-earning women, her apprehensive contemporaries commonly reacted by widening the distance between themselves and the outsiders in their midst.

Accelerated industrialization and trade provided working-class women with more job opportunities in mills, factories, and—to a lesser extent—stores and offices. Still, one-third to one-half of all female wage earners continued to find employment as domestic servants. The choice had less to do with preference than availability. Service continued to be the primary occupational recourse for lower-class, unskilled women and, for some, a last resort when all other possibilities were exhausted. Outside rural and frontier regions, native-born white women continued to eschew service whenever possible. In the years following 1880, progressively larger numbers of immigrants came into the United States, this time from regions in southern and eastern Europe. Many of the new arrivals—Italian and Jewish women, for example—brought along a cultural disdain for service. Therefore, they did little to displace the domination of African American workers in the South, Scandinavians and Germans in the Midwest, and the Irish in the Northeast. These groups were already and inexorably identified with paid household labor.[16]

Salmon, in her 1897 study, listed the "industrial disadvantages" of service—factors, she asserted, that dissuaded intelligent and capable (i.e. native-born white) women from such work. These included the lack of opportunities for promotion, drudgery and mechanical repetition of tasks, long and irregular hours, limited freedom, and "competition with the foreign born and the negro element." From her survey of the domestics themselves, she found that social stigma continued to be the primary drawback:

[The present-day working woman] does not understand why work that society calls the most honorable a woman can do when done in her own home

without remuneration, becomes demeaning when done in the house of an-
other for a fixed compensation, but she recognizes the fact; she sees that dis-
credit comes not from the work itself but from the conditions under which it
is performed, and she does not willingly place herself in these conditions;
she sees that a class line is always drawn as in no other occupation.[17]

Within the Gilded Age household, the "class line" had become obvious in a num-
ber of ways.

## Badges of Social Inferiority

Several strategies were used to keep servants in their social, psychological, and
physical place in the household. Some, such as the assignment to specified precincts
of the home or the expectation of deference to the family, had existed in varying de-
grees throughout the century. Others, such as the use of the term "servant" and
the institution of livery, were European customs that had not been imposed on
American white workers since the colonial era. In Salmon's view, these new and old
conventions combined to form a "badge of social inferiority" that was placed on
domestic employees "in characters as unchangeable as are the spots of a leopard."[18]
Most had been imposed on African American domestics continuously through-
out the century. The infliction of the symbols of servitude upon white workers
once again—a practice generally regarded as unrepublican and distasteful before the
Civil War—increased proportionately with the growing number of immigrant
workers. At the end of the century, Salmon described the common assumption by
homemakers that "domestic employees belong to a separate and obnoxious class in
society and cannot be met as individuals on the same plane as are other persons of
like attainments." Both the foreign-born maid and her black counterpart were sub-
ject to now fashionable practices that outwardly signaled their subordinate sta-
tus.[19]

Many employers saw no need to apologize for the institution of class distinc-
tions in their homes. Spofford, for example, defended the "servant" title as com-
pletely appropriate: "To hand your dishes, to prepare your food, to cleanse your
rooms and scrub your floors, to wash and iron your clothes, to dress your hair
and your feet—all that is service, and they who render it serve, and are exactly and
precisely servants; and we are at a loss to see why the English language should be
changed to suit a false pride on their part should they dislike to hear their work
called by its own name."[20]

The use of the title was often accompanied by the imposition of stricter rituals of
interaction through which, Salmon noted, servants "are made not only to feel but

to acknowledge their social inferiority."[21] In an attempt to emulate a hereditary leisured class, masters and mistresses addressed domestics with the aristocratic imperiousness they believed typical of English ladies and gentlemen.[22] According to Salmon, such lofty treatment erected a psychological wall:

> The domestic employee receives and gives no word or look of recognition on the street except in meeting those of her own class; she is seldom introduced to guests of the house, whom she may faithfully serve during a prolonged visit; the common daily courtesies exchanged between the members of the household are not always shown her; she takes no part in the general conversation around her; she speaks only when addressed, obeys without murmur orders which her judgment tells her are absurd, "is not expected to smile under any circumstances," and ministers without protest to the whims and obeys implicitly the commands of children from whom deference to parents is never expected.[23]

There were more than psychological barriers between servants and employers. Masonry walls also separated the "foreign element" from the family. Following patterns established in previous decades, servants were relegated to and became associated with the less important, least comfortable areas of the house: the kitchen, basement, and attic. The kitchen was the primary multipurpose area in which a maid-of-all-work labored, spent limited leisure time, and, in many instances, slept. In urban town houses, kitchens were underground, and servants remained there until summoned through a bell box activated by pulls "abovestairs." Workers were also housed in the attic, where rooms, up three or four flights of stairs, usually lacked plumbing, heat, and often windows. Limited space was the principal reason for their relegation to such ancillary spaces, but architects and homeowners alike recognized the growing desire for minimal contact with workers. By the late decades, house designs routinely included cross passages, pantries, and china closets as buffer zones between service and family spaces. Unless given permission or orders to enter family areas, servants were expected to stay in specific precincts within the home and make use of back entrances, halls, rooms, and stairs.[24]

For the residences of wealthy clients, architects introduced entirely separate service wings that typically included the kitchen suite (pantries, laundries, china rooms), a servant's dining room, gender-segregated dormitories, and the offices of the housekeeper and butler. Of the seventy rooms in the grand Newport mansion The Breakers, designed by Richard Morris Hunt for Cornelius Vanderbilt II, thirty were allotted to the domestic staff. Integration of such substantial service zones in house design was a challenge. At Biltmore, the massive country estate that Hunt created for Vanderbilt's brother George, the exceptionally large service wing is hidden on the outside by a dense screen of trees and a change of level.

Other architectural solutions were an ell or attached wing with a service court or an area within the main block from which servants might come and go through hidden corridors. Some architects favored a basement sector connected with family spaces through the use of elevators, dumbwaiters, and speaking tubes.[25] Modest or elaborate, all were devised to render the staff invisible and to protect families and their guests from inconvenient or unwanted proximity to workers. One millionaire established a contingency plan for accidental encounters: when he walked through the halls, servants were instructed to press their faces against the wall until he passed.[26]

In an ink and watercolor elevation made around 1880 by architect George B. Post, more than a dozen servant figures are pictured scurrying through corridors or performing chores throughout the palatial New York residence he had designed for Cornelius Vanderbilt II. Footmen lounge at the carriage door while laundresses scrub clothes and butlers fetch silver in the basement. In the right half of the sectional presentation drawing (fig. 5-1), uniformed maids sweep and dust various rooms while other domestics travel between floors by means of a service staircase. At the door of the art gallery, Post has delineated the figure of a liveried doorman in a formal ensemble complete with knee breeches.

The practice of requiring servants to don special uniforms was not limited to the residences of wealthy Americans such as Vanderbilt and his siblings. It was in these and similar households, however, that the custom was taken to its most extreme form in the 1880s and 1890s. In this heyday of house parties and grand balls given in New York and Newport mansions, legions of specialized attendants—footmen, butlers, waiters, and parlor maids—were tricked out in elaborate costumes of varying cut and color. The Vanderbilts chose maroon livery with white wigs for special events. On one occasion, William K. and Alva Vanderbilt entertained with enough maroon-draped footmen to stand on each step of their great marble staircase. Caroline Schermerhorn Astor, the society queen who reigned over the exclusive Four Hundred who could fit into her ballroom, chose to dress her servants in copies of the blue uniforms worn by the staff of the British royal family at Windsor Castle.[27]

Of all the badges of separateness, the imposition of livery—even in its simplest form—was the most despised by domestic workers. Livery had been associated with aristocratic pretension from the Revolution through the antebellum years, and attempts by fashion-conscious Americans to outfit their servants in uniforms were often met with derision.[28] In the second half of the century, however, mistresses began to regulate servant wardrobes in the name of neat and orderly housekeeping. An 1864 article describes one homemaker who kept "a supply of white caps and gingham dresses, and makes it a condition, on hiring a waiting-maid or nurse, that she should put her head into the one and her body into the other."[29] By

Fig. 5-1. George B. Post (1837–1912), *Residence of Cornelius Vanderbilt II, New York City*, detail of presentation drawing, 1878–1882, ink and watercolor on paper, 30 × 50 in. (76.2 × 127 cm). Collection of The New-York Historical Society.

the 1880s, a dark dress, white apron, and white cap had become the standard apparel required for female servants in middle- and upper-class urban homes. Even maids-of-all-work in modest households were asked to at least wear a cap.[30]

This obvious mark of distinction was the subject of a cartoon in *Harper's New Monthly Magazine* in 1888 (fig. 5-2). During an employment interview in her parlor,

Fig. 5-2. Unknown artist, cartoon published in *Harper's New Monthly Magazine* 76 (March 1888): 649.

CAPPING THE CLIMAX.

a genteel mistress inspects a coarse-looking, overdressed candidate. "You will have to wear caps, of course!" she states. The worker, with crossed arms, responds, "Caps! I wear no one's livery! If you"re so afraid we"ll be took for each other, I advise you to engage with some plainer person." As in previous decades, domestics had a reputation for lavishing their small wages on flashy garments. One mid-century writer described the typical maidservant as carrying "a twelve-month's wages on her back." On duty she was "as slattern as a beggar," but, "outside on a Sunday or a holiday she is as fine a lady as her mistress, and might readily be mistaken for her."[31] By imposing dress regulations, the Gilded Age mistress could ensure not only that her servant would have appropriate clothing for work but also that a visitor—with a single glance—could easily tell them apart.

In the *Harper's* cartoon, the candidate is made to stand before the mistress during the interview, which also underscores class difference. Sitting in the presence of a lady was considered disrespectful, and an invitation for a subordinate to do so was unusual. The behavioral ritual could serve as a test for would-be workers. The author of a contemporary etiquette manual observed, "In New England, it was formerly the custom for the mistress of a household to offer a seat to every one, 'gentle or simple,' who entered her doors. It is now not the custom, in engaging servants, to ask them to be seated. Servants, who cannot stand while answering the questions put to them pronounce their own incapacity by such an exhibition of

want of training."[32] If, by standing, the candidate in the cartoon complies with the unspoken expectation of deference, she openly balks at the requirement of livery. Most domestics, however, had little say if they wanted a position; some even indicated their willingness to wear caps or uniforms. Those who resisted were likely to draw the same sharp response that one nursemaid received when she asked to be excused from the dress code: "You must remember that if you take a servant's place you have to accept the limitations of a servant."[33]

The cap and apron offered the wearer practical protection from the dust and dirt of manual labor. Nevertheless, the costume had long been associated with social subordination—a denotation that affected the self-esteem of mistress and maid alike.[34] Many workers, including the writer for an 1887 labor newspaper, perceived livery as "a sign of the loss of self-respect among poor people condemned to a wretched struggle for the privilege of earning a living. It is also a sign of the growth of an un-American spirit among the rich; of a desire to perpetuate and mark caste difference."[35] The uniform that on one hand signified the working status of servants conversely announced a family's leisure status.

## More for Show Than for Service

Even before the Gilded Age, the hiring of a domestic worker was often the single distinguishing mark of a family's middle-class standing. With the tightening of social ranks in later decades, fashion-conscious Americans attached new importance to the status function of servants and were willing to expend an even higher proportion of their incomes to keep a domestic or two. By surrounding themselves with liveried workers, they offered visible proof of their social arrival. In her 1897 study, Salmon accused some employers of gratifying "personal vanity . . . by the constant presence of those deemed to be of an inferior station."[36] Two years later, another economics professor, Thorstein Veblen of the University of Chicago, gave the practice its most memorable treatment.

Although Veblen published *The Theory of the Leisure Class* (1899) at the end of the century, he formed the concepts for his treatise in the midst of the frenzy of acquisition and accumulation that had marked the previous two decades. Written with dry humor and biting satire, Veblen's pseudoscientific study probes the ways in which pecuniary ambition and gain had influenced social relationships in the late nineteenth century. Veblen characterized the ostentatious habits of the monied elite with his now famous catchphrases "conspicuous consumption" and "conspicuous leisure." He determined that the capacity to consume the "latest properties of dress, furniture and equipage" had become a criterion for respectability and the model for an aspiring American middle class.[37] With comic exaggerations, par-

odies, and sardonic comparisons, Veblen's convoluted treatise attacks the waste of human and material resources that he believed accompanied a ruthless striving for wealth and social prominence. Undermining social Darwinist assumptions of evolutionary progress, the economist argued that concepts of class superiority and inferiority were but continuations of ancient systems of exploitation and drudgery. In the old "predatory" system, he wrote, manual labor was "a mark of inferiority, and therefore . . . unworthy of a man in his best estate."[38] Veblen thought contemporary society had advanced little beyond its barbarian roots: "We have a realising sense of ceremonial uncleanness attaching in an especial degree to the occupations which are associated in our habits of thought with menial service. It is felt by all persons of refined taste that a spiritual contamination is inseparable from certain offices that are conventionally required of servants."[39] The prominent display of servants figures largely in Veblen's tongue-in-cheek theory. Domestics, he noted, were still important for their labor, especially since the increased consumption of goods—"dwellings, furniture, bric-a-brac, wardrobe and meals"—required more human labor to keep things in order. However, the servants themselves had been transformed into luxury commodities—status objects with the primary function of signifying a family's power and position. Personal servants were singled out by Veblen as being "useful more for show than for service." Waiting at their employer's elbow, they enacted a "vicarious leisure" through the display of their own consumption of time and materials. The more unproductive the servant, Veblen wryly asserted, the more evidence of the abundant wealth of the household that could afford to throw money away.[40]

The majority of domestic workers in the Gilded Age were hardly loafing about. The gritty realities of the physical labor they expended to maintain leisure-class households were simply screened from genteel eyes. As historian Faye Dudden comments, their activities proved "a remarkably effective compromise between status and display on the one hand, and mundane necessities on the other, a combination that left servants not in idleness but busier than ever." Despite technological advancements in food preparation and residential care, Americans aspired to higher standards of domestic production and cleanliness that required even more attention and work.[41]

American artists had not needed to wait for the publication of Veblen's treatise to understand the visual impact of a well-placed, clearly defined servant. They were already building on long-standing conventions of representation in which the simple inclusion of a worker elevated the social position of privileged sitters. Dependent on the patronage of a monied and aspiring elite, Gilded Age artists aligned themselves with their patrons' values and beliefs when they delineated the glamorous new aristocracy and their paid attendants. Perhaps, like the fictional painter Wetmore in William Dean Howells's 1890 novel, *A Hazard of New Fortunes,* they

anticipated the advent of a more formal class system in America: "When we do have an aristocracy, it will be an aristocracy that will go ahead of anything the world has ever seen. . . . We've got liveries, and crests, and palaces, and caste feeling. We"re all right as far as we've gone, and we've got the money to go any length."[42] No longer did artists have to wrestle with ambiguous figures of help who acted and dressed like their employers. The figures of uniformed workers were clearly displayed as black-and-white properties that enhanced the affluent—or, following Veblen's satirical reasoning, "honorific"—status of the principal figures.

## The Vanderbilt Family Portrait

When the National Academy of Design opened its spring exhibition in 1874, Seymour Joseph Guy's *Going to the Opera (Family of William H. Vanderbilt)* (1873, fig. 5-3) drew special attention among the hundreds of canvases on display. Although the sitters' names did not appear in the painting's original title, few who visited the exhibition failed to learn that the conversation piece depicted the family of William Henry Vanderbilt. Even before the show's opening, the *New York Times* noted that Guy's "famous Vanderbilt picture, containing the portraits of the family" would be included, an announcement that surely whetted public curiosity about the appearance of the affluent son and progeny of the well-known Commodore.[43]

When commissioned to undertake the project, the English-born Guy had already established a favorable reputation in the New York art world for his polished, intricately detailed genre scenes.[44] The artist drew on his skills as both genre painter and portraitist to create the complex group composition. Providing a narrative framework, he portrayed the family gathered in the Vanderbilt home just as the adult children were taking their leave for the opera.[45] The *New York Times* offered the following description:

> The first idea that will probably strike the spectator is that the Vanderbilts are an uncommonly good-looking family, and the second that with two or three exceptions, they have all got their best clothes on, and are perfectly conscious that they are being looked at, yet are endeavoring to appear as if they were not. . . . Mr. Guy has struggled manfully with the difficulty of so disposing some ten or a dozen figures in the space of an ordinary drawing-room in that each should appear at home and at ease, but he has not succeeded in overcoming it entirely.[46]

Although the setting of Guy's painting is the well-appointed drawing room of a brownstone town house and not yet the vast rococo mansion that Vanderbilt

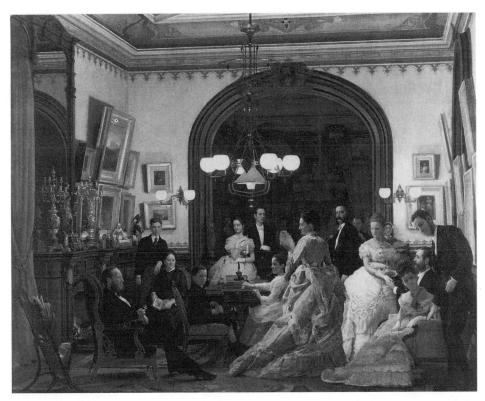

Fig. 5-3. Seymour J. Guy (1824–1910), *Going to the Opera (Family of William H. Vanderbilt)*, 1873, oil on canvas, 42¼ × 54 in. (108 × 137.2 cm). Courtesy Biltmore Estate, Asheville, North Carolina.

would build for himself upon inheriting his father's fortune a few years later, a quick glance would have confirmed for an exhibition spectator that the room and its inhabitants were far from ordinary. Upper-class success and contentment are made manifest in Guy's sharply focused delineation of gleaming woodwork, antique ornaments, picture frames, and satin gowns. The yellow walls, trimmed with red and brown, house a golden atmosphere of polished furnishings and manners.

At left, the patriarch is ensconced in a red plush armchair. He casually stretches his legs out before him and holds wire-framed spectacles as if he will soon turn to the various newspapers waiting on the carved stand nearby. His wife, Maria Kissam, is pictured at his side as she looks up from the small volume in her lap. The couple seems at ease before their crackling hearth, yet their association with reading material conveys traditional values of industry and responsibility. Both are pictured in dark, conservative clothing. Vanderbilt friend and biographer William Croffut noted that William Henry "never wore jewelry or made any show of

wealth, and always dressed in plain black."[47] With their sedate poses and somber attire, the older couple is nearly overshadowed by the pomp and color of the youthful opera party before them.

To the right, their numerous offspring are tightly assembled. The three youngest children are pictured near their parents and wear the expectant expressions of youngsters who have permission to stay up past bedtime to witness their older siblings' departure. The grown children—three daughters, two sons, and three in-laws—are portrayed in elegant evening dress. The women wear brilliant, lace-trimmed gowns adorned with flowers and jewelry, and the men appear in black suits with gloves and white ties. Guy has placed the eldest daughter, Margaret, at center under the spotlight of the gasolier. Opening her fan, she turns away from the viewer to exhibit the magnificently layered bustle and train of her blue gown. Her husband, Elliott Shepherd, stands at her side awaiting the placement of a coat across his shoulders by a bewhiskered manservant. A parlor maid stands behind them with several cloaks in her arms.

The room also serves as a gallery for Vanderbilt's budding collection of paintings, which hang in gilded frames on every wall. Through the arch, one can also make out a number of marble sculptures in the darkened formal parlor beyond. Like many of his wealthy counterparts in business and industry, Vanderbilt began collecting art following the Civil War. He confined his initial purchases and commissions to works by American artists. After gaining possession of his large inheritance, however, he began to favor European pieces. The transition came about, Croffut wrote, "since he was able to buy the best and most costly in the world. He decided at the outset, to procure nothing that was not important."[48]

William Henry Vanderbilt's gradually acquired preferences for European manners, fashions, art, and architecture were far exceeded by those of his children. As suggested in Guy's portrait, the younger group was already outdistancing their parents in their striving for high culture and elegance. In the following decades they would build sixteen elaborate mansions, each costing over a million dollars and all emulating great palaces in Europe. Vanderbilt's nouveau riche daughters-in-law would insinuate themselves into the old, exclusive New York society, and by century's end, his granddaughter would marry into one of the most respected noble families of Great Britain.[49] It was this grandchild, Consuelo, who would later remember a confrontation between her mother and their Irish nursemaid. The Roman Catholic worker was bold enough to suggest, "You have so many houses on earth, Mrs. Vanderbilt, don't you think it is time to build one in heaven?" Alva Vanderbilt replied, "Oh no, Bridget—you live in my houses on earth, but I look forward to living in yours in heaven."[50] In many respects, it was this third generation's vast appetite for material acquisition that gave Gilded Age high society its reputation for ostentatious display.

One of the criticisms of the Vanderbilt portrait was the crowded arrangement of so many figures into a single space. As Guy "struggled manfully" with the composition, he was doubtless aware of the difficulties of fitting in the entire group. The family alone constituted thirteen persons; nevertheless, he chose to include the servants. Their vaguely delineated heads and hands float above the shoulders of their elegant superiors. One domestic would have sufficed to offset an unlucky number, yet the appearance of two—especially the white manservant—offers a stronger intimation of the family's privileged standing. Indeed, the Vanderbilts had a large servant staff housed in their Fifth Avenue brownstone.[51] These figures, however, function more as symbols of servants than as portraits of real persons.

Along the back wall, the parlor maid has been positioned at the right base of the arch. She appears in quiet readiness and as still as the small bronze figurines pictured on either side of the doorway. Her duties are equally ornamental, though she has been given an additional function as human hall tree. She wears a dark bodice, red tie, and the white collar and cap of livery. Her tiny head and shoulders appear just to the right of Emily Vanderbilt Sloane's carefully coiffed blond head. The visual play of the working woman's dark figure next to the pale, bare shoulders and white gown of the newly married Emily provides not only a sharp tonal contrast but a social contrast of leisure and labor. Among all the figures, it is only the male servant's face that has been obscured. As he places a wrap on an impassive Vanderbilt son-in-law, the domestic's mouth is hidden by Shepherd's broad shoulder. Though the representation hints at the requisite silence of the subordinate, the significance of the manservant's presence is not diminished.

## The Call for Butlers

Throughout this period and into the twentieth century, men were employed as servants in only the most affluent households. Although Americans continued to retain "hired men" to help with the heavy work of gardening, animal care, or house maintenance, women invariably made up about 90 percent of the workers who served in the home. Excluding the west coast, with its tradition of Chinese menservants, and the South, with its abundant supply of African American workers, the hiring of male domestics was generally the exclusive privilege of the urban upper class. Because service entailed the performance of menial and personal tasks, typically at the behest of the mistress, the occupation was generally perceived as demeaning and unmanly for strong, able-bodied white men. Those who were enticed into homes came usually with the promise of authority over the rest of the staff and, certainly, higher wages. As a result, only the more well-to-do families could afford them.[52] Veblen perceived the display of male domestics as one of the

more overt exercises in conspicuous consumption: "Men, especially lusty, person-able fellows, such as footmen and other menials should be, are obviously more powerful and more expensive than women. They are better fitted for this work, as showing a larger waste of time and human energy. Hence it comes about that in the economy of the leisure class the busy housewife of the early patriarchal days, with her retinue of hard-working handmaidens, presently gives place to the lady and the lackey."[53] The acquisition of a male servant or two became the ultimate sta-tus symbol. Menservants, therefore, were placed in highly visible positions—an-swering doors, greeting callers, serving meals, and delivering messages. In the 1880s, the decade that saw the largest increase in the number of male domestics, the ultimate fashion coup for the status-conscious American family was the acquisi-tion of an English butler. Renowned for a haughty demeanor that could surpass that of any employer, British butlers were imported with other European luxuries to lend an air of refinement to the great houses of the New World.[54]

Despite the growing fashion for male servants in affluent households, American painters in this period tended to avoid the subject altogether. As a whole, they concentrated their efforts on picturing young, attractive maidservants in portraits and genre pictures. In one respect, Edwin H. Blashfield is no exception, with his 1882 painting, *Waterloo: Total Defeat* (plate 7), an image that features a slim uni-formed serving woman who bends over to clear a dining room table of a little boy's toy soldiers. Blashfield did, however, make the rare addition of a butler figure to the scene. The painting's focus is a toddler dressed in a white gown and paper hat. His pretend war has come to an abrupt halt as the parlor maid and butler re-claim the imaginary battlefield to prepare for tea. The pretty brunet domestic, shown in a black gown and white ruffled cap, has brushed some of the miniature soldiers onto a tray. A tiny mounted general has landed unexpectedly at the blond youngster's feet. Leaning back into an elaborately carved chair, the unhappy child turns to face the viewer with the direct, despairing look of one who realizes that he must surrender the field.

Blashfield was no stranger to cosmopolitan manners and themes, having studied briefly in Germany and then in France for nine years. During that time he regularly submitted canvases to the Paris Salon and the Royal Academy exhibitions in Lon-don. The year before he produced this painting, he returned to the United States to establish a studio in New York City.[55] The canvas's European overtones—including its title—are unmistakable. The setting for *Waterloo: Total Defeat* could easily be a residence in Paris, London, or Munich. Instead, it represents a prosperous Amer-ican home whose owners have formed a predilection for fine books, furnishings, objets d'art, and tidy, efficient servants.

Blashfield's manservant appears as a somber, elderly man in a black evening suit—the traditional butler's costume.[56] He is a far cry from the "lusty, personable

fellows" described by Veblen. In some respects, the painting may offer the more accurate, if unflattering, representation. Younger men did perform service in American residences, as is evidenced by the Vanderbilt portrait, but domestic positions were more frequently filled by older men who could find no other work.[57] The manservant in this painting places a heavy silver tea service on the damask-covered table. He seems to bow his head with an expression of tired resignation. The artist has positioned him before a sculptured bust on the shelf in the background. The heads, of similar size and positioning, offer a study in contrasts. Against the idealized countenance of the virile, young Hercules-like figure with curly hair and beard, the balding manservant seems aged, emasculated, and as powerless as the vanquished child. Unlike the toddler's loss, however, which is temporary, the manservant's defeat appears total. All three figures—the child, the butler, and the maid—are subordinated to the timing, wishes, and orders of the unseen master and mistress. The willful-looking toddler, whom Blashfield pictures with sturdy legs and a strong grip, will likely exercise his own authority in good time. He may not grow up to command an army, but he will eventually rule his own household, including its domestic staff.

## *Maidservants in Black and White*

When another painter, William Henry Lippincott, returned to the United States after several years of art instruction in France, he probably sought Blashfield's advice and support. Both men had been students in the Paris atelier of Léon Bonnat, and Lippincott followed his former classmate to New York City in 1882. On his arrival, the Philadelphia-born painter would have been able to see *Waterloo: Total Defeat,* Blashfield's entry in the annual exhibition at the National Academy.[58] Five years later, as an academy instructor, Lippincott submitted for exhibition his own version of a leisure-class household.

The setting for Lippincott's *Infantry in Arms* (1887, fig. 5-4) is also the well-appointed dining room of an affluent, urban family. The painter has lavished attention on the rich surfaces of material stuffs: silver, brass, and gold leaf glitter, and the deep reds of the leather chairs and Oriental carpet create a warm atmosphere. Blue-and-white Chinese vases and a porcelain tea set testify to the homemaker's enthusiasm for the current decorative trends of the Aesthetic movement. Beautifully arranged and orderly within the friezelike composition, the scene is visually balanced. The elongated chandelier, the sideboard with its large oval tray, the fruit-filled epergne on the table, and the single pedestal below are nearly aligned to form a vertical line down the center of the canvas.

At the conclusion of the morning meal, a liveried nursemaid approaches from

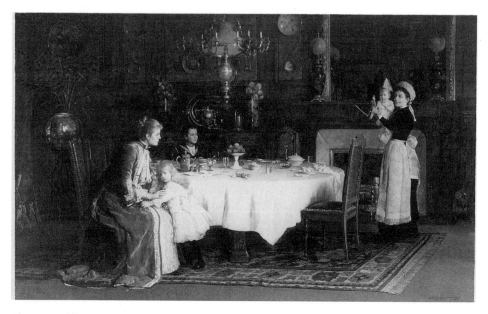

Fig. 5-4. William Henry Lippincott (1849–1920), *Infantry in Arms,* 1887, oil on canvas, 32 × 53¼ in. (81.3 × 135.3 cm). Courtesy Pennsylvania Academy of the Fine Arts; gift of Homer F. Emens and Francis C. Jones.

the right to collect three young children from her blond mistress. Already holding the infant, the servant is clearly removed from the circle of the family, articulated by the round table with its four chairs. The seated young mother, dressed in a green velvet morning gown, leans down to reassure her unhappy, clinging daughter. The little girl casts a troubled look over her shoulder toward the hired caretaker and the baby. As she shies away, she leans over to shield her yellow-haired doll in the lap of her comforting parent. Her two brothers, dressed in military costume, appear unafraid—expected behavior for little boys.[59] The older brother is seated at the table near his mother and calmly watches as the nurse distracts his infant brother with a toy. The smiling baby—the "infantry in [servant] arms"—wears a paper soldier's hat and brandishes a miniature sword.[60]

As the two women dominate their respective halves of the canvas, there is no mistaking the attractive, brunet domestic for the mother. The fact that one is seated while the other stands immediately establishes the class difference. Light and dark in coloring and costume, they are presented as opposites. Though the smiling, uniformed nurse appears both capable and benign, the little girl's obvious reluctance to go to her suggests a lack of trust in the servant's ability to restrain the energetic baby boy. Moreover, the child's reach toward her parent intimates not just a stereotypical female dependency but also an innocent's natural mistrust of out-

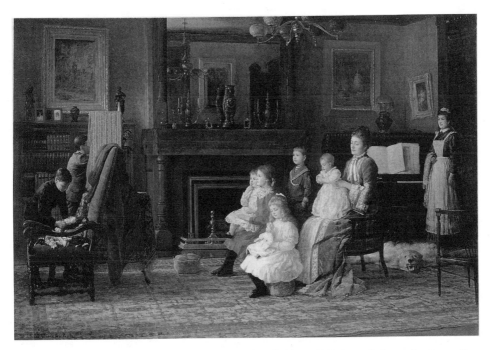

Fig. 5-5. William Henry Lippincott, *Punch and Judy Show (A Private Rehearsal)*, 1896, oil on canvas, 22 × 32 in. (55.9 × 81.3 cm). The Frances Lehman Loeb Art Center, Vassar College, Poughkeepsie, New York; purchase 1896.1.

siders. In turn, the gesture heightens the beneficent aura of a mother who offers love and protection. Historian Phyllis Palmer comments,

> In Western culture of the past two centuries, with servants often acting as mother substitutes to children of the middle class, the split between adored good, nonthreatening mother and bad women who could be despised because of their class and race was overlaid onto other social relations that defined goodness and badness for women. Even when children adored the nurturant mother surrogate, they learned early that she was not the good mother and to shift their allegiances.[61]

In the painting, Lippincott's "good mother" looks up from her troubled daughter and fixes her gaze on the servant standing opposite as if to gauge the worthiness of that dark counterpart.

Nearly a decade later, the painter portrayed the same family, this time gathered in their parlor to watch a children's puppet show. The setting for *Punch and Judy Show (A Private Rehearsal)* (1896, fig. 5-5) is an opulent, jewel-like room similar to that delineated in the artist's previous painting. The walls shine with gilded paper,

and an orange and gold Oriental carpet covers the floor. Gilt-edged books, gleaming figurines, and gold-framed paintings attest to the family's refined, aesthetic tastes and their upper-income status. The seemingly ageless matron wears the same lace-trimmed velvet gown as in the earlier painting, this time pictured as blue-gray. Her children, including two older boys who work the puppet show, have increased from three to seven. Facing the makeshift stage at left, mother and children cluster in the center of the room to form a small audience. All are seated except a young lad who, wearing a sailor suit similar to the one pictured in the previous image, stands near the matriarch with his hands in his pockets. As the mother supports a wobbly infant on her lap, her two daughters emulate her maternal demeanor: the older girl cuddles a toddler, and the other, seated at her mother's feet, gives the baby doll in her lap a loving look and a comforting pat.

The painting's ninth figure is a dark-haired maid who resembles the servant in *Infantry in Arms*. Removed from the activity, she waits behind the family at far right in the traditional doorway post. Dressed in black gown, white bib apron, collar, cuffs, and a tiny cap, the domestic is obviously on duty as she stands stiffly at the edge of the room. Over one arm, she keeps an embroidered shawl ready to drape over the mistress's shoulders or to receive the infant on request. Though Lippincott has included an empty chair nearby, it is clear that the maid is neither invited nor expected to sit. She also stands off the carpet—a visual code that underscores class distinctions within the home. Since mid-century, carpeted spaces were understood to be the domain of the family, and the less comfortable, uncarpeted areas were given over to service use. Domestics were invited onto the carpet to receive orders or perform chores. They were also "called on the carpet" to be reprimanded.[62]

A white bearskin rug forms an additional barrier between the liveried maid and the family. The animal hide marks a frontier between the realms of private and public, leisure and labor, and—in accordance with the ideology of separate spheres—civilization and wilderness. Though Lippincott has positioned the animal's head to show vicious, sharp teeth, it is easy to see that the beast has been captured, conquered, and ultimately transformed into a domestic ornament. The dutiful servant might also be perceived as an upper-class trophy, tamed and domesticated from a dangerous population. Lippincott's serene mistress faces the fantasy world displayed in the box of the toy theater. At the same time, she turns her back on the working woman and the threshold that leads out of the constructed environment of the room.

There is nothing beyond the threshold to threaten a well-bred lady in the sunny, bright world created in 1892 by Alice Barber Stephens in *A Spring Morning in the Park* (fig. 5-6). The painting's stretcher is inscribed, "Memory Sketch—Morning in Early Spring, Rittenhouse Square, Phila." For the outdoor scene, Stephens worked

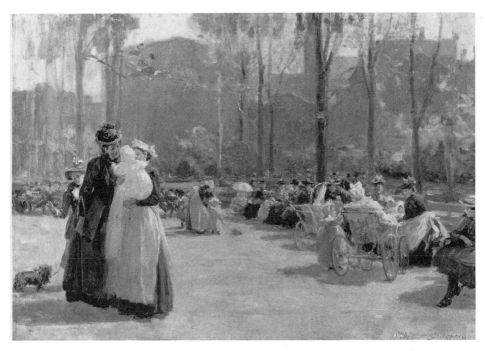

Fig. 5-6. Alice Barber Stephens (1858–1932), *A Spring Morning in the Park,* 1892, oil on canvas, 18 × 26 in. (45.7 × 66 cm). Private collection; photograph courtesy R. H. Love Galleries, Inc.

from sketches made on-site of the daily gathering of nurses and their charges in the fashionable residential park.[63] Liveried servants, young mothers, children, and infants in carriages line the benches around the square's inner courtyard. In the far distance at left are also three or four top-hatted gentlemen shown browsing through newspapers. Before them, a finely dressed lady and her young daughter have stopped to admire a baby in the arms of its uniformed nurse. As the woman brings her veiled face close to the infant, the attendant respectfully draws her own head back.

In the 1890s, Alice Barber Stephens was a well-known professional illustrator whose drawings appeared regularly in many of the major American newspapers and magazines. Though her primary media included engraving, pen and ink, and crayon, she earned several awards as a painter. The artist had trained in the late 1870s at the Pennsylvania Academy of the Fine Arts under Thomas Eakins. Afterward, she continued her studies in Paris at the Académie Julian and the Académie Colarossi in 1886–1887, during which time she came under the spell of French impressionism.[64] In *A Spring Morning in the Park,* Stephens employs the loose brush-

work and high-keyed colors characteristic of that style. Across a background of bright green foliage and salmon-colored town houses, she punctuates the canvas with the dark verticals of tree trunks and patches of black and white from the distinctive costumes of the nurses. While giving emphasis to these decorative surface patterns, Stephens also creates depth with the sharp diagonal of the benches—a line that leads the eye to the group at left. Like the impressionists, Stephens selected her subject from modern urban life. The obvious display of livery on several of the figures readily informs the viewer that this is an upper-class setting. Within the exclusive green space, all seem to interact harmoniously. While men, women, and children enjoy the park on a bright spring morning, the uniforms indicate the presence of women whose active labor supports the comfortable life-style of the residents of Rittenhouse Square.

Such an elegant park would have been considered an appropriate destination for a nurse and young child. Outings also afforded workers rare moments away from the authority and scrutiny of employers. Under the guise of taking the air, servants sometimes followed circuitous routes past the homes of friends and family. Historian Samuel Eliot Morison recounted such journeys during his Boston childhood in the 1890s:

> My nurse and the maids had numerous relations scattered along Charles Street or on the back side of Beacon Hill; and when they were supposed to be walking me in the Public Garden, I was apt to be conducted into one of these fascinating one-room tenements, where the coal stove was the center of life. The mothers greeted me as "darlint," and gave me a share of whatever was cooking, while the children stared at me suspiciously. These nurses gave the "well-bred" children of my generation an intimate touch with a life of which the carefully groomed and mamma-raised suburban kids of today are unhappily ignorant. The nurses not only showed us how the poor lived, but imparted folklore and wisdom that cannot be got from books.[65]

Such a fond and happy memory as the older Morison's was also the realization of many a mistress's worst suspicion—that her sheltered children might be exposed to undesirable elements by untrustworthy servants.

## The Mammy as Nanny

In *Gossip* (fig. 5-7), a painting by Thomas Waterman Wood of 1890, an infant girl and her attendant are also portrayed on an outing. As the black nursemaid pauses to chat with a friend on the sunny sidewalk, the child waits patiently within her elaborate wicker perambulator. She is dressed in a white lace gown and a wide-

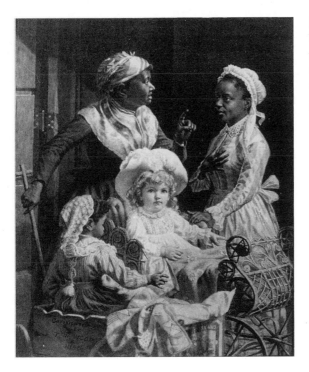

Fig. 5-7. Thomas Waterman Wood (1823–1903), *Gossip*, 1890, watercolor, 25 × 30 in. (63.6 × 76.2 cm). T. W. Wood Gallery and Arts Center, Montpelier, Vermont.

brimmed bonnet that surrounds her head like a halo. She alone is fully illuminated by the morning light. Much like Lilly Martin Spencer's "little human sunbeam" in *Dixie's Land* (fig. 3-17) from a generation earlier, the fair-haired, blue-eyed baby looks out to meet the viewer's gaze. Her bright face, positioned in the exact center of the canvas, floats impassively in the midst of gesturing dark hands, reaching arms, and bright fabrics. Her nurse has met another black woman who takes her own baby out for a stroll. By placing the children side by side, Wood invites racial and class comparisons. The African American child, who is turned away from the viewer, sits below the blond girl in a wagon made from a tomato crate. She is neatly dressed in a striped bodice, light-colored skirt, and white lace snood with a jaunty tassel that hangs down her back. A pillow and colorful patchwork quilt have been placed at the foot of her makeshift carriage. From her lower, subordinate position, the little girl seems to pay homage to the aloof, golden-haired toddler.

Above the children, the two women are engaged in animated conversation. The young, attractively dimpled nurse appears in standard white apron, cuffs, collar, and a cap complete with ruffles and long, dangling lappets. She seems to have rejected the typical dark dress in favor of a gown with wide yellow stripes. Her friend or relative, dressed more conservatively in a brown dress and white fichu, wears a brilliantly colored head wrap. Though the painting's title suggests that the two are

Fig. 5-8. Thomas Waterman
Wood, *The Faithful Nurse,* 1893,
oil on canvas, 28 × 20 in. (71.1
× 50.8 cm). T. W. Wood Gallery
and Arts Center, Montpelier,
Vermont.

gossiping, the pointed-finger gesture of the older woman and the younger's hand-
to-breast response suggest that a lecture might be under way—or, perhaps, an im-
promptu lesson in child care. No matter the purpose of the conversation, the
nurse's task of taking the baby for a stroll has been interrupted. The viewer is in-
vited by the quiet, almost knowing gaze of her little charge to acknowledge the
momentary lapse in duty.

Thomas Waterman Wood was a Vermont-born painter who established a studio
in New York City in 1852. Like his contemporary Spencer, the self-taught artist
studied paintings on exhibition there at the National Academy and at the Düssel-
dorf Gallery. After a trip to Europe in 1858–1859, he returned to the United States,
where he traveled to the South in search of portrait commissions. Remaining in
Tennessee and Kentucky throughout the Civil War, Wood sketched scenes from
African American life, which he incorporated into genre paintings on his return
to New York in the late 1860s. Among his subjects, he depicted black soldiers, ven-
dors, field workers, and families.[66] In most of the paintings he produced through

the following decades, he avoided the extreme caricature that had come to domi-
nate popular written and visual imagery.

Wood features a handsome black female servant in *The Faithful Nurse* of 1893
(fig. 5-8). She is not pictured in the black-and-white livery favored by mistresses
at that time, nor does she wear the standard collar and cap shown on the nursemaid
in the earlier painting.[67] Illuminated by a strong circle of light from above, the
sturdy nurse is pictured in a dark olive-colored shawl and a tan plaid skirt, which
shows through her thin white apron. A multicolored head wrap hides her hair and
has been folded so that a band of bright red fabric cuts across her forehead. While
the background vanishes into dark shadows, the embroidered hem of a decorative
portiere and a small Oriental rug are all that are visible of the space around her.
Looking left with her face turned away from the light, the nurse embraces and
supports a blond girl on one hip. The fully illuminated toddler wears a lacy white
gown and bonnet and meets the viewer's gaze with the same quiet, direct glance
that characterizes the child in Wood's previous image.

In this painting, the artist turns to an old formula for representing African
American women. Although it can be argued that he has created a fairly dignified
representation, he has nevertheless relied on Mammy imagery in his portrayal of a
plump, turbaned, cheerful black nurse who exhibits loving devotion toward her
white charge. Also in keeping with the decades-old convention, the child is pic-
tured as having little awareness of the dark protectress who supports her. Though
Wood has obviously taken great care in his delineation of the servant, it is once
again the white child who is elevated in ways that go beyond her high position
on the nurse's hip. Despite her diminutive size, the toddler dominates the canvas in
her coloring, lighting, and presentation. Moreover, through the subtle gesturing of
the child's hands, the artist also implies that she dominates her environment. Her
fingers rest atop the servant's dark hand, while her other pudgy fist clasps the silken
cord of a kimonoed rag doll. Viewed in the context of the mounting racism and
imperialism of the 1890s, the image might be understood as a visual corrobora-
tion of the prevailing rhetoric of Anglo-Saxon supremacy.

The future and health of the "American race" became an explosive issue at the
end of the nineteenth century. Ever increasing numbers of immigrants flooded
into the United States, and in 1890, the percentage of the foreign-born and their
children reached a new high.[68] Among the newcomers—Italians, Poles, Serbians,
Hungarians, Greeks, Chinese—few came from northern Europe. The influx seemed
to many alarmed Americans a threat to both the homogeneity and the hegemony
of a white, Protestant culture. From this period through the early decades of the
twentieth century, new waves of racism and nativism swept the country. Eminent
Americans were moved by class antagonism, economic competition, and distorted
science to promote the doctrine of Anglo-Saxon superiority. The concept was not

entirely connected to Anglican heritage. "Increasingly," historian John Higham writes, "Anglo-Saxon culture seemed to depend on the persistence of a physical type. Nationalism was naturalized; and 'race' in every sense came to imply a biological determinism."[69] Planted within the ideology was the social imperative of keeping supposedly inferior races in a subordinate position. Proponents reasoned that failure to do so would bring about dire consequences. In a book published in New York and London in 1893—the same year Wood completed *The Faithful Nurse*—one writer predicted, "We shall wake to find ourselves elbowed and hustled, and perhaps even thrust aside by peoples whom we looked down upon as servile, and thought of as bound always to minister to our needs. . . . in some of us the feeling of caste is so strong that we are not sorry to think we shall have passed away before that day arrives."[70]

Growing xenophobia and racism triggered the general movement to restrict immigration into the United States—a legislative battle that would continue into the 1920s. In the West, the Chinese bore the brunt of the nativist backlash as the U.S. Congress passed the first exclusionist acts in 1882 to prohibit entry of Asian laborers. Two more laws passed in 1888 and 1892 effectively closed all loopholes and brought Chinese immigration to a halt. Over the same period, measures ostracizing African Americans reached an all-time high. "The great evil native white Americans associated with blacks in this era was essentially identical to what they discerned in immigrants," John Higham writes. "The evil in both cases was pollution: politically, through the sale of votes; socially, through the spread of crime, disease, and immorality; racially, through contamination of the very body of the nation."[71]

Attitudes toward African Americans changed rapidly in the years following the Civil War. The withdrawal of federal troops from the South in 1877 marked the beginning of a national retreat from the race issue.[72] As popular opinion shifted to the right, legal action followed. In 1883, the U.S. Supreme Court declared the Civil Rights Act of 1875 unconstitutional, stripping African Americans of equal rights to public accommodations and jury participation. The social and political climate became increasingly restrictive, culminating in the high court's 1896 upholding of the *Plessy* v. *Ferguson* decision, which led to social segregation and the mass disenfranchisement of blacks. Justice Henry B. Brown of Michigan, speaking for the majority, argued, "If one race be inferior to the other socially, the Constitution of the United States cannot put them upon the same plane." Unfortunately, the broad movement against African Americans did not stop at the political level. The fears and prejudices that strengthened Jim Crow restrictions were also manifested in violence. Between 1889 and 1898, the number of lynchings rose to an unprecedented average of 187 a year. Victims were accused of such crimes as attempting to participate in labor union activities, registering to vote, bringing suit, or simply being disrespectful to whites.[73]

Caricatures of African Americans became even more distorted and grotesque in the popular press as race relations worsened. Trade cards, sheet music, and cartoons all portrayed black people as coarse or animal-like.[74] Prints, such as those in the Darktown Comics series by Currier and Ives, lampooned them as simpleminded, bumbling buffoons—stereotypes perpetuated from earlier minstrel characterizations. Other images glorified the Old South's antebellum plantation system, a nostalgic theme popularized in contemporary "moonlight and magnolia" fiction. In these romanticized scenes, happy, loyal, and servile "darkies" frolic and work the fields free of cares, their lives controlled by wise and giving white folks.[75] Painters from both sides of the Mason-Dixon line—William Aiken Walker of Charleston and Harry Roseland of Brooklyn, for example—found a lucrative market for such scenes of "the antebellum type." Artists were less willing to incorporate figures of free blacks into images of everyday life.[76] The number of images from this period in which African Americans appear even as domestic servants is limited. Wood's paintings are among the exceptions.

The painting of the Mammy-style nanny and the angelic white baby may have been a straightforward effort at representation, but Wood's *Faithful Nurse* implies a racial and social hierarchy. His bright-eyed little girl, representative of the future of the so-called American race, takes a black woman by the hand and, more ominously, suspends a foreigner—in this instance, an Asian figure—by a rope. Moreover, the representation anticipates by only a few years the imperialist rhetoric that would dominate during the Spanish-American War of 1898 and after. At the conclusion of that three-month conflict, the United States gained control of Cuba, the Philippines, Guam, Hawaii, and Puerto Rico. The care of "our little brown brother," in the words of William H. Taft, was cast as a racial and a patriotic duty. In Rudyard Kipling's often quoted phrase, it also became the "white man's burden" to lead the "new-caught sullen peoples, half devil and half child."[77] Such concepts were an extension of the paternalistic yet mistrustful stance already taken by many Americans toward the outsiders within their national borders and within their homes.

## Silent Service

A year after Wood completed his painting of child and nurse, Cecilia Beaux treated the theme in a portrait of her young niece, *Ernesta (Child with Nurse)* (1894, fig. 5-9). According to the artist's recollections, the inspiration for the painting was her observation of the two-year-old being taken outside for a walk by her Irish nursemaid. "Suddenly," she wrote, "I saw that that was what I wanted to paint. A child of that age is habitually being led by the hand."[78] The canvas reveals the figure of a

sturdy, white-gowned toddler who, hand in hand with her uniformed nanny, steps
confidently forward. As the child gazes outward with intelligent, shining eyes, the
viewer is left to ponder, who is leading whom?

Beaux experimented with more traditional poses in preliminary studies but re-
jected them by bringing the vantage point of the viewer down to the level of the
child. Her dramatic composition leaves no confusion about the painting's focus.
Ernesta is centered squarely in the canvas, and the nurse's figure is cropped at the
waist; only her skirt and a single hand are pictured. The folds of her crisply starched
apron provide a curtained backdrop for the little figure. The painter used feath-
ery, broken brushstrokes and a limited palette to create a silvery tonality in the
shimmering whites and lavender shadows of the child's gown and the woman's
apron, the pale gray of the servant's dress, and the brown ocher of the floor and
background. The only bright color is Ernesta's pink hat, which, pulled close around
her dark hair, draws the eye to the small face with its quizzical, expectant gaze.

By the time she painted the little girl, Beaux had gained an international repu-
tation as a portraitist. Having studied at the Académie Julian, the artist exhibited
regularly in the Paris Salons throughout the 1880s and 1890s. Her portraits were

also well received in New York and in her native Philadelphia, where she became the first woman instructor at the Pennsylvania Academy. Her quick, fluid style was often compared favorably to the bravura brushwork of her contemporary John Singer Sargent. Like that American expatriate, she attracted well-connected, monied patrons whose conservative attitudes she shared.[79] Though the artist and her family did not figure among the ranks of the wealthiest, they were nonetheless financially comfortable and well accustomed to the services of a domestic staff. Matty, the nursemaid pictured with Ernesta, was one of several Irish women employed through the years by Beaux's sister. Another domestic, Anna Murphy, provided devoted service to the artist herself for more than forty years. In reminiscences of visits to Beaux's residence, Thornton Oakley describes the artist as an energetic mistress. As she directed Murphy and Natale, the Italian houseman, "Bo's vitality flamed high. Her eye was on every article in studio and house. Each object was required to be in its appointed place. . . . Every morning, with swift stride, she was now here, now there, issuing commands." Oakley expressed delight in the perfect "silent service" rendered by her staff.[80]

Beaux's portrayal of Ernesta and her nurse is strikingly different from traditional servant imagery. Stylistically, it appears to be a combination of decorative aestheticism and impressionism. It is also a tour de force display of the artist's assimilation of current French modernist approaches that synthesized photographic realism with the pictorial vocabulary of japonisme. The deliberate crowding of figures to the upper right conveys the impression of a momentary encounter with the little girl as she and the nurse go by. At the same time, this asymmetrical organization; shallow and oblique recession of space; the flat, decorative arrangement of shapes; and dramatic slicing of the servant's figure by the picture's edge all suggest design elements found in Japanese prints. Beaux's decision to picture Ernesta with a servant instead of with her mother implies her desire to capture not merely the likeness of the little girl but also her privileged circumstances.[81] All that shows of the guardian is a wide expanse of livery. By reducing her to a glimpse of that significant costume, Beaux informs the viewer of the family's ability to purchase a nursemaid's care and attention. While Ernesta leads the way, the headless domestic renders perfect, silent service.

The painting's disconcerting balance and bold cropping brought praise from those who enjoyed the modern composition.[82] Others were puzzled by the unconventional treatment. When the portrait was exhibited at the Art Institute of Chicago in 1899, critic Lorado Taft offered a literal reading:

There is a dainty little niece of Miss Beaux's who has figured in two noteworthy compositions. The first showed her taking a walk with a fragmentary nurse. The nurse had not only lost her head, as young and pretty nurses

often do, but also all her upper part, which was more serious. The artist cut her off in her prime, right at the waist, by the picture frame, but charming little Ernesta still clung trustfully to the hand of her fractional companion. It was a bold thing to compose a picture in that way, and not altogether a happy inspiration perhaps, but the painting was something wonderful and the little toddler a perfect gem.[83]

Taft's assumption that the servant is young, pretty, and apt to lose her head invites speculation about the woman's physical appeal, her limited intelligence, and, perhaps, her susceptibility to flirtatious advances. Inspired only by the corner of an aproned uniform, Taft projects into the image prevailing biases and fantasies about serving women.

On examining together the images of children and nursemaids by Thomas Waterman Wood, Alice Barber Stephens, and Cecilia Beaux, it is difficult to believe that the paintings were all made within a two-year period. In *The Faithful Nurse,* Wood employs the same static, linear style favored by genre artists in the first half of the century. The paintings by Stephens and Beaux, which feature broken brushstrokes, a light palette, asymmetrical cropping, and attention to surface, reveal the artists' knowledge of recent, cosmopolitan techniques. Wood, Stephens, and Beaux were all highly respected in the 1890s, yet their divergent approaches and styles epitomize the transformation of American painting in the last twenty-five years of the century. The most significant reason for the change was the enormous impact of European—primarily French—trends on art collecting, art training, and art making in the United States.

### *Peasants and Servants: Searching for "Well-Determined Types"*

Communication advances, improved transportation, and the rapidly expanding print media brought European art more immediately to a receptive and prosperous American market. Wood's old-fashioned brand of sharply focused, anecdotal, native subjects lost favor among wealthy American collectors who, like William Henry Vanderbilt, sought the most "important" art that money could buy. After the late 1870s, this meant Old Masters and contemporary French painting. In response, the younger generation of American artists looked overseas for inspiration and direction, traveling abroad in unprecedented numbers to train in the ateliers of the Ecole des Beaux-Arts and various independent academies in Paris. In 1887, Henry James observed, "It sounds like a paradox, but it is a very simple truth, that when to-day we look for 'American art' we find it mainly in Paris. When we find it out of Paris, we at least find a great deal of Paris in it." Painters were greatly

influenced by the successive and overlapping currents coming out of France: Barbizon, academic idealism, realism, and impressionism.[84]

If there is a predominant theme in most of these stylistic movements, it is the emphasis on the human figure—the mainstay of European academic training.[85] In particular, the solitary female figure predominated, and the beautiful young peasant woman became its most popular manifestation. Following the example of Jean-François Millet, Jules Breton, and Jules Bastien-Lepage—artists who gained an enormous following in the United States—painters from this country produced hundreds of images of peasant women at work in fields or in their rustic homes.[86]

For American audiences, the peasant represented a laboring class that belonged wholly to Europe. In the United States, the farmer had long epitomized the republican values of individualism and industriousness. Consequently, American rural images tended to celebrate a strong work ethic, rugged self-reliance, and the love of family and community—concepts often projected onto the idyllic scenes of peasant workers produced overseas.[87] The more graphic European depictions of brutal, backbreaking labor and grueling poverty—subjects that stemmed from the political impulses of Realism—only bolstered the belief in heroic American yeomanry. Such images served to confirm the notion that there was no such peonage in this democratic, "classless" country.[88]

Acutely aware of the lively patronage for peasant imagery on this side of the Atlantic, artists struggled to reconcile European subject material with traditional American themes. As one critic noted in 1873, Breton's paintings of "brown-skinned, strong-limbed" peasant girls reveal "something of the inner life of a class of whom there is no exact counterpart in this country—whose daily bread is won only by the severest toil, and whose sorrows and pleasures are limited to the smallest sphere."[89] That there were impoverished people in this country—and, certainly, laboring women—who did indeed scrape out a subsistence through severe toil seemed antithetical to the American way of life. Those painters attracted to this theme either looked abroad for peasant subjects or, when working in the United States, modified, diluted, or abandoned the subject altogether. With limited exceptions (including Winslow Homer's mid-1870s paintings of African American women laboring in cotton fields), there were few attempts to adapt the figures of American workers to the peasant formula.[90]

Some complained that laborers in the United States lacked visual interest. Echoing the old argument that our "peasantry" had nothing "peculiar" to depict,[91] critic Samuel Isham asserted that the late nineteenth-century painter had difficulty finding material in this country:

There were no Moors from Algeria, no Gypsies from Spain, no Breton or Dutch peasant girls in sabots or picturesque caps, nor even any workingmen

in blouses, nor interesting, well-determined types of any kind in their old-fashioned settings of cottage or shop. Most of the people who the young artist saw looked and dressed pretty much alike, and the costumes and surroundings, though comfortable, did not strike him as worth recording.[92]

Perhaps in an attempt to create an indigenous peasant type, some painters explored servant imagery. Domestic workers provided the most visible population of female laborers in the United States. In the households of art patrons and painters alike, serving women answered doors, prepared food, waited tables, scrubbed floors, and minded children. Washerwomen worked in the dark regions of the home or appeared weekly at the back door to collect and deliver laundry. The immigrant woman who daily performed heavy, manual labor was generally perceived as coming directly from peasant stock. With her much-publicized, incongruous manners, the stereotypical domestic had much to offer that was "peculiar." Of the foreign worker, Harriet Spofford noted that "her unlettered state, her strange habits of speech, her wild traditions, her outlandish custom of wakes and ulalus, may make her seem something like a creature of another race, a rougher and more primitive race, nearer the earth, of whom one can require more than one could of one's peers."[93]

When domestic workers were portrayed on canvas in the last quarter of the century, however, artists seldom delineated the effects or evidence of the long hours, limited freedom, or heavy physical toil that defined their lives. Nor did they overtly perpetuate the written and visual stereotypes from the popular press that continued to portray domestics as coarse, rough-featured, and clumsy. In painting, servant imagery was adjusted to suit the current taste for portrayals of attractive, healthy, and robust female workers. As principal subjects, they were idealized as lovely young maids who effortlessly performed their duties. The shift also suited new aesthetic undercurrents that minimized narrative content and placed more value on formal qualities of color, pattern, line, and shape. In seeking decorative results, painters achieved more unified, harmonious compositions.[94]

Like the European peasant women in their native folk costumes, American domestics were also distinctive in their clothing. Caps and aprons offered visual interest and drama for a modern bourgeois audience that "looked and dressed pretty much alike." Even before the general reinstitution of livery in the United States, writer Robert Tomes expressed an appreciation for the decorative qualities of worker uniforms:

In France and England female servants are always dressed in a neat and appropriate costume, consisting of a white cap, a frilled apron of the same color, and a tightly-fitting spencer, with a short skirt or gown of plain gingham or calico. Thus neatly and simply attired, European waiting and nursery maids

are ornaments to a household, and even the cooks and scullions fresh from the kitchen are not unsightly. This plain dress so accords with the occupation and rude beauty of the class, that the ruddy English maid and the dark-faced French *bonne,* thus attired, are a great deal more picturesque, and not less attractive than their fashionably-draped mistresses.[95]

Even Lucy Salmon, who in the 1890s denounced the imposition of livery, confessed she found the cap and apron not only practical but also becoming. She wrote that the "picturesque effect of both is appreciated by all young women who take part in public charitable entertainments, it was understood by the matrons of an earlier generation, and it has formed the theme of many letters written on foreign soil. No costume in itself could be more desirable."[96] Ironically, society ladies could appreciate or even envy the ornamental qualities of the uniform so hated by their maidservants. Participating in occasional dramas or tableaux vivants gave them the opportunity to enhance themselves with the distinctive raiment. Perhaps the most unusual event was the Servants' Ball given by Henry Clews, Jr., at Newport. The guests—his circle of friends, not their domestics—were invited to come dressed as maids, cooks, butlers, chauffeurs, or whatever "backstairs types" they fancied. On the evening of the ball, "no one had the courage to face their servants," one participant recalled, "dressed in what appeared to be clothes purloined from their own wardrobes, with the result that Freebody Park was thronged with maids and menservants who had been given an unexpected evening off."[97]

## Winslow Homer

One of the first American painters to explore the picturesque effect of a serving woman in livery was Winslow Homer, who painted *Nurse and Child* (1866, fig. 5-10) only months before his first trip abroad. After receiving critical acclaim for his Civil War paintings, the young artist was granted several immediate honors, including an invitation to exhibit at the Universal Exposition in Paris in spring 1867. At about the same time, he was elected a full member of the National Academy and was also invited to join the Century Association in New York. It was on his return from France at the end of 1867 that Homer presented *Nurse and Child* to the Century as his initiation fee.[98]

Just before his departure for France, the artist resided at his parents' home on Center Street in Belmont, Massachusetts, where he was given an upstairs back room for a studio. On the room's white plaster walls, the artist scrawled a few drawings, and in October, he boldly signed his name followed by the prestigious new initials, "N.A." Among these wall sketches is one that he might have put up to

Fig. 5-10. Winslow Homer (1836–1910), *Nurse and Child,* 1866, oil on panel, 18 × 14½ in. (45.7 × 36.8 cm). The Century Association; photograph courtesy Frick Art Reference Library.

deter any hapless domestic from cleaning the premises in his absence. Homer pictured a tiny maid with hair tied in a knot and an apron about her waist. She is overshadowed by a huge, shoulder-high dust pan and whisk broom. The Lilliputian servant turns to face a towering, fully uniformed Civil War soldier who, with hand on hip, points at her and commands, "Leave this room."[99]

Whatever "domestic" battles were being waged in the Homer residence at the time, the artist was gentle in his treatment of the servant he portrayed in *Nurse and Child*. The painting features a young liveried nursemaid who has brought a toddler outdoors to enjoy the springtime weather. Standing in profile, she is pictured in a charcoal-gray bodice with red piping on the shoulders and thin blue cuffs. She wears a white apron over her black skirt and a white cap with a broad, ruffled brim and two long, streaming lappets. Homer positions her before a sloping, yellow-green hillside in a field dotted with wildflowers. Facing the pale morning sunshine, the self-absorbed nurse has pulled a branch full of white fruit blossoms down before her. As she examines it, she seems not to notice the little child at her feet. Dressed in the characteristic white bonnet, gown, and pale blue sash of well-to-do children, the youngster leans into her skirt and tugs at her apron. Homer himself has given the sketchily painted child little attention, for he has not bothered to give it a face. The child is clearly secondary to the figure of its lovely nanny.

It appears that Homer was already aware of progressive European currents that would dominate in succeeding decades. The bright colors, fluid brushstrokes, outdoor setting, intense sunlight, and dappled effect of the flowers all suggest the early impressionism of Eugène Boudin and Claude Monet—artists whose paintings had been exhibited in 1866 in New York and Boston. These effects are also closely related to the plein-air techniques favored by Barbizon landscape artists, many of whose canvases were included in private Boston collections at the time. The sharp diagonal, flat treatment of the background and the decorative spotting of the white blossoms also offer evidence of Homer's study of Japanese woodblock prints.[100] Finally, the theme of the contemplative female is reminiscent of the work of the British Pre-Raphaelites, contemporary artists whose paintings of moody and dreamy-eyed "stunners" were reproduced regularly in the American press.[101] While the solemn nursemaid recalls some of the qualities of those aesthetic females, she is also closely related to the Barbizon-style figures Homer would produce the following year in France.

Of the nearly twenty known paintings Homer completed during his ten-month stay in Paris and the rural village of Cernay-la-Ville, *Girl with a Pitchfork* (1867, fig. 5-11) is the work most often cited as being related to French peasant imagery of the time.[102] The canvas shows a young woman facing the setting sun and standing

Fig. 5-11. Winslow Homer, *Girl with a Pitchfork,* 1867, oil on canvas, 24 × 10½ in. (61 × 26.7 cm). The Phillips Collection, Washington, D.C.

against a golden brown field. She wears a short navy jacket with a red collar and thin white cuffs; her white apron is lifted and twisted by the wind. Pausing from work, she holds two red poppies in the right hand that rests on an upright pitchfork. There is little question that Homer produced *Girl with a Pitchfork* under the spell of the Barbizon artists, who were reaching the apogee of their popularity in Paris at the time of his visit.[103] However, the American painter had already worked through the image's theme, design elements, and composition the year before in *Nurse and Child*—the prototype for the French image.

In *Girl with a Pitchfork,* he departed from the earlier painting by changing the scenery, reversing the figure, adjusting her position, and—of course—modifying the servant uniform into peasant garb. Both women wear aprons, but the French worker is pictured in sabots and a patterned scarf. There is little difference in the women's physical appearances. They both stand in profile and exhibit the same round-shouldered stance. Their faces are similar, each with a broad forehead, low hairline, full upper lip, and rounded chin; and they exhibit the same impassive, distant expression as they gaze straight ahead. Seen side by side, the images offer some contrast in coloring and light that are evocative of morning and evening, spring and autumn. In both paintings, Homer treats the theme of the woman laborer. The working-class status of each woman is conveyed through her costume, which also renders her as different and somehow exotic to an American audience. Both are imbued with the dignity and strength that would characterize his later studies of working women in the cotton fields of Virginia and the seashores of Tynemouth and Prout's Neck.[104]

Before returning to the United States, Homer produced yet another servant image. *The Nurse* (1867, fig. 5-12) portrays what seems to be the same pensive model depicted in the preceding two works. She is positioned, once again, in profile. The vantage point is from behind, so that the viewer sees the nursemaid's face from over her right shoulder. She looks down with eyes that appear almost closed. Since she is turned away in the three-quarter-length study, only a glimpse of blanket indicates the presence of an infant in her arms. The nurse shields herself and the baby from the late afternoon sun with a small parasol. Blocking the light, the umbrella totally encircles her head, and its radiating ribs and golden fringe create a halo effect behind her. Thus, she appears as a modern Madonna—though clearly a hired one, as her cap with streamers announces.

Homer was known for the multiple use of his figure studies, and he was not finished with his servants from *Nurse and Child* and *The Nurse*.[105] In 1874, he produced an illustration for *Harper's Weekly* that resurrected both, this time back to back. In the woodcut print *On the Beach at Long Branch—The Children's Hour* (fig. 5-13), they are reintroduced as nursemaids who care for children at a fashionable New Jersey resort. The artist added more figures and interjected a narrative ele-

Fig. 5-12. Winslow Homer, *The Nurse,* 1867, oil on panel, 19 × 11 in. (48.3 × 28 cm). Daniel J. Terra Collection, 2.1994. Photograph © 1994; courtesy of the Terra Museum of Art, Chicago.

ment to create an image for the popular press. The servants stand at center—the French bonne with the striped jacket at left and the liveried nurse from the blossom-filled landscape at right. The parasol has been given over to a stylishly dressed lady who kneels at left to chat with a little girl. Though the servant reaches toward the youngster, the child turns away, fully engaged in conversation with the genteel woman, who may be her mother. To the right, the figure from *Nurse and Child* extends her arms, but instead of blossoms, she holds a strangely weightless baby to her face. Homer had treated each servant as the central figure of earlier paintings. In this composition for the popular media, however, the nurses become secondary figures that function primarily as signifiers of class. No longer individuals who explore their own thoughts, they are now clearly workers on duty.

Fig. 5-13. Winslow Homer, *On the Beach at Long Branch—The Children's Hour,* wood engraving, $9\frac{1}{4} \times 13\frac{5}{8}$ in. (23.5 × 34.6 cm), published in *Harper's Weekly* 18 (15 August 1874): 672. Duke University Museum of Art; gift of Elizabeth von Canon.

## Charles Courtney Curran

Like Winslow Homer, Charles Courtney Curran traveled to France shortly after his election as a full member of the National Academy. Twenty years separated Homer's journey abroad from Curran's. In the interim, the assimilation of French techniques and themes by American artists had become pervasive and complete. Even before Curran arrived in Paris in 1889 to attend the Académie Julian, he and hundreds of other painters like him had already received basic French academic training in the United States from instructors who had studied overseas. Curran, who was born in Kentucky and raised in Ohio, attended the Cincinnati Academy of Design. He came to New York in the early 1880s to study at the National Academy and the Art Students League. His contribution of a painting titled *A Breton Girl* to the 1885 academy exhibition indicated his participation in the ongoing national obsession with peasant imagery.[106]

In the following two years, Curran turned his attention to female workers on this side of the Atlantic—a focus that culminated in his series of paintings of laun-

Fig. 5-14. Charles Courtney Curran (1861–1942), *Breezy Day*, 1887, oil on canvas, 11$\frac{15}{16}$ × 20 in. (30.3 × 50.8 cm). Courtesy Pennsylvania Academy of the Fine Arts, Philadelphia; Henry D. Gilpin Fund.

dresses. These images are far removed from Lilly Martin Spencer's mid-century portrayal of a washerwoman (plate 3). Spencer's painting presents a cheery worker yet nevertheless conveys the tedious, physically demanding realities of the chore. In contrast, Curran's beautiful laundresses bend and move as if dancing. They pose, instead of work, in sunlit pastoral settings, effortlessly unfolding huge, billowing sheets and gingerly lifting laundry-filled baskets.

Curran's *Breezy Day* (1887, fig. 5-14) brought him his first public acclaim. After being awarded a special prize at the National Academy exhibition of 1888, the painting was purchased by Thomas B. Clarke, a prominent patron of American art.[107] It pictures two laundresses who spread out clean, wet sheets on a windswept field. One woman, dressed in a black gown with a gold apron, kneels on the ground with her back to the viewer. Her fair-haired companion stands to the front, bending over to open a sheet to the wind. The breeze that fills and lifts it also catches the worker's clothing. In her pink bodice, cream skirt, and white scarf, she appears like a large pastel flower against the sea of grass that dominates the background. Curran represented the tall growth with quick, oblique brushstrokes, which, along with the bold, amorphous shapes of the white laundry, create a strong horizontal movement across the painting's surface. The figures appear self-absorbed and do not interact as they perform their choreographed movements. Cur-

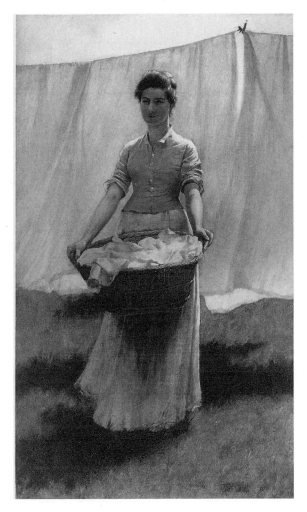

Fig. 5-15. Charles Courtney Curran, *Hanging Out the Clothes,* 1887, oil on canvas, 20 × 12 in. (50.8 × 30.5 cm). Collection of Walter and Lucille Rubin.

ran's inclusion of two workers provides a sequence to the quiet, rhythmic labor. Alternating positions, each laundress will pick up a wet sheet, fling it forward across the grass, and return to pick up another. Their bending poses are reminiscent of the gleaning and sowing gestures so frequently represented in contemporary peasant imagery—an allusion only strengthened by the figures' close association with the earth.

Curran made at least two other paintings of laundresses in 1887, each portraying a servant before a sheet-draped clothesline. *Hanging Out the Clothes* (fig. 5-15) depicts a young brunet woman dressed in the same pastel costume of the laundress from the previous image. Her full-length figure, positioned at center, is shown turning slightly to the left, where she directs a somber, distant gaze. As she lifts a

large load of clothes, her extended arms give little indication of the weight of the wide wicker basket filled with laundry. White sheets on the line, illuminated by a golden midday sun, form a brilliant curtain behind her. Curran once again explores patterns and textures, contrasting the soft folds of the fabric with the spiky grass below. The bright background, brought close to the picture plane, gives strong definition to the soft contours of the worker's uncorseted body. Her tight bodice has been unbuttoned at the throat, and her sleeves have been pushed up above shapely arms. In a related painting, *Shadow Decoration* (Frances Lehman Loeb Art Center, Vassar College), Curran offers a closer view of the same laundress. Her solid form is shown in profile, once again in high relief against light-filled sheets, this time softly dappled with the leafy, calligraphic shadows of trees behind them. The viewer has visual access to her narrow waist and the swell of her breast as she reaches up to secure the wash to the line. In all three of these paintings, Curran invites the audience to enjoy the aspect of the lovely laundresses as they go about their tasks. He has taken a commonplace chore and common (in both senses of the word) female domestics and has produced images of timeless, transcendent beauty.[108]

In popular literature, laundresses were hardly portrayed as visions of feminine beauty and grace. More typical is the description offered in Frances Willard's behavior manual, *How to Win: A Book for Girls* (1886), published at the same time Curran created his series. In a chapter titled "How Do You Treat Your Laundress?" Willard contrasts the appearance and bearing of Nocturne, a "better class" friend, with her own Irish washerwoman, whom they happened to meet on the street: "There was no mistaking the identity of this person who had so ruthlessly put a radiant reverie to flight; no mistaking the heavy mouth, retreating forehead, and upturned nose; the faded shawl and worn-out hood; the rounded shoulders and clumsy step. No, the badges were upon her, branded into the face by life-long consciousness of inferiority; by a thousand stifled ambitions and thwarted purposes; certified by the mode of that life and its result." Willard, a longtime reformer and temperance activist, decided that "Nocturne and Bridget may fairly serve as types of their respective classes" and contemplated the "great gulf" between the two. Her readers are asked to consider the laundress's "deformed soul" along with her "deformed body," since she is doubly impoverished by her ignorance of art, poetry, and music. The "weary, uncouth woman" goes through life unenlightened, while "artists evoke from canvas the visions which haunt their dreams, sculptors carve their thoughts in marble, and singers wake from lyre and organ mystic voices to mingle with their own; but these radiant revelations of the beautiful are lavished on more favored lives than hers."[109]

Though not part of the privileged art-viewing public, the laundress, nurse, and parlor maid continued to be subjects for its contemplation. When the Gilded Age

painters presented them as principal figures, they may have implied some of the class badges imposed on servants, but they did not promote Willard's contention that the badges were also "branded into the face." The domestic worker, like her peasant counterpart, was often transformed into an idealized and sometimes eroticized female figure.

## Gari Melchers

Few of the Gilded Age artists returned to the subject of maidservants as frequently as did painter Gari Melchers in the years just after the turn of the century. At least ten of his surviving canvases feature domestic workers—beautiful women who attend their duties in elegant residential settings.[110] A year older than Curran, Julius Garibaldi (Gari) Melchers also came from the Midwest. The Detroit-born artist did not, however, follow the path of most aspiring American painters, who studied first in New York before going abroad. With family connections in Germany, Melchers was able to proceed directly to Europe in 1877. After four years of academic training in Düsseldorf, the twenty-one-year-old painter relocated in Paris, where he enrolled at the Académie Julian. His advanced skills quickly ensured him a highly coveted place in the painting section of the Ecole des Beaux-Arts. After only a few months, the young artist received his first international recognition with the acceptance of his painting *The Letter* to the Salon of 1882.[111] This canvas, also exhibited in New York the following year, depicts two Breton women who appear in work dresses, aprons, and white caps. The painting marked the beginning of his extended interest in portraying European peasant women in traditional folk costumes.

In 1884, Melchers moved to a small fishing village in Holland with his fellow Americans painter George Hitchcock and Hitchcock's wife, Henrietta. Settling at Egmond aan Zee, the two artists established a studio that became, in a few short years, the center of a successful art colony and school. Over the next three decades, they turned their attention to local fisherfolk and peasant families as subjects of their numerous depictions of rural Dutch life. Although Melchers remained in Holland through most of his career (returning to the United States only after the outbreak of World War I), the expatriate regularly visited and exhibited his work in New York, Chicago, and Detroit, as well as Paris, London, Munich, and Vienna. After receiving many international awards, including a grand prize medal in the American section at the 1889 Universal Exposition in Paris, Melchers became one of the most respected American painters of his time—a celebrity that would fade in the years between the great wars.[112]

In the 1890s, Melchers shifted his interest in depicting universal peasant types to

creating scenes of significant life events such as birth, confirmation, courtship, marriage, and death. He continued to turn to the local people and places at Egmond for inspiration, employing his own cook—a Dutch woman named Anna Dekker—as the model for numerous images exploring themes of marriage and motherhood.[113] At the turn of the century, Melchers made a further transformation from peasant and costume pieces, beginning a new genre series portraying the elegant home life of leisure-class women. Though he continued to paint in Holland, these images are no longer recognizably Dutch. Instead they represent the beautifully appointed interiors found in affluent, cosmopolitan households in the United States as well as Europe.

The artist's decisive shift was likely related to his marriage in 1903 to Corinne Mackall, a young art student from Baltimore, and to the increasingly prosperous circumstances of his own home life. Joseph Dreiss comments,

> Although not moneyed to begin with, Melchers by this stage had achieved a respectable economic standing. As his fortunes rose, so did the richness of the domestic interiors he depicted. The peasant hovels represented in his earlier Dutch works were now replaced by the spacious and well-furnished rooms of an upper-middle-class home. The paintings of the bourgeoisie enjoying the comforts that result from economic security are painted with the pride and satisfaction of a self-made man contemplating his own material success.[114]

For this group of interior scenes, Melchers turned his practiced eye from stolid peasant women to liveried maidservants.

For *The China Closet* (fig. 5-16) of 1904–1905, the painter posed Henrietta Hitchcock and her Dutch servant, Kierie Blok, before a green cupboard filled with sets of porcelain dinnerware.[115] The young maid stands quietly, with downturned eyes, as her employer selects from the open shelves and places dishes on the tray in her hands. Hitchcock has been given the active role; as she carefully sets a dish on the tray, she reaches for another with her other hand. As the lady of the house, she takes charge of the task and appears in full control of her possessions—the delicate porcelain in the cupboard as well as the porcelain-skinned worker at her side. Yet it is the obedient domestic who has been given visual preference in this composition. The mistress is turned away from the viewer with her face in the shadows. By contrast, the maid's features are fully revealed as she stands in profile, facing the light source from the left. Her pastel uniform—a lavender dress, white bib apron, and white ruffled cap with lappets—stands out in the darkness of the room. Her attractive young face is given further emphasis by the brightly colored cupboard door that frames her head and shoulders. There is a sense of permanence about the servant, as if she could remain in the patient, demure stance forever.[116]

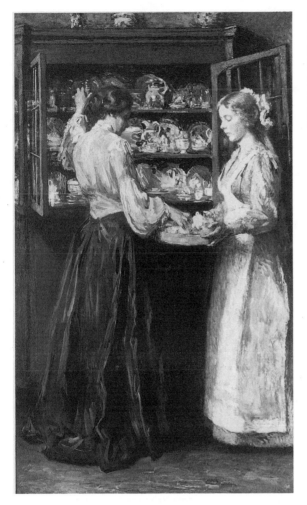

Fig. 5-16. Gari Melchers (1860–1932), *The China Closet,* 1904–1905, oil on canvas, 59⅜ × 30⅜ in. (150.8 × 77.2 cm). Belmont, The Gari Melchers Estate and Memorial Gallery, Mary Washington College, Fredericksburg, Virginia.

The quick dashes of pink and blue that define the dinnerware and the broad, thickly painted brushstrokes that flash across the figures' clothing reveal Melchers's assimilation of impressionistic techniques he learned during his frequent international travels. Though his palette and style seem quite modern, he does not appear to have abandoned his affinity for seventeenth-century Dutch conventions, exhibiting the traditional northern European attention to the tactile qualities of surfaces. Moreover, *The China Closet* and other related paintings seem to recreate the well-appointed, orderly interiors pictured in the domestic genre of the Dutch Golden Age. His images of conscientious supervision and quiet interchange between mistress and maid recall the hushed atmosphere of *The Linen Cupboard,* by Pieter de Hooch (1663, fig. 3-2). Melchers's modern interpretations, however, reject

Fig. 5-17. Gari Melchers, *The Open Door*, ca. 1905–1910, oil on canvas, 63 × 49½ in. (160 × 149.7 cm). Belmont, The Gari Melchers Estate and Memorial Gallery, Mary Washington College, Fredericksburg, Virginia.

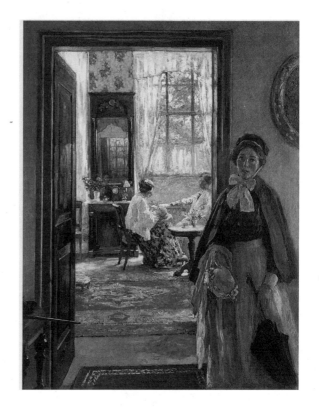

the small scale of seventeenth-century paintings and are instead staged on large canvases. As a result, he gives the intimate, day-to-day activities of women monumentality and grandeur.[117]

Such is the case with *The Open Door* (ca. 1905–1910, fig. 5-17), which measures a little over five feet tall. The ambitious composition is an elaborate exercise of the artist's ability to delineate interior space and light. As in most of the paintings in this series, the setting is the drawing room at Schuylenburg, the Hitchcock home in Egmond ann den Hoef. In this image, the viewer is asked to play the role of a caller. The foreground is a darkened hallway or vestibule in which stands a young maid. With a somber expression and parted lips, she appears to be conversing with the new arrival. She has already collected the guest's outer apparel: a blue shawl, black parasol, and a straw hat trimmed with flowers. A walking stick rests on the table at left. The servant's black-and-white costume, which corresponds to the neutral tones of the entryway, includes a cape and black bonnet. She might be leaving on an errand or she may have been instructed to receive visitors on the porch before announcing their arrival to the mistress, who is at home in the parlor.

Beyond the doorway is an inviting room filled with warm light, bright patterns,

and colors. Leafy branches of the trees outside are pressed against a large window; inside, the yellow wallpaper is printed with bouquets of pink roses and blue ribbons. Real blossoms have been arranged in vases around the room, and bright orange and blue geometric shapes are splashed across the Oriental carpet. In this vibrant bower, two ladies face each other before the sun-drenched window. Their admiring gazes fall on an infant held in the arms of the young woman at left.

In delineating the separate spaces of the home, Melchers captures a housemaid's typical role in the "front door drama," as Faye Dudden describes the rather elaborate nineteenth-century ritual of visiting. The servant, upon answering the door, acted as the family's gatekeeper, admitting or excluding visitors on orders. By being "inconspicuous, deft, and deferential," a properly trained domestic was to convey to visitors the crucial first impression of a well-ordered household. As a social nonparticipant, she was also discouraged from bringing undue notice to herself.[118] Yet in *The Open Door,* Melchers intentionally directs attention to the parlor maid by positioning her in the immediate foreground. Moreover, he enhances the viewer's identification with the young woman by giving her a direct, appealing gaze. Momentarily, one shares the servant's post at the doorway, as well as her social uncertainty of being allowed to enter the private realm beyond. By visually bringing the viewer through the gray hall to the space beyond, the artist enhances the golden allure of the inner sanctuary. Ultimately, the open door is for the viewer—with the implied assumption of his or her privileged standing—and not for the servant. Contact with the worker is pleasant but customarily brief; the visitor will be asked into the bright family room, and the well-behaved maid will remain in the passageway outside.

As in *The China Closet,* the servant Kierie Blok posed once again for the fair-haired parlor maid pictured in *Penelope* (1910, fig. 5-18). Wearing black-and-white livery, she stands before her mistress as she sorts through a small basket filled with colorful skeins of floss. Corinne Melchers, the artist's wife, sits near the brightly lit window and embroiders at her freestanding frame. With bowed heads and quiet expressions, both mistress and maid concentrate on their respective tasks, though the servant's efforts are clearly on behalf of the lady of the house. The painting's title, *Penelope,* refers to the ancient tale of Odysseus's faithful wife, who found a cunning way to discourage suitors during her husband's long absence. After declaring she would not marry until she completed a fine weaving, she wove by day but secretly unraveled her work at night. Melchers's modern version may have been a tribute to his patient young wife, who remained at home during his frequent world travels.[119]

With vivid colors, shimmering light, and disintegrating forms, the artist creates an ideal world for his wife. He surrounds her with lovely objects: antique furniture, fresh flowers, the Old Master oil painting and delicate watercolor on the

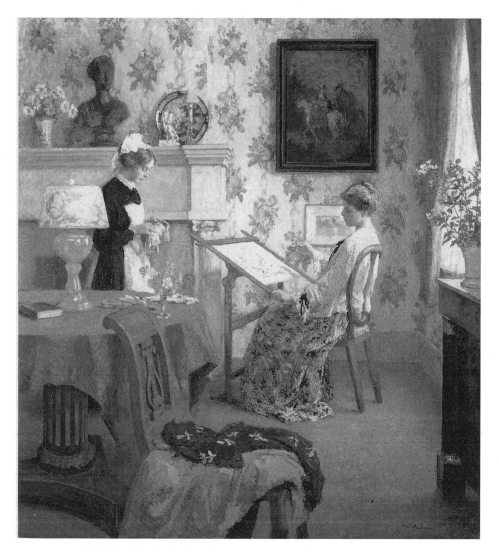

Fig. 5-18. Gari Melchers, *Penelope*, 1910, oil on canvas, $54\frac{1}{2} \times 50\frac{7}{8}$ in. (138.4 × 129.2 cm). Collection of The Corcoran Gallery of Art; Museum purchase.

wall, shining porcelains, the bronze bust of a woman on the mantelpiece, and, of course, the attentive servant. All seem to mesh to form a decorative whole. Corinne herself is no less ornamental than her maid. Melchers makes much of their equally fresh and youthful beauty, but in pose and costume, he nonetheless articulates the difference in their stations.

Portrayed in customary livery, Melchers's servant figures attest to the affluent

circumstances of the households in which they serve. His trim, demure maids are important items in a visual inventory of material assets, yet they are not fully subordinated as secondary figures. Melchers brings them to the forefront for the viewer's consideration. In these paintings, the workers are as much the focus as the genteel ladies they serve. Like them, the servants are presented as beautiful objects to be studied and desired.

Through his connections with the American impressionist group The Ten and his election to the National Academy in 1904–1906, Gari Melchers must have been aware of the similarity of his interior scenes to those produced at the same time by painters of the Boston School in the United States. Like Melchers, the Boston artists portrayed elegant, leisure-class women and their servants as decorative properties in elegant interiors—images that found favor with an upper-class audience. Though working on opposite sides of the Atlantic, Melchers and the Boston painters were trained in the social and artistic climate of the Gilded Age, when wealthy and aspiring Americans adopted "many European habits of living and thinking and speaking."[120] Their milieu led them to define household workers visually as servants and to render them as status symbols through distinctive costume, position, and demeanor. In keeping with current artistic trends, they were able to exploit the decorative qualities of the servants' uniforms and, at the same time, emphasize the aesthetic form of the female figure beneath the cap and apron. Melchers's Boston counterparts would bring these elements together to create some of the most striking servant images in American art.

*Chapter Six*

---

# Bridget in Service to the Boston School
## 1892–1923

In December of 1911, William McGregor Paxton sent a letter to New York dealer William Macbeth offering him his soon to be completed painting, *A Girl Sweeping* (1912, fig. 6-1). "This is my best picture," the artist wrote, "and I'm desirous of giving you first crack at it." In following months, Paxton copyrighted the work— the only painting for which he secured legal rights. Quite pleased with his portrayal of a lone maidservant, he was confident it would have public appeal.[1] He was correct. In April, the painting was purchased by the Pennsylvania Academy of the Fine Arts for its permanent collection. A critic for *Art and Progress* praised it as "a good type of American interior, cleverly rendered and pleasing in effect."[2]

Paxton and his Boston School colleagues were indeed striving to produce "good types" of American interiors at the turn of the century. *A Girl Sweeping* is one of their many beautifully rendered domestic scenes—and one of several featuring a servant. The painting is a product of the earlier artistic and social impulses of the Gilded Age. A latter-day version of the theme of the solitary female laborer, it is reminiscent of paintings like Jean-François Millet's *Woman with a Rake* (1854–1857, fig. 6-2) that portray self-effacing peasant women at work. In Paxton's painting, a young chambermaid solemnly sweeps a parlor with a push broom. She wears a gray pinafore apron over her rose-colored shirt with rolled sleeves. Looking down, she faces away from the steady light coming from an unseen window at right. The room's furnishings are understated yet elegant: a marbletop table with carved cabriole legs, a dresser with ormolu mounts, a glass-front cupboard, and a large Chinese urn decorated in the same rose and gray colors as the servant's clothing.

Fig. 6-1. William McGregor Paxton (1869–1941), *A Girl Sweeping,* 1912, oil on canvas, 40¼ × 30⅜ in. (102.9 × 77.2 cm). Courtesy Pennsylvania Academy of the Fine Arts, Philadelphia; Joseph E. Temple Fund.

Fig. 6-2. Jean-François Millet (1814–1875), *Woman with a Rake*, 1854–1857, oil on canvas, $15\frac{5}{8} \times 13\frac{1}{2}$ in. (39.7 × 34.3 cm). The Metropolitan Museum of Art; gift of Stephen C. Clark, 1938. All rights reserved, The Metropolitan Museum of Art.

The painting's domestic setting, indirect lighting, and calculated naturalism also reveal the artist's attentive study of seventeenth-century Dutch genre painting. These characteristics and the pervasive atmosphere of hushed gentility were recognized as qualities distinctive in the work of the small, close-knit group of artists

known today as the Boston School. On the painting's showing in 1912 at the Pennsylvania Academy, an unnamed critic wrote,

"A Girl Sweeping" by William M. Paxton, perhaps reveals the virtues and defects of a school which basks in the glory of one Jan Vermeer of Delft. This canvas shows all possible lavish care given to the little details of texture and still-life and true Bostonian polish in its handling—Paxton can paint porcelain when he wants to: lingering still in our memory is a little canvas of a girl reading [*The House Maid,* fig. 6-7], exhibited here two years ago, in which this artist produced most amazingly cunning results in porcelain—but alas! to finish the tale, the girl too was porcelain. And so looking on this canvas of "A Girl Sweeping," a lovely but bloodless girl of porcelain, we imagine what Teniers would have done to make the blood of this pretty creature tingle, or how in our own day, the brush of George B. Luks could make us see the dust fly from the vigorous handling of the household implement in the hands of a live young woman who does not mope at her work.[3]

In their domestic genre, portraits, and figure studies, the Boston School painters defined and celebrated a privileged New England life-style devoid of either high-spirited maids or flying dust. They consciously avoided the earthy realism of Luks and the other painters of the Ashcan School, who were, at the same time, choosing to depict the harsher aspects of contemporary life. Invoking instead a refined world of inherited wealth and manners, the Boston canvases present tasteful rooms appointed with antique furnishings, Oriental objets d'art, and lovely mistresses who read, pour tea, or drift in quiet reverie.

More important to this study, their images also portray "a good type" of domestic: one who quietly orders and maintains the lush spaces of her employers, seemingly without supervision. Beautiful themselves, these "porcelain" servants are highly objectified and delineated with the same care and precision given to the gleaming furnishings they tend. The paintings offer little evidence of the acute tensions between Boston's upper class and the ever-growing masses of immigrant workers who flooded into the city at the end of the century. Nor do they convey the heightened discord between families and their Irish maids.

## *Near-Vermeer*

"Why not make it like?" was the popular saying of the group of artists associated with the School of the Museum of Fine Arts in Boston during the decades spanning the turn of the century. Closely allied by personal friendships and professional connections, these men—Edmund C. Tarbell, Frank Benson, Joseph Rode-

fer DeCamp, William McGregor Paxton, and Philip Leslie Hale—produced paint-
ings very similar in style and subject. Massachusetts-born Tarbell, Benson, Hale,
and Paxton all studied at the Académie Julian in Paris in the 1880s and 1890s. Pax-
ton was also admitted to the Ecole des Beaux-Arts, where he trained under Jean-
Léon Gérôme; DeCamp, a native of Cincinnati, studied at the Royal Academy in
Munich and with Frank Duveneck in Florence and Venice.[4] After receiving years of
academic training abroad, each returned to find his place as a professional teacher
and practicing artist in Boston.

In the 1890s, these painters (dubbed Tarbellites by contemporary critics, after
their apparent leader) adopted a modified impressionistic approach. In fact, Tarbell,
Benson, and DeCamp joined other American impressionists to found The Ten, an
association of painters who exhibited together and promoted the movement. Just
after the turn of the century, however, the Boston artists turned seemingly en masse
to also embrace the more polished, tonalist style for which they are best remem-
bered.[5] In their distinctive approach, they synthesized impressionistic light and
color, fine academic draftsmanship and attention to form, and compositions and
motifs borrowed from Old Master paintings.[6] Philip Hale, the group's frequent
spokesman, claimed that the change came about with their discovery and study of
the paintings of Jan Vermeer. During their student years in Paris, the Americans
had witnessed a widespread resurgence of interest in the seventeenth-century
Dutch artist. It wasn't until around 1904, however, that their focus sharpened
when Hale edited a chapter on Vermeer in *Masters in Art,* one of the earliest pub-
lications in the United States to discuss and depict the artist's work. Afterward,
Hale dedicated the remainder of his life to pursuing research on Vermeer and, in
collaboration with Paxton, published a scholarly monograph in 1913.[7]

One of several Vermeer paintings that Hale illustrated in his first study was *The
Love Letter* (ca. 1670, fig. 6-3). The canvas exhibits some of the qualities most ad-
mired and frequently emulated by the Boston School: a tranquil interior illumi-
nated with unbroken light from a lateral source, muted colors and soft half-tones,
careful perspective, and a vantage point from an adjoining space. Vermeer typi-
cally portrayed bourgeois women who read, write letters, play musical instruments,
or exchange a quiet glance or word with a maidservant. In *The Love Letter,* the lute-
playing mistress pauses to receive a letter from a servant. In answer to her mis-
tress's inquisitive glance, the worker's knowing smile suggests that the communi-
cation comes from a lover. The figures are positioned against the distant wall, and
space from the viewer is marked by the measured placement of objects and furni-
ture. The painting's naturalism is enhanced by the artist's close attention to sur-
faces and texture—from the soft ermine trim of the lady's jacket to the hard sheen
of her pearls and the polished carvings of the chair in the darkened foreground.

The Boston artists constructed their own interpretations of Vermeer's images,

Fig. 6-3. Jan Vermeer (1632–1675), *The Love Letter*, ca. 1670, oil on canvas, 18¼ × 15¾ in. (44 × 38.5 cm). Collection of the Rijksmuseum, Amsterdam, The Netherlands. Photograph © Rijksmuseum-Stichting, Amsterdam.

updating them with contemporary elements and subjects. In their depictions of leisure-class women ensconced in light-filled, New England interiors, they achieved a similar high degree of naturalism and sense of hushed timelessness. The painters believed that while emulating the Dutch master, they were producing the latest

development in the Western tradition of art.[8] One critic, easily spotting the source of their inspiration, quipped that "a near-Vermeer is a mere veneer." Hale responded that their efforts were nonetheless noble: "To paint like nature is to paint like Vermeer and in this sense many Bostonians were and are his followers." The Dutch artist, he continued, "looked at nature again and again to see if there was anything he could do to his picture to make it more 'like'."[9]

Ultimately the Boston painters found a successful formula that appealed to the traditional values of their primary audience, the local Brahmin elite. Their patrons comprised prominent businessmen and professionals, many of whom could trace their families back to the colonial era. Predominantly Harvard-educated and Republican, they were representative of the city's oldest establishment. The collectors, not unlike the patrons of Vermeer two centuries before, appreciated art as an investment and, at the same time, valued the representation of a charming, comfortable world.[10] Hale's assessment of the seventeenth-century Dutch burghers might easily be a description of his and his friends' own clientele:

> The pictures which the aristocracy and the rich *bourgeoisie* liked were precisely the kind of pictures Vermeer painted. As has been hinted, they liked their own country, they were proud of it and liked to see it portrayed. They were proud of their fine houses with their tessellated floors, their fine rugs and their Chinese vases. Proud, too, they were of their women, with pretty white satin dresses and natty morning jackets trimmed with swansdown. . . . The patrons liked certain subjects—the artists painted them.[11]

The Boston artists had much in common with their upper-class patrons. Although Hale was the only one of the group who could truly claim an impeccable Brahmin heritage, Paxton was descended from a New England sea captain and Tarbell's English ancestors had come to the region in the late 1630s. Tarbell grew up in the less fashionable South Boston and played baseball with Irish Catholic boys in Dorcester. Yet as an adult, he gained acceptance and prestige by affecting upper-class manners and tastes. All of the painters came to be associated with Brahmin society through friendships and memberships in the same exclusive clubs and civic organizations.[12] At the apex of their careers, the painters were respected citizens of high social standing and, it appears, in sympathy with the values of the older elite. As art historian Theodore Stebbins notes, they "were essentially Brahmins, and thus they shared that class's keen sense of a society on the defensive."[13]

The painters' alignment of conservative themes with a conservative style drew comment from contemporary critics. Assessing the Boston canvases, Guy Pène duBois maintained that they exuded "airs of a gentleman and that means airs of a particular class." Associated with the realist painters in New York, the artist and critic had little patience for what he dubbed "bits of Chesterfieldian talk."[14] Charles

Caffin was more appreciative of the "holiness of beauty" he perceived in Tarbell's *Girls Reading* (1907, private collection). Nevertheless, he noted that the artist seemed to ignore "the spiritual and mental conflict that is seething around him," much like a man who insists upon building a perfect house in an ugly neighborhood. Still, Caffin concluded, by painting tranquil scenes, "Tarbell proves himself responsive to the mental needs and conditions of his time. His art, in fact, has the quality of symbolism by which the modern mind is endeavoring to interpret 'the substance of things hoped for, the evidence of things not seen.'"[15]

The Boston artists created pleasing images "more like" the harmonious world that they and their patrons feared was slipping away. By 1900, Massachusetts had become the most thoroughly industrialized of all the states. An influx of new immigrants on top of an already burgeoning foreign-born population exacerbated labor tensions throughout the region. As a result, class disparity in Boston intensified as never before.[16] There were also pressures on the home front. In her study "The Boston Lady as a Work of Art," Bernice Kramer Leader determined that many Brahmin wives and daughters were far from the dreamy, inert figures pictured on canvas. A large number were actively involved in the suffrage movement as well as various civic and social reform causes. The paintings of compliant, passive women, Leader argues, deny the political and social tensions that were being played out in the city and in the home. "For Boston men," she writes, the canvases may have "served as retreats from their own energetic, achieving, reforming wives." Several members of Boston's upper class—including artist Philip Hale—supported a national crusade to block the female vote.[17]

In the visual paeans to domestic harmony offered by the Boston artists, both mistress and maid are sequestered, docile, and ornamental. For the most part, female servants go about their chores silently and efficiently. Rarely do they exhibit the bothersome idiosyncrasies widely attributed to their ethnic group and class. These are paintings of "things hoped for" that offer a comforting antidote to the changing conditions beyond the mahogany parlor doors of the Back Bay district.

## Brahmins and the Exiles of Erin

Before 1845, Boston had been a small, gracious city built upon decades of successful commerce, finance, and industry. Incidents of crime and poverty were rare, and civic and private institutions easily met the demands of the small but growing town. For nearly a century, Boston's population was homogeneous, with a citizenry that for the most part shared a common Anglo-Saxon, Protestant heritage. Boston ideals, shaped by the Revolutionary experience and later by Unitarianism and Transcendentalism, tended to uphold the dignity of the individual. While a

small number of European immigrants regularly arrived in Boston—usually on their way to other destinations—liberal Bostonians upheld the belief that the new-comers would be assimilated into the fabric of American life.[18]

The city was wholly unprepared for the overwhelming number of Irish refugees who began arriving at mid-century. More than any other American city, Boston bore the burden of the massive influx. With the British Cunard shipping line ter-minating at Boston Harbor, thousands upon thousands of indigent immigrants arrived—and stayed. By 1850, the foreign-born population was almost equal to na-tive Bostonians; in five years, the older inhabitants were outnumbered by 10,000. "By their immobility," writes historian Oscar Handlin, "the Irish crammed into the city, recasting its boundaries and disfiguring its physical appearance; by their poverty they introduced new problems of disease, vice, and crime, with which nei-ther they nor the community were ready to cope."[19] In the early years of this great transatlantic migration, Mayor Theodore Lyman articulated ethnic boundaries, declaring the Irish "a race that will never be infused into our own, but on the con-trary will always remain distinct and hostile." The immigrants, suspicious of Protes-tant agendas, tended to reject efforts by native New Englanders to reform or ac-culturate them to fit expected norms. Further, the sharp prejudice and sometimes violent acts directed against them during the height of the Know-Nothing move-ment hastened the development of a strong group consciousness. Segregated into densely populated slums in the peninsular city, the Irish established their own sys-tems of support through the Roman Catholic church, community organizations, fraternal clubs, labor groups, and a significant bloc in the Democratic party.[20]

After a brief period of stability following the Civil War, in which Irishmen fought with distinction for the Union, antagonisms reemerged in the last decades of the century. The Boston upper class felt the tipping of the balance of power as the Irish gained political strength. In 1884, Hugh O'Brien was elected the first Irish-born mayor. Reelected to four consecutive terms, he filled municipal posi-tions with Irish Catholic appointees and shocked the old elite by instituting such changes as closing the Boston Public Library on Saint Patrick's Day. By 1890, Irish Catholics dominated the government of nearly seventy Massachusetts cities and towns.[21]

Predictably, Brahmin society went on the defensive. Spurred by the energetic leadership of a group of newly graduated Harvard men in the late 1890s, the city soon became the nucleus of a nationwide movement to limit immigration into the United States. Massachusetts senator Henry Cabot Lodge sponsored the Immi-gration Restriction League in its massive—and ultimately successful—campaign to do so over the next twenty years. Through newspapers, magazines, pamphlets, and lectures, proponents alerted the public to the dangers of an unchecked "foreign element." Using pseudoscientific theories and statistics from census records that

indicated a declining Yankee birthrate, the league cautioned that the so-called American race could be subsumed by the more than one million aliens who were entering the United States annually. The old guard, no longer believing in assimilation, gave overwhelming support to the Republican party, whose platform consistently endorsed immigrant quotas.[22]

Although predicated on frustrations with Irish encroachment, the nativist crusade came to be directed against the immense wave of new immigrants, among them Italians, Greeks, Russians, Poles, Armenians, and Jews from many regions. The Latin and Slavic newcomers were perceived as even more alien than English-speaking Paddy and Bridget. Some of the Irish middle and working class, fearing economic competition from not only new immigrants but also Chinese and African American laborers, participated in the era's xenophobic and racist fever.[23] Nevertheless, powerful Irish leaders, including John Fitzgerald and James Michael Curley—men who controlled Boston's mayoral office in the early decades of the century—championed the arrival of new immigrants and actively opposed any federal restriction upon their numbers.[24]

An increasing number of Irish-born Bostonians and their children moved into skilled and white-collar jobs, and more and more became homeowners. Though making inroads into the middle class, they found themselves shut out of certain businesses, professions, private clubs and schools, and the "better" homes. Social mobility had become openly linked to ethnicity. With the growing glorification of Anglo-Saxon roots, Brahmins tended to make much of their well-documented British heritage. Gilded Age Anglophilia encouraged many to model their tastes and manners after the English aristocracy, a society disdainful of the Irish and their attempts to gain political control of their island homeland. The older Bostonians firmly blocked infiltration into their own private circle, which, at the end of the century, was highly exclusive and almost impenetrable. Within that insulated realm, the Irish figured primarily as they had in the previous four decades—as house servants.[25]

## *Maids Were Always Irish*

The presence of a liveried domestic or two was commonplace in Brahmin residences. Between 1880 and 1920, Boston households employed a higher number of servants per capita than those in other major U.S. cities outside the South—a ratio that increased in affluent neighborhoods.[26] In 1900, the *Massachusetts Labor Bulletin* published the results of a survey of 181 Boston homes that was conducted in an effort to determine the "social conditions in domestic labor." The statistics reveal that the typical servant was in her early twenties and labored alone as a maid-

of-all-work. She was almost always Irish by nationality (with Canadians a distant second), had a rudimentary grammar-school education, and was typically a practicing Catholic who went to one or two church services a week. Her employers paid her between $3.50 and $4.00 a week and gave her Thursday and Sunday evenings off. Over half of the servants had savings accounts, and two-thirds of them assisted others with their earnings.[27]

The young Irish domestic was also a fixture in the homes of the Boston School painters. The 1900 census indicates that three maidservants, two from Ireland and one from Canada, worked in Edmund Tarbell's Alban Street residence. In his most successful years, the painter was able to retain a large staff that included a gardener, cook, three maids, stable groom, and coachman. In 1900, Joseph DeCamp listed two live-in domestics, probably sisters, who had come from Ireland two years apart: Mary Lee, age twenty-five, and Margaret Lee, age twenty-three.[28] Philip Hale's household also included the customary assemblage of Irish women. According to his daughter, Nancy, the family employed a cook ("Bridie or Theresa or Norah who slept up in the room over the kitchen") and a general maid ("responsible for feeding the kitchen stove").[29] Accustomed to daily service, both the artists and their clientele would have expected and casually accepted the presence of liveried figures in paintings of upper-class interiors. Moreover, they would have made equally casual assumptions about the workers' ethnicity. "Maids were always Irish in those days," Nancy Hale recalled.[30]

The Irish Bridget was still ubiquitous in popular imagery. The immigrant maid continued to be the focus of ethnic jokes, derision, and employer frustration.[31] Late-century articles and books offered the standard litany of complaints. "If two matrons meet in the street, one cannot fail to catch the names of Bridget or Nora in their colloquy, for it is not beneath their dignity to sympathize upon a thing that has grown into an overpowering shadow upon domestic life," wrote Harriet Spofford in *The Servant Girl Question,* a manual for mistresses published in Boston. "When Bridget is good she is so very good, indeed, that enough cannot be said on the astonishing circumstance; and, like the little girl in the versicle, 'when she is bad she is horrid.'" The author elaborated,

> Viewed aesthetically, and we may say, of course, rather superficially, the exile of Erin is something all very fine to have in your house as an object of sympathy and compassion; but when the exile shatters the delicate edges of every piece of your best china set with rough handling, cracks your engraved glass, and melts the hafts off your knives with too hot water, scorches her sign manual on your table-clothes with too hot irons, burns your dinner to a crisp with neglect, pays no attention to gentle correction, shirks wherever shirking can be done, determined to get along with the least effort possible, spoils

Imaginativeness Large—Lamartine, a celebrated French poet and historian.

Imaginativeness Small—A babbler, an ignorant Irish woman of Edinburgh.

Fig. 6-4. Unknown artist, illustration in Joseph Simms, *Physiognomy Illustrated,* 6th ed. (New York: Murray Hill, 1887), p. 277.

more than she wastes, wastes more than she gives away, gives away more than she uses, and you pay her for doing it all . . . why, then you feel a right to look at her more critically than casually, and inevitably find yourself wishing she were an exile from America too![32]

Visual caricatures continued to employ the usual Irish facial features: broad forehead, beady eyes, and tiny pug nose. With new emphasis placed on race and eugenics at the end of the century, these physical distortions fed the notion of ethnic inferiority. Interest in physiognomy resurged in the last quarter of the century as Americans tried to define the "right type." Joseph Simms's handbook, *Physiognomy Illustrated* (1887), catalogues various ethnic and racial stereotypes—including African, Asian, Native American, and Irish—as examples of weak humanity. One illustration (fig. 6-4) pictures a woman with a monkeylike profile as a specimen of one who lacks "imaginativeness." The caption reads, "A babbler, an ignorant Irish woman of Edinburgh."[33] The cliché recurred most frequently in popular illustra-

Fig. 6-5. B. D. Piney, cartoon in *Harper's Bazar* 33 (12 May 1900): 124.

tions, advertisements, and cartoons. A drawing in *Harper's Bazar* (1900, fig. 6-5) shows a scrappy Bridget who gets news of her dismissal from the family pet. The caption explains, "Everyone wondered what Meekly wanted with a prize bull-dog, when his cook could scare any tramp that ever walked. The trouble was she scared Meekly too!"

In looking at the representation of domestics in the Boston School paintings, one can hardly discern the rampant prejudice still being directed against the Hibernian sisterhood. For the most part, workers are portrayed as the best servants in the best of all possible worlds. However, when examined "more critically than casually," in Spofford's words, the images subtly underscore upper-class fears and desires concerning foreign laborers.

## The Business of Cleanliness

At the end of the century, a desire to rationalize domestic service grew out of the overwhelming dissatisfaction that had developed on both sides of the working re-

lationship. In keeping with Boston's long tradition of social philanthropy and re-
form, a women's group was established to study the city's servant problem. The
Domestic Reform League identified issues similar to those articulated in previous
decades: few native-born white women entered service, which left the work to ill-
trained immigrants who tended to go from position to position. Over the next
twenty years the organization made surveys, published reports, sponsored lectures,
established training schools, and set up employment agencies. The reformers at-
tempted to redefine and promote the occupation in a more positive light in an
effort to attract a larger and better qualified labor pool.[34]

Ultimately, their success was limited, but such Progressive Era endeavors kin-
dled new dialogue. Professor Lucy Salmon, who used several Massachusetts labor
surveys in her 1897 treatise, *Domestic Service,* asserted that the quality of workers
could not be improved until homemakers themselves achieved a working knowl-
edge of household labor.[35] Harriet Spofford, on the other hand, argued that it was
"preposterous to expect ladies and scholars and women of wealth to educate them-
selves as kitchen girls." The Boston writer advocated the use of training schools
where workers would learn not only cooking and cleaning skills but also neatness,
precision, and frugality. Through practical education and the inculcation of middle-
class values, they could then be molded to meet employer expectations. Spofford
exhorted both maid and mistress, "Be good and know your business, and you will
be happy."[36]

The Boston School paintings exhibit the promised results of such improved
and approved efficiency. The viewer is shown polished floors and furniture, swept
carpets, sparkling silver, and dust-free porcelain. Meals are silently prepared and
served; tea trays are delivered and taken away on cue. In some respects, the sani-
tized spaces are microcosms of the Brahmin ideal of a well-ordered society in which
all know their business. The paintings display the material results of a man's steady
income and a woman's skillful capabilities as homemaker—not as the performer
of the labor, but as the supervisor of hired workers.

Domestic order was linked to social order. In a 1902 article, "What a Mother
Can Do for Her Daughter," Lavinia Hart described the broader implications of
housekeeping:

Culture is cleanliness. It is thoroughness. It has to do with clean linen, as
well as clean morals. It stands for the lack of smut behind actual doors, no less
than behind the inlets and outlets to character. . . . Its influence is as strong in
interviews with the cook as with the King. Its magnitude increases and its
power is as keenly felt in the judicious guiding of the fall house cleaning, as it
is in the presiding chair of a club for the liberal arts. . . . the woman who is fa-

Fig. 6-6. Philip L. Hale (1865–1931), *A Family Affair,* 1916, oil on canvas, 30 × 36 in. (76.2 × 91.4). Los Angeles County Museum of Art; gift of Mr. and Mrs. Hoyt Pardee.

miliar with, and conducive to, the welfare of every department of her household is she who can abandon herself in the drawing-room.

Hart advised readers to allow their daughters "to supply the larder, to direct the servants, to arrange the menus, and to take temporary charge of the household regime."[37]

Philip Hale's painting *A Family Affair* (1916, fig. 6-6), portrays three generations through which such a supervisory torch will pass. The bustling servants attest to the silver-haired matriarch's skillful command over home and subordinates. Family visitors enter her parlor to find an impeccably clean room with highly polished, colonial-period furnishings.[38] As the older woman holds out her arms to receive flowers from her small granddaughter, a maid in gray-and-white livery quietly adjusts a shawl about her mistress's shoulders. In the background, another uniformed domestic arranges the damask-covered table. The well-trained workers

perform their duties without recognition and without intruding upon the small celebration that is, the title reminds us, a family affair.

Late-century reformers often pointed to social isolation of the live-in domestic as one of the major disadvantages of service. "Industrially her position is peculiar," stated a 1900 labor report. "She is in the family, but not of it."[39] Boston author Helen Campbell recorded workers' reactions to the enforced sense of invisibility. One woman, though finding her circumstances comfortable and her salary good, left service for a factory job. Her chief complaint was the humiliation of being ignored. Each evening, she related, father and son would enter the house and, without word or glance, stand expectantly before her to have their coats removed. Another former domestic said of the family she had served, "Except to give orders, they had nothing to do with me. It got to feel sort of crushing at last. I cried myself sick, and at last I gave it up, though I don't mind the work at all."[40]

*A Girl Sweeping* (fig. 6-1) captures a sense of the servant's isolation in Paxton's portrayal of a solemn chambermaid working alone. The soft light suggests early-morning labor; the hush of the empty room intimates a still-sleeping family upstairs. Rising before daybreak, housemaids were expected to accomplish several chores before the mistress came down. The daily cleaning of main-floor rooms began with the servant's removing ashes from fireplaces, cleaning grates, and sweeping carpets and floors with stiff horsehair brooms.[41] If it was lonely labor, it was also physically difficult. Although Paxton's dainty model has lifted the bulky carpet onto a table in the foreground, she appears spotless and tidy. While holding the broom, the maid stands in a quiet, restful pose. There is little indication of the strenuous effort required to accomplish what one household writer described as "the hardest torture of the week." To protect their health when sweeping, the author advised workers to tie a scarf over nose and mouth and to alternate the job with other, less demanding tasks.[42]

Two middle-class writers who entered service for a limited time described their own efforts at chamber work at the turn of the century. Lillian Pettengill discovered that it took her an hour and a half just to sweep the dining room carpet.[43] Similarly, Inez Godman spent two hours one morning cleaning a sitting room to her mistress's specifications: "I could not finish in less time. Everything had to be carried into the adjoining room, and there was much china and bric-a-brac; the carpet was new and heavy, and there were inside blinds each slat of which my lady wished dusted separately. Five times during the two hours I was called off by the door bell and twice I went down to look after my bread."[44] By noon, Godman had been on her feet for seven straight hours. Nevertheless, she worked steadily through the rest of the day, stopping in late evening after the dinner dishes had been washed. She, like Pettengill, described aching limbs, hands, and painful, throbbing feet. Both women believed that their bodies would grow accustomed to the

strain of domestic labor, but Godman admitted, "Instead of toughening I was breaking; each week I lost something that I did not regain." Through her experiences, she became convinced that daily drudgery took a physical toll on workers. "Norah used to be pretty," Godman quoted an oblivious upper-class mistress, "but these Irish girls don't keep their good looks."[45]

## Surveillance—in Both Directions

If some servants felt discounted or isolated, others were all too aware of the unwavering and critical eye of employers. During job interviews, Pettengill experienced the sharp gaze of potential mistresses, "from top to toe . . . for all the world as if I were a prize cow for sale."[46] Inside the household, the scrutiny often continued as servants made their way through their regular routine of cleaning rooms, preparing and serving meals, washing dishes, answering the door, doing the laundry, and running errands. Experienced domestics were careful to pace themselves, but they also learned to stay occupied even between chores. One servant explained, "A smart girl keeps on her feet all the time to prove she isn't lazy, for if the mistress finds her sitting down, she thinks there can't be much to do and that she doesn't earn her wages. Then if a girl tries to save herself or is deliberate, they call her slow. They want girls on tap from six in the morning till ten and eleven at night. . . . And then, if there's a let-up in the work, maybe they give you the baby to see to."[47]

Freely watching Paxton's chambermaid as she sweeps, the viewer also assumes such a supervisory role. Covert observation may verify not only that she undertakes the task but also that she goes about it properly. The attractive worker, available for appraisal "from top to toe," appears dutiful and compliant. This invitation to watch underscores the general notion that the worker herself, not just the service she performs, is subject to unlimited surveillance.[48]

There were other reasons for ongoing employer scrutiny. The servant was seen as a representative of the lower class in the home, and so a servant's character was always in question. Household workers were the first to come under suspicion when something was missing. Should a theft be reported, the common assumption among officials was that "the servant did it"—an attitude that produced the proverbial guilty butler. Some domestics deserved investigation, yet household workers did not as a whole constitute a criminal class, despite the abiding aura of dishonesty that popularly enveloped them.[49] Pettengill described her surprise at finding loose coins as she moved carpets for sweeping. After completing the chore, she returned them to their original location. An older servant later explained that the mistress planted money around the house to test the servants' integrity.[50]

In *The House Maid,* by Paxton (1910, fig. 6-7), the viewer catches a liveried maid as she peers intently into a book. The telltale feather duster tucked under one arm

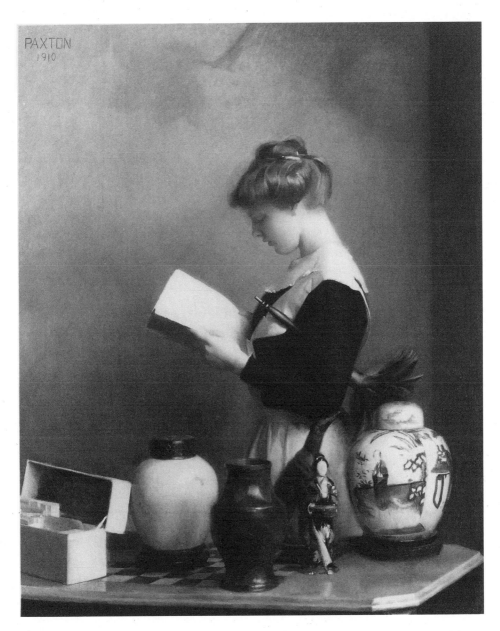

Fig. 6-7. William McGregor Paxton, *The House Maid,* 1910, oil on canvas, 30¼ × 25⅛ in. (76.8 × 63.8 cm). Collection of The Corcoran Gallery of Art; Museum purchase, Gallery Fund.

implies neglected duties. Standing in profile before a solid brown wall, the figure becomes the apex of a triangular composition formed with a horizontal arrangement of ceramic objects on the table before her. As in *A Girl Sweeping,* Paxton places the maid with her back to the light source so that her face falls into soft

shadows. At center, the bright pages of the book float against the darkness. The wayward housemaid is an exception to the well-behaved servant figures who typically populate the Boston canvases. The image resurrects the specter of the "eye-servant" who shirks chores behind the employer's back. Inez Godman, in her chronicle of servant life, confessed that she took advantage of her mistress's absence one day to rest in the sitting-room armchair. For an hour she browsed through magazines on the table. "Ah, madam," she addressed the reader, "I can see your chin rise."[51] No matter her need for a break from labor, she knew the general censure such a liberty would bring.

Beyond the lapse in duty implied in Paxton's painting, there remains the question of the object of the maid's examination. As she scans the book, she also stands before an open file box, indicating that she is in her employer's office and, perhaps, surreptitiously into his or her effects.[52] Does Paxton portray the conventional snooping servant, or is this an image of a lower-class woman who seeks to educate herself when the opportunity arises? Whatever the perceived motive for the maid's behavior, a contemporary audience might have forecast unpleasant consequences from the breach of protocol.

As in ages past, turn-of-the-century employers feared servant gossip. Personal boundaries were vague for workers who had access to the private rooms and activities of employers. Unavoidably privy to conversations and functions, domestics experienced circumstantial familiarity with the family. Such a bright-eyed, curious servant could learn and pass on embarrassing information. The same year Paxton completed *The House Maid,* Charlotte Perkins Gilman addressed the problem of privacy in a household with servants:

> Private?—a place private where we admit to the most intimate personal association an absolute stranger; or more than one? Strangers by birth, by class, by race, by education—as utterly alien as it is possible to conceive—these we introduce in our homes—in our very bedchambers; in knowledge of all the daily habits of our lives—and then we talk of privacy! Moreover, these persons can talk. As they are not encouraged to talk with us, they talk the more among themselves; talk fluently, freely in reaction from the enforced repression of "their place," and, with perhaps a tinge of natural bitterness, revenging small slights by large comment.[53]

One of the villains of Edith Wharton's 1905 novel, *The House of Mirth,* is an observant charwoman who extorts money for information. She is first introduced as she wipes down the stairs of a New York apartment building on her hands and knees. Observing Lily Bart's departure from a gentleman's residence, the servant later blackmails the aspiring socialite with love letters retrieved from a garbage can. In her dealings with the worker, Lily "felt herself in the presence of some-

thing vile, as yet but dimly conjectured—the kind of vileness of which people whispered, but which she had never thought of as touching her own life." She impulsively purchases the incriminating scraps, which were not hers but a married rival's. In the end, Wharton's heroine—socially isolated and as desperate for money as the cleaning woman—finds she cannot lower herself to commit the vile act of blackmail herself.[54]

## Studies in Contrast

The charwoman in *The House of Mirth* is portrayed as the opposite, socially and physically, of the radiantly beautiful Lily Bart. Where the slender Lily is described as having a porcelain smoothness and "purity of tint," the stout domestic has "a broad sallow face, slightly pitted with small-pox, and thin straw-coloured hair through which her scalp shone unpleasantly."[55] The lovely maids in the Boston paintings are far more attractive than Wharton's threatening worker, yet they too serve as foils. In work aprons or livery, with sleeves rolled up and hair caught back in mobcaps or buns, they strike a balanced rather than incongruent note in the elegant interiors. Visually, the rooms become more luxuriant and objects more precious for having the worker in their midst. The color of carpets, porcelains, and food appears richer in contrast to the black or muted gray of work clothing. In much the same way, genteel mistresses appear more refined and delicate when juxtaposed with their maids.

In an interior scene executed about 1903 (fig. 6-8), Tarbell pictures what a contemporary critic described as "a breakfast-room of the well bred."[56] At bottom right, a seated couple is portrayed lingering over their morning meal. The young wife, still tousled from bed, wears a loosely draped dressing gown that reveals a daring amount of shoulder and bust. She props her head with her hand and, arrested in thought, looks down at the table. Her spouse, fully dressed in a black business suit and bow tie, carefully peels the orange he has impaled on a fork. Self-absorbed or self-conscious, the two do not look at each other.

A great expanse of polished floor separates the couple from the room's back wall. There stands a maid, framed by an open doorway to the adjoining pantry. Sketchily defined in black-and-white livery, she reaches up to retrieve something from a cabinet.[57] A Japanese screen, the demarcation between family and service spaces, has been momentarily moved aside so that she may pass through to attend the silent couple. Morning light, shining through the venetian blinds of the pantry window, is reflected in the gleaming hardwood floor and illuminates the servant's path to the table. The worker is clearly the third party, the stranger who is admitted "to the most intimate personal association" in the name of convenience and leisure.

Fig. 6-8. Edmund C. Tarbell (1862–1938), *The Breakfast Room,* ca. 1903, oil on canvas, 25 × 30 in. (63.5 × 76.2 cm). Courtesy Pennsylvania Academy of the Fine Arts, Philadelphia; gift of Clement B. Newbold.

Perhaps her presence silences communication between husband and wife.

*The Breakfast Room* drew positive comment in 1904, including an enthusiastic review that called it "one of the best modern interiors ever painted." The writer associated the painting not only with the earlier Dutch images but also with canvases by the contemporary French artist Edgar Degas.[58] Tarbell, at this time still feeling the pull of impressionism, employed a light palette and broken brushwork to create the rose-toned scene. The large, empty floor space rises up at a sharp, thrusting angle. Bold asymmetrical balance and the dramatic cropping of the man at bottom right reveal the artist's study of both Degas and Japanese woodblock prints (two of which are pictured on either side of the doorway). The painting, also known as *The Studio,* presents a sampling from a diverse art collection. Displayed along the back wall with the Japanese screen and prints are an Italian Re-

Fig. 6-9. William McGregor Paxton, *The Breakfast,* 1911, oil on canvas, 28 × 34 in. (71.1 × 86.4 cm). Photograph courtesy of Jordan-Volpe Gallery, New York.

naissance bust, a copy of Titian's *Venus and Dog with an Organist,* and a Velázquez-like portrait of a soldier.[59]

Eight years later, Paxton produced his own version of the theme in *The Breakfast* (1911, fig. 6-9). Like his friend's earlier canvas, Paxton's painting pictures a fashionable couple being served their morning meal by a uniformed maid. The young wife wears a soft, pale pink gown trimmed with satin. A basket of cut flowers sits next to her on a table in the left foreground; its delicate blossoms seem to refer to the gossamer ruffles of her dress. At right, a brunet maid in livery has turned from the couple and, tray in hand, briskly leaves the room. All is not right in the pristine, fragrance-filled room. Ignoring the repast laid out before her, the wife turns sideways in her chair. Head on hand, she stares toward the floor while her husband reads his newspaper. When *The Breakfast* was pictured in the *Ladies' Home Journal* in 1913, the editors interpreted the wife's pensive expression as a reaction to "the-newspaper-at-breakfast stage" of marriage. It conveys the bride's realization,

Fig. 6-10. Harrison Fisher
(1875–1934), *A Morning Greeting*,
1904, published in *The Harrison
Fisher Book* (New York: Charles
Scribner's Sons, 1907).

they wrote, "that the days of her husband's courtesy to her and consideration for her are over."[60]

Both canvases communicate separate gender spheres in which the husband's attention is drawn to the outside world—signified by the newspaper or business suit—and his wife is left to the concerns of the cloistered realm of the home.[61] Alienation between figures, accentuated by the spatial tension of formal composition, evokes an atmosphere of ennui, melancholy, and emotional distance. Domestic tensions seem to increase with the addition of the servant figures. Unlike the mistresses and servants in Vermeer's paintings, who exchange intimate conversation and meaningful glances (fig. 6-3), the women in the Boston canvases do not communicate. The servants, framed by or near doorways, are placed at some distance from the petulant young wives. This separation contributes to the atmosphere of household discord. In 1910, *McClure's Magazine* described a fierce battle taking place in homes across the United States: "On one side are ranged a million housewives, fighting for the ordered comfort of home. On the other side is a ragged army of conscripts, working joylessly, struggling hopelessly, deserting whenever

Fig. 6-11. Unknown artist, advertisement for Aluminum Cooking Utensil Company, published in *Cosmopolitan* 36 (January 1904).

possible, shirking when desertion is impossible. Naturally, mistress blames maid; and, also naturally, maid blames mistress."[62] This perpetual friction, Helen Moody argued in *The Unquiet Sex* (1898), stemmed from "the constant action and reaction of the one class upon the other."[63]

The juxtaposition of server and served produces a dynamic visual dialogue. Dark foreigners—brunet and in the dark broadcloth of livery—offset blond Anglo-Saxon ladies whose air-spun, pastel gowns announce their exemption from physical labor. The contrast of active worker with passive mistress, labor with leisure, appeared with some regularity in advertisements and illustrations. Harrison Fisher's 1904 cartoon titled *A Morning Greeting* (fig. 6-10) portrays a uniformed domestic who serves morning tea. Her young mistress, swathed neck to toe in ruffles, smiles as she reads the note from a box of long-stemmed roses that has just arrived. This is the morning greeting to which the title refers, not an exchange between mistress and maid. Back to back, they focus on their respective concerns. An advertisement for aluminum saucepans, published in *Cosmopolitan* the same year (fig. 6-11), employs a similar back-to-back motif. The reader learns that by purchasing the proper

Fig. 6-12. Unknown artist, advertisement for Standard Sanitary Manufacturing Company, published in *Cosmopolitan* 36 (April 1904).

cooking utensils for her servant, she can "make heavy housekeeping light" and retire to her powder puff and mirror. The liveried housemaid, in turn, smiles happily at her own reflection in the bottom of the shiny new pot. In painted representations and popular images alike, the servants are adjuncts to their employers. Their labor both supports and magnifies the privileged status of the mistress.

### Personal Service

In some of the Boston images, servants function as lady's maids—those specialized workers who render assistance with personal hygiene and grooming. The job was a demanding one that required the domestic to display round-the-clock skills as hairdresser, dressmaker, wardrobe attendant, resident apothecary, and companion.[64] Wealthier households sought and acquired highly coveted European maids to attend the mistress. Within the large staff of his boyhood home in Boston, historian Samuel Eliot Morison remembered the lady's maid as having been "always

Good morning, Carrie. Thank you for bringing the Hunyadi János. Always be sure to get **Hunyadi János** (full name) and bring two glasses. My husband takes it before breakfast—half a tumbler. It always relieves him of **Constipation** as it does me of biliousness.

Fig. 6-13. Unknown artist, advertisement for Hunyadi János, published in *Cosmopolitan* 34 (March 1903).

French or Swiss-French, so that my grandmother and mother could keep up their proficiency in that language." Pettengill, whose own experiences were limited to general housework, noted that lady's maids were usually found in "the bigger houses." The higher servant position provided a larger wage and a promotion of sorts for aspiring domestics, though, Pettengill sniffed, "how can anybody care for such work as personal waiting upon an able-bodied adult who ought to wait upon herself."[65]

Popular imagery did not shy away from the intimate duties required of personal servants. In magazine illustrations and advertisements, domestics were frequently pictured attending to the bodily care of the family.[66] They casually enter private spaces where members are in various stages of dishabille. The uniformed domestic in a 1904 Standard porcelain ad (fig. 6-12) is likely as responsible for cleaning the bare-bottomed child perched on the tub's edge as she is for maintaining the "snowy purity" of the new bathroom fixtures. A 1903 cartoon for Hunyadi János elixir (fig. 6-13) shows the entrance of a liveried domestic into her employers' bedroom. The

Fig. 6-14. Unknown artist, advertisement for Seven Sutherland Sisters, published in *Cosmopolitan* 34 (March 1903).

caption indicates that the tonic she brings on a silver tray will relieve her half-dressed mistress of biliousness and her master, who stands by in his robe, of constipation. More plentiful are the images of lady's maids who assist the mistress with bathing and dressing. In a 1903 advertisement, a lady watches herself in the mirror as she receives a shampooing with Seven Sutherland Sisters scalp cleaner (fig. 6-14). The logo announces, "It's the hair—not the hat that makes a woman attractive." While tending her mistress's luxuriant long hair, the uniformed servant covers her own with the requisite hat of her profession.

In two canvases by Tarbell, *The Bath* and *Interior*, there is clear visual differentiation between mistress and lady's maid. If the artist had not pictured the servants in aprons, their poses—kneeling on the floor before the lady of the house—would still clearly imply subordination. In the first painting, the domestic is pictured drying the mistress after her bath; the maid in the other scene is shown brushing her employer's long hair. In both images, the mistress sits passively while she receives the painstaking ministrations of her hired attendant.

Visually floating on a white sheet, the nude woman portrayed in *The Bath* (1893,

Fig. 6-15. Edmund C. Tarbell, *The Bath,* 1893, oil on canvas, 40 × 30 in. (101.6 × 76.2 cm). Present location unknown; illustrated in *The Bostonians: Painters of an Elegant Age,* Museum of Fine Arts, Boston, exhibition catalogue, 1986; photograph courtesy Museum of Fine Arts, Boston.

fig. 6-15) leans back on her cushioned sofa in an almost regal pose. Her servant, crouching on the floor between sofa and basin, leans forward to towel the bather's body. The maid's back is to the viewer and her face is hidden. Displayed frontally, the mistress modestly raises one leg to conceal her genitals, while she extends the other to dangle a foot in the shallow water of the tub. Her torso and breasts are vaguely defined by a flurry of small brushstrokes. In delineating the nude in this manner, Tarbell diminished the sensual overtones of the intimate boudoir scene.

The theme of bather and servant goes back several centuries in the Western tradition of art. Its treatment includes classical images of Venus or Diana and biblical motifs of Susanna or Bathsheba at their baths. Separated from traditional narrative contexts by eighteenth-century genre artists like Jean-Antoine Watteau, the theme became more erotic in nature. There followed the production of hundreds of French paintings, drawings, and prints that depicted nude or partially nude women being assisted at their bath by their maids. In them, there is an element of homage as the servant offers—and elicits from the viewer—admiration for the woman she attends. The maid sometimes becomes an accessory to the voyeuristic desires of a hidden suitor as she knowingly reveals her mistress's physical charms. The viewer

is also implicated as an unseen witness to the bath. In the nineteenth century, the subject was claimed by realists such as Gustave Courbet, Edouard Manet, and Degas. By the turn of the twentieth century, it was a common theme in the images of the French intimists.[67]

With *The Bath* Tarbell may have been recreating the 1870 painting *La Toilette* (Montpellier, Musée Fabre), by Frédéric Bazille. The earlier French canvas pictures a nude woman whose slippers are being removed by a kneeling black attendant. The African servant wears a turban and striped towel about her waist.[68] In the composition, Bazille contrasts dark flesh against light. The servant's face is silhouetted against the bather's breast; in turn, the mistress's white hand shows brightly on the maid's bare shoulder. Tarbell produced a more conservative scene for his audience—Americans with a low tolerance for either nudity or overt sensuality.[69] He transformed the half-dressed black servant into a white lady's maid who, fully clothed, wears a light-colored patterned dress with a white apron and cap. Her mistress, showing little interest in the proceedings, does not return the worker's touch.

*The Bath* was favorably received in 1893 when it was awarded the Shaw Fund prize at the annual exhibition of the Society of American Artists. Despite Tarbell's attempts to soften the theme, however, some reviewers complained that he did not provide "the charm which one expects in such a subject to relieve its animality."[70] In choosing the theme, Tarbell may also have been recalling the many paintings and pastels of bathers made by Degas in the 1880s and 1890s, the years when the young Bostonian was in Paris as a student. Art historian Eunice Lipton has argued that Degas's contemporaries identified his bathing scenes with brothel activities. Degas sometimes included the figure of a man in his boudoir interiors. More frequently, he pictured a maid whose clothed figure contrasts with the stark nudity of the woman she grooms.[71] It is unlikely that Tarbell was intentionally representing a prostitute when he created *The Bath*. Yet judging from contemporary criticism concerning the painting's "animality," it appears that he could not separate the theme from its association with the demimonde. In 1901, Sadakichi Hartmann described the canvas as featuring "a life-size nude, rather coarsely painted after a model of the lower classes."[72]

Tarbell retreated from the erotic overtones of this canvas when he produced *Interior* (fig. 6-16) around 1900. In the sequestered, dimly lit scene, a kneeling maid brushes the hair of her fully dressed mistress. The women are sketchily painted; Tarbell pays equal attention to the play of light across the floor in the bottom half of the canvas.[73] A gaping space is imposed between the viewer and the small figures, who are pushed against the distant wall. Bernice Kramer Leader has observed, "The erotic implications of the motif and the model's odalisque-like pose are tempered by her fully clothed appearance and her physical remoteness. The vast empty

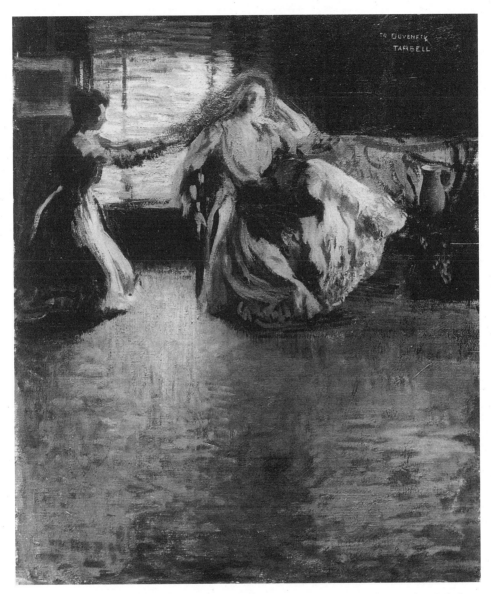

Fig. 6-16. Edmund C. Tarbell, *Interior*, ca. 1900, oil on canvas, 29½ × 24½ in. (74.9 × 62.2 cm). Cincinnati Art Museum; gift of Frank Duveneck.

space may indicate the artist's uneasiness in the presence of an intimate feminine act, and his need to keep the figures remote and untouchable by creating a physical distance between himself and them."[74] Tarbell also institutes a wide space between the two women. The mistress turns away from her kneeling attendant. Only by

fully extending her arms can the maid reach across the distance to brush the ends of the reclining woman's hair.

## Working-Class Eve

The fresh, spotless domestics who grace the Boston canvases seem detached from the messy realities of service. Yet the uniformed figures could not have been entirely disassociated from the labor they represent. Whether sweeping floors or attending the personal needs of a mistress, household laborers were paid to handle and remove the unappealing evidence of a family's daily life. By association, the workers themselves were perceived as somehow tainted—physically and morally—through their unavoidable contact with dirt. Social historian Phyllis Palmer's study of domestic service describes a long-standing psychological correlation of dirt with impurity. She notes that "women who clean up things associated with bodies find themselves mysteriously deemed sexual and powerful regardless of their actual social status." In a culture where a good woman was physically and morally pristine, what else could a dirty woman be but bad?[75]

As in previous decades, snooping and stealing were not the worst transgressions laid on the reputation of servants. As a class, they were still suspected of sexual misconduct. In 1893, Helen Campbell wrote that "household service has become synonymous with the worst degradation that comes to woman." Though sympathetic toward wage-earning women, the Boston reformer contended that "domestic service is the cover for more licentiousness than can be found in any other trade in which women are at work."[76] Such perceptions contributed to the ongoing incidents of sexual harassment and abuse directed against female servants. Workers had to contend with leering glances, pinches, touches, lewd comments or gestures, and sexual violence. One factory worker described for Campbell the tragic circumstances of her fifteen-year-old daughter. Raped by a banker in the boardinghouse where she worked, the young maid reported the attack to her mistress. "Such things don't happen unless the girl is to blame," the worker was told before being fired and hustled out the door.[77] With their economic survival at stake and their credibility already in doubt, servants had few options in these unhappy circumstances. Generally, a woman's only recourse was to quit her job, usually without hope of a reference.

Some servants, out of infatuation, ambition, or loneliness, became willing participants in romantic liaisons with employers or their sons. Because of the sharp divisions between workers and the people who hired them, however, domestics rarely married into their employers' families. When a relationship had the unusual outcome of matrimony—as in the 1897 marriage between Dr. G. F. Cadwalader

and his housemaid Bridget Mary Ryan—it was treated by society and the press as an oddity and foolishness.[78] Theodore Dreiser explored the social taboo in his 1911 novel, *Jennie Gerhardt*. The title character is a chambermaid who is seduced, financially and physically, by two men, a United States senator and a millionaire. Jennie, described as "lady-like and lovely," draws the attention and pity of these men, who give her money to support her poor (German) immigrant family. Inconveniently, the senator dies before marrying the pregnant maid. When the millionaire assumes her financial support and becomes her lover, he proclaims, much like his predecessor, "You belong to me." Unwilling to marry beneath his station, he nevertheless brings Jennie into his home; when the relationship threatens his inheritance, he abandons her. Although Jennie remains financially cared for, her only comfort comes at the end of the story when her remorseful lover calls her to his deathbed to ask her forgiveness.[79]

Young household workers exuded an earthy attraction in popular imagination, especially in comparison with the cool and remote ideal of Victorian womanhood. In her 1880 essay, "The Women of Boston," Ednah Cheney described the well-bred Boston lady as capable of great nervous force and energy. However, she continued, she is "more intellectual than passionate, her impulses are under control; and she is reserved and cold in manner, while a gentle purity inspires confidence even before it awakens affection."[80] What Cheney defined as cool control, Henry Adams characterized as prudishness. In his 1907 autobiography, the Brahmin-born historian lamented the sexless state of "proper" American womanhood. He believed that modern society had grown ashamed of feminine sexuality—to him, a vibrant life force that had sustained and nurtured earlier societies. In a culture now driven by technology, the "American Venus" had become an impossibility. The "monthly-magazine-made American female," he wrote, "had not a feature that would have been recognized by Adam. The trait was notorious, and often humorous, but anyone brought up among Puritans knew that sex was sin."[81]

If middle- and upper-class females were viewed as distant, self-controlled, or, to some, repressed, immigrant servants carried the dubious reputation of being nearly irresistible. Popular imagery was fairly explicit on this point. Beginning in 1900, a series of ten stereograph cards were produced that depict the illicit embraces of a flirtatious cook and the man of the house (fig. 6-17). As the photographic narration unfolds, the master cautions the laughing servant to keep quiet when the mistress approaches. Floury hand prints on the back of his dark jacket ultimately give them away. The mistress discharges the servant and replaces her with a grim-looking cook, ending further dalliances in the kitchen. The series was so popular that eight stereograph competitors made their own versions of the same titillating melodrama, with several editions published between 1900 and 1930.[82]

Had the mistress been careful and discerning in the first place, such an attractive

Fig. 6-17. Unknown photographer, *Oh! How Dare You, Sir!* ca. 1900, stereographic card, $3\frac{3}{8} \times 5\frac{7}{8}$ in. (8.6 14.9 cm). Division of Photographic History, National Museum of American History, Smithsonian Institution.

servant would never have been hired. This is the situation portrayed in a 1903 cartoon by Charles Dana Gibson (fig. 6-18) showing a beautiful worker who interviews for a position with an affluent couple. She has been rejected by the stern-looking wife; her comely appearance is the obvious reason "why she didn't get the place." The caption elaborates, "The man behind the paper ventured the opinion

Fig. 6-18. Charles Dana Gibson (1867–1944), *Why She Didn't Get the Place,* published in *Life* 41 (2 April 1903): 298–299.

that she might do." Gibson, a Boston-born illustrator, studied in New York at the Art Students League, where he was a classmate of Philip Hale's in the early 1880s. Soon afterward, he became a regular contributor to *Life* magazine and gained wide acclaim as the creator of the visually perfect Gibson Girl. With biting humor, Gibson often lampooned the presumed air of superiority affected by the urban elite and championed the plight of the working class.[83]

Among the Boston School canvases, Paxton's painting *The Breakfast* (fig. 6-9) hints at the sort of domestic triangle that was being played out in novels, stereographic photos, plays, and cartoons. Tension between mistress, husband, and maid is obvious, but its source is ambiguous. A Boston critic, on seeing the painting in a 1911 exhibition, noted, "A domestic storm-signal may be said to be flying, though the man of the house does not notice it. A demure maid, in black, is just leaving the room and her back says as plainly as words could express it: 'I know my business and this is none of it.'"[84] The young wife, in unhappy reflection, is the only one whose face is clearly shown. The husband's face is cut oddly at the eyes by the corner of his newspaper; the maid's is hidden by shadows. Like the Boston reviewer, the spectator may read the image as a marital tiff beyond the business of the maid. However, the two averted faces also suggest that the servant might be more involved in the situation than the mistress realizes.

## *Shown to Advantage*

Among the material properties that grace the softly lit interiors of the Boston School paintings, the attractive maids are presented as if they, too, are household accessories.[85] Much like the figures of their leisure-class mistresses, the servants are

highly objectified. Yet their status as hired workers underscores the implication that they, too, belong to the house as purchased acquisitions.

Paxton's images are imbued with a sensuality that is less obvious in the paintings of his colleagues. Carefully posed among beautiful accessories, his servant figures are presented for the viewer's delectation. The young worker in *The House Maid* (fig. 6-7) is displayed in much the same manner as the still-life items lined up before her. The soft curves of her aproned bust and abdomen are echoed by the rounded shoulders of the Chinese ginger jars on either side of her hips. The attractive figure prompted one enamored reviewer to describe her in sensual terms: "'The House-maid' is a very pretty, young girl with fine figure shown very much to advantage by her dress. Her face in profile and long neck are tenderly painted. Her hair catching the light looks soft and glossy."[86]

Though the housemaid is turned in profile, a small Japanese figurine of a female musician—most likely a geisha—has been positioned to engage the viewer directly. In Japanese culture, the geisha employed her skills as a musician, dramatist, and raconteur to entertain men in special houses where they gathered to socialize and conduct business. She was always meticulous in the arrangement of her hair and dress in order to be visually pleasing to the clientele.[87] If the Boston audience did not fully grasp the social function of the geisha, it could certainly appreciate the careful beauty of the small ceramic figurine. Several of the Boston School patrons were also collectors of Asian artifacts and were practiced at exploring their aesthetic qualities of pattern, color, and costume.[88] By including the Japanese figure in the foreground, Paxton invites his viewers to explore similar ornamental characteristics in the housemaid. Both are possessions of the house, but which would be more valuable in the eyes of the beholder? A quick, informed glance could have confirmed that the figurine cost considerably more than the typical maid earned in a lifetime. Of the two, it is likely that only the small porcelain figure would have been considered irreplaceable.

Another figurine comes into play in *A Girl Sweeping* (ca. 1912, fig. 6-19), Paxton's smaller version of the earlier canvas of that name (fig. 6-1). The fair-haired chambermaid sweeps a sitting room with a push broom. She wears a light-blue pinafore apron, white shirt, and mobcap. Like the servant in the previous painting, she turns away from the light source as she bends to her task. Paxton pictures a Sheraton-style sidetable in the foreground that holds a ceramic bowl and ginger jar. There is also a small, classically styled statuette of a nude woman. Although portions of its arms are missing, it appears that the twisting figure is shielding its face in a gesture of modesty.

This small sculpture was identified by Paxton as "Phryne" when he pictured it again in a later painting.[89] The prop seems to be a copy of a figurine by Paxton's famous teacher, Gérôme, based on his celebrated Salon painting *Phryné before the*

Fig. 6-19. William McGregor Paxton, *A Girl Sweeping,* ca. 1912, oil on canvas mounted on board, 17¼ × 14¼ in. (43.8 × 36.2 cm). Collection of Mrs. Harry Mallinson.

*Areopagus* (1861, Hamburg Kunsthalle).⁹⁰ The subject was a famous courtesan and artist's model of ancient Greece, renowned for her perfect features. Accused of impiety, the woman was brought to trial. When her counsel exhausted his arguments on her behalf, it became apparent that Phryne would be condemned to

death. As a last resort, the defender tore off her clothing to display her breasts. The judges, moved to tears at the sight of Phryne's stunning beauty, acquitted her. "As a matter of fact," the historian Athenaeus rounds out the story, "Phryne was more beautiful in the unseen parts."[91] Near the exquisite form of Phryne, Paxton has placed the figure of the young chambermaid. Soft light illuminates the worker's neck and dimpled arm as she quietly sweeps. Though the servant is fully dressed in work clothing, her profile reveals a curvaceous and uncorseted body. The viewer is invited to ponder if the woman's "unseen parts" might resemble those clearly displayed by the nearby statuette.

For these interior scenes, Paxton attempted to recreate the themes, compositions, and technical approaches he discovered in the work of Vermeer. Bernice Kramer Leader contends that he and the other Boston School artists interpreted Vermeer's female figures as virtuous, wholesome women: "They had no idea that many of [the women] were involved in erotic situations, or were even prostitutes."[92] Nevertheless, their latter-day versions still carry the eroticism encoded in the earlier Dutch prototypes. Edward Snow, in his study of Vermeer, describes the sexual undercurrents in paintings such as *The Milkmaid* (ca. 1658–1660, Rijksmuseum, Amsterdam). The image depicts a kitchen maid who pours milk from a pitcher into an earthenware bowl. Snow describes the way the woman cradles the pitcher with care and notes that the vessel's interior is held toward the viewer with "a gesture whose connotations are unmistakably sexual."[93]

Paxton's servant in *The Kitchen Maid* (1907, plate 8) handles a mixing bowl with similar care. Looking down as she stirs, the woman tilts the bowl toward the viewer with, following Snow's analysis, a gesture of openness and invitation. The cook is quite beautiful, with shining auburn hair and clear complexion. The stark beige wall gives emphasis to her delicate coloring. Wearing a navy pinafore over a pale blue shirt, she stands at the kitchen table before a carefully arranged still life of cream-colored crockery, golden lemons, and crisp white linen. As is the case in most of Paxton's studies of female figures, the servant is brightly illuminated by a lateral light that bathes the nape of her neck. This erogenous area, so "tenderly painted," becomes the focus of the canvas.

For *The Waitress* (fig. 6-20), Paxton's 1923 diploma painting for the National Academy of Design, the artist brings the servant figure even closer. Austere in black-and-white livery, the worker is monumental and elegant. She stands before a formal buffet that includes gleaming porcelain, a silver samovar, and candelabra. Balancing a tray in her left hand, she tilts her head to gaze at its contents: a small tea service and a plate brimming with fruit. As a working-class Eve, the waitress tempts the viewer with the traditional apple. From the same level as the ripe fruit, she also displays a long, soft neck above her dark uniform.

Despite the cliché of the coarsely featured Bridget that had dominated popular

Fig. 6-20. William McGregor Paxton, *The Waitress,* 1923, oil on canvas, 30¼ × 25 in. (76.8 × 63.5 cm). National Academy of Design, New York.

imagery for half a century, Paxton's paintings offer the possibility that immigrant serving women could rival their genteel mistresses in appearance. His servants were painted from the same professional models who appear in other canvases as elegantly attired, upper-class ladies.[94] The artist easily interchanged their attrac-

Fig. 6-21. Charles Dana Gibson, *Studies in Expression: Bridget Announces That She Is Engaged to Be Married,* published in *Life* 43 (25 February 1904): 186–187.

tive features between images of maid and mistress. To meet the standards of the much celebrated "American Girl" at the turn of the century, a young woman had to conform to social, economic, and racial criteria.[95] Some Irish women, with their northern European heritage, easily met the physical requirements for the Anglo-Saxon feminine ideal.

That an immigrant woman could visually pass was recognized by other artists. Gibson explored the ironic humor of the situation in a 1904 cartoon (fig. 6-21) in which he portrays a maid's audacious ability to outshine her blue-blooded employers. When "Bridget announces that she is engaged to be married," as the caption reads, the timid servant receives only stony glances from her four mistresses. The dour maiden sisters are privileged in every way but looks. William Merritt Chase employed one of Gibson's models, Minnie Clark, for his acclaimed 1893 painting, *Portrait of Mrs. C. (Lady with a White Shawl)* (fig. 6-22). It features a full-length representation of the brunet beauty, who, wearing a black dress, is adorned only by a voluminous white shawl. Chase praised the Irish-born model's "clear-cut, classic face with splendid profile" as the "perfect type of American womanhood."[96] In *American Pictures and Their Painters* (1917), Lorinda Bryant declared that it "matters not one whit" who the anonymous woman may be in Chase's painting, "she is every inch a woman and a woman gently born. Possibly it is the shawl that designates the woman's character, for only one to the manner born can wear a shawl characteristically."[97]

Another Boston-born painter, Abbott H. Thayer, found a most satisfactory model in his housemaid Elizabeth "Bessie" Price, who arrived from Ireland in 1896. Participating in the typical chain of Irish migration, she was the last of her large family to be brought over. Her six older siblings had come previously, one at

Fig. 6-22. William Merritt Chase (1849–1916), *Portrait of Mrs. C. (Lady with a White Shawl),* 1893, oil on canvas, 75 × 52 in. (190.5 × 132.1 cm). Courtesy Pennsylvania Academy of the Fine Arts, Philadelphia; Joseph E. Temple Fund.

a time, and were all employed in Thayer's New Hampshire household as servants. The artist had sporadically recruited some of them to pose for his paintings, but it was Bessie who became one of his favorite models. With her clear, delicate features, she represented the artist's vision of ideal young womanhood. Thayer paid the domestic a modeling fee in addition to her wages for household service. If a picture sold, he then gave her a small commission.[98]

Of the several paintings for which Bessie Price posed, the large *Stevenson Memorial* (1903, fig. 6-23) is one of the most compelling. Thayer pictures her as a beautiful, contemplative angel who sits on a rock inscribed "VAEA." The painting was made in commemoration of Robert Louis Stevenson, who a few years earlier had been buried atop Mount Vaea in the Samoan Islands.[99] As in several of Thayer's other canvases, the young Irish domestic has been transformed into an ethereal being. The full-length study shows her dressed in a classical white chiton and

Fig. 6-23. Abbott Handerson
Thayer (1849–1921), *Stevenson
Memorial,* 1903, oil on canvas,
81⅞ × 60⅛ in. (207.2 × 152.6
cm). National Museum of
American Art, Smithsonian In-
stitution; gift of John Gellatly.

graced with a halo and large wings. She reaches out to clasp her robed knee with
soft hands; it seems impossible that they could have had earthly contact with
brooms, dishes, or aluminum pots.

## *Acculturation*

Boston School painter Joseph DeCamp conveyed another kind of transformation
in his 1909 painting *The Blue Cup* (fig. 6-24). The image portrays a housemaid
who, standing at a table filled with an assortment of Asian porcelain, stops to ad-
mire a blue-and-white teacup. Facing the steady daylight from an unseen window
at right, the woman's figure appears solid and in sharp relief against the shifting
gray tones of the back wall. As she lifts the cup, its round form throws a soft
shadow across the right side of her face. This tiny eclipse does little to disguise the
young woman's healthy attractiveness. The light that illuminates the delicate porce-
lain also reveals the maid's own graceful loveliness. As art historian William Gerdts

Fig. 6-24. Joseph R. DeCamp (1858–1923), *The Blue Cup*, 1909, oil on canvas, $50\frac{1}{8}$ × $41\frac{1}{4}$ in. (128.2 × 105.4 cm). Courtesy Museum of Fine Arts, Boston; gift of Edwin S. Webster, Lawrence T. Webster, and Mary M. Sampson, in memory of their father, Frank G. Webster. *33.532*

points out, "There is thus a curious kinship between her and the cup she admires, for the viewer is invited to appreciate *her* in much the same way and for the same reasons."[100]

The worker's gesture—whether made impulsively or in emulation of her mistress—reveals an intelligent curiosity. She lifts the cup upward to ascertain its weight, turns it upside down to see its maker's mark, and holds it before the light to test its translucency. Her practiced handling does not match Spofford's stereotype of the clumsy servant who shatters every piece of good china. Nevertheless, a reviewer for the *Boston Evening Transcript* kept class lines intact by expressing doubts about the safety of the porcelain cup: "The figure is admirably painted and the still-life is still more admirable; perhaps it is a shade too well painted in a relative sense. The egg-shell cup on the corner of the table, for instance, is a choice and dainty morsel of painting and one almost trembles lest the girl should knock it off the table when she turns."[101] Any movement of DeCamp's young servant, however, is arrested in this quiet moment of contemplation. Enveloped in a halolike glow, she appears transfixed; her radiant expression suggests an almost spiritual metamorphosis. Before the viewer's eyes, the young woman becomes enlightened, literally, through the tiny piece of porcelain. Her pose resurrects the maxim of the Aesthetic movement in which one strives to be worthy of fine objects, just as Oscar Wilde once declared that he wanted to "live up" to his blue-and-white china.[102] Ignorance and vulgarity vanish in the presence of beauty.

Many Brahmins came to believe in the transforming power of culture when the English-inspired Aesthetic movement swept through Boston in the 1870s and 1880s. The movement's reform impulse fostered the introduction of art education into public school curricula, where instruction was aimed not only at upgrading standards of industrial design but also at inculcating working-class youths with middle-class values. The concept was introduced through the writings of English art critic John Ruskin, but many of the Boston elite embraced it through the theories of Matthew Arnold.[103] In *Culture and Anarchy* (1869), Arnold responded to tensions erupting in England over the struggle for working-class suffrage. The poet and critic prescribed culture—defined as the study of perfection—as the remedy for social chaos. Culture, he argued, "seeks to do away with classes; to make the best that has been thought and known in the world current everywhere; to make all men live in an atmosphere of sweetness and light."[104]

DeCamp's inspired young maid seems to exemplify the spiritual process described by Arnold. As she pursues the "sweetness and light" of aesthetic knowledge, she begins to assume an air of gentility. In some respects, DeCamp is playing Pygmalion. Instead of picturing a marble Venus coming to life, he shows a young woman in the process of transcending class. Her status becomes ambiguous. Her short-sleeved white shirtwaist is trimmed with lace and pink ribbons, and her

apron, edged with wide ruffles, seems more ornamental than useful. In his pre-
liminary sketch for *The Blue Cup*, DeCamp included the maid's dusting rag, which
was draped over the edge of the table. He omitted the cloth in the final canvas
and, consequently, eliminated the most obvious sign of domestic labor. In the
transition from drawing to painting, DeCamp also decided to place a thin gold
bracelet on the woman's left arm. Does the figure represent a maid who pauses
midtask or a middle-class homemaker who stops to admire her own beautiful pos-
sessions? DeCamp withholds the answer, concentrating instead on the moment
of transformation. Servant or homemaker, the aproned woman is beatified in the
domestic sphere.[105] The home becomes a training ground, a place where immi-
grant maids learn, as do the daughters of the house, that "cleanliness is culture."

Few employers found the acculturation of their servants an easy task. It was one
thing for an artist to turn a housemaid into an angel on canvas or to elevate her sta-
tus by the simple addition of a shiny bracelet. It was far more difficult for em-
ployers to transform the hired laborers in their homes. Spofford viewed the process
as an artistic endeavor:

> The artist models his clay, and makes it what he will. The young Irish girl
> comes to us as plastic as any clay in all the world. She is fresh, emotional,
> strong, willing, full of the energy that sent her three thousand miles across the
> water, and so totally ignorant of any other civilized ways than ours that she is
> completely ready to be moulded to our wish. It is true that stupidity and su-
> perstition work against us, but they are foes that reason and patience and the
> loving heart easily baffle. And if we do not model our clay to the thing we
> want—if after years of life with us the girl is not the desirable handmaiden of
> our house, fit to become a helpful and economical wife to the poor work-
> man who marries her—can it be that she herself is more responsible for the
> fact than we who had such power to shape her ends?[106]

Through close, daily contact, families had unlimited opportunity to test their pow-
ers to educate and reform the workers under their roofs. Small campaigns were
waged through acts of benevolence; more overt tactics took the form of strict reg-
ulations.[107] Other efforts were little more than exercises of noblesse oblige. Work-
ers like Lillian Pettengill could only wonder at the motives behind their employers'
interest and efforts. Having been at the receiving end of the shaping process, the
former housemaid described the uneven treatment she received from one mistress
and asked,

> But to Mrs. Scharff what was I? Doubtless of mean account, or I would not
> be earning my bread by domestic service. So Mrs. Scharff as mistress, having
> paid me wages and provided passing well for my creature comforts—whether

Fig. 6-25. Joseph J. Gould (ca. 1880–1935), *One Touch of Melody Makes the Whole World Kin,* published in *International Studio* 35 (July 1908): xxix.

from business interests or kindness of heart matters little—her mind was free; and I was hers: her servant, her drudge, her show doll, her property, if only I could be kept from feeling otherwise. . . . It is not for one moment suppos-able that Mrs. Scharff recognized the ideas of which she seemed to me a living exponent, or realized their ugliness. There were moments when I did her the honour of believing she meant well.[108]

The year before DeCamp painted *The Blue Cup,* Joseph J. Gould pictured a "well-meaning" couple in an illustration published in *International Studio* (fig. 6-25). The master and mistress have assembled their servants to listen to their new phono-graph. The uniformed staff includes a cook, butler, and chambermaid—apparently from various European origins—as well as an African American steward. As the workers listen to the music, they smile in wonder and tilt their heads in a manner much like the famous canine mascot that would soon grace Victrola advertise-ments. The caption for the illustration reads, "One touch of melody makes the whole world kin."

Though paternalism was nothing new in the relationship between servants and their mistress or master, the practice became yet another strategy for maintaining community control at the end of the nineteenth century. By trying to elevate their servants' standards and behavior, employers imagined they were bringing benefit to

both the workers and society.[109] In Gould's illustration, however, server and served maintain their separateness as they face each other across a table. Between them sits the large phonograph, its horn turned cannonlike toward the workers. The upper-class couple, shown in evening dress at left, stands by with hands withdrawn to observe the effects of the musical bombardment. They resemble a pair of social scientists conducting an experiment to test the normative effects of culture on the lower classes. Contrary to Arnold's theory and the optimistic caption, the results do not indicate a unification of classes and people. Instead, the image pictures a master and mistress who define, own, and control access to "sweetness and light" and who determine when and how it will be shared.

## Bridget Becomes Barbara

Domestic service was, nevertheless, a gradual and effective agent of acculturation. As foreign-born domestics moved through Boston's elegant ancestral homes, glittering New York palaces, and more modest middle-class residences all across the country, they quietly assimilated the values, customs, and language of Americans. After two or three years at service, workers like Spofford's malleable Irish girl went on to become helpful wives to working-class men. They also played active roles in disseminating bourgeois norms and aspirations within their own families.[110]

It became less likely that the daughters of these domestics would accept the limitations and difficulties of service. Second-generation Irish American women of the early 1900s tended to find other ways of earning a living. In 1913, sociologist E. A. Ross noted, "Of the first generation of Irish, fifty-four percent are servants and waitresses; of the second generation, only sixteen percent. Whither have these daughters gone? Out of the kitchen into the factory, the store, the office, and the school."[111] This trend also reveals the upward mobility of Irish Americans in general. Mark Sullivan, the tenth child of an immigrant couple, earned his law degree from Harvard in 1903. Soon afterward, he became a leading reform journalist who contributed political essays to several national magazines.[112] In his *Our Times* anthology (published from 1926 to 1930), Sullivan described the transformation of his people:

By 1900 and after, the Irish-born in America, failing renewal because of dwindling immigration, had become a less pungent ingredient in the melting-pot. Those who had arrived in the first great immigrations slept beneath the crosses of a thousand Catholic graveyards; with them slept many of the characteristics and customs that had given distinctive flavor to the race. The Irish strain in the American scene now depended upon the somewhat attenuated blood of second and third generations who had, in the expressive Irish

phrase, "lost the brogue," . . . or had dropped the "Bridget" and called themselves "Belle" or "Barbara," had exchanged "Mary" and "Mollie" for "Marie" or "Mae," had exchanged "Kathleen" for "Kathryn"—to find a "Bridget" one would have been obliged, by 1900, to rub the moss from a tombstone somewhere.[113]

After World War I, sweeping changes in government policies resulted in a substantial reduction in the number of all immigrants admitted to the United States. General labor strikes, believed to be instigated by syndicalist and anarchist agents, and the perceived threat of Bolshevism fed the already high xenophobic sentiment. These new fears, combined with continued anxiety about "race suicide," refueled support for immigrant restriction. Through the long-term efforts of groups like the Boston-based Immigration Restriction League, a bill was passed in 1917 requiring all newcomers to take a basic literacy test. Four years later, a quota system was enacted to control the number and composition of the immigrants. Ethnicity became the primary determinant for entry, and under the new laws, 85 percent of the allowable number was held in reserve for the older stocks from northwestern Europe.[114]

In 1921, newly inaugurated vice president Calvin Coolidge asked Americans, "Whose country is this?" in an article that outlined the prevailing arguments for restriction laws. The government's primary obligation, Coolidge stated, was to maintain a healthy citizenship. The country could not continue to be a "dumping ground" for either cheap manhood or subversive aliens who bore enmity toward society, religion, "and so basic an institution as the home." Coolidge argued that there were grave "racial considerations. . . . Biological laws tell us that certain divergent people will not mix or blend. The Nordics propagate themselves successfully. With other races, the outcome shows deterioration on both sides. Quality of mind and body suggests that observance of ethnic law is as great a necessity to a nation as immigration law."[115] Three years later, immigration legislation became still more restrictive. The million or so immigrants who entered the country annually in the years spanning the turn of the century was reduced to a firm 150,000. Entirely excluded from this number were Asians. While great value was still being assigned to art and artifacts from the East, Asian peoples could not enter the United States. Those who had arrived previously were "noticeable," the *Massachusetts Labor Bulletin* commented, "not from the fact of their number, which is very small, but from their Asiatic origin, their personal appearance, their Oriental dress. . . . the majority still retain their peculiar characteristics and stand out prominently, an anomalous feature as compared with their surroundings." Chinese exclusion acts, which had been reinstated every ten years since 1882, were made permanent in the 1920s. At the same time, new laws were passed to restrict the entry of all Japanese.[116]

Fig. 6-26. William McGregor Paxton, *The Figurine,* 1921, oil on canvas, 18½ × 15⅛ in. (47 × 38.4 cm). National Museum of American Art, Smithsonian Institution; bequest of Henry Ward Ranger through the National Academy of Design.

Just as Coolidge was calling upon Americans to consider the future as "we put our house in order for the advancing hordes of aliens," Paxton was creating his own serene vision of orderly housekeeping.[117] *The Figurine* (fig. 6-26), painted in 1921, depicts an aproned maid who dusts the glass case of a Chinese figurine. Placed at center against a stark gray wall, the servant is bathed by a steady lateral light. Her skin, clothing, and hair are all presented in the same soft texture. The undu-

lating curves of her shoulders and hips are echoed by the pink brocade backs of a pair of gilded Louis XVI chairs that stand behind her. As in other of his images, Paxton directs the young worker's attention to the ceramic objects before her: a blue-and-white Chinese jar with a dragon-dog handle and, in the tall glass case, the figurine of a woman in a teal-blue robe, both typical examples of late nine-teenth-century export ware.[118]

The maid reaches around to dust the front of the transparent box with a soft cloth; her other hand, steadying the case from behind, is refracted by the glass. Reminiscent of the maid in DeCamp's *Blue Cup*, the woman's gentle touch might suggest her appreciation for the delicate object, or it could simply demonstrate the careful movements of a well-trained domestic. The woman seems absorbed in her task, unaware of the observing eye of employer or viewer. Her downturned gaze invites close inspection of her flawless skin and soft auburn hair, which she wears cropped short in the bob that was fashionable at the time. The servant's gen-tle demeanor, however, is anything but modern. Her quiet expression emulates the modest, averted countenance of the figurine.

On several levels, this would have been a reassuring image for the conservative patrons of the Boston School. Paxton produced *The Figurine* only a year after the passage of the Nineteenth Amendment, granting suffrage to American women. In preceding years, as the battle for passage was being waged, the idea of foreign-born women voting alongside native-born females troubled activists on both sides of the issue. Suffragists, affected by their own class and ethnic biases, tended to avoid as-sociation with immigrant women.[119] In turn, opponents of the vote for women were quick to play upon nativist and racial fears to block the amendment. In 1910, Mar-garet Deland charged that suffragists were playing with "terrible elements":

> "Am not I," [the New Woman] cries, reproachfully, "an intelligent and edu-cated woman, better qualified to vote than my ashman?" "True," replies pub-lic opinion, "but shall the suffrage therefore be given to your cook?" But to gratify that desire for power, the New Woman is willing to include her cook; she is willing to multiply by two the present ignorant and unconscientious vote. . . . We have suffered many things at the hands of Patrick; the New Woman would add Bridget also. And—graver danger—to the vote of that fierce, silly, amiable creature the uneducated Negro, she would add (if logical) the vote of his sillier baser female.[120]

There is nothing for the conservative to fear from Paxton's docile maid. She goes about her dusting as if she not only accepts but also enjoys the task. Her full at-tention is given to housework—an appropriate female concern for mistress and servant alike. The representation is static, and the young woman seems perma-nently fixed within the domestic sphere, unwilling and unable to cause any mis-chief, at the polls or anywhere else. The room's hushed atmosphere, with its al-

most palpable airy light, descends on her like a bell jar. Encapsulated and displayed like the figurine in its case, she, too, becomes a "show doll." As the red-haired servant refers to the older immigrant population, the Asian porcelain piece represents the new. Foreign elements, both are contained—just as immigrants were being controlled either through strategies of acculturation or, more effectively, through legal restrictions.

## *Permanence and Continuity*

Throughout their careers, the Boston School artists and many of their students held steadfast to the academic principles of solid draftsmanship and technical excellence. They also remained loyal to the concept that art should reveal beauty and elevate the viewer by portraying the ideal. Their approach was solidly grounded in the traditions of the nineteenth century, a conservative stance that brought the painters into direct conflict with the new movements of the twentieth. Initially taking a defensive posture against the urban realism of the Ashcan painters, the Boston men became outspoken critics of European modernism after the Armory Show of 1913.[121]

Painter and critic Kenyon Cox best articulated the conservative position in *The Classic Point of View,* published in 1911. He argued for the importance of maintaining high standards of academic training as handed down through previous centuries. For Cox, this heritage offered much more than training in technical excellence; it also represented an aesthetic philosophy that honored and perpetuated the finest qualities of the past:

> The Classic Spirit is the disinterested search for perfection; it is the love of clearness and reasonableness and self control; it is, above all, the love of permanence and continuity. It asks of a work of art, not that it shall be novel or effective, but that it shall be fine and noble. It seeks not merely to express individuality or emotion but to express disciplined emotion and individuality restrained by law. It strives for the essential rather than the accidental, the eternal rather than the momentary. And it loves to steep itself in tradition.[122]

Sympathetic with these goals, the Boston School artists chose to portray a privileged, refined world ruled by discipline and law. Their paintings prescribe feminine behaviors of domesticity and passivity that did little to threaten the traditional power structures of nation or home. Idealized and peaceful images, their works were far removed from the intense power struggles being waged in bourgeois households in Boston and other urban regions of the United States. Discord between employers and servants escalated as Bridget began the process of abdicating her long tenure in American kitchens and parlors.

By the time Paxton painted *The Figurine* in 1921, it had become increasingly difficult to find a young Irish woman—or any other white female—serving as a live-in domestic in the American home. "One of the problems today," lamented a writer in *Arts and Decoration* the year before, "is how to find wealth enough to allow of indulgence in the labor-saving devices we all need so much, now that the housemaid and the once common maid-of-all-work seem as extinct as the great auk and dinosaurus."[123] Paxton's maidservant may have been viewed in her time as a museum piece from days gone by, preserved like a relic under glass. World War I had opened new opportunities for female employment in manufacturing, retailing, and the professions. Faced with new choices, native-born white women—including the second- and third-generation daughters of immigrants—soundly rejected service. As immigration dropped sharply, there came a substantial decrease in the number of foreigners who were willing to enter the unpopular occupation. Immigrant maids were soon replaced by internal migrants.[124]

After 1910, large numbers of African American women began arriving in the northern cities as part of the Great Migration from the South. Previously, black servants had figured primarily in residences and laundries below the Mason-Dixon line. At just the time when more urban white females were moving into office and shop work, these migrants arrived in full force to fill the growing number of household vacancies. Facing stricter limitations in employment than their white counterparts, black workers found few alternatives to service. Soon, they comprised a significant proportion of domestic servants in nearly all major cities regardless of region. According to census information, the number of white servants declined by one-third between 1890 and 1920, while African American domestics increased by 43 percent.[125] Black women brought important changes to the nature of domestic service. As a group, they were older than immigrant workers, and they were more likely to be married with families of their own. Moreover, they resided in their own homes. African Americans overwhelmingly preferred live-out housework, a pattern that had predominated in the South since Emancipation.[126] Faced with little choice, many employers had to adjust to the hiring of day workers and, in doing so, were forced to abandon their expectations of round-the-clock service.

A number, however, explored other options. In the years between 1920 and 1945, more mistresses became "house-wives," serving the needs of their homes and families themselves. Electricity, new equipment, efficient plumbing, mass-produced goods, and prepared foods opened the possibility of maintaining a middle-class life-style without the assistance of any hired labor.[127]

In the midst of significant shifts in the structure of American households, the Boston School artists continued to delineate their traditional views of home and family life. "The artistic intention must dominate everything, control everything,

mould everything to its purpose," Kenyon Cox encouraged in *The Classical Point of View*. "Its sovereignty must be absolute and complete. But so to control facts, and to bend them to one's purpose, one must know them."[128] Like their Brahmin patrons, the Boston painters believed they knew the "facts" concerning domestic servants, many of which included prevailing biases toward working-class immigrants. Turning away from issues that threatened genteel Boston, the painters responded by shaping the domestic worker into "the thing we want . . . the desirable handmaiden of our house."[129] In defending an aesthetic program, the Boston School painters also defended and preserved a charming and comfortable nineteenth-century ideal.

# Conclusion

Servant! . . . I am a true blue son of liberty, for all that. . . . no man shall master me.—
Jonathan, a servant in *The Contrast,* by Royall Tyler (1784)

Therefore, until popular usage has taken its blight from that word "servant," I will be a servant no more. A domestic tradeswoman I am, a chamber-maid, a waitress, an employee with an employer, but a servant with a mistress—never. I am an American.—Lillian Pettengill, *Toilers of the Home* (1903)

The representation of domestic servants in nineteenth-century America was not a neutral exercise. Theoretically, the United States was a classless society built on democratic principles. The very word "servant"—with its connotations of caste, personal subjugation, and dependence—became and remained an anathema. Despite attempts to introduce new titles for household laborers in the early decades of the republic, however, the controversial appellation returned to the national vocabulary once the overwhelming majority of domestic workers had become African American or immigrant—and almost all of them poor, working-class women.[1] Thereafter, the term was invariably connected with another word, "problem," in the collective imagination of white, middle-, and upper-class families who yearned for the labor of "our own people . . . servants of our own race, religion, and habits," as one late nineteenth-century writer put it. Otherwise, she lamented, "where the elements are naturally so antagonistic, and the interests are so utterly apart, union is hardly possible, there is always something foreign in the household, and there is disintegration at the very foundation of home."[2]

In speech, the written word, and visual representation, the identification of servants became a process of naming those who, by the very nature of their work, fell outside the American ideal. "Naming is a form of power," art historian Guy McElroy observed, "and visual images have the persuasive power to identify and define place and personality."[3] In portraying domestic workers, American painters became active participants in the ongoing social and political discourse concerning the place of servants—and the cultures that they represented—within both the

262

home and the nation at large. Painters sometimes identified the "help." Most often, however, they visually defined the "servants"—household members who were "in the family, but not of it."[4]

Creating paintings within and for the dominant culture, artists seem to have shared and endorsed the ideological stance that defined the Servant Problem. In content and form, their images generally reinforced prevailing biases against the workers who came into American households with class, racial, ethnic, and religious differences. Building on European conventions established in the colonial era, for example, American painters continued to represent the black domestic— whether enslaved or free—as a subsidiary figure whose primary function was to elevate the status of the white sitter through apparent devotion. In the nation's collective consciousness, color was linked to caste, and images of African Americans were inexorably associated with servitude. By the second half of the century, the most enduring of black stereotypes were established: Auntie, Dinah, Mammy, and the fatally compliant Uncle Tom, household servants all. These popular characterizations underscored white Americans' continuing desire for obedience in African Americans during and long after the turbulent years of the Civil War. Also at mid-century, Bridget became the stock characterization of the Irish maidservant who, for nearly eighty years, was perceived as "both the necessity and plague of our homes."[5] The illustrated press invested the stereotype with all the contemptuous qualities that were being assigned to Irish Catholics during their massive influx into the United States throughout the second half of the century. Painters responded with their own, less harsh depictions of white domestics that nonetheless supported the general perception of the immigrants as morally and mentally incapable of assimilation.

The formal language of painting also reinforced the pervasive derision and mistrust directed against household workers. Artists understood the physical and psychological boundaries that separated the server from the served, setting apart the figures of black and white workers by clothing, activities, and positioning. Servants were relegated to the distant margins or lower registers of the illusory spaces of canvases, held in place by the edges of walls and furniture, or contained within the frames of doorways. Giving evidence of deference rituals, they were recurrently portrayed as standing as their supposed betters sat or waiting quietly alongside them with averted gazes.[6]

On occasion, artists brought domestics out of the shadowy edges and into the foreground of their paintings to function variously as comic simpletons, uniformed status symbols, or beautiful ornaments. Late-century painters, such as the Boston School artists, produced exquisitely rendered portrayals of lovely maids going about their duties with efficiency and grace. These works picture servants as splendid possessions within well-ordered interiors. Masking the heightened discord be-

tween the household's inhabitants above and below stairs, they project and pre-
scribe a hierarchically ordered realm in which the mistress and the maid each knows
her place. Consistent with labor and census demographics, the great majority of ex-
tant servant images depict female workers. Though there was a numerical increase
in the employment of menservants during the Gilded Age, few appear in paint-
ings. Throughout the century, artists tended to avoid representing white male
workers performing the menial labor that was generally believed more appropriate
for either black men or working women of all colors.

Common in images produced across the decades is the implication of sexual
availability on the part of female servants. Society glorified the ideal of pristine
femininity, and wage-earning women who performed dirty, menial labor became
the objects of sexual fantasy and innuendo. Long reputed to be earthy, sensual,
and even degenerate, female servants of all races and backgrounds were the persis-
tent targets of sexual harassment and exploitation—practices encouraged, perhaps,
by images that objectify and sexualize.[7]

Though painters rarely deviated from established servant stereotypes and for-
mulas of portrayal throughout the century, there were some exceptions. Among
them is Susan Sedgwick's 1811 miniature of *Elizabeth "Mumbet" Freeman* (fig. 2-
6), a work that offers warm tribute to the brave civil rights pioneer and beloved sec-
ond mother. Such mutual affection seems to flourish in *A Window, House on Hud-
son River* (1863, fig. 4-17), by Worthington Whittredge, which depicts the
face-to-face embraces of a servant and child in the heart of the home. Lilly Martin
Spencer produced a sympathetic, individualized portrait of her maid in *Shake
Hands?* (1854, fig. 3-1), but she apparently created a figure who seemed too bright,
too capable, and, perhaps, too fully human to fit the mid-century conception of do-
mestic labor. After the painting drew incredulous response from the press and the
artist was called to task for choosing such a vulgar subject, Spencer adjusted her
representations to suit the tastes of audiences who had come to expect satire and
derision in servant imagery. Winslow Homer seems to have comprehended the
accepted formula so well that he subverted the rules of representation to give dra-
matic emphasis to the emancipated slaves' momentous release from servitude in
*A Visit from the Old Mistress* (1876, fig. 4-19). His portrayal of the confrontation
between an older matron and her stolid exslaves reverses the sign systems that di-
fferentiate those who belong in the household and those who remain perpetual
outsiders. At the turn of the century, Joseph DeCamp obscured marks of class in
*The Blue Cup* (1909, fig. 6-24). The status of his aproned worker, whose thought-
ful expression communicates warmth and intelligence, seems of little importance.

Most artists, however, chose to portray the distance and differences between
families and the people who daily served them. In doing so, they provided bour-
geois audiences with a vehicle for solidifying social identification and class con-

sciousness. Their work invited comparison through which viewers could recognize servant behaviors and types as negative opposites of themselves and come away with an enhanced sense of their privileged status and freedom. While nineteenth-century American painters generally eschewed themes that dealt directly with urban poverty, class conflict, labor unrest, racial strife, and prostitution, they nevertheless touched on these issues in their portrayals of servants. Their images hint at the perceived dangers and difficulties of bringing outsiders into the home; they also provide strategies for solutions. In creating comforting visual documents of social control, they normalized and justified surveillance and subordination of suspect groups. Ultimately, the paintings played an ongoing role in creating and communicating the character and role of those who labored at the beck and call of the American family.

# Notes

## INTRODUCTION

1. Ralph Waldo Emerson, "Education" (1867), in *The Complete Works of Ralph Waldo Emerson,* vol. 10 (Boston: Houghton Mifflin; Cambridge, Mass.: Riverside Press, 1904), 128; Emerson, "The American Scholar" (1837), *Complete Works,* vol. 1, 111–112; Emerson, "Domestic Life" (1859), *Complete Works,* vol. 7, 107. Here and in direct quotations throughout the book, emphasis is from the original.

2. Ralph Ellison best articulated the quandary of the simultaneous presence and absence of African Americans in American society, a dichotomy similar to the ambiguous status of household servants. In the poignant opening words of his novel, *Invisible Man,* the nameless protagonist explains, "I am invisible, understand, simply because people refuse to see me. . . . When they approach me they see only my surroundings, themselves, or figments of their imagination—indeed, everything and anything but me." Ralph Ellison, *Invisible Man* (New York: Random House, 1952), 3.

3. For want of a better adjective, I use "American" throughout this book to indicate people, concepts, and objects associated with the United States, rather than as an all-inclusive term that refers to Canada, Mexico, Central America, and South America as well.

4. Faye E. Dudden, *Serving Women: Household Service in Nineteenth-Century America* (Middletown, Conn.: Wesleyan University Press, 1984), 1, 51–52; Daniel E. Sutherland, *Americans and Their Servants: Domestic Service in the United States from 1800 to 1920* (Baton Rouge: Louisiana State University Press, 1981), 10, 88–94; Phyllis Palmer, "Overview of Domestic Service in the First Half of the Twentieth Century," paper presented at "The View from the Kitchen," National Trust for Historic Preservation Conference, Boston, 25 October 1994.

5. Sutherland, *Americans and Their Servants,* 4–5.

6. Dudden, *Serving Women,* 3–7, 44. The shift was also recognized in the nineteenth century by Catharine Beecher and her sister, Harriet Beecher Stowe, who viewed the earlier period as a "golden age" of service. See their household manual, *The American Woman's Home* (New York, 1869; reprint, Hartford, Conn.: Stowe-Day Foundation, 1975), 305–321. Lucy Maynard Salmon was the first to document the transition clearly in her sociological study, *Domestic Service* (New York, 1897; reprint, New York: Arno Press, 1972), 55, 69–72.

7. Judith Rollins, *Between Women: Domestics and Their Employers* (Philadelphia: Temple University Press, 1985), 7. Following one of the constants in American labor history, domestic workers con-

tinue to be drawn from the latest pool of economic refugees. Today, the fastest-growing servant population is immigrants from Latin American countries. For a discussion of Chicana domestics, see Mary Romero, *Maid in America* (New York: Routledge, 1992).

## CHAPTER 1. THE CUSTOM OF THE COUNTRY: THE COLONIAL ERA

1. Henry Bradshaw Fearon, *Sketches of America: A Narrative of a Journey of Five Thousand Miles through the Eastern and Western States of America,* 2d ed. (London: Longman, Hurst, Rees, Orme, and Brown, 1818), 80–81. See also the account in Charles William Janson, *The Stranger in America, 1793–1806* (London, 1807; reprint, New York: Press of the Pioneers, 1935), 88.

2. Richard S. Dunn, "Servants and Slaves: The Recruitment and Employment of Labor," in *Colonial British America: Essays in the New History of the Early Modern Era,* ed. Jack P. Greene and J. R. Pole (Baltimore: Johns Hopkins University Press, 1984), 159–160; Julia Cherry Spruill, *Women's Life and Work in the Southern Colonies* (New York: W. W. Norton, 1972), 3–4.

3. Dunn, "Servants and Slaves," 158–159; Abbott Smith, *Colonists in Bondage: White Servitude and Convict Labor in America, 1607–1776* (New York: W. W. Norton, 1971), 25–27.

4. A. Smith, *Colonists in Bondage,* 16–19; Sharon V. Salinger, *To Serve Well and Faithfully: Labor and Indentured Servants in Pennsylvania, 1682–1800* (New York: Cambridge University Press, 1987), 10.

5. Dunn, "Servants and Slaves," 158–159; David W. Galenson, *White Servitude in Colonial America: An Economic Analysis* (New York: Cambridge University Press, 1981), ix. For a discussion of the attempt to use Native Americans as laborers, see Edmund S. Morgan, *American Slavery, American Freedom: The Ordeal of Colonial Virginia* (New York: W. W. Norton, 1975), 80–81, and Winthrop D. Jordan, *White over Black* (Chapel Hill: University of North Carolina Press, 1968), 89–91.

6. A. Smith, *Colonists in Bondage,* 259; Galenson, *White Servitude,* 23–24, 47–50; John Van der Zee, *Bound Over: Indentured Servitude and American Conscience* (New York: Simon & Schuster, 1985), 92–94.

7. John Demos, *A Little Commonwealth: Family Life in Plymouth Colony* (London: Oxford University Press, 1970), 69–73; Spruill, *Women's Life,* 43–44.

8. Galenson, *White Servitude,* 8–9.

9. A. Smith, *Colonists in Bondage,* 23; Van der Zee, *Bound Over,* 29–30.

10. Van der Zee, *Bound Over,* 29–30.

11. Dunn, "Servants and Slaves," 161.

12. E. Brooks Holifield, *Era of Persuasion: American Thought and Culture, 1521–1680* (Boston: Twayne, 1989), 33, 37–38; John C. Miller, *The Colonial Image: Origins of American Culture* (New York: George Braziller, 1962), 34.

13. Stephanie Coontz, *The Social Origins of Private Life: A History of American Families, 1600–1900* (London: Verso, 1988), 80–81; Bernard Bailyn, *The Ideological Origins of the American Revolution* (Cambridge: Belknap Press, Harvard University Press, 1967), 302–303.

14. Ephesians 6:1–9; Holifield, *Era of Persuasion,* 135.

15. J. Jean Hecht, *The Domestic Servant Class in Eighteenth-Century England* (London: Routledge & Kegan Paul, 1956), 177; Daniel E. Sutherland, *Americans and Their Servants: Domestic Service in the United States from 1800 to 1920* (Baton Rouge: Louisiana State University Press, 1981), 3–4.

16. Benjamin Franklin, "Father Abraham's Speech," in *The Complete Poor Richard Almanacks,* ed. Whitfield J. Bell, Jr. (Barre, Mass.: Imprint Society, 1970), 2 (1858): 375; Ronald W. Clark, *Benjamin Franklin: A Biography* (New York: Random House, 1983), 15, 22–23.

17. Van der Zee, *Bound Over,* 32, 52.

18. Oscar Handlin and Mary Handlin, *The Dimensions of Liberty* (New York: Atheneum, 1966), 14.

19. Bailyn, *Ideological Origins,* 26–27, 51; Priestley quoted by Isaac Krammick, "Tommy Paine and the Idea of America," in *The American Revolution and Eighteenth-Century Culture,* ed. Paul J. Korshin (New York: AMS Press, 1986), 81.

20. Samuel Johnson (London, 1776), quoted by Donald Greene, "Sweet Land of Liberty: Libertarian Rhetoric and Practice in Eighteenth-Century Britain," in *American Revolution and Eighteenth-Century Culture,* 130.

21. Hecht, *Domestic Servant Class,* 71, 78–87, 177–179.

22. T. C. Duncan Eaves and Ben D. Kimpel, introduction to *Pamela; or, Virtue Rewarded,* by Samuel

Richardson (Boston: Houghton Mifflin, 1971), xvii–xxii; Tate Gallery, *Manners and Morals: Hogarth and British Painting, 1700–1760* (London: Tate Gallery, 1987), 156–159.

23. Hamilton quoted by Henry F. May in *The Enlightenment in America* (New York: Oxford University Press, 1976), 37. The edition of *Pamela* mentioned by Hamilton was probably the one just published by Franklin. Kenneth Silverman, *A Cultural History of the American Revolution* (New York: Columbia University Press, 1987), 589.

24. Tate Gallery, *Manners and Morals,* 96–101.

25. Robert Etheridge Moore, *Hogarth's Literary Relationships* (New York: Octagon Books, 1969), 58–61; Jack Lindsay, *Hogarth: His Art and His World* (London: Hart-Davis, MacGibbon, 1977), 88–89; Joan Dolmetsch, "Prints in Colonial America: Supply and Demand in the Mid-Eighteenth Century," in *Prints in and of America to 1850: Winterthur Conference Report,* ed. John D. Morse (Charlottesville: University Press of Virginia, 1970), 55; Silverman, *Cultural History,* 12. Robert H. Saunders and Ellen G. Miles observe that the working class had become an international theme for artists during the 1730s. They cite Jean-Baptiste-Siméon Chardin's *Governess* (National Gallery of Canada) and *Scullery Maid* (Hunterian Art Gallery, University of Glasgow), both engraved in the 1740s. See their *American Colonial Portraits, 1700–1776* (Washington, D.C.: Smithsonian Institution Press, 1987), 171n.

26. Sinclair Hitchings, "London's Images of Colonial America," in *Eighteenth-Century Prints in Colonial America,* ed. Joan Dolmetsch (Williamsburg: Colonial Williamsburg Foundation, 1979), 12–13; Suzanne Latt Epstein, "The Influence of European Prints on Early American Art" (Ph.D. diss., Northwestern University, 1967), 1–6, 96.

27. Tate Gallery, *Manners and Morals,* 80–85. For examples of French images, see H. L. Lawrence and B. L. Dighton, *French Line Engravings of the Late Eighteenth Century* (London: Lawrence and Jellicoe, 1910), plates 26 and 47, p. xiii; Saunders and Miles, *American Colonial Portraits,* 44.

28. Henry Wilder Foote, *Robert Feke: Colonial Portrait Painter* (Cambridge: Harvard University Press, 1930), 55–56, 121.

29. Phillis Cunnington, *Costume of Household Servants from the Middle Ages to 1900* (New York: Barnes & Noble, 1974), 45.

30. Richardson, *Pamela,* 283.

31. Ralph Peter Mooz, "The Art of Robert Feke" (Ph.D. diss., University of Pennsylvania, 1970), 35–36; Wayne Craven, *Colonial American Portraiture* (Cambridge: Cambridge University Press, 1986), 281.

32. Saunders and Miles, *American Colonial Portraits,* 170–171; Alan Burroughs, *John Greenwood in America* (Andover, Mass.: Addison Gallery of American Art, 1943), 11–12, 48.

33. Saunders and Miles, *American Colonial Portraits,* 170–171.

34. Carl Degler, *Out of Our Past: The Forces that Shaped Modern America,* rev. ed. (New York: Harper & Row, 1970), 44–47.

35. Van der Zee, *Bound Over,* 31; Salinger, *To Serve Well,* 44–45; Degler, *Out of Our Past,* 45.

36. Gay Wilson Allen and Roger Asselineau, *St. John de Crèvecoeur: The Life of an American Farmer* (New York: Viking, 1987), xvi–xvii, 74–75, 39; Thomas Philbrick, *St. John de Crèvecoeur* (New York: Twayne, 1970), 16–20.

37. J. Hector St. John de Crèvecoeur, *Letters from an American Farmer* (Gloucester, Mass.: Peter Smith, 1968), 20, 28–29, 64–65. In 1778 Crèvecoeur produced a watercolor of his estate, Pine Hill (collection, Jean St. John de Crèvecoeur, Paris). The pastoral scene depicts his Georgian home in the midst of cultivated fields. In the foreground are his wife and himself in the shade of a tree. They watch as their young son rides the beam of a plow guided by one of their slaves.

38. E. S. Morgan, *American Slavery,* 258–270; Gary B. Nash, "Social Development," in *Colonial British America,* ed. Greene and Pole, 244–245. Since the 1950s, there has been active scholarly debate regarding the status of the earliest black laborers. See Alden T. Vaughn, "The Origins Debate: Slavery and Racism in Seventeenth-Century Virginia," *Virginia Magazine of History and Biography* 97 (July 1989): 311–354.

39. Jordan, *White over Black,* 52–61; Edgar J. McManus, *Black Bondage in the North* (Syracuse, N.Y.: Syracuse University Press, 1973), 11, 57, 59; Dunn, "Servants and Slaves," 164–166.

40. Winthrop Jordan, *The White Man's Burden: Historical Origins of Racism in the United States* (New York: Oxford University Press, 1974), 51, 53. Not all whites served by free choice. Besides transported debtors and criminals, a small percentage were kidnapped and spirited to the colonies by merchants who "raised a cargo." A. Smith, *Colonists in Bondage,* 29, 52.

41. McManus, *Black Bondage,* 4–5, 56; Coontz, *Social Origins,* 135; Jordan, *White over Black,* 91–92.

42. E. S. Morgan, *American Slavery,* 344–346; Galenson, *White Servitude,* 171.

43. McManus, *Black Bondage,* 57; Jordan, *White over Black,* 81.

44. David Dabydeen, *Hogarth's Blacks: Images of Blacks in Eighteenth-Century English Art* (Athens: University of Georgia Press, 1987), 17, 85; E. S. Turner, *What the Butler Saw: Two Hundred and Fifty Years of the Servant Problem* (New York: St. Martin's Press, 1963), 81–82; Cunnington, *Costume,* 33–34.

45. Cunnington, *Costume,* 15–18; Ann Buck, *Dress in Eighteenth-Century England* (New York: Holmes & Meier, 1979), 103–119; Jean Devisse, *The Image of the Black in Western Art,* vol. 2, bk. 1 (New York: William Morrow, 1979), 82, 88.

46. Dabydeen, *Hogarth's Blacks,* 21–36. Paintings include Titian's *Laura dei Dianti* (ca. 1523, Dreuzlingen, Heinz Kisters), Van Dyck's *Marchesa Grimaldi-Cattaneo* (1762, National Gallery of Art, Washington, D.C.) and *Henrietta of Lorrain* (1634, Iveagh Bequest, Kenwood, English Heritage), Kneller's *Duchess of Portsmouth* (1684, Dresden, Gemäldegalerie), Joseph Wright's *Two Girls and Negro Servant* (ca. 1769, Heirs of Oliver Vernon Watney), and Reynolds's *Count Schaumburg-Lippe* (1764, Royal Collection, London).

47. Saunders and Miles, *American Colonial Portraits,* 44.

48. Guy C. McElroy, *Facing History: The Black Image in American Art, 1710–1940* (Washington, D.C.: Bedford Arts, Corcoran Gallery of Art, 1990), 3; J[acob] Hall Pleasants, *Justus Engelhardt Kühn* (reprint of proceedings, October 1936; Worcester, Mass.: American Antiquarian Society, 1937), 5–10, 14, 28–29.

49. Dabydeen, *Hogarth's Blacks,* 21–26.

50. Saunders and Miles, *American Colonial Portraits,* 251–252.

51. Elizabeth Mankin Kornhauser, "Ralph Earl: Artist-Entrepreneur," (Ph.D. diss., Boston University, 1988), 34, 48, 52–59. The expression of the slave child is similar to the servant's in *First Lieutenant Paul Henry Ourry,* by Reynolds (1748, Morely Collection, National Trust, Saltram, England).

52. Anne Wells Rutledge, "After the Cloth Was Removed," *Winterthur Portfolio* 4 (1968): 47–48.

53. Albert Ten Eyck Gardner and Stuart Feld, *American Paintings, Catalogue of the Collection, Metropolitan Museum of Art,* vol. 1 (New York: Metropolitan Museum of Art, 1965), 101; Hugh Honour, *The Image of the Black in Western Art,* vol. 4, bk. 1 (Cambridge: Harvard University Press, Menil Foundation, 1989), 44.

54. Honour, *Image of the Black,* bk. 1, 44.

55. John Trumbull, *The Autobiography of Colonel John Trumbull, Patriot-Artist, 1756–1843,* ed. Theodore Sizer (New Haven: Yale University Press, 1953), 51; Silverman, *Cultural History,* 387.

56. John Singleton Copley replaced the original figure of a turbaned black page with two hounds in the final group portrait of William Pepperrell and his family (1778, North Carolina Museum of Art). See Honour, *Image of the Black,* bk. 1, 311n.

57. Wendy C. Wick, *George Washington: An American Icon* (Washington, D.C.: Smithsonian Institution Traveling Exhibition Service, National Portrait Gallery, 1982), 122; Honour, *Image of the Black,* bk. 1, 47.

58. Wick, *Washington,* 122.

59. Ibid.; Honour, *Image of the Black,* bk. 1, 47–58.

60. Theodore Sizer, *The Works of Colonel John Trumbull: Artist of the American Revolution,* rev. ed. (New Haven: Yale University Press, 1967), 81; Louisa Dresser, "Edward Savage, 1761–1817," *Art in America* 40 (autumn 1952): 203; Sidney Kaplan, *The Black Presence in the Era of the American Revolution, 1770–1800* (New York: New York Graphic Society, Smithsonian Institution Press, 1973), 35.

61. Images of slave nurses are also found in *The First, Second, and Last Scenes of Mortality,* by Prudence Punderson (ca. 1775, Connecticut Historical Society); *Alexander Spotswood Payne and His Brother, John Dandridge Payne* (1790–1800, Virginia Museum of Art) and *Wife and Children of Major Marsh and Servants* (ca. 1790, Chrysler Museum), both by unknown artists.

62. Richard K. Doud, "John Hesselius, Maryland Limner," *Winterthur Portfolio* 5 (1969): 132–141.

63. Sona K. Johnston, *American Paintings, 1750–1900, from the Collection of the Baltimore Museum of Art* (Baltimore: Baltimore Museum of Art, 1983), 81.

64. Ibid.

65. McManus, *Black Bondage,* 126; Jordan, *White over Black,* 113–114; Philip D. Morgan, "Slave Culture in Eighteenth-Century Virginia and South Carolina," presented to the Philadelphia Center for Early American Studies, Philadelphia, 30 November 1990, 29–33.

66. Drastic methods of slave control included hamstringing or amputation. See Jordan, *White over Black,* 112–114.

67. Rosamond Randall Beirne and John Henry Scarff, *William Buckland, 1734–1774: Architect of Virginia and Maryland* (Annapolis, Md.: Board of Regents, Gunston Hall and Hammond-Harwood House, 1970), 11–16, 44, 147; Charles Coleman Sellers, *Portraits and Miniatures by Charles Willson Peale* (Philadelphia: American Philosophical Society, 1952), 43–44.

68. Craven, *Colonial American Portraiture,* 259.

69. Charles Willson Peale, *The Selected Papers of Charles Willson Peale and His Family,* ed. Lillian B. Miller, vol. 1 (New Haven: Yale University Press, 1983), xxvii.

70. Charles Willson Peale, "Autobiography," in *The Collected Papers of Charles Willson Peale and His Family,* ed. Lillian B. Miller (National Portrait Gallery, Smithsonian Institution, Washington, D.C.; Millwood, N.Y.: Kraus-Thomson Organization, 1980), microfiche, typescript pp. 8–9, series II-C/14B4.

71. Craven, *Colonial American Portraiture,* 383; Peale, *Selected Papers,* xxvii, 262, 301; Sellers, *Portraits and Miniatures,* plate 241, p. 165.

72. Philip S. Foner, *History of Black Americans,* vol. 1 *From Africa to the Emergence of the Cotton Kingdom* (Westport, Conn.: Greenwood Press, 1975), 526–527; Silverman, *Cultural History,* 214.

73. Jeanne Noble, *Beautiful, Also, Are the Souls of My Black Sisters: A History of Black Women in America* (Englewood Cliffs, N.J.: Prentice-Hall, 1978), 151; Silverman, *Cultural History,* 216–217.

74. Foner, *History of Black Americans,* 1:528–529; Noble, *Beautiful,* 152–153.

75. Saunders and Miles, *American Colonial Portraits,* 309–310.

76. Galenson, *White Servitude,* 4.

77. McManus, *Black Bondage,* 150–179; Bailyn, *Ideological Origins,* 239–246.

78. Coontz, *Social Origins,* 138–139; Sutherland, *Americans and Their Servants,* 4, 40; McManus, *Black Bondage,* 55.

79. Michael Kammen, *People of Paradox: An Inquiry Concerning the Origins of American Civilization* (New York: Alfred A. Knopf, 1972), 45–47.

80. Bailyn, *Ideological Origins,* 309; McManus, *Black Bondage,* 55.

## CHAPTER 2. A REPUBLICAN INDEPENDENT DEPENDENT: 1790–1840

1. *Adams Family Correspondence,* ed. L. Y. Butterfield, vol. 1 (Cambridge: Belknap Press, Harvard University Press, 1963), 370, 382.

2. Cathy N. Davidson, *Revolution and the Word: The Rise of the Novel in America* (New York: Oxford University Press, 1986), 213–214.

3. Kenneth Silverman, *A Cultural History of the American Revolution* (New York: Columbia University Press, 1987, 559–561; Constance Rourke, *American Humor: A Study of the National Character* (New York: Harcourt, Brace, 1931), 16–17.

4. Davidson, *Revolution and the Word,* 213–214.

5. Royall Tyler, *The Contrast: A Comedy in Five Acts* (New York: AMS Press, 1970), 54–55.

6. [Catharine Maria Sedgwick], *Home* (Boston and Cambridge: James Munroe, 1835), 39.

7. Christina Dallett Hemphill, "Manners for Americans: Interaction Ritual and the Social Order, 1620–1860" (Ph.D. diss., Brandeis University, 1987), 200–201.

8. Henry Bradshaw Fearon, *Sketches of America: A Narrative of a Journey of Five Thousand Miles through the Eastern and Western States of America,* 2d ed. (London: Longman, Hurst, Rees, Orme, and Brown, 1818), 55, 375.

9. Alexis de Tocqueville, *Democracy in America,* ed. J. P. Mayer and Max Lerner, trans. George Lawrence (New York: Harper & Row, 1966), 554.

10. Benjamin Rush, "The Influence of the American Revolution," 1 October 1788, in *Selected Writings of Benjamin Rush,* ed. Dagobert D. Runes (New York: Philosophical Library, 1947), 331–333.

11. Abigail Adams to Mary Smith Cranch, 5 January 1790, *New Letters of Abigail Adams, 1788–1801,* ed. Stewart Mitchell (Westport, Conn.: Greenwood Press, 1973), 35.

12. Billy G. Smith, *The Lower Sort: Philadelphia and Laboring People, 1750–1800* (Ithaca: Cornell University Press, 1990), 23–24.

13. Tyler, *Contrast,* 55.

14. David W. Galenson, *White Servitude in Colonial America: An Economic Analysis* (New York: Cambridge University Press, 1981), 177–179.

15. In *The Age of Jackson* (1945) Arthur M. Schlesinger, Jr., determined that the impetus behind "Jacksonian Democracy" came from ordinary workingmen who pushed against the controlling power of banks and business. Historians have since engaged in an active dialogue concerning Schlesinger's theory of class conflict. For an overview of the various arguments see the editorial note "Jacksonian Democracy, Fact or Fiction?" in *Interpretations of American History: Patterns and Perspectives,* ed. Gerald N. Grob and George Athan Billias, 5th ed., vol. 1 (New York: Free Press, 1987), 253–269.

16. Harriet Martineau, *Society in America,* ed. Seymour Martin Lipset (New Brunswick, N.J.: Transaction, 1981), 304–305.

17. Tocqueville, *Democracy in America,* 522.

18. A Gentleman, *The Laws of Etiquette; or, Short Rules and Reflections for Conduct in Society* (Philadelphia: Carey, Lea & Blanchard, 1836), 9–11, 119.

19. Edward Pessen, *Riches, Class, and Power: America before the Civil War* (New Brunswick, N.J.: Transaction, 1990), 2–3; Edward Pessen, *Jacksonian America: Society, Personality, and Politics* (Homewood, Ill.: Dorsey Press, 1969), 57; Oscar Handlin and Mary Handlin, *The Dimensions of Liberty* (New York: Atheneum, 1966), 29–30.

20. Fearon, *Sketches of America,* 80; Albert Matthews, "Hired Man and Help," *Publications of the Colonial Society of Massachusetts* 5 (March 1898): 250–253. Frances Trollope noted it was "more than petty treason in the Republic to call a free citizen a servant" in her *Domestic Manners of the Americans,* ed. Donald Smalley (New York: Alfred A. Knopf, 1949), 52.

21. See descriptions also in Trollope, *Domestic Manners,* 52–57, 425–426; [James Fenimore Cooper], *Notions of the Americans: Picked Up by a Travelling Bachelor,* vol. 1 (Philadelphia: Carey, Lea & Blanchard, 1838), 66–67; Timothy Dwight, *Travels in New England and New York,* ed. Barbara Miller Solomon, vol. 4 (Cambridge: Belknap Press, Harvard University Press, 1969), 247; Elias Pym Fordham, *Personal Narratives of Travels in Virginia, Maryland, Pennsylvania, Ohio, Indiana, Kentucky; and of a Residence in the Illinois Territory,* ed. Frederick Austin Ogg (Cleveland: Arthur H. Clark, 1906), 192–195, 229; and [Thomas Hamilton], *Men and Manners in America* (Edinburg, 1833; reprint, New York: Augustus M. Kelley, 1968), 88, 106.

22. Fearon, *Sketches of America,* 81; C. W. Janson, *The Stranger in America, 1793–1806* (London, 1807; reprint, New York: Press of the Pioneers, 1935), 88.

23. A Gentleman, *Laws of Etiquette,* 73.

24. Faye E. Dudden, *Serving Women: Household Service in Nineteenth-Century America* (Middletown, Conn.: Wesleyan University Press, 1983), 28–29; Lucy Maynard Salmon, *Domestic Service* (New York, 1897; reprint, New York: Arno Press, 1972), 69–70.

25. [Sedgwick], *Home,* 8, 72.

26. [Catharine Maria Sedgwick], *Live and Let Live; or, Domestic Service Illustrated* (New York: Harper & Bros., 1837), 81–82.

27. Dudden, *Serving Women,* 35–37; Blaine Edward McKinley, "The Stranger in the Gates: Employer Relations toward Domestic Servants in America, 1825–1875" (Ph.D. diss., Michigan State University, 1969), 57–58; Jane C. Nylander, *Our Own Snug Fireplace: Images of the New England Home, 1760–1860* (New York: Alfred A. Knopf, 1993), 41–53. Between 1785 and 1800, Martha Ballard of Hallowell, Maine, employed thirty-nine women to assist her at separate times with cleaning and home production. Most were from local families with middle incomes. See Laurel Thatcher Ulrich, *A Midwife's Tale: The Life of Martha Ballard, Based on Her Diary, 1785–1812* (New York: Alfred A. Knopf, 1990), 82.

28. Carl Degler, *At Odds: Women and the Family in America from the Revolution to the Present* (New York: Oxford University Press, 1980), 150–152; David Chaplin, "Domestic Service and Industrialization," *Comparative Studies in Sociology* 1 (1978): 98–99.

29. James Fenimore Cooper, *The Pioneers; or, The Sources of the Susquehanna* (Philadelphia: John C. Winston, 1923), 185, 191–193.

30. The New-York Historical Society, *Catalogue of the American Portraits,* vol. 2 (New Haven: Yale University Press, 1974), 609–610.

31. John Adams to Abigail Adams, 21 August 1776, Abigail Smith Adams, *The Book of Abigail and John: Selected Letters of the Adams Family, 1762–1784* (Cambridge: Harvard University Press, 1975), 156.

32. Charles Willson Peale to Rembrandt Peale, 11 September 1808, *The Selected Papers of Charles*

*Willson Peale and His Family,* ed. Lillian B. Miller, vol. 2, bk. 2 (New Haven: Yale University Press, 1988), 1136.

33. Charles Willson Peale, "Autobiography," in *The Collected Papers of Charles Willson Peale and His Family,* ed. Lillian B. Miller (National Portrait Gallery, Smithsonian Institution, Washington, D.C.; Millwood, N.Y.: Kraus-Thomson Organization, 1980), microfiche, typescript pp. 36 and 137–141, series II-C/14E14, II-C/16C8–12, II-C/16C12–14.

34. Ibid., typescript p. 140, series II-C/16C12–14.

35. Raphaelle Peale to Charles Willson Peale, 25 November 1798, Peale, *Selected Papers,* bk. 1, 229. On occasion Peale also rented slaves, as evidenced by his letter on 8 July 1775 to Ann Boone. Peale, *Collected Papers,* series II-A/5C3. Thanks to David Steinberg for bringing this to my attention and for other insights concerning the family portrait.

36. Dudden, *Serving Women,* 20–22.

37. Margaret Bayard Smith to Mrs. Kirkpatrick, 2 January 1804, Smith, *The First Forty Years of Washington Society,* ed. Gaillard Hunt (New York: Frederick Ungar, 1965), 44–45.

38. *Analectic Magazine* 1 (1820), quoted by Milo M. Naeve, *John Lewis Krimmel: An Artist in Federal America* (Newark: University of Delaware Press, 1987), 110–111.

39. In *Churchyard Chippes* (1575), Thomas Churchyard describes a servant who cleans with "Her taile tucke up in trimmest gies." Quoted by Phillis Cunnington, *Costume of Household Servants from the Middle Ages to 1900* (New York: Barnes & Noble, 1974), 132–140. In painting, the convention is present in several paintings including Pieter de Hooch's *Woman Drinking with Two Men and a Serving Woman* (ca. 1658, National Gallery, London), Jan Vermeer's *Milkmaid* (ca. 1660–1661, Rijksmuseum, Amsterdam), Jean-Baptiste-Siméon Chardin's *Kitchen Maid* (1738, National Gallery of Art, Washington, D.C.), and David Wilkie's *Breakfast* (1817, private collection).

40. Catherine Hoover, "The Influence of David Wilkie's Prints on the Genre Paintings of William Sidney Mount," *American Art Journal* 13 (Summer 1981): 5–30.

41. Naeve, *Krimmel,* 15–22, 28, 42.

42. "Review of the Third Annual Exhibition of the Columbian Society of Artists and the Pennsylvania Academy of the Fine Arts," *Port Folio* 2 (August 1813): 139.

43. Henry Nichols Blake Clark, "The Impact of Seventeenth-Century Dutch and Flemish Genre Painting on American Genre Painting, 1800–1865" (Ph.D. diss., University of Delaware, 1982), 2. See also ch. 1, Elizabeth Johns, *American Genre Painting: The Politics of Everyday Life* (New Haven: Yale University Press, 1991).

44. "On the Fine Arts," *North American Review and Miscellaneous Journal* 2 (1816), quoted by Naeve, *Krimmel,* 59.

45. *Analectic Magazine* 2 (1820), quoted by Naeve, *Krimmel,* 111–113. The original paintings are presently unlocated.

46. Ibid.

47. [Sarah Savage], *Advice to a Young Woman at Service, in a Letter from a Friend* (Boston: John B. Russell, 1823), 28–29.

48. Ulrich, 146.

49. In the fifth edition of *Domestic Manners of the Americans,* Frances Trollope included a brief story about a quilting frolic in a rustic home. The household includes a borrowed slave, Lily, and the "white help," Clementina, who announces, "I'll look after the cakes; but I won't carry 'em, mind," 417–420.

50. A painting that offers the more typical presentation of the black child servant at the feet of her mistress is *The Itinerant Artist* (ca. 1830, New York State Historical Association), by Charles Bird King. Two white help are included in the background.

51. Guy C. McElroy, *Facing History: The Black Image in American Art, 1710–1940* (Washington, D.C.: Bedford Arts, Corcoran Gallery of Art, 1990), 14.

52. Stephanie Coontz, *The Social Origins of Private Life: A History of American Families, 1600–1900* (London: Verso, 1988), 136; Albert Boime, *The Art of Exclusion: Representing Blacks in the Nineteenth Century* (Washington, D.C.: Smithsonian Institution Press, 1990), 7.

53. Charles Mackay, *Life and Liberty in America; or, Sketches of a Tour in the United States and Canada in 1857–1858,* vol. 1 (London, 1859; reprint, New York: Johnson Reprint Corporation, 1971), 46.

54. Coontz, *Social Origins,* 136.

55. Edward Halsey Foster, *Catharine Maria Sedgwick* (New York: Twayne, 1974), 29.

56. Catharine Maria Sedgwick, "Recollections of Childhood" (1853), in *The Life and Letters of Catharine M[aria] Sedgwick,* ed. Maria E. Dewey (New York: Harper & Bros., 1871), 40–42.

57. Sidney Kaplan, *The Black Presence in the Era of the American Revolution, 1770–1800* (Washington, D.C.: National Portrait Gallery, 1973), 216–217.

58. Sedgwick, "Recollections of Childhood," 42; Foster, *Sedgwick,* 30.

59. Robert William Fogel, *Without Consent or Contract: The Rise and Fall of American Slavery* (New York: W. W. Norton, 1989), 248–249; Winthrop D. Jordan, *White over Black* (Chapel Hill: University of North Carolina Press, 1968), xi–xii.

60. Jordan, *White over Black,* 403–425; Coontz, *Social Origins,* 137–142; Leon F. Litwack, *North of Slavery: The Negro in the Free States, 1790–1860,* 6th ed. (Chicago: University of Chicago Press, 1970), 97–98, 168.

61. The concept of a racially hierarchical Great Chain of Being was put forth in Alexander Pope's *Essay on Man,* which gained popular acclaim in colonial America throughout the second half of the eighteenth century. Jordan, *White over Black,* 248–249, 483–501.

62. Thomas F. Gossett, *Race: The History of an Idea in America* (Dallas: Southern Methodist University Press, 1963), 62; Genesis 9:20–27, *The Interpreter's Bible,* vol. 1 (New York: Abingdon-Cokesbury Press, 1952), 556–558.

63. P. H., "The Colored Population of the United States, No. 2," *Liberator* 1 (22 January 1831): 14.

64. Robbin Legere Henderson, "Prisoners of Image," in *Prisoners of Image: Ethnic and Gender Stereotypes* (New York: Alternative Museum, 1989), 6; Jordan, *White over Black,* xiv; Coontz, *Social Origins,* 139.

65. [Hamilton], *Men and Manners,* 88.

66. Jadviga M. da Costa Nunes, *Baroness Hyde de Neuville: Sketches of America, 1807–1822* (New Brunswick, N.J.: Jane Vorhees Zimmerli Art Museum, Rutgers University, and New-York Historical Society, 1984), 1–3.

67. Ibid., 19, 37.

68. Charles G. Wright, "Alburtus D. O. Browere, 1814–1887," Presented to the Green County Historical Society, N.Y., 1971. See "Browere, Alburtus Del Orient," vertical file, National Museum of American Art, National Portrait Gallery Library, Smithsonian Institution, Washington, D.C.

69. Carl N. Degler, *Out of Our Past: The Forces That Shaped Modern America* (New York: Harper & Row, 1970), 167–168.

70. Jordan, *White over Black,* 150–151; John D'Emilio and Estelle B. Freedman, *Intimate Matters: A History of Sexuality in America* (New York: Harper & Row, 1988), 107.

71. Leonard L. Richards, "Gentlemen of Property and Standing: Anti-abolition Mobs in Jacksonian America," in *Jacksonian Democracy,* ed. James L. Bugg, Jr., and Peter C. Steward (New York: Praeger, 1976), 131–132.

72. Henderson, "Prisoners of Image," 6.

73. Coontz, *Social Origins,* 140.

74. Quoted by Philip S. Foner, *History of Black Americans,* vol. 1, *From Africa to the Emergence of the Cotton Kingdom* (Westport, Conn.: Greenwood Press, 1975), 521–523.

75. Jane C. Nylander, "Henry Sargent's *Dinner Party* and *Tea Party,*" *Antiques* 121 (May 1982): 1175.

76. Robert Roberts, *The House Servant's Directory; or, A Monitor for Private Families* (New York: Charles S. Francis; Boston: Munroe & Francis, 1827), 18–33, 44–66.

77. Nylander, "Henry Sargent's *Dinner Party* and *Tea Party,*" 1176.

78. Roberts, *House Servant's Directory,* 50.

79. Abigail Adams to Mary Smith Cranch, 3 November 1789, *New Letters of Abigail Adams,* 33.

80. Roberts, *House Servant's Directory,* 70–74.

81. Daniel E. Sutherland, *Americans and Their Servants: Domestic Service in the United States from 1800 to 1920* (Baton Rouge: Louisiana State University Press, 1981), 60. A boy servant is pictured in *The Poor Author and the Rich Bookseller,* Washington Allston (ca. 1810, Museum of Fine Arts, Boston). Edwin H. Blashfield portrayed an elderly white butler in *Waterloo: Total Defeat* (1882, collection, Edward Wilson, Fund for Fine Arts), plate 7, discussed in ch. 5.

82. Fearon, *Sketches of America,* 81; Martineau, *Society in America,* 303; Fogel, *Without Consent or Contract,* 49; Sutherland, *Americans and Their Servants,* 84, 87.

83. M. B. Smith, *First Forty Years,* 359–362.

84. James Oliver Robertson, *American Myth, American Reality* (New York: Hill & Wang, 1980), 92–93.

85. Other contemporary representations using this convention include *The Children of Commodore John Daniel Danels,* by Robert Street (1826, Maryland Historical Society, Baltimore), *Rustic Dance after a Sleigh Ride,* by William Sidney Mount (1830, Museum of Fine Arts, Boston), and *The Pedlar Displaying His Wares,* by Asher B. Durand (1836, New-York Historical Society).

86. Salmon, *Domestic Service,* 57; Martineau, *Society in America,* 304; E. S. Turner, *What the Butler Saw: Two Hundred and Fifty Years of the Servant Problem* (New York: St. Martin's Press, 1963), 181.

87. [James Fenimore Cooper], *Notions of the Americans: Picked Up by a Traveling Bachelor,* vol. 1 (Philadelphia: Carey, Lea & Blanchard, 1838), 86.

88. James Fenimore Cooper, *The Travelling Bachelor; or, Notions of the Americans,* vol. 2 (New York: Stringer & Townsend, 1852), 47.

89. Paul S. D'Ambrosio and Charlotte M. Evans, *Folk Art's Many Faces* (Cooperstown: New York State Historical Association, 1987), 84.

90. An inscription on the back of the canvas reads, "A representation of the hall of the mansion house of the late William Cooper Esqr. [illegible]. Also the likeness of their old servant Joseph Stewart generally known by the name of Governor. [P]ainted by Mr. Freeman in the summer of 1816–." Ibid., 84–85.

91. Cooper, *Pioneers,* 28–29.

92. Ibid., 59–64, 244–245.

93. Charles A. Goodrich, *The Universal Traveller* (Hartford, Conn.: Canfield & Robins, 1838), 45–46.

94. McKinley, "Stranger in the Gates," v–vi.

95. Catharine E. Beecher and Harriet Beecher Stowe, *The American Woman's Home; or, Principles of Domestic Science* (New York, 1869; reprint, Hartford, Conn.: Stowe-Day Foundation, 1975), 319.

## CHAPTER 3. LILLY MARTIN SPENCER: IMAGES OF WOMEN'S WORK AND WORKING WOMEN, 1840–1870

1. "Mrs. Lilly M. Spencer's Paintings," *Cosmopolitan Art Journal* 1 (September 1857): 165.

2. Mrs. [Elizabeth Fries] Ellet, *Women Artists in All Ages and Countries* (New York: Harper & Bros., 1859), 317.

3. Recent studies, while acknowledging Spencer's use of her servants as models, interpret the figures more broadly as housewives. See Elizabeth Johns, *American Genre Painting: The Politics of Everyday Life* (New Haven: Yale University Press, 1991), 163–164, 239n, and David Lubin, *Picturing a Nation: Art and Social Change in Nineteenth-Century America* (New Haven: Yale University Press, 1994), 180–183.

4. Henry Nichols Blake Clark, "The Impact of Seventeenth-Century Dutch and Flemish Genre Painting on American Genre Painting, 1800–1865" (Ph.D. diss., University of Delaware, 1982), 3, 57–87.

5. Patricia Hills, *The Painters' America: Rural and Urban Life, 1810–1910* (New York: Praeger, 1974), 24–25; Clark, "Impact of Seventeenth-Century Dutch," 10–11, 275–276; Ralph Waldo Emerson, "The American Scholar," in *The Complete Works of Ralph Waldo Emerson,* vol. 1, *Nature: Addresses and Lectures.* (Boston: Houghton Mifflin; Cambridge, Mass.: Riverside Press, 1903), 111–112.

6. Simon Schama, *The Embarrassment of Riches: An Interpretation of Dutch Culture in the Golden Age* (New York: Alfred A Knopf, 1987), 377–391.

7. Ibid., 393, 455.

8. Peter C. Sutton, *Pieter de Hooch* (Oxford: Phaidon, 1980), 45–46. Schama, *Embarrassment of Riches,* 455. Schama notes that in ancient comedies, the fool is permitted to prevail as an indirect attack on hierarchy. "When fools turned servants, though," he continues, "the loyalty of their candor became more questionable and the line between salutary frankness and subversive insolence more ambiguous" (455–458).

9. Jane Iandola Watkins, ed., *Masters of Seventeenth-Century Dutch Painting* (Philadelphia: Philadelphia Museum of Art, 1984), 322–323.

10. H. Nichols B. Clark, *Francis W. Edmonds: American Master in the Dutch Tradition* (Washington,

D.C.: Smithsonian Institution Press, Amon Carter Museum, 1988), xi–xiii, 19–35, 57–66; H. Nichols B. Clark, "A Taste for the Netherlands: The Impact of Seventeenth-Century Dutch and Flemish Genre Painting on American Art, 1800–1860," *American Art Journal* 14 (Spring 1982): 32.

11. "National Academy of Design," *Knickerbocker* 23 (June 1844): 597.

12. Clark, *Edmonds,* 108; Eldon Walker, introduction to *New York 1850 Census Index,* vol. 1 (Bountiful, Utah: Accelerated Indexing Systems, 1977), n.p.

13. Blaine Edward McKinley, "The Stranger in the Gates: Employer Reactions toward Domestic Servants in America, 1825–1875" (Ph.D. diss., Michigan State University, 1969), 65.

14. Clark, *Edmonds,* 107–108.

15. Mrs. A. J. Graves, *Women in America: Being an Examination in the Moral and Intellectual Condition of American Female Society* (New York, 1841), quoted in *Root of Bitterness: Documents of the Social History of American Women,* ed. Nancy F. Cott (Boston: Northeastern University Press, 1986), 144.

16. Julie A. Matthaei, *An Economic History of Women in America: Women's Work, the Sexual Division of Labor, and the Development of Capitalism* (New York: Schocken Books, 1982), 102; Jeanne Boydston, *Home and Work: Housework, Wages, and the Ideology of Labor in the Early Republic* (New York: Oxford University Press, 1990), 69.

17. There has been an active debate among scholars as to whether the cult of domesticity produced a rise or loss of authority for women. See Gerda Lerner, "The Lady and Mill Girl: Changes in the Status of Women in the Age of Jackson," *Midcontinent American Studies Journal* 10 (Spring 1969): 5–15; Nancy F. Cott, *The Bonds of Womanhood: "Woman's Sphere" in New England, 1780–1835* (New Haven: Yale University Press, 1977), 99–100, 200–201; Carl N. Degler, *At Odds: Women and the Family in America from the Revolution to the Present* (New York: Oxford University Press, 1980), 27–28, 49; and Boydston, *Home and Work,* 74.

18. Barbara Welter, "The Cult of True Womanhood, 1820–1860," *American Quarterly* 18 (summer 1966): 151–174; Sarah Josepha Hale, *Lady's Magazine* (1830), quoted by Stephanie Coontz in *The Social Origins of Private Life: A History of American Families, 1600–1900* (London: Verso, 1988), 186; Cott, *Bonds of Womanhood,* 63.

19. Boydston, *Home and Work,* 155.

20. Matthaei, *Economic History of Women,* 54; Nancy Woloch, *Women and the American Experience* (New York: Alfred A. Knopf, 1984), 115, 136–139; Coontz, *Social Origins,* 200–202, McKinley, "Stranger in the Gates," 1, 23–26.

21. Louisa May Alcott, *Little Women; or, Meg, Jo, Beth, and Amy* (1868; Boston: Little, Brown, 1910), 126.

22. For detailed discussions of the kinds of housework undertaken by women in the nineteenth century, see ch. 5 in Jane C. Nylander, *Our Own Snug Fireplace: Images of the New England Home, 1760–1860* (New York: Alfred A. Knopf, 1993), and Susan M. Strasser, *Never Done: A History of American Housework* (New York: Pantheon Books, 1982).

23. Boydston, *Home and Work,* 77–78, 123, 125, 139; Coontz, *Social Origins,* 173.

24. Harvey Green, *The Light of the Home: An Intimate View of the Lives of Women in Victorian America* (New York: Pantheon Books, 1983), 90.

25. McKinley, "Stranger in the Gates," 8; Faye E. Dudden, *Serving Women: Household Service in Nineteenth-Century America* (Middletown, Conn.: Wesleyan University Press, 1983), 1; [Sarah Josepha Hale], "Maids-of-All-Work," *Godey's Lady's Book* 54 (March 1856): 286.

26. Matthaei, *Economic History of Women,* 198–199, 202. Throughout the nineteenth and twentieth centuries, females consistently comprised over 90 percent of all domestics in the United States. Judith Rollins, *Between Women: Domestics and Their Employers* (Philadelphia: Temple University Press, 1985), 33–34, 244n.

27. Matthaei, *Economic History of Women,* 202; Catharine E. Beecher, *A Treatise on Domestic Economy, for the Use of Young Ladies at Home and at School,* rev. ed. (1841; New York: Harper & Bros., 1856), 26.

28. Ruth Schwartz Cowan, *More Work for Mother: The Ironies of Household Technology from the Open Hearth to the Microwave* (New York: Basic Books, 1983), 42; Daniel E. Sutherland, *Americans and Their Servants: Domestic Service in the United States from 1800 to 1920* (Baton Rouge: Louisiana State University Press, 1981), 10–12.

29. Catharine Maria Sedgwick, *Live and Let Live; or, Domestic Service Illustrated* (New York: Harper & Bros., 1837), 123; Lydia Maria Child, *Letters from New York; Second Series* (1841), quoted by Christine Stansell in *City of Women: Sex and Class in New York, 1789–1860* (New York: Alfred A. Knopf, 1986), 159.

30. Beecher, *Treatise,* 61–62.

31. William A. Alcott, *The Young Wife; or, Duties of Women in the Marriage Relation* (Boston: George W. Light, 1838), 153–166; Ralph Waldo Emerson, "Domestic Life," in *Complete Works,* vol. 7, *Society and Solitude,* 116–117. For a discussion of Emerson's own household dynamics, see Barbara Ryan, "Emerson's 'Domestic and Social Experiments': Service, Slavery, and the Unhired Man," *American Literature* 66 (September 1994): 485–508.

32. Dudden, *Serving Women,* 44; McKinley, "Stranger in the Gates," 191–192; "Household Service," *Harper's New Monthly Magazine* 20 (February 1860): 405.

33. Catharine E. Beecher, *Letters to Persons Who Are Engaged in Domestic Service* (New York: Leavitt & Trow, 1842), 164–166. The condescending tone of the handbook may have resulted in its placement in the "Juvenile" section of rare books in the Library of Congress.

34. One 1846 survey estimated that there were between 10,000 and 12,000 domestics in New York City, of which nearly 8,000 were Irish. McKinley, "Stranger in the Gates," 148–160.

35. Emerson, "Man the Reformer," in *Complete Works,* vol. 1, 252–253; Beecher, *Treatise,* 40.

36. Ellet, *Women Artists,* 321.

37. Morton, "The Arts in the West," *Marietta Intelligencer,* 12 September 1839. Lilly Martin Spencer papers (hereafter referred to as Spencer papers), microfilm roll 131, Archives of American Art, Smithsonian Institution, Washington, D.C.

38. Robin Bolton-Smith and William H. Truettner, *The Joys of Sentiment: Lilly Martin Spencer, 1822–1902* (Washington, D.C.: Smithsonian Institution Press, 1973), 11–12.

39. William Herbert to Giles Martin, 30 July 1829. The London businessman wrote to recruit the couple to immigrate to the United States. The proposed new community was to be composed of individuals with "liberal views" who would offer "an equal contribution of industry, whether bodily or mental." Lilly Martin Spencer family papers (referred to hereafter as Spencer family papers), Campus Martius Museum of the Ohio Historical Society, Marietta, Ohio, microfilm roll 132, Archives of American Art, Smithsonian Institution, Washington D.C.

40. Bolton-Smith and Truettner, *Joys of Sentiment,* 11; Elsie Freivogel, "Lilly Martin Spencer," *Archives of American Art Journal* 12 (1972): 9. In the 1840s there were twenty-six Fourierist communities across the United States. The best known, Brook Farm, was associated with the Transcendentalists. Anne C. Rose, *Transcendentalism as a Social Movement, 1830–1850* (New Haven: Yale University Press, 1981), 51.

41. Josephine Withers, "Artistic Women and Women Artists," *Art Journal* 35 (Summer 1976): 330.

42. Bolton-Smith and Truettner, *Joys of Sentiment,* 15–19. Giles Martin wrote that he was teaching French to Mr. [John Insco] Williams in exchange for art lessons for Lilly. 10 June 1842, Spencer family papers.

43. Angelique Martin to Giles Martin, 19 December 1841; Lilly Martin Spencer (hereafter referred to as LMS) to her mother, 21 January 1842; Giles Martin to LMS, 5 April 1842.

44. Census listings from 1850 and 1860 indicate that Ben was born in Ireland. Eventually, he disguised his origins, claiming in the 1870 census to be a native of New Jersey, with American-born parents. *Population Schedules of the Seventh Census of the United States, 1850,* New York, New York County, New York City, ward 14 (Washington, D.C.: National Archives, 1963), microfilm roll 551, p. 250; *Population Schedules of the Eighth Census of the United States, 1860,* New Jersey, Essex County, City of Newark, ward 1 (Washington, D.C.: National Archives, 1967), microfilm roll 688, p. 28; *Population Schedules of the Ninth Census of the United States, 1870,* New Jersey, Essex County, City of Newark, ward 1 (Washington, D.C.: National Archives, 1965), microfilm roll 879, p. 62.

45. W. A. Adams to LMS, 5 February 1845, Spencer papers. While her liberal parents and her own early commitment to painting prepared her for an unconventional role, she was not an active feminist. Asked if she would attend the 1850 national women's convention, Spencer declined: "You know dear Mother that that is your point of exertion and attention and study like my painting is mine." LMS to her mother, 11 October 1850, Spencer papers.

46. LMS to her parents, 11 March 1845, Spencer papers.

47. Bolton-Smith and Truettner, *Joys of Sentiment,* 21, 79n; LMS to her parents, 28 May 1845, Spencer papers.

48. His contributions were probably limited to background passages. After relocating to New York, Ben was listed in the city directory as an artist, though none of his paintings have been located. Bolton-Smith and Truettner, *Joys of Sentiment,* 22, 33, 35. Lilly also recruited her husband, whose hand-

writing was neater than hers, to write the headings of some of her letters (see LMS to her parents, 21 November 1848, Spencer papers). He also penned her text panel for *The Gossips* (Spencer papers) and an annotated inventory of paintings (Charles Roberts Autograph Collection of American Artists, Haverford Collection Library, Archives of American Art, roll P88).

49. LMS to her parents, 3 February 1847, Spencer papers. *Population Schedules, Seventh Census, 1850; Population Schedules, Eighth Census, 1860; Population Schedules, Ninth Census, 1870.*

50. Bolton-Smith and Truettner, *Joys of Sentiment,* 26–28.

51. LMS to her parents, 11 October 1850, Spencer papers.

52. LMS to her parents, 11 October 1850, Spencer papers.

53. Sutherland, *Americans and Their Servants,* 126.

54. LMS to her mother, August (?) 1851, Spencer papers.

55. LMS to her parents, 8 December 1851, Spencer papers.

56. *Population Schedules, Seventh Census, 1850.*

57. Margaret D. Bale to Angelique Martin, 18 May 1851, Spencer family papers.

58. See ch. 6 in Strasser's *Never Done.* Also, by the same author, "An Enlarged Human Existence? Technology and Household Work in Nineteenth-Century America," in *Women and Household Labor,* ed. Sarah Fenstermaker Berk (Beverly Hills, Calif.: Sage, 1980).

59. For many years, the painting was misattributed to a Düsseldorf artist, until its rediscovery and authentication in 1993. Barbara J. MacAdam, curator of American art, Hood Museum of Art, Dartmouth College, Hanover, N.H., letter to author, 9 May 1994.

60. Nicholas Longworth owned "several excellent specimens of the Dutch School." Worthington Whittredge, "The Autobiography of Worthington Whittredge," ed. John I. H. Baur, *Brooklyn Museum Journal* 2 (1942): 17.

61. Similar paintings include Dou's *Woman Cleaning Kettle* (ca. 1640, Buckingham Palace, London), and *The Cook* (ca. 1640, Louvre, Paris); Nicholas Maes's *Eavesdropper* (Rijksbeeldende Kunst, The Hague) and *Listening Maid* (1656, Wallace Collection, London); Jan Steen's *Girl with Oysters* (1658–1660, Mauritshuis, The Hague).

62. The Dutch believed the onion to have aphrodisiac qualities. As the cook chops onions in Dou's painting, a boy holds up a bulb for her inspection. Other erotic emblems—the dead fowl, bird cage, and tipped vessel—implicate the woman as a prostitute. Schama, *Embarrassment of Riches,* 384; Bob Haak, *The Golden Age: Dutch Painters of the Seventeenth Century,* ed. and trans. Elizabeth Willems-Treeman (New York: Harry N. Abrams, 1984), 121–122; Philadelphia Museum of Art, *Masters of Seventeenth-Century Dutch Painting,* 184.

63. Ellet, *Women Artists,* 328.

64. Bolton-Smith and Truettner, *Joys of Sentiment,* 23, 26, 30.

65. Frank Carnes to LMS, 10 December 1848, Spencer papers.

66. Ellet, *Women Artists,* 324.

67. The painting was one of the few that made a profit for the American Art-Union at its final auction. Set at the purchase price of $160, it sold for $240. That was an excellent earning for the artist considering that in 1850, the average annual income for a man working at a trade like printing or shoemaking in New York was $300. Bolton-Smith and Truettner, *Joys of Sentiment,* 30–33, 148; Boydston, *Home and Work,* 62.

68. The theme once again suggests the artist's study of seventeenth-century imagery. The Dutch motif of peeling onions connoted disrobing, an activity that brought tears of remorse to young women. Spencer would probably not have known or recognized the emblematic tradition of the theme. But it is interesting to note that here and in an earlier sketch ("Peeling Onions," Munson-Williams-Proctor Institute), the servant displays an open décolletage. When the figure is transformed into a middle-class matron in the oil study *The Young Wife* (Ohio Historical Society), Spencer presents her with upper chest covered in accordance with dress standards for ladies. Haak, *Golden Age,* 122; [Sarah Josepha Hale], "Fast Women," *Godey's Lady's Book* 54 (February 1857): 178.

69. In an earlier version of my study, I had concurred with Bolton-Smith and Truettner that the model for *Peeling Onions* and *Shake Hands?* was the same woman portrayed in *Our Servant* (fig. 3-6). After seeing the newly discovered *Jolly Washerwoman,* however, I believe that the drawing better matches the worker pictured in that painting. By comparison, the two later canvases seem to portray a different woman—one with a more slender build and angular face.

70. In his chapter on Spencer, David Lubin offers a revealing study of the ambivalent and sometimes contradictory subtexts of the artist's domestic genre. He argues that her work was, at the same time, an instrument of social control and social subversion concerning prevailing ideas of domesticity. Lubin, *Picturing a Nation,* 159–203.

71. Ruth Cowan has noted that refined white flour—compared with rye, whole wheat, or corn meal—was expensive in the antebellum period. "The conversion from meal to flour and from quickbreads to time-consuming breads indicated that the household could afford both the cash that was necessary for the purchase of the flour and the house-wifely (or servantly) time that was required for its preparation. Thus white bread became one of the first symbols of status in the industrial period." Cowan, *More Work for Mother,* 49–51.

72. Johns, *American Genre Painting,* 163–164; Christina Dallett Hemphill, "Manners for Americans: Interaction Ritual and the Social Order, 1620–1860" (Ph.D. diss., Brandeis University, 1988), 362–363, 384. Thanks to David Steinberg for sharing his thoughts about the gesture with me.

73. Spencer describes a raucous water fight in which she and her husband doused each other with buckets of water outside on a hot summer afternoon. LMS to her parents, 11 August 1851, Spencer papers.

74. Other representations of serving women in Edmonds's paintings include waitresses in *The Epicure* (1838, Wadsworth Athenaeum, Hartford, Conn.) and *The Organ Grinder* (ca. 1848, private collection). His *Dame in the Kitchen* (ca. 1859, Masco Collection, Taylor, Mich.) is unusual in its depiction of a single worker. However, unlike Spencer, he fails to construct a believable work station. The maid scrubs clothing or dishes in a large, water-filled tub that is placed on a small tripod table. Isolated in the middle of the room, there are no surfaces nearby on which to lay her cleaning.

75. [T. S. Arthur], *Trials and Confessions of an American Housekeeper* (Philadelphia: Lippincott, Grambo, 1854), 22, 26–27.

76. Bolton-Smith and Truettner, *Joys of Sentiment,* 166–167. Other painters from this period may have borrowed the theme of the strong kitchen maid from Spencer's popular image. Enoch Wood Perry pictures a domestic, in his *Young Cook with Bird* (1859, Walters Art Gallery, Baltimore), who gently kisses white doves before wringing their necks. In *Caught in the Act* (ca. 1860–1864, Vassar College Art Gallery), Tompkins Matteson depicts a brawny cook twisting the ear of a boy who has raided her pantry. Both servants wear their overskirts tucked and their sleeves rolled above the elbows.

77. Two versions of the painting are in the collections of the Hunter Museum of American Art, Chattanooga, Tenn., and the Masco Collection, Taylor, Mich.

78. There are at least two extant sets of the plaques, which appear to be made by the same manufacturer. The one pictured in fig. 3-12 is from a pair made for wall display. The second set, in a private collection in New Orleans, Louisiana, has been mounted on the bases of a pair of candelabra. See Dorothy E. Ellesin, "Lilly Martin Spencer and a Pair of Girandoles," *Antiques* 107 (February 1975): 264.

79. Rev. Daniel Wise, *The Young Lady's Counsellor; or, Outlines and Illustrations of the Sphere, the Duties, and the Dangers of Young Women* (New York, 1851). Reprinted in *The American Ideal of the "True Woman" as Reflected in Advice Books to Young Women,* ed. Carolyn De Swarte Gifford (New York: Garland, 1987), 173.

80. Johns, *American Genre Painting,* 165.

81. "Exhibition of the National Academy," *The Crayon* 3 (May 1856): 146.

82. "Editorial Etchings," *Cosmopolitan Art Journal* 1 (July 1856): 27.

83. The image's dual message, Elizabeth Johns observes, is that a woman can be "attractive *and* proper." Johns, *American Genre Painting,* 170.

84. "Household Service," *Harper's New Monthly Magazine* 20 (February 1860): 405.

85. Helen S. Langa also notes the change in class status between the two paintings, which she attributes to the artist's shift from "good-humored camaraderie to elegance and more distanced amusements." See her "Lilly Martin Spencer: Genre, Aesthetics, and Gender in the Work of a Mid-Nineteenth Century Woman Artist," *Athanor* 9 (1990): 39–40. Elizabeth Johns, on the other hand, suggests that the more decorative appearance of the woman in *Kiss Me* was a result of the artist's attempt at producing a more sexually provocative figure that would appeal to male viewers. At the same time, the glimpse into the parlor "assimilates the flirtatious woman into a proper sphere." Johns, *American Genre Painting,* 164, 168.

86. LMS to her mother, 10 September, 1856, Spencer papers.

87. James L. Huston, *The Panic of 1857 and the Coming of the Civil War* (Baton Rouge: Louisiana State University Press, 1987), 1–34.

88. LMS to her parents, 7 March 1857, Spencer papers.

89. Parke Godwin, *A Popular View of the Doctrines of Charles Fourier* (New York, 1844; reprint, New York: AMS Press, 1974), 58.

90. LMS to her parents, 7 March 1857, Spencer papers.

91. Alice B. Neal, "The Servant Question," *Godey's Lady's Book* 55 (October 1857): 325–330.

92. "The Miseries of Mistresses," *Harper's New Monthly Magazine* 14 (January 1857): 285–286. Published the previous autumn was another two-page spread of servant cartoons, "The Miseries of Mistresses," *Harper's New Monthly Magazine* 13 (October 1856): 717–718.

93. Ellet, *Women Artists*, 325–326.

94. "Sketchings: Exhibition of the National Academy of Design," *The Crayon* 5 (June 1858): 177.

95. James L. Yarnall and William H. Gerdts, eds., *Index to American Art Exhibition Catalogues*, vol. 5 (Boston: G. K. Hall, 1986), 3335. Encouraged by publicity, Spencer placed a steep $1000 sales price on the painting. The invoice is in the Charles Roberts Autograph Collection, James P. Magill Library, Haverford College, Penn.

96. "The Gossips," Spencer papers.

97. Bolton-Smith and Truettner, *Joys of Sentiment*, 54–55.

98. LMS to her parents, 28 June 1858, Spencer papers.

99. LMS to her parents, 29 December 1859 and 14 October 1860, Spencer papers.

100. *Population Schedules, Eighth Census, 1860*, New Jersey, Essex County, City of Newark, ward 1, p. 38.

101. Bolton-Smith and Truettner, *Joys of Sentiment*, 85–86.

102. Yarnall and Gerdts, *Index*, 3335. The original text appears in an invoice in the Charles Roberts Autograph Collection. For another painting on this list, *Helping the Cook*, Spencer noted, "like many a cook's assistant, [the servant] puts her more astray than helps her." The unlocated painting is yet another in Spencer's kitchen series.

103. Giles Martin to Charles Martin, 14 February 1851, Spencer papers.

104. Harriet Beecher Stowe, *Uncle Tom's Cabin; or, Life among the Lowly*, vol. 1 (1896; reprint, New York: AMS Press, 1967), 191–192.

105. Two of her paintings, *Power of Fashion* and *Height of Fashion*, portray black children who emulate stylish white adults. The images were widely circulated in lithographic form. Bolton-Smith and Truettner, *Joys of Sentiment*, 39–41, 142–143, 163.

106. C. Vann Woodward, *The Strange Career of Jim Crow*, 3d. rev. ed. (New York: Oxford University Press, 1974), 7.

107. Stowe, *Uncle Tom's Cabin*, 313–314, 323–324.

108. LMS to Mr. Ewers, 5 February 1862, Charles Roberts Autograph Collection.

109. Frederick Douglass, "Independence Day Speech at Rochester," in *The American Reader: Words That Moved a Nation*, ed. Diane Ravitch (New York: Harper Perennial, 1990), 115.

110. George Templeton Strong, 5 November 1867, quoted in *The Hone and Strong Diaries of Old Manhattan*, ed. Louis Auchincloss (New York: Abbeville Press, 1989), 251.

111. LMS to her parents, 12 May 1862, Spencer papers.

112. In 1961, Lillian Spencer Gates, the artist's granddaughter, identified the figures. Her father, Pierre Spencer, is the toddler in the foreground, followed by Lilly Caroline and Charles. The baby in Spencer's arms is Flora Serena. Mrs. Gates confirmed that the woman in the background is the maid. "Employee Keepsakes Retrace Period of Civil War in Library Exposition," *Electricity and Gas Public Service News* 21 (1 May 1961): 11–13, Spencer papers.

113. Jerry Korn, *War on the Mississippi: Grant's Vicksburg Campaign* (Alexandria, Va.: Time-Life Books, 1985), 156–157. Using the actual wording and placement of the *New York Times* front-page headlines for 7 July 1863, Spencer embellished the announcement with a drawing of the American flag.

114. Hills, *Painters' America*, 65.

115. Perhaps perpetuating family oral tradition, Ann Byrd Shumer reports that Spencer's son, Angelo, was the one who had gone to fight for the Union, in "Lilly Martin Spencer, American Painter of the Nineteenth Century" (M.A. thesis, Ohio State University, 1959), 68. A review of military files shows that Angelo enlisted in the Navy in 1870 and served off and on until 1900. "Spencer, Angelo P.,"

pension records, U.S. Navy, XC-2451602, National Archives, Washington, D.C.

116. Spencer submitted canvases to several exhibitions including ones at the Boston Athenaeum, the Brooklyn Art Association, Pennsylvania Academy of the Fine Arts, and the Centennial Exhibition in Philadelphia. Bolton-Smith and Truettner, *Joys of Sentiment,* 67–71, 85–86.

117. Hills, *Painters' America,* 41.

### CHAPTER 4. BRIDGET AND DINAH:
### IMAGES OF DIFFERENCE AT MID-CENTURY, 1836–1876

1. *Harper's Weekly* 11 (27 November 1858): 760–762.

2. Roger B. Stein, "Picture and Text: The Literary World of Winslow Homer," in *Winslow Homer: A Symposium, Studies in the History of Art* 26, Center for Advanced Study in the Visual Arts, Symposium Papers 11 (Washington, D.C.: National Gallery of Art, 1990), 36.

3. Abraham Lincoln to Joshua F. Speed, 24 August 1855. *The Collected Works of Abraham Lincoln,* ed. Roy P. Basler, vol. 2 (New Brunswick, N.J.: Rutgers University Press, 1953), 323.

4. "Household Service," *Harper's New Monthly Magazine* 20 (February 1860): 406–407.

5. John Higham, *Strangers in the Land: Patterns of American Nativism, 1860–1925* (New York: Atheneum, 1969), 132.

6. Ibid., 6–8; Ray Allen Billington, *The Protestant Crusade, 1800–1860: A Study of the Origins of American Nativism* (Gloucester, Mass.: Peter Smith, 1963), 1–21.

7. Abigail Adams to Mary Smith Cranch, 28 April 1790, *New Letters of Abigail Adams, 1788–1801,* ed. Stewart Mitchell (Westport, Conn.: Greenwood Press, 1973), 48.

8. Edward Pessen, *Jacksonian America: Society, Personality, and Politics* (Homewood, Ill.: Dorsey Press, 1969), 64.

9. Harriet Martineau, *Society in America,* ed. Seymour Martin Lipset (New Brunswick, N.J.: Transaction, 1981), 183.

10. Lawrence H. Fuchs, *The American Kaleidoscope: Race, Ethnicity, and the Civic Culture* (Hanover, N.H.: University Press of New England, Wesleyan University Press, 1990), 38.

11. Faye E. Dudden, *Serving Women: Household Service in Nineteenth-Century America* (Middletown, Conn.: Wesleyan University Press, 1983), 61; Carol Groneman, "Working-Class Immigrant Women in Mid-Nineteenth Century New York: The Irish Woman's Experience," *Journal of Urban History* 4 (May 1978): 258, 260; Hasia R. Diner, *Erin's Daughters in America: Irish Immigrant Women in the Nineteenth Century* (Baltimore: Johns Hopkins Press, 1983), 30–41.

12. David Katzman, *Seven Days a Week: Women and Domestic Service in Industrializing America* (Urbana: University of Illinois Press, Illini Books, 1981), 67–72; Diner, *Erin's Daughters,* 40, 70–71, 80–81.

13. Catharine E. Beecher and Harriet Beecher Stowe, *The American Woman's Home; or, Principles of Domestic Science* (New York, 1869; reprint, Hartford, Conn.: Stowe-Day Foundation, 1975), 13, 307–311, 318–320. Stowe immortalized the paragon of help in the character of Nabby Higgins in *Poganuc People* (1878), a novel set in an early 1800s New England village.

14. Dudden, *Serving Women,* 194–203; Blaine Edward McKinley, "The Stranger in the Gates: Employer Reactions toward Domestic Servants in America, 1825–1875" (Ph.D. diss., Michigan State University, 1969), 27–32, 160.

15. Katzman, *Seven Days a Week,* 45, 55, 184–185; Dudden, *Serving Women,* 62; Daniel E. Sutherland, *Americans and Their Servants: Domestic Service in the United States from 1800 to 1920* (Baton Rouge: Louisiana State University Press, 1981), 49.

16. Francis A. Walker, "Our Domestic Service," *Scribner's Monthly Magazine* 11 (December 1873): 273.

17. McKinley, "Stranger in the Gates," 149.

18. Diner, *Erin's Daughters,* 85–86; "Household Service," 405–406.

19. [Robert Tomes], "Your Humble Servant," *Harper's New Monthly Magazine* 29 (June 1864): 53–59; Diner, *Erin's Daughters,* 85. The inclination of Irish maids to change jobs frequently was the subject of a painting by genre artist Louis Lang, who submitted *Bridget Flanagan Thinking How She Can Better Her Situation* to the 1860 National Academy exhibition. *National Academy of Design Exhibition Record, 1826–1860,* vol. 1 (New York: New-York Historical Society, 1943), 284.

20. [Tomes], "Your Humble Servant," 57.

21. Billington, *Protestant Crusade,* 196–203, 293–309, 345, 380, 430; Fuchs, *American Kaleidoscope,* 41–42.

22. McKinley, "Stranger in the Gates," 166, 186n; Doris Weatherford, *Foreign and Female: Immigrant Women in America, 1840–1930* (New York: Schocken Books, 1986), 147; Timothy Titcomb [Josiah Gilbert Holland], *Titcomb's Letters to Young People, Single and Married* (New York, 1858), quoted by Harvey Green, *The Light of the Home: An Intimate View of the Lives of Women in Victorian America* (New York: Pantheon Books, 1983), 90; Billington, *Protestant Crusade,* 312.

23. [Tomes], "Your Humble Servant," 57.

24. *New York Daily Sun,* 11 May 1853, quoted by Robert Ernst, "The Economic Status of New York City Negroes, 1850–1863," in *The Making of Black America: Essays in Negro Life and History,* ed. August Meier and Elliott Rudwick, vol. 1 (New York: Atheneum, 1969), 255.

25. Robinson concluded, "[I] mentally painted on my door posts until we are all lazier than we are now, 'No Irish need apply,'" 2–3 April 1864, quoted by Claudia L. Bushman, *A Good Poor Man's Wife: Being a Chronicle of Harriet Hanson Robinson and Her Family in Nineteenth-Century New England* (Hanover, N.H.: University Press of New England, 1981), 110–111.

26. Harry T. Peters, *Currier and Ives: Printmakers to the People* (Garden City, N.Y.: Doubleday, Doran, 1942), 2, 33.

27. Morton Keller, *The Art of Politics of Thomas Nast* (New York: Oxford University Press, 1968), 159–162.

28. On another level, the combative maid could represent the problem of foreign—i.e. British—intervention in the Civil War. English shipbuilders constructed commerce raiders for the Confederacy's use in breaking the blockade.

29. M. C. [Matthew Carey?], "Essay on the Relations between Masters and Mistresses, and Domestics," *Lady's Book* 10 (June 1835): 245. Thanks to Barbara Ryan for bringing this passage to my attention.

30. Catharine E. Beecher, *A Treatise on Domestic Economy, for the Use of Young Ladies at Home and at School,* rev. ed. (1841; New York: Harper & Bros., 1856), 208.

31. *Henry Bebie (Hans Heinrich Bebie) 1800?–1888: Portrait and Genre Painter of Baltimore* (Baltimore: Maryland Historical Society, 1956), 2.

32. Billington, *Protestant Crusade,* 142–143, 222, 293–294.

33. [Tomes], "Your Humble Servant," 59; Rev. Daniel Wise, *Bridal Greetings: A Marriage Gift* (New York: Carlton & Phillips, 1854), reprinted in *The American Ideal of the "True Woman" as Reflected in Advice Books to Young Women,* ed. Carolyn De Swarte Gifford (New York: Garland, 1987), 152–154.

34. William R. Johnston, "Alfred Jacob Miller—Would-Be Illustrator," *Walters Art Gallery Bulletin* 30 (December 1977): 2; William R. Johnston, "The Early Years in Baltimore and Abroad" and "Back to Baltimore," in *Alfred Jacob Miller: Artist on the Oregon Trail,* ed. Ron Tyler (Fort Worth: Amon Carter Museum of Western Art, 1982), 12–17, 69–70, 96.

35. Peter Ackroyd, *Dickens* (New York: Harper Collins, 1990), 289, 320–322; Johnston, "Miller," 2; Una Pope-Hennessey, *Charles Dickens* (New York: Howell, Soskin, 1946), 150.

36. Charles Dickens, *The Old Curiosity Shop,* introduction by the Earl of Wicklow (London: Oxford University Press, 1957), 271–273, 426–428, 478–481, 552.

37. Dickens, who spent some childhood years as a factory boy, was kind to servants both in practice and in his novels. Ackroyd notes, "He seems to have been in some ways more tolerant of them than he was of his own family, which is perhaps not surprising in a man whose paternal grandparents were 'in service' and who understood only too well the humiliation of being in a lowly position," *Dickens,* 534.

38. Two other Miller sketches, now in the collection of the Walter Art Gallery, treat the theme of threatening servants. One depicts Tom Croesus, who, in a struggle for happiness, has built a large mansion. Miller notes in the caption that Croesus has become a "servant to his servants." The second drawing, an illustration from Dickens's *Little Dorrit,* portrays Mr. Merdle, who hides from his butler behind the door. See Richard H. Randall, Jr., "A Gallery for Alfred Jacob Miller," *Antiques* 106 (November 1974): 842–843.

39. Dudden, *Serving Women,* 179.

40. Harriet Beecher Stowe, "Woman's Sphere," in *The Chimney-Corner* (1868; reprint, New York: AMS Press, 1967), 262; Sutherland, *Americans and Their Servants,* 36. The term "eye-servant" is used in the Bible to describe those who work to please men instead of "doing the will of God from the heart." Eph. 6:6; Col. 3:22.

41. Oliver Wendell Holmes, *The Autocrat of the Breakfast-Table* (Boston: Houghton, Mifflin; Cambridge: Riverside Press, 1893), 147–148.

42. Bruce Chambers suggests that the painting's caged bird refers to the captive existence of domestic service. However, it may also convey a different, erotic meaning. Like other of his canvases, *Wash Day* reveals Blythe's study of Dutch low-life genre. Though he could not have known the double entendre for the word *vogelen*—which, in Middle Dutch, meant both bird-catching and human copulation—he may have grasped and perpetuated the sexual pun when he juxtaposed the caged bird with the lusty laundress. Bruce Chambers, "David Gilmour Blythe," in *Masterworks of American Art from the Munson-Williams-Proctor Institute*, ed. Paul D. Schweizer (New York: Harry N. Abrams, 1989), 62; E. De Jongh, "Erotica in Vogelperspectief," *Simiolus* 3 (1968–1969): 29, 46–52; Bob Haak, *The Golden Age: Dutch Painters of the Seventeenth Century*, trans. and ed. Elizabeth Willems-Treeman (New York: Harry N. Abrams, 1984), 74–76.

43. Bruce William Chambers, "David Gilmour Blythe (1815–1865): An Artist at Urbanization's Edge" (Ph.D. diss., University of Pennsylvania, 1974), 133.

44. Chambers, "Blythe" in *Masterworks*, 62.

45. Bruce W. Chambers, *The World of David Gilmour Blythe, 1815–1865* (Washington, D.C.: Smithsonian Institution Press, National Collection of Fine Arts, 1980), 100–105, 116.

46. Ibid., 105; Chambers, "Artist at Urbanization's Edge," 17, 28, 37–41, 60–63, 97.

47. John D'Emilio and Estelle B. Freedman, *Intimate Matters: A History of Sexuality in America* (New York: Harper & Row, 1988), 107; Charles E. Rosenberg, "Sexuality, Class, and Role in Nineteenth-Century America," *American Quarterly* 25 (May 1973): 143.

48. Eunice Lipton, *Looking into Degas: Uneasy Images of Women and Modern Life* (Berkeley: University of California Press, 1986), 134.

49. Catharine Sedgwick, *The Poor Rich Man, and the Rich Poor Man* (New York: Harper & Bros., 1837), 22; Wise, *Bridal Greetings,* 158; Rosenberg, "Sexuality, Class, and Role," 143–144.

50. Weatherford, *Foreign and Female,* 57; Dudden, *Serving Women,* 214. The divorce hearing of Edwin Forrest exemplifies the general discrediting of immigrant servants in legal proceedings. See Thomas Baker, "Kitchen Testimony: Servants, Character, and Credibility in the Forrest Trial, 1851–52," presented to the American Studies Association, Boston, 5 November 1993.

51. Lipton, *Looking into Degas,* 132–133.

52. Phyllis Palmer, *Domesticity and Dirt: Housewives and Domestic Servants in the United States, 1920–1945* (Philadelphia: Temple University Press, 1989), 140.

53. Ibid., 147.

54. Ibid., 144, 146.

55. Louisa May Alcott, "How I Went Out to Service," in *Alternative Alcott,* ed. Elaine Showalter (New Brunswick, N.J.: Rutgers University Press, 1988), 352.

56. Beecher and Stowe, *American Woman's Home,* 13.

57. Richard J. Koke, Jr., ed., *American Landscape and Genre: Paintings in the New-York Historical Society,* vol. 2 (New York: New-York Historical Society, 1982), 104–105.

58. Elizabeth Johns suggests that the loud, uncoordinated "Bowery" clothing marks the would-be domestic "not only as lower-class but as risque." See her *American Genre Painting: The Politics of Everyday Life* (New Haven: Yale University Press, 1991), 238n; Christine Stansell, *City of Women: Sex and Class in New York, 1789–1860* (New York: Alfred A. Knopf, 1986), 94.

59. Sutherland, *Americans and Their Servants,* 16–23.

60. [Charles Loring Brace], "The Servant Question," *Nation* 1 (26 October 1865): 528; Mary Abigail Dodge ("Gail Hamilton"), *Woman's Worth and Worthlessness* (1872), quoted by Dudden, *Serving Women,* 81.

61. Housework was traditionally regulated by human need, not the clock. The appearance of the timepiece in the office suggests new businesslike expectations imposed on domestic labor with the increased emphasis on time-disciplined work habits that had come with industrialization. See Nancy F. Cott, *The Bonds of Womanhood: "Woman's Sphere" in New England, 1780–1835* (New Haven: Yale University Press, 1977), 58–60.

62. Dudden, *Serving Women,* 82; Stansell, *City of Women,* 166.

63. Quoted by Samuel A. Roberson and William H. Gerdts, "So Undressed, Yet So Refined: The Greek Slave," *Museum* 17 (Winter–Spring 1965): 19.

64. Nathaniel Hawthorne, *The Scarlet Letter,* ed. and intro. Brian Harding (New York: Oxford

University Press, 1992), 110; Revelation 17: 3–5; J. C. J. Metford, *Dictionary of Christian Lore and Legend* (London: Thames & Hudson), 263.

65. Stowe, "Woman's Sphere," 261.

66. *Liberator* 1 (30 July 1831), 123; William Sanger, *History of Prostitution: Its Extent, Causes, and Effects throughout the World* (New York: Harper & Bros., 1859), 524, 526; Stansell, *City of Women*, 167; Dudden, *Serving Women*, 218; Ruth Rosen, *The Lost Sisterhood: Prostitution in America, 1900–1918* (Baltimore: Johns Hopkins Press, 1982), 154–156; D'Emilio and Freedman, *Intimate Matters*, 132.

67. Beecher and Stowe, *American Woman's Home*, 467.

68. Diner, *Erin's Daughters*, 114–119; [Tomes], "Your Humble Servant," 57.

69. *Ballou's Dollar Monthly Magazine* 7 (May 1858): 502; Jacques, "My Boarding House," *Harper's Weekly* 11 (9 January 1858): 21–22.

70. Diner, *Erin's Daughters*, 72; Carl Wittke, "The Immigrant Theme on the American Stage," *Mississippi Valley Historical Review* 39 (September 1952): 215; Dale T. Knobel, *Paddy and the Republic: Ethnicity and Nationality in Antebellum America* (Middletown, Conn.: Wesleyan University Press, 1986), 10–12, 84–88, 102–103.

71. Philip S. Foner, *History of Black Americans*, vol. 2, *From the Emergence of the Cotton Kingdom to the Eve of the Civil War* (Westport, Conn.: Greenwood Press, 1983), 203–205, 214; Leon F. Litwack, *North of Slavery: The Negro in the Free States, 1790–1860*, 6th ed. (Chicago: University of Chicago Press, 1970), 165; Ernst, "Economic Status," 256–257.

72. Litwack, *North of Slavery*, 166; Sutherland, *Americans and Their Servants*, 48; Foner, *History of Black Americans*, 2:214, 216.

73. Quoted by Litwack, *North of Slavery*, 166.

74. Ernst, "Economic Status," 255–256; Bushman, *Good Poor Man's Wife*, 110; [Tomes], "Your Humble Servant," 53.

75. Fuchs, *American Kaleidoscope*, 43–44; Philip S. Foner, *History of Black Americans* vol. 3, *From the Compromise of 1850 to the End of the Civil War* (Westport, Conn.: Greenwood Press, 1983), 206–207; Keller, *Art of Politics of Thomas Nast*, 220–221.

76. Karen Adams, "Black Images in Nineteenth-Century American Painting and Literature: An Iconological Study of Mount, Melville, Homer, and Twain" (Ph.D. diss., Emory University, 1977), 9; George M. Fredrickson, *The Black Image in the White Mind: The Debate on Afro-American Character and Destiny, 1817–1914* (New York: Harper Torchbooks, 1971), 114–115.

77. Alexander Kinmont, *Twelve Lectures on the Natural History of Man* (1839), and Joseph Henry Allen, "Africans in America and Their New Guardians," *Christian Examiner* (July 1862), both quoted by Fredrickson, *Black Image in the White Mind*, 105, 169.

78. Quoted by Litwack, *North of Slavery*, 174; Ernst, "Economic Status," 255.

79. E. H. Gombrich, *Art and Illusion: A Study in the Psychology of Pictorial Representation,* rev. ed. (New York: Pantheon Books, 1961), 87–90.

80. Hugh Honour, *The Image of the Black in Western Art*, vol. 4, bk. 2 (Cambridge: Harvard University Press, Menil Foundation, 1989), 72–75; J. Stanley Lemons, "Black Stereotypes as Reflected in Popular Culture, 1880–1920," *American Quarterly* 29 (Spring 1977): 104–106.

81. Francis S. Grubar, "Richard Caton Woodville: An American Artist, 1825–1855" (Ph.D. diss., Johns Hopkins University, 1966), 5, 30–31, 43, 49–50; Guy C. McElroy, *Facing History: The Black Image in American Art, 1710–1940* (San Francisco: Bedford Arts, Corcoran Gallery of Art, 1990), 44. Another related Woodville painting, *The Sailor's Wedding* (1852, Walters Art Gallery), depicts the interruption of the lunch of a justice of the peace by an impromptu wedding party. Besides the bridal group, the artist included three black figures: a small serving girl who waits on the cranky justice and, looking from the door, a driver and a turbaned nursemaid. A missing version of the canvas included a fourth servant, an older black woman who kneels on the floor to prepare the squire's meal. Henry T. Tuckerman, *Book of the Artists: American Artist Life* (1867; reprint, New York: James F. Carr, 1967), 410.

82. Grubar, "Woodville," 55.

83. Ibid., 5, 139.

84. Ibid., 7, 139.

85. Quoted in ibid., 137.

86. Foner, *History of Black Americans,* 3:3–15; Patricia Hills, "Picturing Progress in the Era of West-

ward Expansion," in *The West as America: Reinterpreting Images of the Frontier,* ed. William H. Truettner (Washington, D.C.: Smithsonian Institution Press, National Museum of American Art, 1991), 103, 108–110.

87. Jacqueline Jones, *Labor of Love, Labor of Sorrow; Black Women, Work, and the Family from Slavery to the Present* (New York: Basic Books, 1985), 11.

88. Koke, *American Landscape and Genre,* 26, 35.

89. Mary Boykin Chesnut, *Diary from Dixie,* ed. Ben Ames Williams (Boston: Houghton Mifflin, 1949), 38, 293.

90. For comparison, see A. D. O. Browere's *Wash Day* (fig. 2-9), which was painted three years earlier. Michele Wallace offers a discussion of the "realism-versus-stereotype" debate in "Defacing History," *Art in America* 78 (December 1990): 121–122.

91. Honour, *The Image of the Black in Western Art,* vol. 4, bk. 2, 22; Albert Boime, *The Art of Exclusion: Representing Blacks in the Nineteenth Century* (Washington, Smithsonian Institution Press, 1990), 5–6.

92. Thomas F. Gossett, *Race: The History of an Idea in America* (Dallas: Southern Methodist University Press, 1963), 47–79; Fredrickson, *Black Image in the White Mind,* 100–101.

93. Flagg also sets up a gender contrast: the intuitive female holds her hand to her heart, and the rational male lifts his hand to his head.

94. Carol E. Hevner, "Harriet Cany Peale," in *A Gallery Collects Peales,* ed. Robert Devlin Schwarz (Philadelphia: Frank S. Schwarz & Son, 1987), 30. Thanks to Ellen H. Grayson, formerly of the Peale Family Papers, for bringing this painting to my attention.

95. Harriet Cany Peale to Anna Sellers, 4 January 1847, *The Collected Papers of Charles Willson Peale and His Family,* ed. Lillian B. Miller (National Portrait Gallery, Smithsonian Institution, Washington, D.C.; Millwood, N.Y.: Kraus-Thomson Organization, 1980), microfiche, series VI-A/15D8–E1.

96. Honour, *Image of the Black,* bk. 2, 58–59; John F. Watson, *Annals of Philadelphia, Being a Collection of Memoirs, Anecdotes, and Incidentals of the City and Its Inhabitants from the Days of the Pilgrim Founders* (Philadelphia: E. L. Cary & A. Hart; New York: G. & C. & H. Carvill, 1830), 479.

97. Foner, *History of Black Americans,* 2:191–192, 204–205.

98. Sojourner Truth, "Address to the Ohio Woman's Rights Convention," in *The American Reader: Words That Moved a Nation,* ed. Diane Ravitch (New York: Harper Perennial, 1990), 88. Such courtesies were nevertheless extended on occasion to white female servants, a practice that irritated Nathaniel Parker Willis. He complained: "Anywhere in public [courtesies to] your wife and your washerwoman, your friend's dainty daughter and your neighbor's greasy cook, are jumbled in a most inconvenient equality of 'chivalric attention.'" N. Parker Willis, "American Homage to Women," in *The Rag-Bag: A Collection of Ephemera* (New York: Charles Scribner, 1855), 169.

99. Rembrandt Peale, *Portfolio of an Artist* (Philadelphia: Henry Perkins; Boston: Perkins & Marvin, 1839), 200–201, 215–216.

100. *Uncle Tom's Cabin* was first printed as a serial in the abolitionist weekly *National Era.* Afterward, Stowe had the story published in two volumes on 20 March 1852. To her great surprise, the edition of 5,000 was sold in two days. By the end of the year, 300,000 copies had been sold in the United States, and by 1857, more than 500,000 copies had been purchased. Foner, *History of Black Americans,* 3:110–113; Peter Conn, *Literature in America* (New York: Cambridge University Press, 1989), 183–185.

101. Harriet Beecher Stowe, *Uncle Tom's Cabin; or, Life among the Lowly* (1896; reprint, New York: AMS Press, 1967), 323–324.

102. "Uncle Tom" became a pejorative epithet denoting a servile black who grovels before whites. In 1962, the term was upheld as slanderous in a Cleveland libel suit. Foner, *History of Black Americans,* 3:119–121, 124–125.

103. Lemons, "Black Stereotypes," 102–103; Jo-Ann Morgan, "Mammy the Huckster: Selling the Old South for the New Century," *American Art* 9 (Spring 1995): 87–109. For an exploration of the perpetuation of the stereotypes in film, see Donald Bogle's *Toms, Coons, Mulattoes, Mammies, and Bucks: An Interpretive History of Blacks in American Films,* expanded ed. (New York: Continuum, 1989).

104. Stowe, *Uncle Tom's Cabin,* 270–271, 277.

105. [David Hunter Strother], "Virginia Illustrated: Adventures of Porte Crayon and His Cousins," *Harper's New Monthly Magazine* 12 (January 1856): 176–177.

106. Karen Sue Warren Jewell, "An Analysis of the Visual Development of a Stereotype: The Media's Portrayal of Mammy and Aunt Jemimah as Symbols of Black Womanhood" (Ph.D. diss., Ohio State University, 1976), 41, 51–52, 110–116.

107. Ibid. Popularized by a cakewalk tune in a minstrel show in the 1880s, the character became an official trademark on pancake products for the Quaker Oats Company. In recent years, the company has transformed the Aunt Jemima image on its packaging into a middle-class matron with softly styled hair, pearl earrings, and a white lace collar.

108. Eugene Genovese, *Roll, Jordan, Roll: The World the Slaves Made* (New York: Vintage, 1976), 558–559; Jewell, "Development of a Stereotype," 12, 15; Jeanne Noble, *Beautiful, Also, Are the Souls of My Black Sisters: A History of Black Women in America* (Englewood Cliffs, NJ: Prentice-Hall, 1978), 78; Philip D. Morgan, "Slave Culture in Eighteenth-Century Virginia and South Carolina," presented to the Philadelphia Center for Early American Studies, 30 November 1990, 20; Susan Tucker, *Telling Memories among Southern Women: Domestic Workers and Their Employers in the Segregated South* (Baton Rouge: Louisiana State University Press, 1988), 265. Thanks to Fath Davis Ruffins, Historian, Archives Center, National Museum of American History, for describing the significance of color and tying technique in head wraps. Interview with author, 15 May 1991.

109. Karen Jewell notes that some male slaves also wore head wraps ("Development of a Stereotype," 15). This is portrayed in *The Old Plantation,* by an unknown artist (ca. 1790–1800, Abby Aldrich Rockefeller Folk Art Collection, Williamsburg, Va.), and *The Verdict of the People,* by George Caleb Bingham (1854–1855, collection, Boatmen's National Bank, Saint Louis).

110. James Kirke Paulding, *The Dutchman's Fireside,* vol. 1 (New York: Harper & Bros., 1837), 72–75.

111. The original title is unknown; *Devotion* is a recent name based on the subject. H. Nichols B. Clark, *Francis W. Edmonds: American Master in the Dutch Tradition* (Washington, D.C.: Smithsonian Institution Press, Amon Carter Museum, 1988), 123.

112. Bishop [William] Meade, *Sketches of Old Virginia Family Servants* (Philadelphia: Isaac Ashmead, 1847), 52–53.

113. Foner, *History of Black Americans,* 3:190–192, 216–219.

114. In a similar manner, the eighteenth-century setting for the 1859 painting *Washington and Lafayette at Mount Vernon, 1784* (Metropolitan Museum, New York) may have also defused concern about the figure of a black nursemaid. It was a collaborative effort by Thomas Rossiter, a New York artist, and Louis Mignot, and landscape painter from Charleston.

115. Jewell, "Development of a Stereotype," 10; Noble, *Beautiful,* 77–78; Janet Sims-Wood, "The Black Female: Mammy, Jemima, Sapphire, and Other Images," in *Images of Blacks in American Culture,* ed. Jessie Carney Smith (New York: Greenwood Press, 1988), 238.

116. Meade, *Sketches of Old Virginia,* 113; Elizabeth Fox-Genovese, *Within the Plantation Household: Black and White Women of the Old South* (Chapel Hill: University of North Carolina Press, 1988), 158.

117. Jewell, "Development of a Stereotype," 35, 37; Foner, *History of Black Americans,* 2:118; Jones, *Labor of Love,* 35–36. Stowe, *Uncle Tom's Cabin,* 216, 223.

118. William T. Henning, Jr., *A Catalogue of the American Collection, Hunter Museum of Art* (Chattanooga, Tenn.: Hunter Museum of Art, 1985), 35–37. Cameron produced an earlier canvas similar to the Whiteside portrait, *Samuel Johnston Boyce and Family* (1856, collection, Mr. and Mrs. Richard Mitchell). It portrays the same vista and also includes a slave nurse. James C. Kelly, "Portrait Painting in Tennessee," *Tennessee Historical Quarterly* 46 (Winter 1987): 232.

119. Kay Baker Gaston, "The Remarkable Harriet Whiteside," *Tennessee Historical Quarterly* 40 (Winter 1981), 334–335, 338–339.

120. Henning, *Catalogue,* 36.

121. Ibid.; Gaston, "Remarkable Harriet Whiteside," 334–345.

122. Lester C. Lamon, *Blacks in Tennessee, 1791–1970* (Knoxville: University of Tennessee Press, 1981), 20–24.

123. Nathaniel Hawthorne, "Twenty Days with Julian and Bunny," 5 August 1851, in *Hawthorne and His Wife,* ed. Julian Hawthorne, vol. 1 (Boston: Ticknor, 1888), 419.

124. Worthington Whittredge, "The Autobiography of Worthington Whittredge," ed. John I. H. Baur, *Brooklyn Museum Journal* 2 (1942): 12, 42.

125. Harriet A. Jacobs, *Incidents in the Life of a Slave Girl Written by Herself,* ed. and intro. Jean

Fagan Yellin (Cambridge: Harvard University Press, 1987), xiii, xvi–xvii, 1, 86–95, 114, 148, 150–158, 168, 191–201.

126. Whittredge, "Autobiography," 55. Whittredge was active in the association, whereas Willis was not a member.

127. T. Addison Richards, "Idlewild: The Home of N. P. Willis," *Harper's New Monthly Magazine* 16 (January 1858): 153. The floor plan of the Gothic residence reveals a U-shaped windowseat like the one pictured by Whittredge. See Design 23 in Calvert Vaux, *Villas and Cottages: A Series of Designs Prepared for Execution in the United States* (New York, 1864; reprint, New York: Dover, 1970), 258; Anthony F. Janson, *Worthington Whittredge* (Cambridge: Cambridge University Press, 1989), 77. Thanks to Jean Fagan Yellin for sharing her thoughts about Jacobs and the Whittredge image.

128. Foner, *History of Black Americans*, 3:458, 461; Gossett, *Race*, 256–258; C. Vann Woodward, *The Strange Career of Jim Crow*, 3d. rev. ed. (New York: Oxford University Press, 1974), 23; Dumas Malone and Basil Rauch, *The New Nation, 1865–1917* (New York: Appleton-Century-Crofts, 1960), 14–22.

129. Woodward, *Strange Career of Jim Crow*, 17.

130. Gossett, *Race*, 258–265; Keller, *Art of Politics of Thomas Nast*, 73–74; Malone and Rauch, *New Nation*, 26–28, 69.

131. Fredrickson, *Black Image in the White Mind*, 323–324; Lemons, "Black Stereotypes," 104–105; Peter H. Wood and Karen C. C. Dalton, *Winslow Homer's Images of Blacks: The Civil War and Reconstruction Years* (Austin: University of Texas Press, Menil Collection, 1988), 72; Alain Locke, *The Negro in Art: A Pictorial Record of the Negro Artist and of the Negro Theme in Art* (Washington, D.C.: Associates in Negro Folk Education, 1940), 139.

132. Lee M. Edwards, "Noble Domesticity: The Paintings of Thomas Hovenden," *American Art Journal* 19 (1987): 5, 9–10.

133. See William T. Oedel and Todd S. Gernes, "The Painter's Triumph: William Sidney Mount and the Formation of a Middle-Class Art," *Winterthur Portfolio* 23 (summer-autumn 1988): 111–127.

134. In an 1845 pamphlet explaining the iconography of his *Court of Death*, Rembrandt Peale argued that his complex image could be understood even "by the unlearned" since his black cook, Aunt Hannah, viewed the canvas and translated it "into her own language, entirely to my satisfaction." *Collected Papers of Charles Willson Peale*, series VI-B, 9/F8.

135. Wood and Dalton, *Winslow Homer's Images*, 88, 92.

136. Chesnut, *Diary from Dixie*, 414, 541, 544–545.

137. Most of Homer's black caricatures appear in his illustrations during the Civil War. See Mary Ann Calo, "Winslow Homer's Visits to Virginia during Reconstruction," *American Art Journal* 12 (Winter 1980): 7–9.

138. G. W. Sheldon, "American Painters—Winslow Homer and F. A. Bridgman," *Art Journal* 40 (1878): 227.

139. "The New York Spring Exhibitions. 1. The National Academy Exhibition," *Art Journal* 42 (1880): 154.

140. William Howe Downes, *The Life and Works of Winslow Homer* (Boston: Houghton Mifflin, 1911), 86–87.

141. Sidney Kaplan, *The Portrayal of the Negro in American Painting* (Brunswick, Maine: Bowdoin College Museum of Art, 1964), n.p.; Ellwood Parry, *The Image of the Indian and the Black Man in American Art, 1500–1900* (New York: George Braziller, 1974), 140.

142. Wood and Dalton, *Winslow Homer's Images*, 95.

143. K. Adams, "Black Images," 130–131.

144. A similar theme was explored earlier by Eastman Johnson in *Negro Life at the South* (1859, New-York Historical Society). In the popularly acclaimed painting, a white mistress gingerly steps into the yard of the slave quarters behind her house. In a pastiche of Negro activities—music making, dancing, child tending—the several black figures seem oblivious to her entrance. The picturesque treatment reinforces the notion of contented slaves, yet Johnson also details their impoverished circumstances. The artist thus straddles the political issues of the slave-owner relationship. See Patricia Hills, *The Genre Painting of Eastman Johnson: The Sources and Development of His Style and Themes* (New York: Garland, 1977), 55–60.

CHAPTER 5. CAPS AND APRONS:
PICTURESQUE SERVILITY, 1875–1910

1. Lucy Maynard Salmon, *Domestic Service* (New York, 1897; reprint, New York: Arno Press, 1972), vii, 54–69, 71–72.

2. Faye E. Dudden, *Serving Women: Household Service in Nineteenth-Century America* (Middletown, Conn.: Wesleyan University Press, 1983), 108; Harvey A. Levenstein, *Revolution at the Table: The Transformation of the American Diet* (New York: Oxford University Press, 1988), 18, 60–63. According to U.S. census statistics, the number of servants increased from 1,252,715 in 1870 to 2,819,443 in 1900. See David M. Katzman, *Seven Days a Week: Women and Domestic Service in Industrializing America* (Urbana: University of Illinois Press, Illini Books, 1981), 46, 282–283.

3. Sean Dennis Cashman, *America in the Gilded Age: From the Death of Lincoln to the Rise of Theodore Roosevelt,* 2d ed. (New York: New York University Press, 1988), 2–4.

4. Ibid., 15, 42–43; Alan Trachtenberg, *The Incorporation of America: Culture and Society in the Gilded Age* (New York: Hill & Wang, 1982), 3–4, 82.

5. Trachtenberg, *Incorporation of America,* 39; Peter Conn, *Literature in America* (New York: Cambridge University Press, 1989), 232–233; Mary Cable, *Top Drawer: American High Society from the Gilded Age to the Roaring Twenties* (New York: Atheneum, 1984), 13.

6. Trachtenberg, *Incorporation of America,* 72.

7. "The Struggle for Wealth," *Scribner's Monthly* [*Century Magazine*] 8 (August 1874): 495–496.

8. Cashman, *America in the Gilded Age,* 234; Trachtenberg, *Incorporation of America,* 54, 87–90, 92.

9. Trachtenberg, *Incorporation of America,* 4, 47–48, 88–90.

10. Richard Hofstadter, *Social Darwinism in American Thought,* rev. ed. (Boston: Beacon Press, 1955), 38–48; Herbert Spencer, *Social Statistics* (1864), quoted by Hofstadter, 41.

11. William Graham Sumner, "Sociology" (1881), reprinted in *American Thought: Civil War to World War I,* ed. Perry Miller (New York: Rinehart, 1954), 80–81.

12. William Graham Sumner, *What Social Classes Owe to Each Other* (1883), quoted by Hofstadter, *Social Darwinism,* 8.

13. Katzman, *Seven Days a Week,* 158–159.

14. Harriet Prescott Spofford, *The Servant Girl Question* (Boston, 1881; reprint, New York: Arno Press, 1977), 101–102.

15. Helen Campbell, *Prisoners of Poverty: Women Wage-Workers, Their Trades and Their Lives* (Boston, 1887; reprint, Westport, Conn.: Greenwood Press, 1970), 235–236.

16. Katzman, *Seven Days a Week,* 271–272, 284.

17. Salmon, *Domestic Service,* 131, 140, 165–166, 211.

18. Ibid., 154.

19. Ibid., 211; Russell Lynes, *The Domesticated Americans* (New York: Harper & Row, 1963), 162–165.

20. Spofford, *Servant Girl Question,* 11.

21. Salmon, *Domestic Service,* 158.

22. Lynes, *Domesticated Americans,* 164; Arthur M. Schlesinger, Jr., *Learning How to Behave: A Historical Study of American Etiquette Books* (New York: Cooper Square, 1968), 28–29.

23. Salmon, *Domestic Service,* 158.

24. Daniel E. Sutherland, *Americans and Their Servants: Domestic Service in the United States from 1800 to 1920* (Baton Rouge: Louisiana State University Press, 1981), 30–33. See also ch. 6 in Blaine Edward McKinley, "The Stranger in the Gates: Employer Relations toward Domestic Servants in America, 1825–1875" (Ph.D. diss., Michigan State University, 1969), 236–267. In George Vanderbilt's vast Biltmore mansion, service areas were also color coded with green walls to help both guests and servants stay in their appropriate spaces. *A Guide to Biltmore Estate,* centennial ed. (Asheville, N.C.: Biltmore Company, 1994), 43.

25. Jerry E. Patterson, *The Vanderbilts* (New York: Harry N. Abrams, 1989), 154; Mark Alan Hewitt, *The Architect and the American Country House, 1890–1940* (New York: Yale University Press, 1990), 101. See also the description of servant spaces in *A Guide to Biltmore Estate,* 63–71, 75.

26. Cable, *Top Drawer,* 89.

27. Sutherland, *Americans and Their Servants,* 129; Louis Auchincloss, *The Vanderbilt Era: Profiles of a Gilded Age* (New York: Charles Scribner's Sons, 1989), 39; Arthur T. Vanderbilt, *Fortune's Children: The Fall of the House of Vanderbilt* (New York: William Morrow, 1989), 106.

28. In *Fashion,* a popular play produced in New York in 1845, the story's hero, Adam Truman, scolds a mistress for dressing her manservant in livery: "To make men wear the *badge of servitude* in a free land,—that's the fashion is it? . . . I will venture to say now, that you have your coat-of-arms too!" Anna Cora Mowatt, *Fashion,* in *Representative Plays by American Dramatists, 1815–1858,* ed. Montrose J. Moses (New York: E. P. Dutton, 1925): 551.

29. [Robert Tomes], "Your Humble Servant," *Harper's New Monthly Magazine* 29 (June 1864): 55.

30. Sutherland, *Americans and Their Servants,* 129.

31. [Tomes], "Your Humble Servant," 55.

32. Mrs. H. O. Ward, *Sensible Etiquette of the Best Society* (Philadelphia: Porter & Coates, 1878), 289.

33. Campbell, *Prisoners of Poverty,* 228.

34. For a discussion about the function of clothing as an indicator of status, see Susan B. Kaiser, *The Social Psychology of Clothing and Personal Adornment* (New York: Macmillan; London: Collier Macmillan, 1985), 364–365, 376–377, 381.

35. *Work and Wages* 1 (August 1887): 7, quoted by Katzman, *Seven Days a Week,* 238.

36. Dudden, *Serving Women,* 108–109, 111–112; Ruth Schwartz Cowan, *More Work for Mother: The Ironies of Household Technology from the Open Hearth to the Microwave* (New York: Basic Books, 1983), 42; Salmon, *Domestic Service,* 211.

37. Thorstein Veblen, *The Theory of the Leisure Class,* intro. Robert Lekachman (New York: Penguin Books, 1979), preface, 28–29, 41, 44–45, 74–75, 82–85.

38. Ibid., 8–10, 36.

39. Ibid., 37.

40. Ibid., 56–57, 62–63, 66, 68.

41. Dudden, *Serving Women,* 126, 144–145.

42. William Dean Howells, *A Hazard of New Fortunes* (New York: New American Library, 1965), 211.

43. "Fine Arts: The Academy Exhibition," *New York Times,* 6 April 1874.

44. "American Painters: Seymour Joseph Guy, N.A., Lemuel E. Wilmarth, N.A.," *Art Journal* 1 (September 1875): 276–278.

45. The figures represent (l. to r.): William Henry, Frederick, Maria Kissam Vanderbilt, George (seated), Florence, William K., Lila (seated), Margaret Shepherd, Elliott Shepherd, Emily Sloane, Alice, William D. Sloane (both seated), Cornelius II, and two unnamed servants in the background at right. Patterson, *Vanderbilts,* 108.

46. "Fine Arts: The Academy Exhibition," *New York Times,* 19 April 1874.

47. W[illiam] A. Croffut, *The Vanderbilts and the Story of Their Fortune* (Chicago, 1886; reprint, Salem, N.H.: Ayer, 1985), 128.

48. Ibid., 164. See ch. 4, Patterson, *Vanderbilts.*

49. Cashman, *America in the Gilded Age,* 38, 44–45. See ch. 5, Patterson, *Vanderbilts.*

50. Consuelo Vanderbilt Balsan, *The Glitter and the Gold* (New York: Harper & Bros., 1952), 10.

51. Patterson, *Vanderbilts,* 80–81.

52. Katzman, *Seven Days a Week,* 45; Sutherland, *Americans and Their Servants,* 106–107.

53. Veblen, *Theory of the Leisure Class,* 57.

54. Dudden, *Serving Women,* 113; Sutherland, *Americans and Their Servants,* 14–15, 106; E. S. Turner, *What the Butler Saw: Two Hundred and Fifty Years of the Servant Problem* (New York: St. Martin's Press, 1963), 270–273.

55. Doreen Bolger Burke, *American Paintings in the Metropolitan Museum of Art,* vol. 3 (New York: Metropolitan Museum of Art, Princeton University Press, 1980), 67–68.

56. Phillis Cunnington, *Costume of Household Servants from the Middle Ages to 1900* (New York: Barnes & Noble, 1974), 71.

57. Sutherland, *Americans and Their Servants,* 60.

58. *Mantle Fielding's Dictionary of American Painters, Sculptors, and Engravers,* rev. ed., ed. Glenn B. Opitz (Poughkeepsie, N.Y.: Apollo Books, 1983), 571; *The National Academy of Design Exhibition Record, 1861–1900,* vol. 1, ed. Maria Naylor (New York: Kennedy Gallery, 1973), 66.

59. Lee Edwards, *Domestic Bliss: Family Life in American Painting, 1840–1910* (Yonkers, N.Y.: Hudson River Museum, 1986), 96–98.

60. Like the previous image by Blashfield and Spencer's *War Spirit at Home* (1866, fig. 3-20), the

specter of war is introduced into the home as a child's game. Military conflict is thus domesticated and presented as an innocuous but appropriate rehearsal of adult roles to come.

61. Phyllis Palmer, *Domesticity and Dirt: Housewives and Domestic Servants in the United States, 1920–1945* (Philadelphia: Temple University Press, 1989), 142–143.

62. Christine Stansell, *City of Women: Sex and Class in New York, 1789–1860* (New York: Alfred A. Knopf, 1986), 160.

63. David Sellin, "Alice Barber Stephens," in *American and European Paintings: Philadelphia Collection 42* (Philadelphia: Frank S. Schwarz & Son, 1990), n.p. (illustrated on cover).

64. Ibid.; Eleanor Tufts, *American Women Artists, 1830–1930* (Washington, D.C.: International Exhibitions Foundation for the National Museum of Women in the Arts, 1987), plate 43. Impressionism was introduced to the United States in a series of exhibitions in the late 1880s and became a major stylistic influence after a successful showing at the World's Columbian Exposition in 1893.

65. Samuel Eliot Morison, *One Boy's Boston, 1887–1901* (Boston: Houghton Mifflin, 1962), 17.

66. William C. Lipke, *Thomas Waterman Wood, PNA, 1823–1903* (Montpelier, Vt.: Wood Art Gallery, 1972), 26, 32–40.

67. Some paintings and photographs indicate that African American servants sometimes wore black-and-white livery but retained the traditional head wrap. They include *The Old Nurse's Visit,* by Thomas Hovenden (1872, fig. 4-18) and, much later, *New Orleans Mammy,* by Wayman Adams (ca. 1920, Morris Museum of Art, Augusta, Ga.).

68. According to the 1890 census, this figure was 14.7 percent. John Higham, *Send These to Me: Immigrants in Urban America,* rev. ed. (Baltimore: Johns Hopkins University Press, 1984), 15.

69. Ibid., 36–37, 46–47.

70. Charles Pearson, *National Life and Character* (London and New York, 1893), quoted by Hofstadter, *Social Darwinism,* 186.

71. Higham, *Send These to Me,* 36–37, 195; Thomas F. Gossett, *Race: The History of an Idea in America* (Dallas: Southern Methodist University Press, 1963), 291–292.

72. C. Vann Woodward, *The Strange Career of Jim Crow,* 3d rev. ed. (New York: Oxford University Press, 1974), 69–70.

73. Cashman, *America in the Gilded Age,* 172–173, 191–192; Gossett, *Race,* 270–273.

74. Robert Jay, *The Trade Card in Nineteenth-Century America* (Columbia: University of Missouri Press, 1987), 68–70; J. Stanley Lemons, "Black Stereotypes as Reflected in Popular Culture, 1880–1920," *American Quarterly* 29 (spring 1977): 105–106.

75. James Edward Fox, "Iconography of the Black in American Art" (Ph.D. diss., University of North Carolina at Chapel Hill, 1979), 315–316.

76. Bruce W. Chambers, *Art and Artists of the South: The Robert P. Coggins Collection* (Columbia: University of South Carolina Press, 1984), 48; Patricia Hills, *The Painters' America: Rural and Urban Life, 1810–1910* (New York: Praeger, 1974), 72.

77. Rudyard Kipling's enormously popular poem "The White Man's Burden" was printed in *McClure's Magazine,* February 1899. Cashman, *America in the Gilded Age,* 328–333; Gossett, *Race,* 323–333.

78. Cecilia Beaux, December 1940, Catherine Drinker Bowen Papers, Library of Congress, quoted by Tara L. Tappert in "Choices—The Life and Career of Cecilia Beaux: A Professional Biography" (Ph.D. diss., George Washington University, 1990), 308.

79. Burke, *American Paintings,* 200–201; Tappert, "Choices," 299, 437.

80. Tappert, "Choices," 412; Catherine Drinker Bowen, *Family Portrait* (Little, Brown, 1970), 28, 77; Thornton Oakley, *Cecilia Beaux* (Philadelphia: [Howard Biddle], 1943), 3, 9.

81. Tappert, "Choices," 308.

82. After exhibition in Paris, London, and several American cities and reproduction in a number of magazines and newspapers, *Ernesta* became one of Beaux's best-known paintings. Burke, *American Paintings,* 111–112.

83. Lorado Taft, "Work of Cecilia Beaux," *Chicago Record,* 21 December 1899. Clipping in the Cecilia Beaux Papers, Archives of American Art, Smithsonian Institution, Washington, D.C., roll 429.

84. See Lois Marie Fink, "The Role of France in American Art, 1850–1870" (Ph.D. diss., University of Chicago, 1970), and H. Barbara Weinberg, "Cosmopolitan Attitudes: The Coming of Age in American Art," in *Paris 1889: American Artists at the Universal Exposition* (Philadelphia: Pennsylvania Academy of the Fine Arts, Harry N. Abrams, 1989). Henry James, "John Singer Sargent," *Harper's New Monthly Magazine* 75 (October 1887): 683.

85. Lois Marie Fink and Joshua C. Taylor, *Academy: The Academic Tradition in American Art* (Washington, D.C.: National Collection of the Fine Arts, Smithsonian Institution Press, 1975), 13, 128.

86. Lois M. Fink, *American Art at the Nineteenth-Century Paris Salons* (Washington, D.C.: National Museum of American Art, Smithsonian Institution; Cambridge: Cambridge University Press, 1990), 205. For discussions of the American embrace of Barbizon style and themes, see Peter Bermingham, *American Art in the Barbizon Mood* (Washington, D.C.: National Collection of the Fine Arts, Smithsonian Institution Press, 1975), and Laura L. Meixner, "Popular Criticism of Jean-François Millet in Nineteenth-Century America," *Art Bulletin* 65 (March 1983): 94–105.

87. Meixner, "Popular Criticism of Jean-François Millet," 97; Bermingham, *Barbizon Mood,* 79; Patricia Hills, "Images of Rural America in the Works of Eastman Johnson, Winslow Homer, and Their Contemporaries," in *The Rural Vision: France and America in the Late Nineteenth Century,* ed. Hollister Sturges (Omaha, Neb.: Joslyn Art Museum, 1987), 64, 77–79.

88. Meixner, "Popular Criticism of Jean-François Millet," 100.

89. "Fine Arts: Goupil Gallery &c.," *New York Times,* 27 April 1873.

90. Michael Quick, *American Expatriate Painters of the Late Nineteenth Century* (Dayton, Ohio: Dayton Art Institute, 1976), 23, 30; Peter H. Wood and Karen C. C. Dalton, *Winslow Homer's Images of Blacks: The Civil War and Reconstruction Years* (Austin: University of Texas Press, Menil Collection, 1988), 96–98.

91. "On the Fine Arts," *North American Review and Miscellaneous Journal* 2 (1816).

92. Samuel Isham, *The History of American Painting,* new ed. and suppl. by Royal Cortissoz (New York: Macmillan, 1943), 464.

93. Spofford, *Servant Girl Question,* 85.

94. Doreen Bolger Burke, "Painters and Sculptors in a Decorative Age," in *In Pursuit of Beauty: Americans and the Aesthetic Movement* (New York: Metropolitan Museum of Art, 1986), 328–329.

95. [Tomes], "Your Humble Servant," 55.

96. Salmon, *Domestic Service,* 209.

97. Richard O'Connor, *The Golden Summers: An Antic History of Newport* (New York: G. P. Putnam's Sons, 1974), 252.

98. Lloyd Goodrich, *Winslow Homer* (New York: Macmillan, Whitney Museum of Art, 1945), 25; A. Hyatt Mayor and Mark Davis, *American Art at the Century* (New York: Century Association, 1977), 52–53.

99. Gordon Hendricks, *The Life and Work of Winslow Homer* (New York: Harry N. Abrams, 1979), 35, 56, 72–73, pictured on 73. Photographs of these wall sketches were sent to Lloyd Goodrich in 1949 from the current owner of the Belmont home, who wrote, "Since we had intended to use this room for a maid, the discovery is somewhat disconcerting; but we shall preserve it, for our own amusement, at any rate." See "Homer, Winslow," vertical file, National Museum of American Art, National Portrait Gallery Library, Smithsonian Institution, Washington, D.C.

100. See Henry Adams, "Winslow Homer's 'Impressionism' and Its Relation to His Trip to France," in *Winslow Homer: A Symposium, Studies in the History of Art* 26, Center for Advanced Study in the Visual Arts, Symposium Papers 11 (Washington, D.C.: National Gallery of Art, 1990), 61–89.

101. Albert Ten Eyck Gardner, *Winslow Homer, American Artist: His World and His Work* (New York: Clarkson N. Potter, 1961), 78–86.

102. Richard R. Brettell and Caroline B. Brettell, *Painters and Peasants in the Nineteenth Century* (Geneva: Skiva, 1983), 147; H. Adams, "Winslow Homer's 'Impressionism,'" 68.

103. Bermingham, *Barbizon Mood,* 53–54; H. Adams, "Winslow Homer's 'Impressionism,'" 68.

104. Bermingham, *Barbizon Mood,* 146.

105. Though not a multiple of previous figures, a servant figure also appears in Homer's watercolor of 1874, *Rustic Courtship* (collection, Mr. and Mrs. Paul Mellon). Dressed in a similar striped bodice and white cap, the maid leans from an upstairs window to converse with a young farmer.

106. Weinberg, "Cosmopolitan Attitudes," 48; Edwards, *Domestic Bliss,* 108; *National Academy of Design Exhibition Record, 1861–1900,* 207.

107. Edwards, *Domestic Bliss,* 128.

108. David C. Huntington, *The Quest for Unity: American Art between World's Fairs, 1876–1893* (Detroit, Mich.: Detroit Institute of Art, 1983), 219.

109. Frances Willard, *How to Win: A Book for Girls* (New York: Funk & Wagnalls, 1886), 95–101.

110. Melchers's other servant images include *In My Garden* (1903, Butler Institute of American

Art, Youngstown, Ohio); *An Unpretentious Garden* (1903–1909, Telfair Academy of Arts and Sciences, Savannah, Ga.); *The Green Mantel* (1905, Macfarlane Collection, Roanoke, Va.); *The Green Lamp* (ca. 1905, collection of Philip L. Brewer, M.D., Columbus, Ga.); *By the Window* (ca. 1905, Montclair Art Museum, Montclair, N.J.); *Young Woman at Her Toilet* (ca. 1912, Belmont, Gari Melchers Memorial Gallery, Fredericksburg, Va.); and *Interior—The Blue Dress* (1916; Belmont, Gari Melchers Memorial Gallery).

111. George Mesman, "The Student Years: Düsseldorf and Paris," in *Gari Melchers: A Retrospective Exhibition,* ed. Diane Lesko and Esther Persson (Saint Petersburg, Fla.: Museum of Fine Arts, 1990), 49–54.

112. Annette Stott, "The Holland Years," in *Gari Melchers,* ed. Lesko and Persson, 63; Joseph G. Dreiss, "Gari Melchers in New York," in *Gari Melchers,* ed. Lesko and Persson, 111–112.

113. Joseph G. Dreiss, *Gari Melchers: His Works in the Belmont Collection* (Charlottesville: University Press of Virginia, 1984), 107–109, 136–138; Stott, "Holland Years," 65, 68–69; Joanna D. Catron, "Catalogue of the Exhibition," in *Gari Melchers,* ed. Lesko and Persson, 189, 204–205, 211. According to Joanna Catron, curator at Belmont, the paintings do not commemorate actual events in the model-servant's life. Letter to the author from David Berreth, Belmont Director, 13 August 1991.

114. Dreiss, *Gari Melchers,* 37.

115. Ibid., 124; Catron, "Catalogue of the Exhibition," 208.

116. Melchers used a photograph of the two women as a compositional aid, pictured in Dreiss, *Gari Melchers,* 124.

117. Diane Lesko, "Gari Melchers and Internationalism," in *Gari Melchers,* ed. Lesko and Persson, 17.

118. Dudden, *Serving Women,* 115–119.

119. Annette Stott, "American Painters Who Worked in the Netherlands" (Ph.D. diss., Boston University, 1986), 161–162.

120. Salmon, *Domestic Service,* 72.

## CHAPTER 6. BRIDGET IN SERVICE TO THE BOSTON SCHOOL: 1892–1923

1. Quoted by Ellen Wardell Lee, R. H. Ives Gammell, and Martin F. Krause, Jr., *William McGregor Paxton, N.A., 1869–1941* (Indianapolis, Ind.: Indianapolis Museum of Art, 1978), 130.

2. L. M., "The Pennsylvania Academy Exhibition," *Art and Progress* 3 (April 1912): 558.

3. "Annual Exhibit of Pennsylvania Academy of the Fine Arts," unidentified clipping, Paxton scrapbook (collection, Robert Douglas Hunter), William McGregor Paxton Papers (hereafter referred to as Paxton papers), microfilm roll 862, Archives of American Art, Smithsonian Institution, Washington, D.C.

4. Bernice Kramer Leader, "The Boston School and Vermeer," *Arts* 55 (November 1980): 172.

5. Ibid. Tonalism as a stylistic movement is defined by Wanda Corn in *The Color of Mood: American Tonalism, 1880–1910* (San Francisco: M. H. de Young Memorial Museum, 1972).

6. Trevor J. Fairbrother, "Painting in Boston," in *The Bostonians: Painters of an Elegant Age, 1870–1930* (Boston: Museum of Fine Arts, 1986), 64.

7. Leader, "Boston School and Vermeer," 174. Bernice Kramer Leader, "The Boston Lady as a Work of Art: Paintings by the Boston School at the Turn of the Century" (Ph.D. diss., Columbia University, 1980), 289–318; Philip L. Hale, *Jan Vermeer of Delft* (Boston: Small, Maynard, 1913).

8. Trevor J. Fairbrother, "Edmond C. Tarbell's Paintings of Interiors," *Antiques* 131 (January 1987): 233.

9. R. H. Ives Gammell, *The Boston Painters* (Orleans, Mass.: Parnassus Imprints, 1986), 118–119; Philip L. Hale, "Painting and Etching," in *Fifty Years of Boston* (Boston: Subcommittee on Memorial History of the Boston Tercentenary Committee, 1932), 357; Hale, *Jan Vermeer of Delft,* 9.

10. Leader, "Boston Lady," 56, 80–82; Leader, "Boston School and Vermeer," 175. Oliver Wendell Holmes first dubbed the elite gentry as the "Brahmin caste of New England" in *Elsie Venner* (1861). The name would thereafter signify Boston's prominent families who shared not only a common heritage but also political, intellectual, and cultural values. Barbara Miller Solomon, *Ancestors and Immigrants: A Changing New England Tradition* (Boston: Northeastern University Press, 1984), 3.

11. Hale, *Jan Vermeer of Delft,* 39–40.

12. Hale was descended from patriot Nathan Hale, and his father was minister and author Edward Everett Hale. *Philip Leslie Hale, A.N.A. (1865–1931)* (Boston: Vose Galleries of Boston, 1988), 4; Patricia Jobe Pierce, *Edmund C. Tarbell and the Boston School of Painting (1889–1980)* (Hingham, Mass.: Pierce Galleries, 1980), 15–17; Lee, Gammell, and Krause, *Paxton,* 23; Leader, "Boston Lady," 22–23, 56.

13. Theodore E. Stebbins, "Introduction: The Course of Art in Boston," in *The Bostonians: Painters of an Elegant Age, 1870–1930* (Boston: Museum of Fine Arts, 1986), 6.

14. Guy Pène duBois, "The Boston Group of Painters: An Essay on Nationalism in Art," *Arts and Decoration* 5 (October 1915): 458.

15. Charles H. Caffin, "The Art of Edmund C. Tarbell," *Harper's Monthly Magazine* 117 (June 1908): 65, 68, 72–73.

16. Stebbins, "Introduction," 4, 6.

17. Leader, "Boston Lady," 131–134, 190. See also Bernice Kramer Leader, "Antifeminism in the Paintings of the Boston School," *Arts* 56 (January 1982): 112–119.

18. Oscar Handlin, *Boston's Immigrants: A Study in Acculturation,* rev. ed. (Cambridge: Belknap Press, Harvard University Press, 1979), 8–23; Solomon, *Ancestors and Immigrants,* 3–5. For a description of the formation of the Brahmin class, see Frederic Cople Jaher, *The Urban Establishment: Upper Strata in Boston, New York, Charleston, Chicago, and Los Angeles* (Urbana: University of Illinois Press, 1982), 15–156.

19. Handlin, *Boston's Immigrants,* 42–55, 82, 88; Jaher, *Urban Establishment,* 108; Ray Allen Billington, *The Protestant Crusade, 1800–1860: A Study of the Origins of American Nativism* (Gloucester, Mass.: Peter Smith, 1963), 240.

20. Handlin, *Boston's Immigrants,* 161–176, 185.

21. Solomon, *Ancestors and Immigrants,* 48, 53.

22. Ibid., 6, 75, 102–116, 122–135; John Higham, *Send These to Me: Immigrants in Urban America,* rev. ed. (Baltimore: Johns Hopkins University Press, 1984), 43–49.

23. Solomon, *Ancestors and Immigrants,* 153–155, 163; Thomas F. Gossett, *Race: The History of an Idea in America* (Dallas: Southern Methodist University Press, 1963), 299; Kerby A. Miller, "Class, Culture, and Immigrant Group Identity in the United States: The Case of Irish-American Ethnicity," in *Immigration Reconsidered,* ed. Virginia Yans-McLaughlin (New York: Oxford University Press, 1990), 123–124.

24. John Fitzgerald, grandfather of president John Fitzgerald Kennedy, was elected mayor of Boston in 1906. Turned out of office by the Brahmin Good Government Association, he won again in 1910. His more notorious successor, James Michael Curley, won office four times between 1914 and 1950. Lawrence H. Fuchs, *The American Kaleidoscope: Race, Ethnicity, and the Civic Culture* (Hanover, N.H.: University Press of New England, Wesleyan University Press, 1990), 47–48.

25. Handlin, *Boston's Immigrants,* 217, 221; Solomon, *Ancestors and Immigrants,* 56–57; K. A. Miller, "Class, Culture, and Immigrant Group," 107, 115, 120, 124; Jaher, *Urban Establishment,* 90, 114–115.

26. David Katzman, *Seven Days a Week: Women and Domestic Service in Industrializing America* (Urbana: University of Illinois Press, Illini Books, 1981), 65–67, 286. In 1901, the fashionable Back Bay district engaged one-fourth of all servants working in Boston. "Occupations of Residents of Boston: By District," *Massachusetts Labor Bulletin* 17 (February 1901): 7.

27. The 1898 survey was conducted by the Women's Educational and Industrial Union of Boston. [Mary W. Dewson], "Social Conditions of Domestic Service," *Massachusetts Labor Bulletin* 13 (February 1900): 1–16. In Massachusetts, domestics generally received a higher wage than female workers in other occupations. In 1906, only teachers commanded a higher salary. Hasia R. Diner, *Erin's Daughters in America: Irish Immigrant Women in the Nineteenth Century* (Baltimore: Johns Hopkins University Press, 1983), 90.

28. Pierce, *Tarbell and the Boston School,* 45–46; *Population Schedules of the Twelfth Census of the United States, 1900,* Boston (Washington, D.C.: National Archives), vol. 82, ED 1532, sheet 11, line 42, microfilm roll 688; vol. 47, ED 869, sheet 2, line 16, microfilm roll 663.

29. Nancy Hale, *The Life in the Studio* (Boston: Little, Brown, 1969), 88, 119.

30. Nancy Hale, *A New England Girlhood* (Boston: Little, Brown, 1958), 77.

31. Daniel E. Sutherland, *Americans and Their Servants: Domestic Service in the United States from 1800 to 1920* (Baton Rouge: Louisiana State University Press, 1981), 40; Diner, *Erin's Daughters,* 86.

32. Harriet Prescott Spofford, *The Servant Girl Question* (Boston, 1881; reprint, New York: Arno

Press, 1977), 15–16, 65–66.

33. Martha Banta, *Imaging American Women: Idea and Ideals in Cultural History* (New York: Columbia University Press, 1987), 104, 111–114. Simms offers another figure with supposedly Irish features as an example of "Inexorableness." Joseph Simms, *Physiognomy Illustrated; or, Nature's Revelations of Characters,* 6th ed., (New York: Murray Hill, 1887), 173–174, 226–227.

34. Susan Strasser, "Mistress and Maid, Employer and Employee: Domestic Service Reform in the United States, 1897–1920," *Marxist Perspectives* 1 (winter 1978): 52–67; Faye E. Dudden, *Serving Women: Household Service in Nineteenth-Century America* (Middletown, Conn.: Wesleyan University Press, 1983), 239–240; Donna L. Van Raaphorst, *Union Maids Not Wanted: Organizing Domestic Workers, 1870–1940* (New York: Praeger, 1988), 135–138.

35. See ch. 15 in Lucy Maynard Salmon's *Domestic Service* (New York, 1897; reprint, Arno Press, 1972), 235–262.

36. Spofford, *Servant Girl Question,* 141–145.

37. Lavinia Hart, "What a Mother Can Do for Her Daughter," *Cosmopolitan* 24 (December 1902): 161–162.

38. Colonial-period architecture and furnishings, evidence of a family's early American heritage, became class emblems in late nineteenth-century Boston. Jaher, *Urban Establishment,* 24.

39. [Dewson], "Social Conditions of Domestic Service," 1.

40. Helen Campbell, *Women Wage-Earners: Their Past, Their Present, and Their Future* (Boston, 1893; reprint, New York: Arno Press, 1972), 242; Helen Campbell, *Prisoners of Poverty: Women Wage-Workers, Their Trades and Their Lives* (Boston, 1887; reprint, Westport, Conn.: Greenwood Press, 1975), 226.

41. Sutherland, *Americans and Their Servants,* 93.

42. "Sweeping Day," *Household* 13 (December 1880): 274–275.

43. Lillian Pettengill, *Toilers of the Home: The Record of a College Woman's Experience as a Domestic Servant* (New York: Doubleday, Page, 1903), 13.

44. Inez A. Godman, "Ten Weeks in a Kitchen," *Independent* 53 (17 October 1901): 2460.

45. Pettengill, *Toilers of the Home,* 113; Godman, "Ten Weeks in a Kitchen," 2461–2463.

46. Pettengill, *Toilers of the Home,* 5.

47. Campbell, *Prisoners of Poverty,* 227.

48. Katzman, *Seven Days a Week,* 149.

49. Sutherland, *Americans and Their Servants,* 67–72.

50. Pettengill, *Toilers of the Home,* 214–217.

51. Godman, "Ten Weeks in a Kitchen," 2461.

52. The theme of the inquisitive maid also appears in Junius B. Stearns's *Woman Reading* (ca. 1880, private collection) and Louis Charles Moeller's *Inquisitive* (1893, DeVille Galleries, Los Angeles). A curious maid who peeps through a keyhole is featured in a cover illustration by Coles Phillips, *Life* 7 (April 1921).

53. Charlotte Perkins Gilman, *The Home* (New York, 1910), excerpt in *The Oven Birds: American Women on American Womanhood, 1820–1920,* ed. Gail Parker (New York: Doubleday, 1972), 342.

54. Edith Wharton, *The House of Mirth* (New York: Charles Scribner's Sons, 1969), 13–14, 102–107.

55. Ibid., 5–6, 13.

56. Frederick W. Coburn, "Edmund C. Tarbell," *International Studio* 32 (September 1907): lxxxii.

57. Tarbell's *Maid Servant in the Pantry* (now unlocated) was painted the previous year.

58. "Mr. Tarbell's Exhibition at the St. Botolph Club," *Boston Evening Transcript* (17 February 1904): 9.

59. Leader, "Boston Lady," 244–248, 255–256.

60. *Ladies' Home Journal* 30 (March 1913): 17.

61. Fairbrother, "Painting in Boston," 79.

62. I. M. Rubinow and Daniel Durant, "The Depth and Breadth of the Servant Problem," *McClure's Magazine* 34 (March 1910): 576.

63. Helen Watterson Moody, *The Unquiet Sex* (New York: Charles Scribner's Sons, 1898), 144.

64. Sutherland, *Americans and Their Servants,* 93; *Biltmore Estate: A National Historic Landmark* (Asheville, N.C.: Biltmore Co., 1993), 39.

65. Samuel Eliot Morison, *One Boy's Boston, 1887–1901* (Boston: Houghton Mifflin, 1962), 18; Pettengill, *Toilers of the Home,* 367–368.

66. Images of liveried domestics appeared regularly in advertisements in women's magazines during this period. For a single issue of *Ladies' Home Journal* (vol. 30, March 1913), in which Paxton's *Breakfast* appears, maidservants are pictured with carpet sweepers, wall paint, face cream (the worker takes it from her employer's jar), cooking lard, table mats, and odorless dress shields (for the mistress, not the maid).

67. Beatrice Farwell traces the history of the motif in "Courbet's 'Baigneuses' and the Rhetorical Feminine Image," in *Woman as Sex Object,* ed. Thomas B. Hess and Linda Nochlin, *Art News Annual* 38 (1972): 64–79. Few American artists attempted the theme before the 1920s. Those who did worked in the liberal atmosphere of Europe. Two such images that depict a servant tending her nude mistress are *La Toilette,* by Julius L. Stewart (1905, private collection), and *Young Woman at Her Toilet,* by Gari Melchers (ca. 1912, Belmont, Gari Melchers Memorial Gallery, Fredericksburg, Va.).

68. Pierce, *Tarbell and the Boston School,* 62. See Hugh Honour's discussion of the Bazille painting in *The Image of the Black in Western Art,* vol. 4, bk. 2 (Cambridge: Harvard University Press, Menil Foundation, 1989), 206.

69. Charles H. Caffin, *The Story of American Painting* (New York: Frederick A. Stokes, 1907), 166–167.

70. Charles De Kay, "The Society of American Artists," *Harper's Weekly* 37 (22 April 1893): 373.

71. See ch. 4 in Eunice Lipton's *Looking into Degas: Uneasy Images of Women and Modern Life* (Berkeley: University of California Press, 1986), 151–186.

72. Sadakichi Hartmann, *A History of American Art,* new rev. ed., vol. 2 (Boston: L. C. Page, 1932), 238. Unlike work produced in England and France, nineteenth-century American art rarely represented prostitutes and their activities. An exception is Henry Bebie's *Conversation Group of Baltimore Girls* (ca. 1873–1875, Peale Museum, Baltimore).

73. As inscribed in the top corner, the painting was a gift to Frank Duveneck. The predominantly brown tones and bravura brushstrokes suggest the style of the painting's recipient. Pierce, *Tarbell and the Boston School,* 200. See also Doreen Bolger Burke's description of Tarbell's *Across the Room* in *American Paintings in the Metropolitan Museum of Art,* vol. 3 (New York: Metropolitan Museum of Art, Princeton University Press, 1980), 438.

74. Leader, "Boston Lady," 251.

75. Phyllis Palmer, *Domesticity and Dirt: Housewives and Domestic Servants in the United States, 1920–1945* (Philadelphia: Temple University Press, 1989), 138–147.

76. Campbell, *Prisoners of Poverty,* 234–235.

77. Ibid., 135; Katzman, *Seven Days a Week,* 216–217; Van Raaphorst, *Union Maids Not Wanted,* 81.

78. Dudden, *Serving Women,* 216–217, 321n.

79. Theodore Dreiser, *Jennie Gerhardt* (New York: Boni & Liveright, 1911), 132, 140, 422–423.

80. Ednah D. Cheney, "The Women of Boston," in *The Memorial History of Boston,* vol. 4 (Boston, 1880–1881), quoted by William L. Vance, "Redefining Boston," in *The Bostonians: Painters of an Elegant Age, 1870–1930,* 24.

81. Henry Adams, *The Education of Henry Adams,* ed. Ernest Samuels (Boston: Houghton Mifflin, 1973), 384–385, 447.

82. The earliest version of *Mr. and Mrs. Newlywed's New French Cook* may have been published by Underwood and Underwood in 1900. William C. Darrah, *The World of Stereographs* (Gettysburg, Pa.: W. C. Darrah, 1977), 65–68.

83. Banta, *Imaging American Women,* 213–217; Henry C. Pitz, "Charles Dana Gibson, Delineator of an Age," in *The Gibson Girl and Her America: The Best Drawings of Charles Dana Gibson,* ed. Edmund Vincent Gillon, Jr. (New York: Dover, 1969), vii–xi. Another of Gibson's 1903 cartoons, "By Way of Change," depicts a domestic staff seated in the formal dining room, merrily enjoying themselves as the mistress and daughter serve them. *Life* 42 (30 July 1903): 104–105.

84. *Boston Transcript* (10 April 1911), quoted by Oswaldo Rodriguez Roque, *Directions in American Painting, 1875–1925: Works from the Collection of Dr. and Mrs. John J. McDonough* (Pittsburgh: Museum of Art, Carnegie Institute, 1982), 56.

85. An unidentified clipping from Paxton's scrapbook includes an advertisement for Wanamaker's Department Store. Included in the pictorial inventory of household items—muffin pans, scrub brushes, bird cages, and a sewing machine—is a reproduction of *The House Maid.* Paxton scrapbook, Paxton papers.

86. Unidentified clipping, Paxton scrapbook, Paxton papers.

87. The figurine appears to be late nineteenth century, based on an earlier prototype (ca. 1700) made for Japanese residential display alcoves. Information about the ceramic piece and the social functions of geishas was provided by Louise A. Cort, curator of ceramics, Freer Gallery of Art and Arthur M. Sackler Gallery, Smithsonian Institution, Washington, D.C., interview with author, 18 May 1992. See also John LaFarge's description of the *gei-sha* in *An Artist's Letters from Japan* (New York: Century Co., 1897), 10, 222–223.

88. By the late nineteenth century, Boston had become the center for Asian art connoisseurship in the United States. Colonial Bostonians had earlier amassed fine collections of Far Eastern ceramics and textiles through a successful maritime trade. After a surge of interest in Japanese and Chinese art in the 1870s, their descendants added new acquisitions to their family heirlooms. Fairbrother, "Tarbell's Paintings of Interiors," 230, 234n.

89. Paxton's painting *Nellie and Phryne* (ca. 1924), which shows a nude model who contemplates the same small sculpture, caused a sensation when it was exhibited. See "'Phryne' Again in Row after 2300-Year Rest," *Boston Traveler* (18 March 1924). Clipping in Paxton scrapbook, Paxton papers.

90. The original figurine, manufactured by Goupil in 1868, was rendered by Falguière and touched up by Gérôme. Gerald M. Ackerman, *The Life and Works of Jean-Léon Gérôme* (London: Sotheby's Publications, 1986), 54–55, 110, 308.

91. Athenaeus, *The Deipnosophists,* trans. Charles Burton Gulick, vol. 6 (Cambridge: Harvard University Press, 1959), 185, 187; Plutarch, *Moralia,* trans. Harold North Fowler, vol. 10 (Cambridge: Harvard University Press, 1960), 443.

92. Leader, "Boston School and Vermeer," 176.

93. Edward A. Snow, *A Study of Vermeer* (London: University of California Press, 1979), 60.

94. For example, Lizzie Young, the model for *The House Maid* (fig. 6-7) and *A Girl Sweeping* (fig. 6-1), also appears wearing a sequined evening gown in *Lamplight and Daylight* (1911, estate of the artist). Lee, Gammell, and Krause, *Paxton,* 130, 140–141.

95. Banta, *Imaging American Women,* 104–105, 111–114. See also Kathleen Pyne, "Evolutionary Typology and the American Woman in the Work of Thomas Dewing," *American Art* 7 (Fall 1993): 13–29.

96. Banta, *Imaging American Women,* 152; William Merritt Chase, "How I Painted My Greatest Picture," *Delineator* 72 (December 1908): 969.

97. Lorinda Munson Bryant, *American Pictures and Their Painters* (New York: John Lane, 1917), 116–117.

98. Other paintings that portray the young Irish servant include *Portrait of Bessie Price* (1897, collection, Nelson H. White), *Young Woman* (ca. 1898, Metropolitan Museum of Art), and *Seated Angel* (1899, Wadsworth Athenaeum, Hartford, Conn.). Polla Price and groundskeeper Edward Meehan were the models for the peripheral figures in Thayer's *Caritas* lunette for Bowdoin College. Nelson C. White, *Abbott H. Thayer: Painter and Naturalist* (Hartford: Connecticut Printers, 1951), 66–67, 75–77; Ross Anderson, *Abbott Handerson Thayer* (Syracuse, N.Y.: Everson Museum, 1982), 68–69.

99. Anderson, *Thayer,* 69.

100. William H. Gerdts, *Masterworks of American Impressionism* (New York: Harry N. Abrams, Thyssen-Bornemisza Foundation, 1990), 122.

101. "The Fine Arts: Exhibition of the Ten Americans," *Boston Evening Transcript* (12 April 1909): 13.

102. Elizabeth Aslin, *The Aesthetic Movement: Prelude to Art Nouveau* (London: Elick Books, 1969), 98.

103. Roger B. Stein, "Artifact as Ideology: The Aesthetic Movement in Its American Cultural Context," in *In Pursuit of Beauty: Americans and the Aesthetic Movement* (New York: Metropolitan Museum of Art, 1986), 22–51; Van Wyck Brooks, *New England: Indian Summer* (New York: E. P. Dutton, 1950), 453.

104. J. D. Jump, *Matthew Arnold* (London: Longmans, Green, 1965), 148–149; Matthew Arnold, *Culture and Anarchy,* in *The Portable Matthew Arnold,* ed. Lionel Trilling (New York: Viking Press, 1949), 473, 498–499. Thanks to Kathleen Pyne for sharing her thoughts concerning Arnold's theories and late nineteenth-century painting.

105. Fairbrother, "Painting in Boston," 69.

106. Spofford, *Servant Girl Question,* 42.

107. Dudden, *Serving Women,* 170–171.

108. Pettengill, *Toilers of the Home,* 240.

109. Solomon, *Ancestors and Immigrants,* 84–87, 136–137, 140–143.

110. K. A. Miller, "Class, Culture, and Immigrant Group," 120; Stephanie Coontz, *The Social Origins of Private Life: A History of American Families, 1600–1900* (London: Verso, 1988), 256.

111. E. A. Ross, *The Old World and the New* (New York, 1913), quoted by Diner, *Erin's Daughters,* 94–95; Katzman, *Seven Days a Week,* 70–71.

112. Mark Sullivan, *Our Times, 1900–1925,* intro. Dewey W. Grantham, vol. 3 (New York: Charles Scribner's Sons, 1971), vii–viii.

113. Ibid., 398–399.

114. Higham, *Send These to Me,* 54–55; Solomon, *Ancestors and Immigrants,* 200–205.

115. Calvin Coolidge, "Whose Country Is This?" *Good Housekeeping* 72 (February 1921): 13–14.

116. "The Chinese in Massachusetts," *Massachusetts Labor Bulletin* 25 (February 1903): 1; Higham, *Send These to Me,* 36, 50–52; Fuchs, *American Kaleidoscope,* 112–116; Sucheng Chang, "European and Asian Immigration into the United States in Comparative Perspective, 1820s to 1920s," in *Immigration Reconsidered,* ed. Virginia Yans-McLaughlin (New York: Oxford University Press, 1990), 62–63.

117. Coolidge, "Whose Country Is This?" 107.

118. Though the figure is late nineteenth century, it represents a woman from an earlier era. Information about these artifacts was provided by Jan Stuart, assistant curator of Chinese art, Freer Gallery of Art and Arthur M. Sackler Gallery, Smithsonian Institution, Washington, D.C., interview with author, 13 May 1992.

119. Dolores Hayden, *The Grand Domestic Revolution: A History of Feminist Designs for American Homes, Neighborhoods, and Cities* (Cambridge: MIT Press, 1981), 22. Diner points out that Irish Catholic women, having cultural differences with the feminist agenda, were seldom involved with the suffrage movement, *Erin's Daughters,* 147–153.

120. Margaret Deland, "The Change in the Feminine Ideal," *Atlantic Monthly* 105 (March 1910): 298–299.

121. Leader, "Boston Lady," 1–2; Fairbrother, "Painting in Boston," 86–87; Gammell, *Boston Painters,* 130–131, 178–179.

122. Kenyon Cox, *The Classic Point of View* (1911; reprint, New York: W. W. Norton, 1980), 3–4.

123. Roland Wood, "The Fight for Culture in the New World: Modes, Morals, and Manners of Today," *Arts and Decoration* 12 (25 March 1920): 137.

124. Katzman, *Seven Days a Week,* 71–72.

125. After 1920, African American women comprised the single largest group in service. They too left the occupation whenever other work possibilities arose. Katzman, *Seven Days a Week,* 71–72, 222.

126. Ibid., 78–79, 87–88; 198–199, 221; Palmer, *Domesticity and Dirt,* 67–68.

127. Palmer, *Domesticity and Dirt,* 13; Susan Strasser, *Never Done: A History of American Housework* (New York: Pantheon Books, 1982), 178. Phyllis Palmer's *Domesticity and Dirt* and Judith Rollins's *Between Women: Domestics and Their Employers* (Philadelphia: Temple University Press, 1985) provide thorough examinations of family-servant dynamics in twentieth-century American households. Their findings may also be heard on audiocassette from papers given at "The View from the Kitchen," National Trust for Historic Preservation Conference, Boston, 25 October 1994.

128. Cox, *Classic Point of View,* 23–24.

129. Spofford, *Servant Girl Question,* 42.

## CONCLUSION

1. Royall Tyler, *The Contrast: A Comedy in Five Acts* (New York: AMS Press, 1970), 54; Lillian Pettengill, *Toilers of the Home: The Record of a College Woman's Experience as a Domestic Servant* (New York: Doubleday, Page, 1903), 242. Despite the term's reintroduction, "servant" faded from common usage once again in the late 1930s. For example, in its listing of headings, the *Reader's Guide to Periodic Literature* discontinued the heading "servant" in 1940; thereafter readers are referred to "Household employees."

2. Harriet Prescott Spofford, *The Servant Girl Question* (Boston, 1881; reprint, New York: Arno Press, 1977), 159–160.

3. Guy C. McElroy, *Facing History: The Black Image in American Art, 1710–1940* (Washington, D.C.: Bedford Arts, Corcoran Gallery of Art, 1990), xi.

4. "Social Conditions in Domestic Service," *Massachusetts Labor Bulletin* 13 (February 1900): 1.

5. [Robert Tomes], "Your Humble Servant," *Harper's New Monthly Magazine* 29 (June 1864): 53.

6. According to sociologist Judith Rollins, such behavior rituals are still viable in employer-domestic interaction today. She has determined that household workers consciously recognize and maintain linguistic, gestural, and spatial deference as an unspoken requirement of employment. See ch. 5 in her *Between Women: Domestics and Their Employers* (Philadelphia: Temple University Press, 1985).

7. Phyllis Palmer, *Domesticity and Dirt: Housewives and Domestic Servants in the United States, 1920–1945* (Philadelphia: Temple University Press, 1989), 144–146.

# Index

Page numbers in italics refer to illustrations